英语影视与文化鉴赏
English Movies & Cultural Essentials

刘诺亚 ◎ 编著

华中科技大学出版社
http://www.hustp.com
中国·武汉

图书在版编目(CIP)数据

英语影视与文化鉴赏 / 刘诺亚编著.— 武汉：华中科技大学出版社，2021.6（2022.6重印）
ISBN 978-7-5680-7093-5

Ⅰ.①英… Ⅱ.①刘… Ⅲ.①电影-鉴赏-英国 ②电影-鉴赏-美国 Ⅳ.①J905.1

中国版本图书馆CIP数据核字（2021）第113712号

英语影视与文化鉴赏 　　　　　　　　　　　　　　　　　　　　　　　　　刘诺亚　编著
Yingyu Yingshi yu Wenhua Jianshang

策划编辑：刘　平
责任编辑：刘　平
封面设计：刘诺亚
责任校对：张汇娟
出版发行：华中科技大学出版社（中国•武汉）　　电话：(027)81321913
　　　　　武汉市东湖新技术开发区华工科技园　　邮编：430223
录　　排：湖北新华印务有限公司
印　　刷：武汉市籍缘印刷厂
开　　本：787mm×1092mm　1/16
印　　张：17　　插　　页：2
字　　数：476千字
版　　次：2022年6月第1版第2次印刷
定　　价：59.90元

本书若有印装质量问题，请向出版社营销中心调换
全国免费服务热线：400-6679-118　　竭诚为您服务
版权所有　　侵权必究

学影视英语,赏英语文化
——《英语影视与文化鉴赏》序

余承法

(湖南师范大学外国语学院教授、博士生导师)

师兄诺亚教授命我为他的新书《英语影视与文化鉴赏》作序,我高兴之余,有点惶恐,因为我很少观影看剧,对时尚的影视英语知之甚少,更谈不上研究,唯恐说出外行话,写下礼节性套语。我带着任务拜读了整本书稿,感受最深的是两大亮点:鲜活的时代感和强大的吸引力。

首先,该书应时代而生,顺潮流而动。21世纪以来,随着全球化浪潮的推进,尤其在习近平主席提出"一带一路"倡议以来,沿线各国不管在历史传统和语言文字方面,还是在社会制度和宗教信仰方面,都存在差异,"一带一路"建设面临诸多机遇和挑战。在这样的时代背景下,跨文化能力显得尤为重要。高校不仅要着眼于培养各学科的专业人才,还要培养从事国际交流的跨文化人才,尤其是涉外国际化服务型人才。

2018年颁布的《外国语言文学类教学质量国家标准》在对外语类专业学生的素质要求、知识要求和能力要求中,都提到了与跨文化相关的能力和知识:在素质要求中,外语类专业学生应具有"中国情怀和国际视野";在知识要求中,"应掌握外国语言知识、外国文学知识、区域与国别知识";在能力要求中,"应具备外语运用能力、文学赏析能力、跨文化交际能力、思辨能力等"。《外国语言文学类教学质量国家标准》还要求,在课程体系的总体框架中,应该"特别突出能力培养和专业知识建构,特别突出跨文化能力、思辨能力和创新能力培养"。2020年出版的《普通高等学校本科外国语言文学类专业教学指南(上)——英语类专业教学指南》,对专业核心和方向课程做出了具体的规定和描述,其中"英语影视文学"被列为文学方向的选修课程。《英语影视与文化鉴赏》的出版正合时宜,在英语类人才培养实践方面率先迈开了步伐。不久前发布的《大学英语教学指南》(2020版)对大学生跨文化教育、跨文化交际能力培养,以及课程设置、课程结构和课程内容等也做出了明确的规定和说明,强调跨文化交际课程旨在进行跨文化教育,帮助学生了解中外不同的世界观、价值观、思维方式等方面的差异,培养学生的跨文化意识,提高学生社会语言能力和跨文化交际能力。该书的出版也为全国大学英语教学在文化类选修课程方面提供了多元的教材选择和新鲜的教学资源。同时,该教材积极响应国家颁布的文件中对课程思政的要求,在编写内容和体例方面将思政教育元素有机融入影视文化课堂,有利于培养学生的反思意识和批判精神,培养具有"家国情怀、国际视野和创新思维"、具有坚定文化自信的应用复合型人才。

其次,该书具有强大的吸引力和强烈的时尚感。语言学习和文化理解相互关联,二者相辅相成,缺一不可。英语影视素材是大学生喜闻乐见的学习材料,但目前很多影视欣赏课

程流于形式，只是课堂上播放一部电影，课后写一篇读后感，学习的深度和广度受到了限制，学习质量和效果大打折扣。虽然已有一些同类教材或出版物，但编写体例单一，组织形式简单，内容缺乏深度和厚度，不能激发学生的兴趣和耐心。有鉴于此，该教材开创性地从影视资源中提炼出17个英语文化主题，包括恋爱、婚姻、父母、职场、交友、娱乐、女权、校园等日常生活中的热门话题，对丰富多样的短视频和文字材料进行有序编排，同时配以有针对性的和实用的课堂训练和练习，旨在打破"聋子英语"或"哑巴英语"的学习现状，营造原汁原味、真实地道的英语学习环境，提高英语学习的趣味性、新鲜度、时尚感，鼓励情景式语言学习和探究式文化鉴赏。

诺亚教授多年来勤心搜集和整理英语学习资源，积累了丰富的教材编写和课程建设经验。本教材是他在出版普通高等教育英语"十二五""十三五"规划教材《英语演讲艺术》和《英美影视演讲欣赏》之后的又一力作，其中《英语演讲艺术》荣获湖北省第八届高校教学成果奖，同名课程也被评为教育部"双万计划"湖北省一流课程，取得了良好的社会效益和经济效益。我有理由相信，《英语影视与文化鉴赏》一定会受到广大师生和英语学习者的欢迎和喜爱。

是为序。

2020年12月18日
于长沙岳麓山游学庵

前　言

随着全球化的加速发展以及21世纪日益频繁的国际交流与合作,中国大学生有越来越多的机会与来自不同国家、不同文化背景的人进行跨文化接触和交流,但是,由于不同国家在历史传统、语言文字、社会制度和宗教信仰等方面存在巨大差异,他们在跨文化接触中不可避免地会遇到许多跨文化交流和沟通的问题和困难。为了进行有效而得体的跨文化交流,作为跨文化接触的主要群体,中国大学生需要具备较强的跨文化能力。

调查结果表明,中国大学生跨文化能力总体上处于较弱至一般水平之间(彭仁忠,2017)。他们在外国文化知识、跨文化交流技能和跨文化认知技能等能力维度方面均处于较弱水平。大学生跨文化能力维度发展的具体情况如下:首先,大学生在本国文化知识方面能力较强,对外国文化知识掌握不足;其次,大学生在态度方面能力较强,如愿意和来自不同文化的外国人进行交流,愿意尊重外国人的生活方式和习俗,愿意学好外国语言和文化等;再次,大学生在跨文化交流出现误解与对方协商时,在出现语言交流障碍借助身体语言或其他非语言方式进行交流时,在使用外语和来自不同社会文化背景和领域的人成功进行交流等方面的能力均较弱,在跨文化认知技能方面的能力也普遍偏低。

近年来,《外国语言文学类教学质量国家标准》(2018)、《英语专业本科教学指南》(2020)和《大学英语教学指南》(2020)等纲领性文件已从国家教育政策层面强调了跨文化能力培养的重要性和紧迫性。这些文件对外语类专业学生的素质要求、知识要求和能力要求都提到了与跨文化相关的能力和知识结构,要求学生具有"中国情怀和国际视野",掌握"外国语言知识、外国文学知识、区域与国别知识",具备"外语运用能力、文学赏析能力、跨文化交际能力、思辨能力等"。在课程设置方面,要求"突出能力培养和专业知识建构,特别突出跨文化能力、思辨能力和创新能力培养"。《大学英语教学指南》指出,大学英语课程是普通高等学校通识教育的一个重要组成部分,兼具工具性和人文性。其人文性主要体现在两个方面:第一,大学英语课程的重要任务之一是进行跨文化教育。大学英语在注重发展学生通用语言能力的同时,应进一步增强其学术英语或职业英语交流能力和跨文化交际能力,以使学生在日常生活、专业学习和职业岗位等不同领域或语境中,能够用英语恰当、有效地进行交流。文件还对课程设置、课程结构和课程内容做出了安排和规定。大学英语教学的主体内容可分为通用英语、专门用途英语和跨文化交际三部分,并由此形成相应的三大类课程。《英语专业本科教学指南》对英语类专业核心和方向课程做出了具体的描述和规定,其中"英美电影赏析"被列为文化类选修课程。本教材的出版响应了国家文件,在实践中贡献了一分力量。

本教材将奉献丰富的跨文化资源和短小精悍的影视片段,配以精心设计的文本体例和

配套习题，线上线下互动。编者从影视资源中提炼出17个英语文化主题（分为17章）进行探讨，作为文化欣赏、主题思考和语言训练的切入点，帮助学习者加深对英美文化的理解，培养跨文化交际的意识和能力。主题内容涵盖英语文化主要的热点话题和生活各方面，包括恋爱、婚姻、家庭、职场、女权、校园、选举、邻居等，资源素材多样，范例鲜活生动。每章包括文化背景、视频欣赏、话题讨论、英语辩论、词汇练习和角色扮演等六个部分，所涉及的视频片段（文字脚本）中的生词都配以汉字注释，每章有多至十个视频例子，且每个例子的体裁种类不尽相同，彰显出本教材独特的优势和特点。

　　本教材旨在帮助英语学习者从文化角度接触英语和训练语言，虽然聚焦于英语国家文化，但是也弃其糟粕取其精华，引导学生形成正确的意识形态和价值观，比如在一些文化主题方面进行中西对比，指出其缺点和弊处。同时，本教材让学生在深度理解文化和解决文化问题的过程中学习语言，适合教师和学生采用主题学习法（theme learning）和任务学习法（task approach）进行教与学。学习者在完成主题和任务的过程中边做边学，其优点和效果是传统被动的教与学无法比拟的。教材后还附有《中国大学生跨文化能力自测量表》，供学习者自测评估使用。

　　本教材适用于影视欣赏、英语文化、英语视听说、英语辩论等课程使用，不仅适合课堂教学使用，也完美适合个人自学。

　　在编写过程中，编者参考和引用了一些国内外学术著作和教材的内容以及一些国外网络资源，在此一并感谢。因作者水平有限，时间仓促，肯定还存在不足和谬误之处，恳请专家、学者和使用本书的教师同人及同学们提出宝贵的批评和建议，以期将来修订和完善。

<div style="text-align:right">

作者
2020年岁末

</div>

致　　谢

《英语影视与文化鉴赏》如期付梓,我暂时得以释怀。这是一本迷人的书。巴赫说过,回报美好事物的最好方式是尽情地享受它。愿读者你也一样,这是本书作者最大的愿望和感激。

回首历程,感受颇多。得益于二十年来的语料收集和素材积累,本书从酝酿到完成初稿都很顺利,但接下来无数次的修改则令人殚精竭虑。有时候半夜灵感忽至,睡意全无,就披衣下床,继续伏案。有的章节修改达十多次,至书稿下厂印刷时仍觉不甚满意,颇多遗憾。

由于时间紧迫,该出版项目也让编辑超负荷运转,所以我首先要感谢华中科技大学出版社的刘平编辑,他同时负责多个出版项目,却给予这本书优先待遇。本书得以顺利出版,受益于他独到的眼光和思想,以及无与伦比的职业精神。一本书的出版汇集了很多人的心血,除作者和编辑外,校对人员、排版人员、美术编辑等都付出了辛勤的劳动,在此一并致谢。

其次,我要感谢荆楚理工学院校长、博士生导师刘建清教授和教务处处长田原教授对我的支持和鼓励;感谢湖南师范大学外国语学院博士生导师余承法教授拨冗写序,他的学识与成就,作为同门师兄的我只能望其项背;感谢我的教学团队——英语视听说教学团队,对我的支持;感谢美国外教 Steve Kempker 为我耐心解答相关文化问题并做文字校订工作;感谢我的两位大学同窗——湖北师范大学教务处秦海涛处长和华中科技大学博士生导师雷洪德教授——对我恒久不变的友情……

同时,我还要感谢即将阅读和使用此书,能够发现和容忍里面的谬误和不足之处,给我提出批评和建议的学者、同行、学生及其他读者。由于时间、水平和能力等因素所限,本书诸多缺点在所难免。假以时日和努力,我相信它会变得越来越好。

<div style="text-align:right">

刘诺亚
2021年仲夏

</div>

Contents

Chapter 1 CLIMBING THE LADDER 成功人生 ·· 1
 1.1 Cultural tidbits ··· 1
 1.2 Video examples ·· 3
 1.3 Questions for discussion ·· 11
 1.4 Debate ··· 11
 1.5 Vocabulary exercises ·· 11
 1.6 Role-play and reenactment ·· 12

Chapter 2 PICK-UP LINES 搭讪艺术 ·· 13
 2.1 Cultural tidbits ·· 13
 2.2 Video examples ··· 14
 2.3 Questions for discussion ·· 23
 2.4 Debate ··· 23
 2.5 Vocabulary exercise ··· 23
 2.6 Role-play and reenactment ·· 23

Chapter 3 SWEET SORROW OF LOVE 酸甜爱情 ··· 25
 3.1 Cultural tidbits ·· 25
 3.2 Video examples ··· 26
 3.3 Questions for discussion ·· 36
 3.4 Debate ··· 36
 3.5 Vocabulary exercises ·· 36
 3.6 Role-play and reenactment ·· 37

Chapter 4 TYING THE KNOT 婚姻殿堂 ··· 38
 4.1 Cultural tidbits ·· 38
 4.2 Video examples ··· 40
 4.3 Questions for discussion ·· 49
 4.4 Debate ··· 49
 4.5 Vocabulary exercises ·· 49
 4.6 Role-play and reenactment ·· 50

Chapter 5 DOMESTIC LIFE 油盐酱醋 ·· 51
 5.1 Cultural tidbits ·· 51

5.2 Video examples ·· 53
5.3 Questions for discussion ······························· 64
5.4 Debate ·· 64
5.5 Vocabulary exercises ···································· 64
5.6 Role-play and reenactment ····························· 65

Chapter 6 PARENT & PARENTING 为人父母 ·········· 66
6.1 Cultural tidbits ·· 66
6.2 Video examples ·· 68
6.3 Questions for discussion ······························· 81
6.4 Debate ·· 82
6.5 Vocabulary exercises ···································· 82
6.6 Role-play and reenactment ····························· 82

Chapter 7 LGBTQ COMMUNITY 同性问题 ············ 83
7.1 Cultural tidbits ·· 83
7.2 Video examples ·· 87
7.3 Questions for discussion ······························· 96
7.4 Debate ·· 96
7.5 Vocabulary exercises ···································· 96
7.6 Role-play and reenactment ····························· 97

Chapter 8 SEX & SEXUALITY 性的窘困 ··············· 98
8.1 Cultural tidbits ·· 98
8.2 Video examples ·· 100
8.3 Questions for discussion ······························· 111
8.4 Debate ·· 112
8.5 Vocabulary exercises ···································· 112
8.6 Role-play and reenactment ····························· 112

Chapter 9 CAMPUS LIFE 校园一瞥 ···················· 114
9.1 Cultural tidbits ·· 114
9.2 Video examples ·· 118
9.3 Questions for discussion ······························· 131
9.4 Debate ·· 132
9.5 Vocabulary exercises ···································· 132
9.6 Role-play and reenactment ····························· 133

Chapter 10 FEMINISM IN DILEMMA 女权困惑 ······· 134
10.1 Cultural tidbits ··· 134
10.2 Video examples ··· 136

10.3 Questions for discussion ·········· 143
10.4 Debate ·········· 143
10.5 Vocabulary exercises ·········· 143
10.6 Role-play and reenactment ·········· 144

Chapter 11 GENERATION GAP 代沟问题 ·········· 145
11.1 Cultural tidbits ·········· 145
11.2 Video examples ·········· 147
11.3 Questions for discussion ·········· 155
11.4 Debate ·········· 155
11.5 Vocabulary exercises ·········· 155
11.6 Role-play and reenactment ·········· 155

Chapter 12 RELIGION & RELIGIOUS 宗教生活 ·········· 157
12.1 Cultural tidbits ·········· 157
12.2 Video examples ·········· 160
12.3 Questions for discussion ·········· 167
12.4 Debate ·········· 167
12.5 Vocabulary exercises ·········· 167
12.6 Role-play and reenactment ·········· 167

Chapter 13 RACISM & STEREOTYPING 种族偏见 ·········· 169
13.1 Cultural tidbits ·········· 169
13.2 Video examples ·········· 171
13.3 Questions for discussion ·········· 180
13.4 Debate ·········· 180
13.5 Vocabulary exercises ·········· 180
13.6 Role-play and reenactment ·········· 180

Chapter 14 IN & OUT OF COURT 法庭内外 ·········· 182
14.1 Cultural tidbits ·········· 182
14.2 Video examples ·········· 188
14.3 Questions for discussion ·········· 202
14.4 Debate ·········· 202
14.5 Vocabulary exercises ·········· 202
14.6 Role-play and reenactment ·········· 203

Chapter 15 CORPORATE WORMS & OFFICE DRONES 无奈职场 ·········· 204
15.1 Cultural tidbits ·········· 204
15.2 Video examples ·········· 206
15.3 Questions for discussion ·········· 215

15.4 Debate ··· 215
15.5 Vocabulary exercises ··· 215
15.6 Role-play and reenactment ··· 216

Chapter 16 TO VOTE & TO BE VOTED FOR 选举生活 ··············· 217
16.1 Cultural tidbits ··· 217
16.2 Video examples ·· 219
16.3 Questions for discussion ·· 226
16.4 Debate ·· 227
16.5 Vocabulary exercises ··· 227
16.6 Role-play and reenactment ·· 227

Chapter 17 BETWEEN THE FENCES 邻里之间 ······················ 228
17.1 Cultural tidbits ··· 228
17.2 Video examples ·· 231
17.3 Questions for discussion ·· 241
17.4 Debate ·· 242
17.5 Vocabulary exercises ··· 242
17.6 Role play and reenactment ·· 242

附录1 练习参考答案 ··· 243
附录2 经典影视台词 ··· 246
附录3 中国大学生跨文化能力自测量表(吴卫平等,2018) ··············· 253
References ·· 255
Bibliography ·· 258

CHAPTER 1

CLIMBING THE LADDER
成功人生

1.1 Cultural tidbits

According to *American Heritage Dictionary of the English Language* (the Fifth Edition), there are three meanings to success: 1. The achievement of a goal, of something desired, planned, or attempted: e.g. success in business, in an academic field, etc. 2. The gaining of fame or prosperity or attainment of higher social status; e.g. an artist spoiled by success. 3. One that is successful: e.g. a successful plan. The verb of it is to succeed, the noun of which, is not to be confused with succession, with a complete different meaning.

When it comes to success in general situations in life, we refer more often than not to a favorable or prosperous outcome; attainment of wealth, position, fame, etc. in a word, the opposite of failure. To climb the social ladder means to improve one's position within the hierarchical (等级的) structure or makeup of a culture, society, or social environment. To climb the corporate ladder means to go up in a corporate environment in order to get a higher position with better pay.

Success means different things to different people in different stages of their life and has a distinct mark of evolvement of times and culture. On a personal level, it may be closely associated with one's beliefs and values. A case in point, while nowadays most Americans measure one's success in wealth, social status and position, others may find it in a personal contribution to the community and the differences he makes in other people's lives, regardless of his wealth and status, which was once deemed as a single greatest value and virtue in the Puritan (清教徒) times in America, when the belief they held was "to make money, save money and to donate the money." And to judge and to show one's pledge and loyalty to God, one has to achieve a certain level of material success.

Another incentive of gaining success is vanity (虚荣), an inevitable and natural outreach and by-product (副产品). Thus, success gives one a sense of satisfaction, thrill, self-esteem, followed by many others, or in the case of Maslow's hierarchy of needs, self-actualization (自我实现).

Self-actualization is a term that has been used in various psychology theories, often in slightly different ways. The term was originally introduced by Kurt Goldstein for the motive to realize one's full potential. Expressing one's creativity, quest (寻求) for spiritual

enlightenment, pursuit of knowledge, and the desire to give to and/or positively transform society are examples of self-actualization. The concept was brought most fully to prominence in Abraham Maslow's (马斯洛,美国社会心理学家和比较心理学家,人本主义心理学创始人) hierarchy (等级) of needs theory as the final level of psychological development that can be achieved when all basic and mental needs are essentially fulfilled and the "actualization" of the full personal potential takes place. Self-actualization can be seen as similar to words and concepts such as self-discovery, self-reflection, self-realization and self-exploration. After self-actualization, there's self-transcendence, i.e., the spiritual pursuit beyond material gains with a much higher goal, such as philanthropy (博爱), altruism (利他主义), etc.

As Abraham Maslow noted, the basic needs of humans must be met (e.g. food, shelter, warmth, security, sense of belonging) before a person can achieve self-actualization—the need to be good, to be fully alive and to find meaning in life. Yet, Maslow argued that reaching a state of true self-actualization in everyday society was fairly rare.

Here comes the question as to how to succeed, again, to which, the answer varies in different minds, but it's safe to say that gaining success through hard work on one's own, and within the legal boundary (界限) is the American dream version of success.

The opposite of success is failure. Failure is the state or condition of not meeting a desirable or intended objective. In science, there's a saying: "If you want to succeed, double your failure rate." (Thomas J. Watson)

As is for success, the criteria for failure are heavily dependent on context of use, and may be relative to a particular observer or belief system. A situation considered to be a failure by one might be considered a success by another, particularly in cases of direct competition or a zero-sum game. Similarly, the degree of success or failure in a situation may be differently viewed by distinct observers or participants, such that a situation that one considers to be a failure, another might consider to be a success, a qualified success or a neutral situation.

Failure can be differentially perceived from the viewpoints of the evaluators. A person who is only interested in the final outcome of an activity would consider it to be an Outcome Failure if the core issue has not been resolved or a core need is not met. A failure can also be a Process failure whereby although the activity is completed successfully, a person may still feel dissatisfied if the underlying process is perceived to be below expected standard or benchmark.

Loser is a derogatory (贬义的) term for a person who is (according to the standards of the observer) generally unsuccessful or undesirable. In American culture, a loser is sometimes called a bum, an underdog, someone that fails to achieve in a specified way or habitually loses, with the latter even worse in people's mind and judgment.

"The law of the jungle" or jungle law (丛林法则) is an expression that means "every man for himself", "anything goes", "survival of the strongest", "survival of the fittest", "kill or be killed", "dog eat dog" and "eat or be eaten". *The Oxford English Dictionary* defines the Law

of the Jungle as "the code of survival in jungle life, now usually with reference to the superiority of brute force or self-interest in the struggle for survival." It is also known as jungle law or frontier justice. The phrase was used in a poem by Rudyard Kipling(吉卜林,英国作家,1907年获诺贝尔文学奖。) to describe the obligations and behavior of a wolf in a pack. However, this use of the term has been overtaken in popularity by the other interpretations above.

A rat race(激烈竞争) is an endless, self-defeating, or pointless pursuit. It conjures up(联想) the image of lab rats racing through a maze to get the "cheese" much like society racing to get ahead financially. The term is commonly associated with an exhausting, repetitive lifestyle that leaves no time for relaxation or enjoyment. This is often used in reference to work, particularly excessive or competitive work; in general terms, if one works too much, one is in the rat race. This terminology contains implications that many people see work as a seemingly endless pursuit with little reward or purpose.

The following are excerpts(片段) on how to succeed in business, in life, the definition of success, and how to deal with frustrations of failures in life and so on. Some are serious, some are funny, and some are between, a bit of both.

1.2 Video examples

- **Video 1-1: *Sky's the limit***

Okay. Here's the deal. I'm not here to waste your time. I hope you're not here to waste mine. So I'm gonna keep this short. If you become an employee of this firm, you will make your first million within three years. Okay? I repeat that: you will make a million dollars within three years of your first day of employment at J. T. Marlin. There is no question whether or not you'll become a millionaire here. The only question is how many times over. You think I'm joking? I am not joking. I'm a millionaire. It's a weird(奇怪的) thing to hear, right? I'll tell ya. It's a weird thing to say. I am a f-ing millionaire. And guess how old I am? Twenty-seven. You know what that makes me here? A f-ing senior citizen(老员工). This firm is entirely comprised of(组成) people your age, not mine. Lucky for me, I'm very f-ing good at

my job, or I'd be out of one（失业）. You guys are the new blood（新员工）. You're gonna go home with the Kessef（希伯来语：金银财宝）. You are the future big swinging dicks（风云人物）of this firm. Now, you all look money-hungry, and that's good. Anybody tells you money is the root of all evil doesn't f-ing have any. They say money can't buy happiness? Look at the f-ing smile on my face. Ear to ear（咧嘴笑，笑得开心）, baby. You want details? Fine. I drive a Ferrari 355 Cabriolet（活顶小轿车，车顶可折叠或拆除的敞篷车）. What's up? I have a ridiculous house（豪宅）in the South Fork（地名：南福克）. I have every toy you could imagine, and best of all, kids, I'm liquid（拥有现金或流动资产的）. So, now you know what's possible. Let me tell you what's required. You are required to work your f-ing ass off（拼命工作）at this firm. We want winners here, not pikers（胆小鬼，畏首畏尾的人）. A piker walks at the bell（循规蹈矩）. A piker asks how much vacation you get in the first year. Vacation? People come and work at this firm for one reason: to become filthy rich. We're not here to make friends. We're not saving the manatees（海牛）, guys. You want vacation time? Go teach third grade, public school. Okay. The first three months at the firm are as a trainee. You make $150 a week. After you're done training, you take the Series Seven（业务考试）. Pass that; you become a junior broker（初级掮客）and you open accounts（账户）for your team leader. You open 40 accounts; you start working for yourself. Sky's the limit（天高任鸟飞）. Word（说几句）about being a trainee. Friends, parents, other brokers, they're gonna give you shit（刁难，瞧不上）. It's true. $150 a week? Not a lot of money. Pay them no mind（不必在意）. You need to learn this business, and this is the time to do it. Once you pass the test, none of that's gonna matter. Your friends are shit. Tell them you made 25 grand last month; they won't f-ing believe you. F- them! F- them! Parents don't like the life you lead? "F- you, Mom and Dad!" See how it feels when you're making their f-ing Lexus（雷克萨斯，日本丰田汽车旗下品牌）payments. Now, go home and think about it. Think about whether it's really for you. If you decide it isn't, it's nothing to be embarrassed about. It's not for everyone. Thanks. But if you really want this, you call me on Monday and we'll talk. Just don't waste my f-ing time. Okay, that's it.

 This is a speech made by the newly rich team leader who talks to the new trainees in a brokerage（经纪业务）company. To succeed with or without a conscience? This is the first lesson the newbies（新人）have to learn from their team leader in the speech: Money talks; Money makes the mare go. But money absolutely is not the root of all evils; instead, it's the source of personal happiness and value.

 The speaker starts with himself as an example of success: young and filthy rich, and convinces the audience to be like him. It's the world of rat race, of jungle rule. For them, the only way to change others' view at them, and first of all, to survive, is to make enough money, to own material wealth. The speaker achieves an impact with his imposing and overbearing tones as well as body languages, not to mention his foul languages.

A broker（经纪人，中间商，掮客），one who acts as an intermediary（中间人）in a sale or other business transaction between two parties. Such a person conducts individual transactions only, is given no general authority by the employers, discloses the names of the principals（主角，关键人物）in the transaction to each other, and leaves to them the conclusion of the deal. The broker neither possesses the goods sold nor receives the goods procured; brokers take no market risks and transfer no title to goods or to anything else. A broker earns a commission（佣金，提成）, or brokerage, when the contract of sale has been made, regardless of whether the contract is satisfactorily executed. The broker is paid by the party that started the negotiation. In practice, merchants and other salespeople act as brokers at times.

Brokers are most useful in establishing trade connections in those large industries where a great many relatively small producers (e.g., farmers) compete for a wide market. They operate in strategic cities and keep in active touch with the trade needs of their localities and with one another. They are important in determining prices, routing goods（设计产品路线）, and guiding production, and in those functions play a part similar to that of the highly organized exchanges. Brokers also negotiate trades in property not directly affecting production; examples are stockbrokers（股票经纪人）and real estate brokers（房产经纪人）.

There is also information broker（信息经纪人）. One is that collects and sells personal information about individuals, although other organizations specialize in this service, also called a "data broker". The other is an individual who searches for information for clients. Information brokers use various resources including the Internet, online services that specialize in databases, public libraries and books. They also make plain old-fashioned telephone calls.

- **Video 1-2:** *They paddle their little asses off*

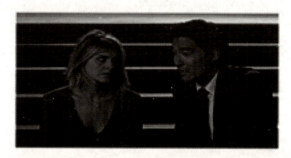

Amanda: I have to do this on my own. But every time I go on a date. It's...it's that!
Sam: Well, I guess that makes you a duck.
Amanda: What?
Sam: My mom used to say that certain people were like ducks, because they make everything look easy. Up there on the water, like they don't have a care in the world（无忧无虑）, but if you look below the surface, you can see how hard their lives really are. Just paddling their little asses off（拼命划水）... just... just like that.

Amanda: You know that's a Chinese saying, right? <u>The duck thing</u>（鸭子理论）?
Sam: That's American.
Amanda: Oh, OK. Who knows more about ducks? They eat millions of them in Beijing.
Sam: <u>Good point</u>（有道理，说的也是）. Ha. I must be more Chinese than I thought.

In this clip, the man expounds the duck theory, and reveals another side of success: success doesn't come easy, but those successful people who make it look easy because we don't see what's behind and what's inside, i.e. the hardship they endure, the effort and sacrifice they make.

Some words about cultural references of ducks. In 2002, psychologist Richard Wiseman and his colleagues at the University of Hertfordshire, UK, finished a year-long LaughLab experiment, concluding that of all animals, ducks attract the most humor and silliness; he said, "If you're going to tell a joke involving an animal, make it a duck." The word "duck" may have become an <u>inherently</u>（内在的）funny word in many languages, possibly because ducks are seen as silly in their looks or behavior. Of the many ducks in fiction, many are cartoon characters, such as Walt Disney's Donald Duck, and Warner Bros.' Daffy Duck, and so on. The duck is also the nickname of the University of Oregon sports teams as well as the Long Island Ducks minor league baseball team.

Some interesting phrases about ducks:

<u>To put the ducks in a row</u> means putting things in good order;

<u>A lame duck</u> means an incapable person, and a lame duck president means an outgoing president;

<u>A sitting duck</u> means an easy target or victim;

<u>To duck out</u> means to escape from a duty and leave work undone;

<u>To duck something</u> means to escape from it or avoid answering a question/dealing with a problem;

<u>Like water off a duck's back</u> means no or little effect of a warning or some advice;

<u>A dead duck</u> means someone doomed to fail, or a useless person or object;

<u>To duck down</u> means to bend down or lower the body so as not to be seen or discovered.

- **Video 1-3:** *It's about the difference you make in people's lives*

And he believes that when you've worked hard, and done well, and walked through that doorway of opportunity, you do not slam it shut behind you: no, you reach back, and you give other folks the same chances that helped you succeed.

So when people ask me whether being in the White House has changed my husband, I can honestly say that when it comes to his character, and his convictions, and his heart, Barack Obama is still the same man I fell in love with all those years ago. Yeah, he's the same man who... who started his career by turning down high paying jobs, and instead working in struggling neighborhoods where a steel plant had shut down, fighting to rebuild those communities and get folks back to work, because for Barack, success isn't about how much money you make, it's about the difference you make in people's lives.

In this speech in a re-election campaign for former President Obama, Michelle Obama talks about her husband's idea of success, which is to let others share the same opportunities that you have had and to help them to succeed. This kind of success has nothing to do with money, but with the difference you make in other people's lives.

In this speech, Michelle mentions that Obama worked in community service when he was young. Community service is a non-paying job performed by someone or a group of people for the benefit of the public or its institutions. Performing community service is not the same as volunteering, since it is not always performed on a voluntary basis. It may be performed for a variety of reasons:

It may be required by a government as a part of citizenship requirements, generally in lieu of (通过) military service. It may be required as a substitution (替代) of, or in addition to, other criminal justice sanctions (刑罚处罚) — when performed for this reason it may also be referred to as community payback (回馈社区). It may be mandated (强制要求) by schools to meet the requirements of a class, such as in the case of service-learning or to meet the requirements of graduation. In the UK, it has been made a condition of the receipt of certain benefits, including disability-related ones.

Some educational jurisdictions in the United States require students to perform community service hours to graduate from high school. In some high schools in Washington, for example, students must finish 200 hours of community service to get a diploma. In colleges, though not technically considered a requirement, many colleges include community service as an unofficial requirement for acceptance. Some require that their students also continue community service for some specific number of hours to graduate. Some schools also offer unique "community service" courses, awarding credit to students who complete a certain number of community service hours. Some academic honor societies, along with many student organizations such as fraternities (大学生兄弟会) and sororities (大学生姐妹会) in North America, require

community service to join and others require each member to continue doing community service.

- **Video 1-4:** *Live your life with integrity*

But my idea of success is different today. And as you grow, you'll realize the definition of success changes. For many of you, today, success is being able to hold down 20 shots of tequila（龙舌兰酒）. For me, the most important thing in your life is to live your life with integrity, and not to give into（屈从于）peer pressure（同辈压力）, to try to be something that you're not. To live your life as an honest and compassionate（有同情心的）person, to contribute in some way.

Ellen DeGeneres's idea of success is expounded in a playful but serious way: no matter how the definition of success changes, the most important thing in your life is to live your life with integrity, honesty and compassion, and contribute in some way.

Peer pressure (or social pressure) is direct influence on people by peers, or an individual who gets encouraged to follow their peers by changing their attitudes, values, or behaviors to conform to（与……保持一致, 遵守）those of the influencing group or individual. This type of pressure differs from general social pressure because it causes an individual to change in response to a feeling of being pressured or influenced from a peer or peer group. Peer pressure can affect individuals of all ethnicities, genders, and ages. Peer pressure serves as an important leadership tool and a powerful motivator for charitable giving and voting.

- **Video 1-5:** *Believe, retrieve and achieve*

Mother: My God, that dress is beautiful on you!
Daughter: Thanks, Vess gave it to me.
Mother: Oh, What are you two doing tonight?

Daughter: Oh, no, I'm not going out with Vess. I'm going out with Toby. Toby is the guy that I like.

Mother: All right, that should be fun.

Daughter: Yeah, oh, I actually kind of feel nervous about it, just because I feel like I might say something stupid. And I don't really know...

Mother: Stop! Believe, retrieve（找回）, achieve. It is a mantra（真言,信条）that I teach all my clients who suffer from performance anxiety（表现焦虑,怯场）. Believe that it happened yesterday; retrieve your confidence; achieve your goals. Just don't concede（放弃,认输）.

Daughter: Hmm, OK. Well, I'm off to do some believing it and hopefully achieving it. Love you. Have fun!

Mother: Unless you have something else?

Daughter: No. I'm good. See you. Have fun!

 In this dialogue between mother and daughter, the mother gives her daughter a lecture on success in life, dealing with anxiety. And the mantra is to believe, retrieve and achieve. This example is trying to tell us that to achieve our goal, confidence is essential. Self-confidence is having confidence in one's self. Confidence can be a self-fulfilling prophecy（自我实现的预言）as those without it may fail or not try because they lack it and those with it may succeed because they have it rather than because of an innate ability. Self-confidence does not necessarily imply "self-belief" or a belief in one's ability to succeed. For instance, one may be inept（笨拙的,无能的）at a particular sport or activity, but remain "confident" in one's demeanor（举止）, simply because one does not place a great deal of emphasis on the outcome of the activity. When one does not dwell on（纠结）negative consequences one can be more "self-confident" because one is worrying far less about failure or the disapproval of others following potential failure. One is then more likely to focus on the actual situation which means that enjoyment and success in that situation is also more probable. Belief in one's abilities to perform an activity comes through successful experience and may add to, or consolidate, a general sense of self-confidence.

Video 1-6: *Number one loser*

The Olympics is really my favorite sporting event, although I think I have a problem with that silver medal. I think if I was an Olympic athlete, I would rather come in last than win the silver, if you think about it. You know, you win the gold, you feel good. You win the bronze, you think, well, at least I got something. But you win that silver, that's like, congratulations, you almost won! Of all the losers, you came in first of that group. You are the number one loser.

A silver medal is a medal awarded to the second-place finisher, or runner-up, of contests or competitions such as the Olympic Games, etc. In this comedy performance, the stand-up comedian gives an insight into the silver medal winner in an Olympic event. In his perspective, it is more of a shame than a win. The observation is keen, unique and funny.

Video 1-7: *Instant credibility, instant respectability, and instant money*

Asian parents want their kids to be doctors. It's <u>weird</u>(奇怪的) because it's true. Right? I know because my parents were the same way. They just wanted us to be doctors. It was like this <u>obsession</u>(执着,迷恋). They just wanted us to be doctors. And it's <u>insidious</u>(阴险的,暗中为害的) as well, because when Asian parents want their kids to be doctors, helping people is like on the bottom of the list of reasons…if it even <u>makes the list</u>(上了名单) of reasons to go into medicine. Helping people is like the unfortunate <u>by-product</u>(副产品) of becoming a <u>health care professional</u>(医疗从业者). It's like, when they first see that they can't even believe it. They're like, "What the f-? You gotta help people?" Well, whatever, get it out of the way. But don't let it get in the way of what this is really about. It's about the money and <u>prestige</u>(荣耀), right? It's the money and prestige. Because if you're a first-generation immigrant, your children becoming doctors is the quickest way you can <u>turn it around</u>(时来运转) in one generation. Instant credibility, instant respectability, instant money. Right? You flip the <u>clan narratives</u>(家族历史记载) around. Boom! Started from the bottom, now we're here! We're doctors!

In this comedy show, the comedian shows us a picture of Asian parents' way of wanting their children to succeed. To be a doctor for the sake of becoming a doctor, without any concern of other causes, except that for making money, credibility and respectability. Anything

else good is just a by-product which should get out of the way if it is in the way to success. It is half true but funny.

In Western civilization, wealth is connected with a <u>quantitative type of thought</u>（量化思维）, involving for instance the quantitative analysis of nature, the rationalization of warfare, and measurement in economics. The invention of coined money and banking was particularly important. Aristotle describes the basic function of money as a universal instrument of quantitative measurement – "for it measures all things" – making things alike and comparable due to a social "agreement of acceptance." In that way, money also enables a new type of economic society and the definition of wealth in measurable quantities.

1.3 Questions for discussion

1) Do you think you're successful in your present stage of life?
2) Who are the most successful people in your mind?
3) What are the distinctive traits of successful people in your mind?
4) Is peer pressure bad for people? Are you presently under any peer pressure?
5) Please share with your class your experience where you once solved an emergency/crisis, or achieved some success in your mind.

1.4 Debate

Winning is always successful.

1.5 Vocabulary exercises

be comprised of, liquid, have no care in the world, peddle, slam, integrity, peer pressure, compassion, mantra, retrieve, insidious, prestige

Try and fill in the blanks of the following sentences with words listed above in proper forms.

1) The committee is _____ representatives from both the public and private sectors.
2) The man loves to _____ gossips in the office.
3) To vent his anger, he _____ the door behind him and stormed off.
4) Failure from this competition for the grant makes him under more _____.
5) Having a _____ for someone means you share pity, sympathy, and understanding for someone who is suffering.
6) A _____ organization or community means one that encourages people to move up the ladder in their professions.
7) His _____ prevents him from doing anything wrong.

8) _____, he spends all his time and money traveling the world.
9) My _____ is, when bad things happen, I tell myself they could have been worse.
10) There is no way that we can _____ the lost data.
11) The changes are_____, and will not produce a noticeable effect for 15 to 20 years.
12) Success in transformation and reform brings the university more _____.

1.6 Role-play and reenactment

1) Please review Video 1-2, acting out the scene with two people discussing the duck theory. Feel the part of culture about an outsider's view on success.
2) Please review Video 1-3, acting out the speech made by Michelle Obama on the definition of success.
3) Please review Video 1-5, acting out the scene of a mother's lecture to her daughter. Feel the part of culture about mantra, or your own motto on success.
4) Please review Video 1-6, acting out the comedy for fun.
5) Please review Video 1-7, acting out the comedy for fun. Feel the part of cultural difference between China and America.

PICK-UP LINES
搭讪艺术

2.1 Cultural tidbits

To "pick up" means to seduce or flirt with a potential sexual partner. A pick-up line is a sentence, phrase, or question used to start a flirtatious conversation with a potential romantic or sexual partner. One of the most-heard lines is "Have we met before?", even though it has a very low success rate with the ladies, for its creepy nature. PUA, an abbreviation for "pick-up artist（把妹达人）", a man devoted to using a specific set of strategies in order to seduce (pick up) women, and who perhaps instructs other men in how to do the same.

As a social and sometimes sexual behavior, <u>flirting</u>（调情，挑逗）involves <u>verbal</u>（口头）or written communication, as well as body language, by one person to another, either to suggest interest in a deeper relationship with the other person, or if done playfully, for amusement. In most cultures, it is socially disapproved for a person to make <u>explicit</u>（明确的，露骨的）sexual advances in public, or in private to someone not romantically acquainted, but indirect or suggestive advances may at times be considered acceptable.

Flirting usually involves speaking and behaving in a way that suggests a mildly greater intimacy than the actual relationship between the parties would justify, though within the rules of social etiquette, which generally disapproves of a direct expression of sexual interest in the given setting. This may be accomplished by communicating a sense of playfulness or irony.

What makes a man or woman desirable, of course, is a complex and highly personal mix of many <u>qualities and traits</u>（性格和品质）. But falling for someone who is much more desirable than oneself, whether because of physical beauty or <u>attributes</u>（特质）like charm, intelligence, wit or status, Baumeister (2011) calls this kind of mismatch "prone to find their <u>love unrequited</u>（单相思，单恋）" and that such relationships are falling upward. According to some psychologists, opposites do attract, but it is not possible to attract those whose moral values are different.

Flirting with someone happens when you interact with someone in a way that shows romantic or sexual interest, or to tease or <u>trifle with</u>（逗弄）someone <u>alluringly</u>（迷人地）. One of the common responses we hear is: "Are you flirting with me?" And the act of it is flirtation, meaning a behavior intended to arouse sexual feelings or advances without emotional commitment. Flirting happens when you try to approach someone in a half joking and serious

way, or to chat someone up. And the sentences or remarks are called pick-up lines.（搭讪语）One-liner（俏皮话）is some witty or funny remark that makes people laugh and be impressed, similar to punch line（包袱，笑点）in stand-up comedy shows in English culture.

The possible consequences are you're accepted or rejected. Contrasted with redamancy（回馈爱的行为）or the act of reciprocal love（回馈的爱）, a rejected flirtation is called unrequited love, which has been a frequent subject in popular culture. Movies, books and songs often portray the would-be lovers' persistence. Unrequited love or one-sided love is love that is not openly reciprocated or understood as such by the beloved. The beloved may not be aware of the admirer's deep and strong romantic affection, or may consciously reject it. The Merriam Webster Online Dictionary（韦伯斯特在线字典）defines unrequited love as "not reciprocated or returned in kind."

Platonic（柏拉图式的）friendships provide a fertile soil（肥沃的土壤）for unrequited love. Thus the object of unrequited love is often a friend or acquaintance, someone regularly encountered in the workplace, during the course of work, school or other activities involving large groups of people. This creates an awkward situation in which the admirer has difficulty in expressing their true feelings, a fear that revelation of feelings might invite rejection, cause embarrassment or might end all access to the beloved, as a romantic relationship may be inconsistent with the existing association. Nonetheless, the literary record suggests a degree of euphoria（狂喜，兴奋异常）in the feelings associated with unrequited love, which has the advantage as well of carrying none of the responsibilities of mutual relationships. Certainly, "rejection, apparent or real, may be the catalyst（催化剂）for inspired literary creation…'the poetry of frustration'."

Eric Berne（2003）considered that "the man who is loved by a woman is lucky indeed, but the one to be envied is he who loves, however little he gets in return. How much greater is Dante（但丁，意大利诗人）gazing at Beatrice（贝雅特丽齐，但丁作品《神曲》中理想化了的一位佛罗伦萨女子之名）than Beatrice walking by him in apparent disdain（藐视）".

How would you approach and express your romantic desire to a girl/boy you've never met or talked to before? Or what would you do in a kind of nonreciprocal situation? Or if you were turned down or thrown a wet blanket? Today we're going to look at some interesting occasions.

2.2 Video examples

- **Video 2-1:** *I hope your plane crashes*

Joe: Let me tell you what happened. This is what Darwin was talking about, when he said natural selection（自然选择）. And I'm the one that wasn't selected.

Liam: Joe, women are absolutely everywhere. OK? See that girl at the counter（吧台）?

Joe: Yeah?

Liam: What do you give her?（你给她打多少分？）

Joe: Solid（确凿的）...six.

Liam: If you flip it around（倒过来看）, you get a nine. Come on, talk to her!

Joe: Come on, dude.

Liam: What?

Joe: No, I can't.

Liam: Why?

Joe: That's ridiculous.

Liam: Why is that ridiculous?

Joe: Are you kidding? Don't you think it's a little psycho（精神变态的，变态人格的）just go and walk up to a girl?

Liam: Yeah. It's psycho when you shank（俚语：自慰）in a shower afterwards.

Joe: All right. Just walk up to her.

Liam: Yeah. Don't bring a knife!

Joe: I'm not bringing it. I'm just...Do I look like Ronald Reagan（罗纳德·里根，美国第40任总统【1981-1989】）?

Liam: On a good day（在他春风得意的时候）... Hesitation leads to masturbation（手淫）.

Joe: Hmm. Hi!

Girl: Hi!

Joe: Oh.（to the bar tender）Is this the butter（黄油）? ...I hope your plane crashes.

Liam: Maybe he's her brother.

Joe: They kissed! What is she? Angelina Jolie（安吉丽娜·朱莉，美国演员，联合国难民署特使）? Can I order a big bowl of shame, please?

In this video, Joe is egged by Liam to approach a girl and chat her up（亲昵地攀谈，与某人搭讪）. He gathers his nerve to do so, but with hesitation. It turns out the girl is not alone. The embarrassment is such that he wants to kill himself, and his friend as well. That's why he

says he hopes his friend's plane crashes. Comparatively speaking, this is not the worst scenario, with some comic ending. Things could have been worse and more embarrassing otherwise.

In this scene, we see how Joe acts in dealing with a <u>courtship</u>（恋爱，求偶）. Normal body language can include <u>flicking the hair</u>（撩头发）, eye contact, brief touching, open stances, <u>proximity</u>（近处晃悠）, etc. Verbal communication of interest can include alterations in vocal tone, such as pace, volume, and intonation. Flirting behavior varies across cultures due to different modes of social etiquette, such as how closely people should stand, how long to hold eye contact, how much touching is appropriate and so forth. Nonetheless, some behaviors may be more universal. For example, ethologist（伦理学家）Irenäus Eibl-Eibesfeldt (1999) found that in places as different as Africa and North America, women exhibit similar flirting behavior, such as a <u>prolonged stare</u>（长时间盯着看）followed by a <u>head tilt</u>（侧头）away with a little smile.

- **Video 2-2: *You want to buy me a drink?***

Liam: Let me guess. <u>Capricorn</u>（摩羯座）.
Girl: <u>Libra</u>（天秤座）.
Liam: Close enough, you want to buy me a drink?
Girl: What makes you think you deserve a drink?
Liam: Because I'm a good person...by Hollywood standards, and by normal standards I'm a f-ing asshole...Do you...do you think I'm a good person?
Girl: I don't even know you.
Liam: Well, the truth is I think you're really cute. And I was <u>compelled</u>（强迫，难以抗拒）to meet you. And normally I wouldn't <u>succumb to</u>（屈从于）my <u>compulsion</u>（强迫行为）so easily, but I'm trying to embrace a new philosophy of life that involves succumbing. And I mean, if I have to succumb, I succumb to you. Hey, think of this drink as an investment for the possibility of mutual growth in this potential relationship. And years from now, when our daughter jumps into your lap and asks you, oh, how did mommy and daddy meet? You can look at this drink. It's the best investment ever made. But you know, I gotta know if you're <u>committed to</u>（决心去做）continuing this

conversation before I waste my time. I'll just go and be talking and nothing happens.

Girl: I'm Georgia（女子名：乔治娅）by the way.

Liam: What a coincidence（巧合）! That is my favorite confederate state（联邦州，指佐治亚州）.

With a glib tongue（油嘴滑舌），cheeky（厚脸皮的）Liam succeeds in talking the girl into buying him a drink, and also the possibility of ensuing（后续的）events afterwards. His strategy is of two steps. The first one: I like you—so buy me a drink—the reason is my philosophy of life—succumbing to compulsion. The second one: Think of this drink as an investment—our daughter is involved in this drink—if no chance, I'll just walk away and be my miserable self. It proves a great strategy, and he wins the girl's heart.

A horoscope（占星术，星象）is an astrological chart or diagram（天文图）representing the positions of the sun, the moon, planets, astrological aspects and sensitive angles at the time of an event, such as the moment of a person's birth. No scientific studies have shown support for the accuracy of horoscopes, and the methods used to make interpretations are pseudoscientific（伪科学的）. In modern scientific framework no known interaction exists that could be responsible for the transmission（传达）of the alleged influence between a person and the position of stars in the sky at the moment of birth.

When we ask people about their horoscope, the question is usually, "What's your horoscope?" Other similar ways are: What's your star sign? What's your zodiac sign? In love affairs, according to astrology（星相学），when stars are aligned（排列整齐，排成一条线），it's good luck for the lovers, and vice versa, when the stars are crossed, it's bad fortune for them, hence, they're star-crossed（命运不好的，倒霉的）and are called star-crossed lovers.

- **Video 2-3: *Would you like to see a card trick?***

Boy 1: Would you like to see a card trick?

Girl: Sure.

Boy 2: All right, pick one and don't show me. Come on, tear it up（撕掉）.（The girl tears the card up）

Boy 2: Can I have it back?

Boy 1: Give it to him.（Boy 2: Give it to me）

Boy 2: Is this your card?

Girl: No. Not even close. (leaving)

Boy 2: Check your bra.

Girl: What?

Boy 2: Check your bra.

Girl: Ah, that's amazing! How did you do that?

Boy 2: I can't tell you. (whispering to boy 1: It's working!)

Girl: Listen, I'm having a party at my house next weekend. You should come.

Boy 2: That sounds amazing!

 This is another trick for winning a girl's heart: a trick, a magic up your sleeve (暗藏……以备不时之需). It could turn things around, from being a geek (呆子) with no friends and no girls around or close to being a popular one. We don't know how the trick is pulled off, but the dramatic effect is achieved; that is, winning a girl's heart maybe difficult but possible.

 In this scene, the girl is impressed with the boy's card magic show, and asks him to join her party at home. Americans are known to be party animals. All kinds of parties are involved in their life for them to get together and socialize: cocktail party (鸡尾酒晚会), tea party, reception (招待晚会), garden party (花园晚会), dinner party, surprise party, birthday party, soirees (正式晚会), dances and balls (交谊舞晚会), block party (街区聚会), costume or fancy dress party (化妆舞晚会), Christmas caroling party (圣诞欢歌晚会), fundraising party (筹款晚会), graduation party, housewarming party (乔迁喜庆晚会), welcome party, farewell party, pre-party (预热派对), after party (余兴派对). There are marriage-related parties, including bridal shower (新娘送礼晚会——为新娘结婚前举办的晚会), bachelor party (单身汉晚会——为新郎结婚前举办的晚会), bachelorette party (单身女郎聚会), wedding reception (婚礼招待会), divorce party, baby shower (宝宝派对——孩子出生庆祝会), etc. There are parties for teenagers and young adults, including pool party (泳池派对), keg party (啤酒派对). There is always loud house music, techno music (动感强烈的电子乐), or industrial music (工业噪音音乐). A house party is a party where a large group of people get together at a private home to socialize. House parties that involve the drinking of beer pumped from a keg are called keg parties or "keggers". These parties are popular in North America, the United Kingdom, and Australia and are often attended by people under the legal drinking age. Sometimes, even older party-goers run afoul of the law (以身试法) for having provided alcoholic beverages to minors. Arrests may also be made for violating a noise ordinance (噪音规定), for disorderly conduct (扰乱秩序行为), and even for operating a "blind pig" (违法贩卖禁酒的场所), an establishment that illegally sells alcoholic beverages.

 On college campuses, parties are often hosted by fraternities and sororities (兄弟会和姐妹会). Outdoor parties include bush parties (丛林聚会, also called "field parties", held in a

secluded area of a forest) and beach parties (沙滩聚会, held on a sandy shoreline of a lake, river, or sea). These parties are often held around a <u>bonfire</u> (篝火). School-related parties for teenagers and young adults include <u>proms</u> (高中正式舞会) and <u>graduation parties</u> (大学毕业晚会), which are held in honor of someone who has recently graduated from a school or university.

- **Video 2-4: *You gotta be an angel from heaven***

Man: Excuse me. Ha, real quick. Just I was over here. I just wondered, did it hurt?
Woman: Did what hurt?
Man: When you fell. You know, from heaven. Cause I was thinking, with a face like that, you gotta be an angel. Right?
Woman: (laughing) <u>Has that line ever worked for you?</u> (你这套管用吗?)
Man: I got you to laugh. Right? It's step one.

In English, verbal flirting is called a pick-up line, like this one from this video—Did it hurt when you fell from heaven? A pick-up line means a sentence, phrase, or question used to start a <u>flirtatious</u> (调情的) conversation with a potential romantic or sexual partner. Another sometimes creepy cliché is "Have we met before?" It is some men's favorite pick-up line, though it has a very low success rate with the ladies. If you hit on girls with such creepy pick-up line, it wouldn't be surprising if you keep getting rejected.

- **Video 2-5: *Would you hold this for me?***

Boy: Do you mind if I sit here? Ah, ah, I'm trying to make that woman over there jealous.
Girl: That homeless woman is sleeping.

Boy: Is she homeless? Oh.

Girl: Why on earth do you want to make her jealous?

Boy: Ah, she is actually my ex.

Girl: Your ex?

Boy: Yes, since we broke up, life has not been easy for her.

Girl: No. I would say not.

Boy: So what should we talk about?

Girl: Talk about? As in a conversation? I don't know about all that. I'm not even sure about your sitting here. Certainly wouldn't want to end up like your ex.

Boy: I certainly wouldn't want to either. The name is Finn by the way.

Girl: Penelope.

Boy: Penelope? That's a nice name. It suits you.

Girl: Well. Finn. It was lovely meeting you.

Boy: You are leaving already?

Girl: Yes.

Boy: Oh...ah. Would you hold this for me? May I walk with you?

Girl: Come on then.

In this scene, the thick-skinned boy plucks up his courage to chat the girl up, with a little creative made-up story of his so-called ex. Far-fetching and cheeky, but it breaks the ice. And he's even brazen（厚脸皮的）enough to offer his hand to the girl to ask for a walk with her.

- Video 2-6: *Will you marry me?*

Waitress: Can I get you guys, eh, anything else?

Man: Will you marry me?

Waitress: Excuse me?

Man: Will you marry me? Seriously! Think about it. What could possibly be more romantic than throwing away your entire life and running off with some handsome dark-haired stranger you spotted（见到）across a restaurant?

Man's friend: Err. I'm sorry. He's had a lot of syrup（糖浆,犹言他药吃多了昏了头）.

Waitress: Okay.

Man's friend: Okay, he's had a lot of syrup?
Waitress: Okay, I'll marry you.
Man: What?
Waitress: Yes. Yes! I'll marry you! Jane! Jane! Will you cover for (顶班) me?
Jane: Where're you going?
Waitress: (screaming) I'm getting married! To this guy! Come on! Come on!
Man's friend: Go. Get out of here! I got the bill (我来买单).
Man: Oh, err, Anderson.
Waitress: Oh, Katie.
Man: Katie. Hi.
Waitress: Two kisses.

In this video, love falls from heaven with an out-of-the-blue pick-up line from the boy customer the girl serves. She would never have dreamed this would happen to her in her life and it caught her off guard (猝不及防). A little melodramatic and far-fetching for a girl to accept marriage proposal from a total stranger though, the girl couldn't help jumping at the chance, in spite of the craziness, to escape from the tedious and dead-end job and way of life that needs some excitement and adventure.

- **Video 2-7:** *That's something in common already*

Girl: Uh, excuse me. Can you help me? I'm looking for the Bregman Building.
Boy: Bre…Bregman? That's across campus. So you go past the Admin Building (行政楼). You turn left, walk for about 30, 40 yards. It will be…
Girl: You know I'm really bad for directions. Do you think you could show me?
Boy: Yeah, I've got class.
Girl: Please? I'd really appreciate it.
Boy: Yeah, yeah, I can, this way.
Girl: What's your major?
Boy: Mechanical engineering.
Girl: Really? I'm an architecture. That's something in common already.

Boy: I'm actually more industrial application sort of thing, so…Any way, that's Bregman there. I've really got go, sorry.

Girl: Oh, wait, I didn't get your name!

Boy: Somner, Somner.

Girl: Well, thanks, Somner, I'd been lost without you. Whoa, hey, can I make it up to you? Maybe we can go out to coffee or something?

Boy: Su…huh, sure.

Girl: Why don't you put your number in here.

Boy: Yeah, OK.

In this scene, the girl takes the initiative to chat up (＜英,非正式＞【受异性吸引而】亲昵地攀谈,与某人搭讪) the boy. The strategy is three steps: first, show me the way; second, we have something in common; three, ask for the name and telephone number.

Besides some specific sentences in a specific scenario from above, here are some more (some with a little creative touch, but some such clichés) pick-up lines:

1) I lost my phone number. Can I have yours?

2) Do you have a map? I just keep on getting lost in your eyes.

3) I bet you $20 you're gonna turn me down (拒绝我).

4) — Do you see that incredibly beautiful girl over there?
　　— Yes?
　　— You're even more beautiful than she is.

5) — Can I take your picture?
　　— Why?
　　— So I can show Santa Claus what I really want for Christmas.

6) Your legs must be tired because you've been running through my mind all night.

7) Your lips look so lonely. Would they like to meet mine?

8) I've gotta call my mom and tell her I just found the girl I'm going to marry.

9) Do you believe in love at first sight? Or should I just walk by again?

10) Were you hurt when you fell from heaven? Because you look like an angel.

11) Have we met?

12) I know hello in 6 different languages. Which one do you want to hear tomorrow morning?

13) Is your last name Google? It's because you have everything I've been searching for.

14) Have you been to the doctor recently? because I think you're lacking some vitamin ME.

2.3 Questions for discussion

1) Have you been chatted up by someone? How did you feel and what was your response?
2) Do you believe love at the first sight? Why or why not?
3) Do you think a female should make the first move in pursuing a relationship?
4) Which pick-up lines are to your liking?
5) What do you think of PDA (public display of affection) on campus or in public places?

2.4 Debate

Love is blind.

2.5 Vocabulary exercise

> flip, chat up, be compelled to, compulsion, succumb to, coincidence, up one's sleeve, flirt, tear up, altruism

Try and fill in the blanks of the following sentences with words listed above in proper forms.

1) When I was waiting for the bus, a boy went up to me and _____, but I quickly got away from him and got on the bus.
2) He was _____ to give up the game by illness.
3) We decided who should be responsible for the housework by _____ the coin.
4) It took a lot of _____ to make father give up smoking.
5) Never will I _____ any outside pressure to change my mind.
6) You have to have some tricks _____ in case of need.
7) The company makes a policy that no _____ should happen between male and female workers in the office.
8) It was a _____ that we went into the same restaurant on a weekend evening.
9) The girl _____ the letter from her boyfriend into pieces and threw them into the bin.
10) When we care about the needs and happiness of other people other than ourselves, this act is called _____.

2.6 Role-play and reenactment

1) Please review Video 2-1, acting out the scene where one man is coercing another to chat up a girl. Feel the embarrassment and funniness.

2) Please review Video 2-2, acting out the scene about the success of hooking up with a girl. Feel the glib tongue of this man and the related cultural knowledge.

3) Please review Video 2-3, acting out the scene about the success of hooking up with a girl. Feel the campus culture of teenagers.

4) Please review Video 2-5, acting out the scene about the success of hooking up with a girl. Feel the awkwardness and confidence mixed in one man.

5) Please review Video 2-6, acting out the scene where a bizarre event happening in a restaurant. Feel the part of the restaurant culture.

6) Please review Video 2-7, acting out the scene where a girl makes the first move pursuing the boy.

SWEET SORROW OF LOVE
酸甜爱情

3.1 Cultural tidbits

As they say in English: love makes the world go round. Love is everywhere, which in its various forms acts as a major facilitator (促进因素) of interpersonal relationships and, owing to its central psychological importance, is one of the most common themes in the creative arts. From different perspectives, there are different types of love. There is love of the soul, from Greek, Agape (基督之爱,灵性之爱); and physical attraction, from Greek, Eros (性爱). There's Plato's love, or Platonic love (柏拉图式恋爱,精神恋爱)—appreciation of beauty within a person, or beauty itself. And there is also Aristotle's love (亚里士多德式恋爱)—a dispassionate virtuous love, including loyalty, virtue, equality and familiarity.

There is interpersonal love, a love between human beings. It is a much more potent sentiment than a simple liking for a person. There is love inside a marriage/relationship; there is also love affair outside a wedlock or relationship, i.e. infidelity, which is morally condemned, legally unjustifiable and socially unacceptable. There is old flame (旧情人), and there is new love. There is reciprocal love and unrequited love, which refers to those feelings of love that are not reciprocated. There is unconditional love; there is love for benefit; there is love in love's name and for love's sake. There is love of oneself (narcissism 自恋) and love of others (altruism or philanthropy, 利他主义,博爱). There is puppy love (早恋), May-December romance (老少恋,忘年恋), twilight love (黄昏恋). Here we focus on the romantic desire, the joys and pains in pursuit of love, the thrill of being in love, the loss of love and the happy endings of love, and so on and so forth.

With love comes dating. Dating is a stage of romantic or sexual relationships in humans whereby two or more people meet socially, possibly as friends or with the aim of each assessing (评估) and exploring the other's suitability as a romantic prospective partner or sexual compatibility (相容,适合) by participating in dates with the other. With the use of modern technology, people can date via telephone or computers or meet in person. This term may also refer to two people who have already decided to share romantic or sexual feelings toward each other. The American terms are "seeing someone", "going out with someone", "I'm with someone", "in a relationship", or "Tom and Shirley is an item", "…and…are a thing", "…and…are together", "…is dating…", "… and… are a couple", "…is my significant other (＜非

正式，常幽默＞至关重要的另一位【指配偶或恋人】）", a sense of the tentative exploratory part of a relationship. The meaning "She is taken" means the dating period is almost over in her part, and they're formally a "couple". Teenagers and college-aged students tend to avoid the more formal activity of dating, and prefer casual no-strings-attached（无附加条件的）experiments sometimes described as hookups（一起约会玩耍）. In American young demographic（＜常用单数＞【具有共同特征的】人群）, "Have you hooked up?" is asking some boy/girl if he/she has had the first sexual experience. It permits young women to go out and fit into the social scene, get attention from young men, and learn about sexuality. Some even bring no-strings-attached to the full and seek one-night stand（一夜情）and become friends with benefits（性伙伴）. Some less formal relationships like "We're just talking", "I'm seeing someone exclusively", "We're hanging out", "We're being casual", etc., underpins a tone of two people on a not so serious basis of relationship.

Now we enter a mixed age of traditional approaches like matchmakers, blind dating and modern ones like online dating. In Shanghai, China, there is a famous marriage market, where parents go dating on behalf of their grown-up children, because their children are too busy at work or simply just want to avoid blind dating. The price and requirement is quite steep in terms of dating and marriage in China. Still remember the girl from If You Are the One（《非诚勿扰》）who would "prefer to weep in a BMW than laugh on a bike"（宁愿坐在宝马车里哭，也不愿坐在自行车后笑）?

A dating advertisement by a woman may speak for this generation of young people's mind on dating or marriage requirement colored by materialism in present day China:

Like other women in my social circle, I have certain demands for a potential mate. He doesn't have to make much more than I do, but he must be doing at least as well as I am, and has to be compatible with me, both morally and spiritually…He should also own an apartment instead of us buying one together. Remember what Virginia Wolf said? Every woman should have a room of her own.—Wei Liu, 45, single, broadcaster

Dating and being in love is both exhilarating（使人兴奋的，令人激动的）and heartbreaking at the same time. There's the thrilling happiness, the heart-pounding excitement, and also broken hearts and other troubles in paradise. As Shakespeare said, love is a sweet sorrow. He also said, the course of true love never runs smooth. Let's buckle up and embark on the bumpy journey to taste the sweet sorrows of love.

3.2 Video examples

- **Video 3-1: *You are a great girl***

Boy: Amber, you're a great girl. You're gonna find someone just as great. Just. I'm not that person.
Girl: Sure. Still, I...I don't know. I guess I thought it was going pretty well between us. I mean, even if we're just getting to know each other.
Boy: Yeah, I mean, things weren't going bad.
Girl: So why don't you want to see me anymore? Wait a minute. Is there someone else?
Boy: No. I just need some time. Be by myself, and I can't be in a relationship right now.
Girl: Fine. Sure. Umm...Ok. Goodbye, John.
Boy: Bye.
Girl: Bye.

- **Video 3-2:** *You are a really great guy*

Man: What?
Woman: Jack, I've been thinking.
Man: You've been thinking?
Woman: Well, you are...You are a really great guy.
Man: Thank you.
Woman: But I don't think we're a good match.
Man: Huh, I...I...I don't agree. I don't...We have so much in common. We love the same music. We laugh at the same jokes. We listen to the same...
Woman: That's all true.
Man: We...we have a special connection, Molly. You know this. Right?
Woman: Jack. I... the point is I don't want to be in a relationship if I can't be there a 100

percent. You know?

Man: I understand.

Woman: You do?

Man: Yeah, I do.

Woman: I just...I want to be fair to you.

Man: You can't say I'm happy about your decision, but thank you for being very straightforward with me. I do appreciate that.

Woman: This necklace...It's...it's beautiful, but it wouldn't be right for me to keep it.

Man: No...no no no, this belongs to you. This is yours. No strings attached（无附加条件的）, OK? Come on, please. Please wear it. Please?

Woman: OK.

Man: OK.

The two cases are about breakups, one a boy with a girl; the other, a girl with a boy.

A breakup is the termination of a usually intimate/romantic relationship with someone. In this video, the girl is obviously not ready to break up with the boy, who, at the same time, offers no plausible reason on his part in doing so. The break-up is a peaceful one to some extent, though, in the sense that no scenes are caused or dramatic exchanges are made in the conversation.

There's usually a signpost, or a routine cliché in the beginning of a conversation if someone wants to initiate the breakup. Usually the sentence begins with "You're a great girl/guy...", which foreshadows the whole conversation, which, if goes on.

- **Video 3-3**: *Where have you been?*

Man: Hi.

Woman: Tom?

Man: Sarah! You still work for your folks（家庭成员，尤指父母）. I see.

Woman: Tom. What are you doing here?

Man: I had to come back in the town and clear some things up.

Woman: Oh, your father. I'm so sorry.

Man: Thanks.

Woman: Tom. Where did you go? It's been ten years.
Man: You look even prettier than when I left.
Woman: Left? You say it like you just ran out of school or something. You just vanished. Your dad didn't know where you were. We all started to think that you were dead.
Man: I'm sorry...It's a beautiful family you have there. I guess it's not Sarah Mercer anymore.
Woman: No. It's Sarah Palmer now.
Man: I never thought Axel would settle down, but he always did like you. I should go.
Woman: Wait.
Man: It's good to see you Sarah.

An old flame (旧情人) is someone with whom you once had a romantic relationship, or former lover. In this video, the woman is shocked to see her former boyfriend popping out in front of her out of nowhere. Apparently, they were in love deeply once and she still is, but things have changed, she has to refrain from her emotion outbreak. The mystery as to the man's disappearance is yet unknown and adds a tin of suspense to the romance.

In this dialogue, the woman says her name is different now. That's because in English culture, and most western cultures, when a woman marries a man, she also marries his last name, i.e., taking his last name. Traditionally, in many European countries (and the US also) for the past few hundred years, it was the custom or law that a woman would, upon marriage, use the surname of her husband, and that any children born would bear the father's surname. That is still the custom or law in many countries. In recent years there has been a trend towards equality of treatment in relation to family names, with women being not automatically required or expected, or in some places even forbidden, to take the husband's surname on marriage, and children not automatically being given the father's surname. Chinese women do not change their names upon marriage. They can be referred to either as their full birth names or as their husband's surname plus 夫人 (wife). In the past, Chinese women's given names were often not publicly known. When married, they were referred by their husband's surname, their birth surname, plus the character 氏.

- **Video 3-4: *Hey, pick me up!***

I've been dating a lot of tall girls lately, because it makes me look successful. No, no, I think tall women are beautiful. But some of them like to wear heels（高跟鞋）. That's just disrespect. I'm like, "You're five inches taller than me. Why the fu- are you wearing heels?" She's like, "It makes my ass look better." I'm like, "Your ass is at my eye level now. Neither of us look good. OK? I look like a child, and you look like a child molester（对【儿童】性骚扰者）."

Last time, last time, I took a tall girl to this concert. I don't know if you guys know this, but apparently, tall people have fun at concerts. Are you guys aware of that? I'm 5'5"（5英尺5英寸，165.1厘米）. I just go to concerts to smell other people's armpits（腋窝）. And what the fu- is the point of this? She was having a time of her life, doing what tall people do at concerts, you know. Jumping around, obstructing other people's views, seeing everything. I was frustrated. I had enough. So I just looked up at her, and I was like, "Hey, pick me up! This is bullshit. I pay for this ticket, OK? I want to see Billie Eillish（比莉·艾利什，美国女歌手）, too. Come on!"

A stand-up comedian is a professional performer who tells jokes and performs comical acts. In this stand-up performance, the comedian recounts his awkward experience dating a tall girl. The jokes are funny in the mechanism of comedy: preparing a punch line to evoke laughter or amusement at the end of a joke. With each anecdote, the actor tries to amuse the audience by making fun of or even demeaning/mocking himself in such a way that it's hilarious, outrageous and the more ridiculous, the better. As in this case, the actor mocks himself in his funny experience of courtship.

Stereotype is a set of inaccurate, simplistic generalizations about a group of individuals which enable others to categorize members of this group and treat them routinely according to these expectations. Thus stereotypes of RACIAL, SOCIAL CLASS, and GENDER groups are commonly held and lead to the perception and treatment of individuals according to unjustified preconceptions. Prevailing stereotypes in the west of Chinese people are bad drivers, knowing kung fu. Men are responsible, loyal in marriage and hardworking, etc.

- **Video 3-5:** *I need to marry a Jackie!*

Warner: To us.

Elle: Hmm.

Warner: Elle.

Elle: Yes.

Warner: One of the reasons I wanted to come here tonight was to discuss our future.

Elle: And I'm fully amenable（顺从的，顺服的）to that discussion.

Warner: Good! Well, you know how we have been having all kinds of fun lately.

Elle: Yeah.

Warner: Well. Harvard is gonna be different. Law school is a completely different world. And I need to be serious.

Elle: Of course.

Warner: I mean my family expects a lot from me.

Elle: Right.

Warner: I expect a lot from me.

Elle: Mm.

Warner: I'm planning to run for office（从政）someday.

Elle: And I fully support that. You know that, right?

Warner: Absolutely. But the thing is, if I'm gonna be a senator（议员）by the time I'm 30, I need to stop dicking around（口语:胡混）.

Elle: Oh, Warner. I completely agree!

Warner: Well. That's why I think it's time for us, Elle, Pooh Bear...

Elle: Yes?

Warner: I wish for us to break up.（Elle: I do!）（Elle以为Warner要跟她求婚）

Elle: What?

Warner: Well, I've been thinking about it. I think it's the right thing to do.

Elle: You're breaking up with me? I thought you were proposing（求婚）.

Warner: Proposing? Hum-hum, Elle! If I'm gonna be a senator, I need to marry a Jackie（Jackie Kennedy Onassis,美国第35任总统约翰·肯尼迪的夫人）, not a Marilyn（Marilyn Monroe,美国女演员）.

Elle: So you're breaking up with me because I'm too blonde?

Warner: No. That's not entirely true.

Elle: Then what? My boobs（胸部）are too big?

Warner: No. Your boobs are fine.

Elle: So when you said you'd always love me, you were just dicking around?

Warner: I do love you. I just can't marry you! You have no idea the pressure that I'm under. My family have five generations of senators（参议员）. My brother is in the top three at Yale law（耶鲁法学院）. And he just got engaged to a Vanderbilt（美国豪门家族）,

for Christ's Sake! ...Bad salad. Sweetie, oh, Pooh Bear?

Elle: Ugh!

Warner: It's not like I have a choice here, sweetheart! OK, you get the car. I'll get the check.

In this video, Elle is expecting to get proposed in this romantic dinner with her boyfriend, only to be told that he wants to break up with her. A bolt from the blue, she is too overwhelmed to accept the truth. In this movie, at the beginning, she is described as an airheaded cheer leader. This is the reason why the boy wants to dump her for a better future, and also gives her a wake-up call to make up her mind to pursue academic achievements. And she did it in the end. The funny thing in this dialogue is, even when she is being dumped by his boyfriend for a "higher purpose", she still thinks it is her blondness and boobs that get in the way of their relationship.

The word <u>senate</u>（参议院）comes from Latin（senatus）, so-called as an assembly of the seniors. In the United States all states with the exception of Nebraska（whose legislature is a <u>unicameral</u>【一院制的】body called the "Legislature" but whose members refer to themselves as "senators"）have a state senate. There is also the US Senate at the federal level.

- **Video 3-6: *Consider the line crossed!***

Girl: Oh, yeah, that feels really nice.

Boy: See. I'm not such a bad guy.

Girl: Hmm, you're a great guy. I mean, maybe in a different world, we could...

（The boy kisses the girl）

Girl: <u>Consider the line crossed!</u>（你越界了!）

Boy: Wha...O...OK, come on! I mean I thought you liked me! I understand you; you understand me!

Girl: I did, I do, but Jake, come on! We barely even know each other! And I have a boy friend, remember?

Boy: Yeah, some boyfriend, a drug dealer!

Girl: He's not a drug dealer. You know what? This little get-together of ours is over! Go

home, Jake!

Boy: It's not how this is supposed to go（事情本不该这样子发展的）.

Girl: I'm sorry, if I gave you the wrong impression, or something, but I genuinely thought we came out here to be a friend.

Boy: I am!

Girl: You're not acting like a friend right now, Jake!

Boy: OK, listen to me. I'm sorry! OK, I didn't mean any of this. We can go slow if you want to? And don't just walk away from me, not now! Not after everything we've done.

Girl: OK.

Boy: Please!

Girl: You're really starting to sound crazy now, Jake. Go home! I'll see you in school tomorrow, OK?

Boy: Come back, you now, or you'll regret it!

In this scene, the boy mistakes the girl's friendship for love for him, and intends to impose his unilateral（单边的）affection on the girl, causing the girl's intense reaction and repulsion. This is the case where friendship and love are two parallel lines and cannot be crossed sometimes. If someone crosses the line, they start behaving in an inappropriate, unacceptable or offensive way. Such expressions as "consider the line crossed!", "You overstepped the boundary", "You're way out of line", "You've crossed the line", "You've overstepped", etc. mean similar to each other and are used often in the situation.

- **Video 3-7:** *Do you mind filling out a quick survey?*

Boy: OK, I think I got one.

Girl: Sorry about my dog. OK, bye.

Boy: Oh, wait! I like your face!

Girl: Huh?

Boy: I...I mean, do you mind filling out a quick survey?

Girl: I guess not. What's the survey for?

Boy: Oh, here!

Girl: Here you go. Well, it was nice meeting you.

Boy: Yeah, it was nice to meet you, too. Do you see that? I got her number! Yeah, yeah!

In this scene, an American boy falls in love with a Chinese girl at the first sight and gets her phone number in a clever way. The nervousness, excitement and joyousness of a successful dating are overwhelming on both parties. The function of a matchmaker is called for when either/both sides show some interest and the exploration of the possibility of a match falls to the matchmaker in a delegated way.

In some societies, the parents or community propose potential partners, and then allow limited dating to determine whether the parties are suited. There is such a type of traditional courtship called 相亲（to evaluate a prospective marriage partner) in China. Parents will hire a matchmaker to provide pictures and résumés of potential mates, and if the couple agrees, there will be a formal meeting with the matchmaker and often parents in attendance. The matchmaker and parents will often <u>exert</u>（施加）pressure on the couple to decide whether they want to marry or not after a few dates.

- **Video 3-8: *This story for me is insane***

Narrator: Shanghainese women have a reputation for ambitious, successful and uncompromising.

Woman: The reason I come to Shanghai is all about my career. To find the right, long-term relationship partner for me is very similar to find the right CEO or manager in a firm. Love is actually a science. You have to learn the theory, then you have to practice. For my mum, my dad is her first love. This story for me is insane. I will never marry someone who is my first love. Without practicing, how can you find the right one?

Narrator: Young people here are determined to get ahead, believing that with enough practice, anything can be learned.

In this part, the young woman from Shanghai is talking about her ambition and her understanding of love and marriage. The new generation of young people in China now holds a very different view about the traditional ideas of their parents.

A career woman is one whose main priority in life is achieving success in her career or profession, also called a careerist, a professional who is intent on furthering his or her career by

any possible means and often at the expense of their own integrity. With the push in education many people have better careers and are then able to have the choice of family matters, personal matters, or career matters. Even though in the United States careerism is very important, family life is also a huge part of the culture. Many people start their families even while in school, then they begin their careers. Extreme careerists measure success by acknowledgements through praise and material possessions, whether it be a new office, a raise or a congratulations in front of an individual's colleagues: notice is success. In the U.S. there is an extreme drive of personal success and those who are ambitious are the ones who gain the power in an organization.

- **Video 3-9: *You want to have kids?***

Older Woman: You want to have kids?

Young man: Of course, very much.

Older Woman: Wonderful! If we are lucky, in nine months or so, we'll have a son, who will be named Chris! And we'll be one happy family. Sleepless nights, changing, feeding, soothing him, but we'll survive. And 8 years from now, you'll hit your 30s, and I'll be past 50. My boobs will sag(胸部下垂), and so will my ass. I'll find more wrinkles and white hair every single day. Not quite the MILF(〈非正式〉性感的年长女人,半老徐娘【多指性感的母亲】) any more. You'll get yourself a tasteful little sidepiece (side chick, 小三), named Cassia, who rocks your world(颠覆你的世界观). Your travel for work all the time, and your kid misses you all the time, and I cover for your filthy little lies all the time. My self-esteem goes out of the window with my looks and my husband. When you do manage to come home, we fight constantly about every little thing. The kid hears it. He thinks I'm evil. He thinks I'm being mean to his perfect little daddy. Cassia never has to deal with any of this shit. She's always in a good mood. So you decide to go and live with her, and take our kid along for the move, because he thinks I'm a bad mother. And the blame for that will be on mine!

In this scene, the older woman is trying to reject him by diffusing the young man's one-sided passion for her by painting to him the bleak picture after the two get married, owing to the

fact that they have a huge age gap between them, or May-December love.

MILF is an acronym (首字母缩略词) for Mom I'd Like to Fu-, usually meaning a middle-aged woman and a mother figure who satisfies a young boy's sexual fantasy and an object of sexual desire.

3.3 Questions for discussion

1) What do you think of Platonic love?
2) How is it that with advance of times and technology, people are still heavily reliant on old ways of doing things, such as meeting someone through a matchmaker or going on a blind date?
3) Do you agree with what the woman on Video 3-8 says about love and marriage?
4) Have you had the experience of meeting someone online? And what did you think of it?
5) Do you think a man and a woman should share the expense in a dating? Or the male part should bear all the expense?

3.4 Debate

There is true friendship between opposite sexes.

3.5 Vocabulary exercises

narcissism, Platonic, facilitator, altruistic, philanthropy, spot, compatibility, exhilarating, downplay, amenable, anecdote

Try and fill in the blanks of the following sentences with words listed above in proper forms.

1) He shows too much of _____ when he brags about himself and his family, which invites disgust and disdain from his friends.
2) Many organizations and families have benefited from wealthy men's _____.
3) This project is a _____ in promoting bilateral relations between the two countries.
4) He dismissed everybody's speculation that he is in love with this girl, but actually their relation is purely _____.
5) When a person holds the belief and engages in the practice of disinterested and selfless concern for the well-being of others, he is an _____ person.
6) When we _____ him in the crowd, we couldn't help screaming his name.
7) Whenever he talks about his role in the teamwork, he is always modest and tries to _____ it.

8) If you describe an experience or feeling as _____, you mean that it makes you feel very happy and excited.

9) Some young people like to try their relationship out by cohabiting for a while before marriage to find out about their _____.

10) The man is _____ to all his wife's ideas, and does everything she tells him to do.

11) A good way to begin a speech is to begin with an _____, a way to tell stories to attract the audience's attention.

3.6 Role-play and reenactment

1) Please review videos 3-1 & 2, acting out the scene where a boy is breaking up with a girl, and vice versa. Feel the part of culture of breakup.

2) Please review Video 3-3, acting out the scene where a woman is emotional when seeing her former boyfriend. Feel the part of culture where two old flames meet up.

3) Please review Video 3-4, acting out the comedy about the awkwardness of an Asian boy's romantic experience.

4) Please review Video 3-7, acting out the scenes. Feel the part of culture of dating.

5) Please review Video 3-8, reciting the girls speech about her idea of love and marriage.

6) Please review Video 3-9, reciting the woman's outburst of an impossible May-December love.

TYING THE KNOT
婚姻殿堂

4.1 Cultural tidbits

With the *Wedding March*（《婚礼进行曲》）by Felix Mendelssohn（门德尔松，德国作曲家、钢琴家、指挥家）or Richard Wagner（瓦格纳，德国作曲家、剧作家、音乐理论家）playing on, the beautiful bride walks the aisle on the red carpet with her father's arm in hers. The bridegroom on the other end of the carpet is waiting by the side of the priest and his best men（伴郎）. The father gives his daughter's hand to the groom ritually. Then start the vow exchanges followed by the priest's words. "By the power vested in me by the laws of the State of..., I pronounce you man and wife. May your days be long together and your joy be ever increasing." And then he turns to the bridegroom, "You may kiss the bride." And the newlyweds indulge in kissing each other...This is what we have been seeing on TV and movies all the time.

Marriage, also called matrimony（结婚）or wedlock（婚姻）, is a socially or ritually recognized union（结合）between spouses（配偶）that establishes rights and obligations between them, between them and their children, and between them and their in-laws. The definition of marriage varies according to different cultures, but it is principally an institution（制度）in which interpersonal relationships, usually sexual, are acknowledged. In some cultures, marriage is recommended or considered to be compulsory（强制的）before pursuing any sexual activity. Often viewed as a contract, marriage can be recognized by a state, an organization, a religious authority, a tribal group, a local community, or peers.

Since the ancient times in Christian world, marriage has been set forth as a sacred obligation between a man and a woman. According to Mathew 19:5（《马太福音》第19章第5节）, "For this reason a man shall leave his father and his mother and be joined to his wife, and the two shall become one flesh." Nowadays the religious color is more or less fading with almost any secular members being able to apply to hold their ceremonies in a church.

A marriage is usually formalized at a wedding or marriage ceremony. The ceremony may be officiated either by a religious official, by a government official or by a state approved celebrant（主持宗教仪式的神父）. In some countries - notably the United States, Canada, the United Kingdom, the Republic of Ireland, the officiant（司仪牧师）at the religious and civil ceremony also serve as agent of the state to perform the civil ceremony.

Some countries, such as Australia, permit marriages to be held in private or at any

location; others, including England and Wales, require that the civil ceremony be conducted in a place open to the public and specially sanctioned（批准）by law for the purpose. In England, the place of marriage formerly had to be a church or register office, but this was extended to any public venue（场地）with the necessary license. Each religious authority has rules for the manner in which marriages are to be conducted by their officials and members. Where religious marriages are recognized by the state, the officiator must also conform with（符合,遵守）the law of the jurisdiction（管辖地区）.

Most marriages are performed in a secular（世俗的）civil（民间的）ceremony or in a religious setting via a wedding ceremony, which is what we see on TV and in movies. Especially, the part of the vow and ring exchanges touches us most. Here are three versions of vow exchanges:

1) I, (name of the bride/groom), take you (name of the bride/groom), to be my lawfully wedded (husband/wife), to have and to hold from this day forward, for better or for worse, for richer, or poorer, in sickness and in health, to love and to cherish, from this day forward until death do us part（分离）.

2) I, (name), take you, (name), to be my lawfully wedded (husband/wife), my constant（恒久的）friend, my faithful partner and my love from this day forward. In the presence（见证,在场）of God, our family and friends, I offer you my solemn（神圣的）vow to be your faithful partner in sickness and in health, in good times and in bad, and in joy as well as in sorrow. I promise to love you unconditionally, to support you in your goals, to honor and respect you, to laugh with you and cry with you, and to cherish you for as long as we both shall live.

3) I, (name), take you (name), to be my husband/wife, my partner in life and my one true love. I will cherish our union and love you more each day than I did the day before. I will trust you and respect you, laugh with you and cry with you, loving you faithfully through good times and bad, regardless of the obstacles（阻碍）we may face together. I give you my hand, my heart, and my love, from this day forward for as long as we both shall live.

Before marriage, there is marriage proposal（求婚）, which is a gesture mostly on the male part during the courtship period（求偶期）. Courtship is the period in a couple's relationship which precedes their engagement and marriage, or establishment of an agreed relationship of a more enduring kind. During courtship, a couple get to know each other and decide if there will be an engagement or other such agreement. A courtship may be an informal and private matter between two people or may be a public affair, or a formal arrangement with family approval. Traditionally, in the case of a formal engagement, it has been perceived that it is the role of a male to actively "court" or "woo"（追求）a female, thus encouraging her to understand him and her receptiveness to a proposal of marriage.

A marriage proposal is an event where one person in a relationship asks for the other's

hand in marriage. If accepted, it marks the initiation of engagement, a mutual promise of later marriage. It often has a ritual quality (仪式感).

In Western culture it is traditional for the man to make a proposal to the woman directly while genuflecting (单膝跪拜) in front of her. The ritual often involves the formal asking of the question "Will you marry me, …?" and the presentation of an engagement ring. It may include him putting the ring on her finger. Sometimes the proposal is intended to be a surprise.

Acceptance of the proposal is not compulsory (法定的,强制性的) in Western culture; a woman may decline a proposal for various reasons, and may not declare what the reasons are. If the woman accepts the proposal, she will typically assent (同意) to the man verbally (口头的) and wear the ring during the time leading up to the wedding, known as the engagement.

Nowadays, it's not much acceptable for a woman to propose to a man. Especially younger people are less likely to approve of women proposing. In Scotland and Ireland, February 29th in a leap year (闰年) is said to be the one day when a woman can propose to her partner. As a monarch, Queen Victoria (维多利亚女王) had to propose to Prince Albert (阿尔伯特亲王). Proposals by women have become more common in the English-speaking world in recent years, so jewelry companies have manufactured engagement rings for men. In the United States, about 5% of proposals are made by women.

Here in this chapter, we're going to look at some wedding ceremonies held in churches in English culture, and at the same time, enjoy some speeches made by the priest, the couple, the family and friends. And meanwhile, marriage proposing is also very important in a relationship, so some examples are offered to give us a sneak peek (先睹为快) into this part of culture.

4.2 Video examples

- ***Video 4-1: By the power invested in me by God, I pronounce you husband and wife***

Dear friends, what a joy it is to welcome you to our church on this wonderful day for Angus and Nora. Before we start the ceremony, let us all join together in the first hymn (赞美诗,圣歌). Dearly beloved, we are gathered together here in the sight of (见证) God and in the

face of this congregation（教友）to join together this man and this woman in holy matrimony, which is an honorable estate（阶段）, instituted（创立）in the time of man's innocence（人类混沌初期）, therefore, if any man can show any just cause（正当理由）or impediment（阻碍）why they should not be lawfully joined together, let him speak now, or forever hold his peace（保持缄默）. Do you promise to love her, comfort her, honor and keep her in sickness or in health, and forsaking（不顾）all others, keep thee（你）only onto her for as long as you both shall live? (Bridegroom and bride: I do. Repeating after the priest) To love and to cherish, till death us do part. And thereto（因此）I pledge thee my troth（誓言）; with this ring, I thee wed（娶）; with my body, I thee worship; and with my all worldly goods（世俗的财产）, I thee endow（赠予）.

This is a typical and traditional ceremony in a church, where we see a priest, altar boys（祭坛助手）, a choir, and the procedures of the wedding. The officiating priest presides the ceremony in the name of God and makes it not only sacred, but also full of Christian coloring.

A church wedding is a ceremony presided over by a Christian priest or pastor. Ceremonies are based on reference to God, and are frequently embodied into other church ceremonies such as Mass（弥撒）. Customs may vary widely between denominations（教派）. In the Roman Catholic Church, "Holy Matrimony" is considered to be one of the seven sacraments（圣礼）, in this case, one that the spouses bestow（赠予）upon each other in front of a priest and members of the community as witnesses. As with all sacraments, it is seen as having been instituted（创立）by Jesus himself. In the Eastern Orthodox Church, it is one of the mysteries, and is seen as ordination（神授）and martyrdom（殉道）.

Felix Mendelssohn's *Wedding March* in C major, written in 1842, is one of the best known of the pieces from his suite of incidental music（配乐组曲）. It is one of the most frequently used wedding marches, generally being played on a church pipe organ（管风琴）. At weddings in many Western countries, this piece is frequently teamed with the Bridal Chorus（《婚礼合唱曲》）from Richard Wagner's opera *Lohengrin*（罗英格林，德国中世纪传说中的圣杯骑士）, or with Jeremiah Clarke's *Prince of Denmark's March*（克拉克的《丹麦王子进行曲》）, both of which are often played for the entry of the bride.

- **Video 4-2: *I pronounce you man and wife***

Dearly beloved, we're gathered here today to join this man and this woman in holy matrimony. Into this holy agreement, these two persons come together to be joined. If any

person here can show the cause why these two people should not be joined in holy matrimony, speak now or forever hold your peace.

We're all here today to witness the joining of the <u>wedded bliss</u>（婚后幸福，婚姻的美满幸福） of Paul and Angela. Do you Paul, take Angela for your lawful wife, to have and to hold, from this day forward, until death do you part? （I do.） Do you, Angela, take Paul for your lawful husband, to have and to hold, from this day forward, until death do you part? （I do.）

With the power vested in me by the State of California, I now pronounce you man and wife. You may kiss the bride.

This is a small private ceremony held out in the garden; similar open venues sometimes can be by the sea, in a park, or even in the register office, or any other location, which is a common practice in the culture.

Most religions recognize a lifelong union with established ceremonies and rituals. Many Christian faiths emphasize the raising of children as a priority in a marriage. In Judaism, marriage is so important that remaining unmarried is deemed unnatural. Islam also recommends marriage highly; among other things, it helps in the pursuit of spiritual perfection. Hinduism sees marriage as a sacred duty that entails both religious and social obligations. By contrast, Buddhism does not encourage or discourage marriage, although it does teach how one might live a happily married life and emphasizes that marital vows are not to be taken lightly.

Different religions have different beliefs as regards the breakup of marriage. For example, the Roman Catholic Church believes that marriage is a sacrament（圣礼） and a valid marriage between two baptized persons cannot be broken by any other means than death. This means that civil divorcés cannot remarry in a Catholic marriage while their spouse is alive. In the area of <u>nullity of marriage</u>（婚姻无效）, religions and the state often apply different rules. A couple, for example, may begin the process to have their marriage annulled by the Catholic Church only after they are no longer married in the eyes of the civil authority.

- **Video 4-3:** *I just love all those little things about you*

Priest: Dearly beloved, we're gathered here to join this man and this woman, in the <u>sacred bonds</u>（神圣的结合） of holy matrimony. I've had chance to spend time with Jennifer

and Vince, and their unusually strong feelings for one another are, huh, quite apparent. I've done this job long enough to know when a couple is getting married for the wrong reasons. Some, they are in love with an idealized version of that person they're marrying. Others, they're just too old to be single anymore. And some, some just want all the gifts. (Bridegroom: That's ridiculous) But what they don't realize is that marriage is a journey, a wonderful, exciting and at times, an <u>excruciating</u>（极痛苦的，造成剧痛的）journey. Am I right? (Audience: Yeah) But Jennifer and Vince, they see each other for who they really are. There's no <u>rose-colored glasses（玫瑰色的眼镜）</u> on these two, not at all. They're standing here today, committing to each other, knowing full ware what they're getting into. The couple has elected to recite their own vows. Vince? (Vince: Yeah?) The vows.

Vince: Yeah. Jennifer. I didn't know how loving a person could be until I met you. Huh...huh... I can't. This cannot be this. I got to speak from heart here. Jennifer, you're the most frustrating person I've ever met. You're opinionated, and stubborn, and at times, really, really, really bossy, and that is why I fall in love with you. I didn't plan on it. Believe me. It just happened. And along the way, I noticed your generosity, your kindness, your great sense of humor, and just basic sense of decency. You're an amazing woman, Jennifer. And I would be proud to call you my wife.

Priest: Jennifer. It's your turn now.

Vince: Read your vows. It's my grandmother's.

Priest: We're not quite to the ring yet（还没到交换戒指环节呢）, guys.

Vince: What do you say?

Jennifer: You know I pride myself on being able to read people. And when I met you Vince, I thought you were <u>sloppy</u>（邋遢的）, and lazy and a <u>lady's man</u>（喜欢与女人厮混的男人，自以为讨女人喜欢的男子）. And I was right. In fact, that was all I can say. But every day that I spent with you, I found little things that I love about you, like the way you <u>light up</u>（两眼放光）when your mom walks into the room, or the way you make my niece and nephew laugh. And ever since then, I just... I don't know...I just love all those little things about you. I love you, Vince.

Vince: Is that a yes?

Jennifer: Yes. Yes! Yeah, huh...

Priest: Guys, the kissing comes later. Still we're at the vows. Well, then, Vince, do you take Jennifer to be your lawfully wedded wife? And Jennifer, do you take Vince to be your lawfully wedded husband? Oh, I now pronounce you husband and wife. You may do that!

 Couples wedding in the Roman Catholic Church essentially make the same pledge to one another. In this part, we see an unusual session of vow exchanges in a ceremony, which are not

repeated after the priest by the couple as a routine, but written and read by the couple themselves. And the bridegroom even changes his mind to give up the vows he has prepared before and speaks his truest heart. The drama and suspense grabs the audiences' attention, and it turns out to be a happy ending after all.

Marriage vows are binding promises each partner in a couple makes to the other during a wedding ceremony. Marriage customs have developed over history and keep changing as human society develops. In earlier times and in most cultures the consent of the partners has not had the importance now attached to it, at least in Western societies and in those they have influenced.

• **Video 4-4: *Don't f- this up!***

Host: <u>Without further ado</u>（事不宜迟）, let me <u>bring up</u>（请出）the actual <u>maid-of-honor</u>（伴娘）, the big sister of the bride, Sarah. Good luck, girl!

Sarah: Thank you, Misty. Oh, when I was twelve, I have just started this new school. And I was truly terrified of the world. And I kept having these really awful nightmares. And one morning, I woke up after a full night of sleep. And I find Carla asleep next to me, holding me. She heard me crying in my sleep and she crawled into my bed and <u>snuggled</u>（依偎）me, 'cause she thought that might help. And she was like five years old. And I never had another nightmare. Umm, you have this selflessness and this hopefulness. That's really special. It's really rare. Huh. Big sisters are supposed to teach baby sisters, but I will, today and forever and ever, ever, be learning from you. Uh, and now, Abe, don't <u>f- this up</u>（搞砸，干蠢事）!

Bridegroom: I won't.

A wedding reception is a party usually held after the completion of a marriage ceremony as hospitality for those who have attended the wedding, hence the name reception: the couple receives society, in the form of family and friends, for the first time as a married couple. Hosts provide their choice of food and drink, although a wedding cake is popular. Entertaining guests after a wedding ceremony is traditional in most societies, and can last anywhere from half an hour to many hours or even days. In some cultures, separate wedding celebrations are held for the bride's and groom's families.

In most Western countries, either before or after food is served, toasts (祝酒) are made by the wedding party, wishing the couple well. Commonly, toasts are proposed by the bride's father, the groom, the best man, and/or the maid of honor, although there is no absolutely required list of people who must make toasts, or indeed any requirement to offer toasts at all.

In this part, the speaker, or toaster, as a sister of the bride, begins by recalling the sweet memories with her sister when they were little kids, in order to show what a wonderful person the bride is, and how the bridegroom should treasure her all his life, so she ends her speech with an abrupt (突然的) warning to the groom. The speech is warm, sincere and concludes with an unexpected ending.

- **Video 4-5: *I will go anywhere for Beth***

Thank you, Reverend (教士大人,牧师大人). Appreciate it a lot. It...it's not easy to get to Rhode Island (美国州名:罗得岛州) from Los Angeles. There was a cab to a plane, to a cab to a train, to a rental car. There was maybe a rickshaw (人力车,黄包车) in there somewhere. Maybe a donkey. Heh-heh. But the truth is I...I would go anywhere for Beth, because she's my best friend and I love her so much. And I'm so happy for her.

When we were in college, senior year, we had this tradition. Beth and Tucker and me and Jesse would meet, come rain or shine (风雨无阻), every Sunday at the bishop (热果子酒). And there was always something there with these two (他们俩一直都很暧昧), even though they were just friends. Just like an ease (自主,闲适) that they had with each other. They are perfect. At last, love wins.

In this rather dull toast, the guest speaks as the bride and groom's friend. She stresses the hardship of getting to the wedding, and then recalls their friendship in college times, then ends with blessings and congratulations.

In China, we have the similar wedding banquet procedure. Typically, the banquet will include a speech from the parents, the best man, the maid of honor, and the guest speaker. There will be cake cutting, toasts, a tea ceremony, some games designed by the DJ, and dancing. The two tables at the center of the room are for the groom's and bride's families.

A Chinese wedding reception typically has nine or ten courses. Expensive dishes such as shark fins（鱼翅）, abalone（鲍鱼）, lobsters, etc., are common on a wedding banquet menu. A whole fish, chicken, or pig means luck and completeness in Chinese wedding culture.

Traditionally, after the fifth dish of the dinner, the groom and bride and their families will approach each table to toast the guests. Very often, the bride will change into a traditional Chinese red wedding dress at that time, if she has been wearing a different style of clothing before.

- **Video 4-6: *My grandmother's engagement ring***

Man: Come here.

Woman: OK.

Man: My grandmother's engagement ring.

Woman: Oh, my Gosh!

Man: Oh, my grandfather brought this from the old country（故国）. He carried it across two continents（大洲）. But he used to say, he carried it to the end of the world with the woman he loved. And now I know just how it felt.

Woman: Are you serious?

Man: Huh. Jennifer, what I want to know is, will you marry me?

Woman: Yes, yes, of course! Ha, oh, it's beautiful!

In this scene, the man proposes to the woman with a ring that belonged to his grandparents, thus the significance of the heirloom（传家宝）, in the seriousness and sincerity of his proposing act.

In many cultures it is traditional for a man to ask permission from a woman's father, in private, before proposing to her, or if her father has already died and she is still young of a near relation of hers. In earlier times it was common for fathers to refuse proposals from men whom they considered unsuitable as husbands for their daughters. Although it is uncommon in the West these days, the parents of the couple may make a marriage arrangement, preceding（在……之前）or superseding（在……之后）the proposal.

- **Video 4-7:** *Just want to show you how committed I am*

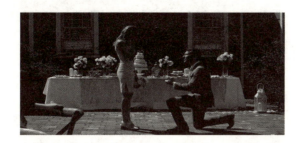

Man: I love you, Marilyn, I just…I hope you feel the same way. Marilyn Benny, will you marry me? (Onlookers: Oh, my God! Girls: Hi!)

Woman: You're gonna do that in front of my scouts（童子军）?

Man: I figured. What's a wedding without flower girls? Hey, honestly, it's not my intention to make you feel any pressure, so if the answer is no, I understand. I just wanted to show you how committed（忠诚的）I am to you. Now I would be honored to marry you right here. Right now.

Woman: I…

Man: I get it. You're not feeling it. Err…

Woman: Yes.

Man: I'm sorry. Did you say…?

Woman: Yes!

Man: Yes?

Woman: I said yes.

 The highlight in this scene is the girl scouts and families as the witnesses of this romantic proceeding.

 An engagement is a promise to wed, and also the period of time between a marriage proposal and a marriage. During this period, a couple is said to be betrothed（订了婚的）, intended, engaged to be married, or simply engaged. Future brides and grooms may be called a wife-to-be or husband-to-be, fiancée or fiancé（from the French word of the same form）, respectively. The duration of the courtship varies vastly, and is largely dependent on cultural norms or upon the agreement of the parties involved.

 In the modern era, some women's wedding rings are made into two separate pieces. One part is given to her to wear as an engagement ring when she accepts the marriage proposal and the other during the wedding ceremony. When worn together, the two rings look like one piece of jewelry.

- **Video 4-8: *Will you marry my dad and be my stepmom?***

Man: Smith and I were talking the other day, and he said, dad, <u>going-away parties</u>（送别会） are kind of sad. And he's got a point. And we were like, "How do we make this a celebration?". Then we got an idea. (whispers to his son)

Son: Kimberly, will you marry my dad and be my stepmom?

Audience: Aww...

Woman: Yes! Yes!

Man: What about me?

Audience: Aww... Yay!

The genius part on the father's side is he arranges his son to do the proposal instead of him, and the effect is surprisingly good.

Some engagements are announced at an engagement party, traditionally hosted by the bride's parents. These parties are given in the family's usual style of entertainment. Traditionally, engagement parties were normal parties at which a surprise announcement of the engagement was made by the father of the bride to his guests. Therefore, it is not a traditional gift-giving occasion since no guests were supposed to be aware of the engagement until after their arrival. In modern times, engagement parties often celebrate a previously publicized engagement. Whether presents are given at these engagement parties varies from culture to culture.

- **Video 4-9: *No. I can't, so sorry, so sorry***

Eli: I'd like to do some celebration of my own, so I need to ask someone a question. Liz, I don't know what the next 25 years will bring us, but I do know, I want to spend them

with you. Liz Henschaw, will you do me the honor of becoming my wife?

Liz: I can't. I can't. Ali, I can't. So sorry, so sorry!

In this scene, the boy's proposal is being rejected by the girl. Acceptance of the proposal is not compulsory in Western culture; a woman may decline a proposal for various reasons, and may not declare what the reasons are. If the woman accepts the proposal, she will typically assent to (同意) the man verbally (口头的) and wear the ring during the time leading up to the wedding, known as the engagement.

It's rather sad to see a romantic and fully prospective proposal rejected for no reason from the girl, and even more so when the poor boy left kneeling there alone, confused.

4.3 Questions for discussion

1) What is the most romantic wedding ceremony have you attended or seen?
2) How different is Chinese style wedding from the western style?
3) Marriage has many pains, but celibacy (独身) is never happy. How do you view it?
4) If you decided to delay your marriage and pursue your career instead, what do you think would be your advantages?
5) Now college students can get married during their studies in China. Please comment on it.

4.4 Debate

Soaring divorce rate is an indicator of civilization advancement.

4.5 Vocabulary exercises

committed to, abrupt, snuggle, sacred, compulsory, sanction, solemn, constant, ritual, assent, light up, sloppy, conform with (to)

Try and fill in the blanks of the following sentences with words listed above in proper forms.

1) His career as a doctor came to an _____ stop owing to his misconduct in profession.
2) When the girl enters the room, the whole room _____.
3) My father will never _____ to me spending so much money on dress.
4) In winter coldness, these animals like to _____ together in their den to keep warm.
5) English is a _____ subject in primary schools in China.
6) The authorities have not given the _____ to these proposals.

7) For him, having dinner is a _____, he will not start eating until everything is in good order and prepared.
8) The world is going through a _____ change, and we must prepare ourselves for it.
9) The president speaks in a _____ manner at his best friend's funeral.
10) In Hindus culture, the cow is considered a _____ animal.
11) The government is _____ to housing the refugees.
12) The secretary got fired from her job because she always did _____ work.
13) As a member of this club, you must _____ the rules of this club.

4.6 Role-play and reenactment

1) Please review Video 4-2, acting out the scene where a priest holds the ceremony. Feel the part of wedding culture.
2) Please review Video 4-5, acting out the scene where a close friend is invited to give a toast on a wedding ceremony. Feel the toast culture.
3) Please review Video 4-6, acting out the scene where a marriage proposal is completed. Feel the part of culture where a ring is presented as a family heirloom.
4) Please review Video 4-7, acting out the scene where a marriage proposal is completed. Feel the part of culture where girl scouts are involved as witness in the process.

Chapter 5

DOMESTIC LIFE
油盐酱醋

5.1 Cultural tidbits

Domestic, of or relating to the family or household, including <u>domestic chores</u>(家务活), i.e. tasks such as cleaning, washing, and <u>ironing</u>(熨衣) that have to be done regularly at home. The other meaning is when someone's fond of home life and in charge of household affairs; hence, we have a domestic man.

Domestic life means work or recreation done with or for one's family, however defined. Family, people who are related by blood or marriage, has been defined differently at different points in history, as have how social relations within families ought to work. However, many political and economic theories hold that family is the basic building block upon which society is founded and therefore that domestic life is something that ought to be protected by the state. For example, Roman Catholic teaching on social justice assumes that domestic life is a foundational right. Likewise, the right to start and raise a family is guaranteed by the <u>Universal Declaration of Human Rights</u>(《世界人权宣言》). As for the man's role in a family, in the movie *God Father*, <u>Don Corleone</u>(柯里昂, 即影片中的"教父") says, "a man who doesn't spend time with his family is not a real man."

Many households now include multiple income-earning members. Government and policy discussions often treat the terms household and family as <u>synonymous</u>(同义的), especially in Western societies where the nuclear family has become the most common family structure.

Home economics applies basic economic concepts such as production, division of labor, distribution, and decision making to the study of the family. Using economic analysis it tries to explain outcomes unique to family—such as marriage, the decision to have children, fertility, time devoted to domestic production and <u>dowry</u>(嫁妆) payments.

(An open-air market in the USA)

Homemaking is a mainly American term for the management of a home, otherwise known as housework, housekeeping, or household management. It is the act of overseeing the organizational, day-to-day operations of a house or estate, and the managing of other domestic concerns. A person in charge of the homemaking, who isn't employed outside the home, is in the U.S. and Canada often called a homemaker, a gender-neutral term for a housewife or a househusband. The term "homemaker", however, may also refer to a social worker who manages a household during the incapacity of the housewife or househusband.

Feminism examines the ways that gender roles affect the division of labor within households. Sociologist Arlie Russell Hochschild (2001) in The Second Shift and The Time Bind presents evidence that in two-career couples, men and women, on average, spend about equal amounts of time working, but women still spend more time on housework. In some cases, women may prevent the equal participation of men in housework and parenting.

Division of labor within the family may decide on which member of the family will do which task. Household work can be categorized in terms of whether the whole family benefits or only some members of the household. Besides the chores like cooking, laundry or cleaning, care-work activities that are done specifically for another member of the household, usually because that member is not able to do that work for himself or herself. Two basic forms of care-work are child care and elder care. Complete specialization comes when the need for domestic work might decrease (especially when children grow up) and women who have completely specialized in household work. Barbara Bergman (1988) wrote that women's complete specialization in household labor, namely their being full-time housewives, often leads to women's financial insecurity and increases their likelihood of being subjected to domestic violence or domestic decision making in the family. With the second wave of <u>feminist movement</u>(女权主义运动) in the 1960s in America, women asked for more freedom from house chores and family burdens. Some even went to extreme to boycott family roles for women and reject woman's duty in a domestic life. With the advance of times, more and more household men appear in a family. Now it's not much of a surprise when we hear a man working at home doing chores while his spouse working in a professional workplace.

It is the tradition in most American and European culture that when a woman marries a man, she marries into his name, which means, she assumes her husband's last name, with the ensuing children.

Family values are upheld in a family, i.e. the moral and social values, ethical principles traditionally maintained and affirmed within a family, and transmitted from generation to generation, as honesty, loyalty, industry, and faith. There is also family legacy, something handed down from an ancestor or a predecessor or from the past, a legacy of religious freedom,

to name one example.

With a couple getting married and a child is born, and then come family burdens and responsibilities, both legally and economically, financially and morally. In this chapter, we're going to take a kaleidoscopic peek at family lives.

5.2 Video examples

- **Video 5-1:** *I'll be honest with you*

Mother: I'd love to see the inside.

Agent: OK, here we are. 4,000 square feet, 2 levels. <u>Open floor plan</u>（开放式内部格局）, just as you requested.

Daughter: Dad, our entire New York apartment can practically fit into this one room!

Father: Yeah, now you can see why we wanted us to make this <u>move</u>（搬家）, huh?

Mother: Yeah, but can we really afford this?

Father: It's the one of the only <u>foreclosures</u>（丧失了抵押品赎回权的房产,如因房贷断供被银行拍卖的房产）on the market.

Agent: OK, everyone follows me this way. Rebecca, you've got to see the kitchen…This is just a chef's dream. <u>Counter space</u>（【厨房中的】长台面,操作台）and cabinets <u>for days</u>（相当大）.

Mother: Wow, isn't this fantastic!

Father: <u>We barely had any room microwaving frozen dinners.</u>（这句话的意思是说以前的公寓房太小）

Daughter: <u>Ice cube</u>（【加入饮料用的】小方冰块）, anyone?

Mother: Oh, Matty!

Daughter: More for me, I guess.

Agent: Wait until you see the pool.

Daughter: There's a pool?

Agent: There's a pool.

Daughter: There's a pool!

Mother: Matty! Matty! Be careful!

Father: We'll sign her up for swim lessons. Don't worry.

Mother: I think that this all happened really quickly, but I think it's perfect.

Agent: You're not going to find a better deal. And the bank is very motivated to sell.

Mother: Oh, really? How long has it been vacant?

Agent: Several years. But as you can see, they put a lot of money into fixing it up.

Mother: Yeah.

Agent: And I'll be honest with you. There's another offer.

Father: Oh, really?

Agent: But I don't know how much liquidity（资产流动性，资产变现能力）the other buyer has, so it might not take much to push the offer over the top, if you know what I mean.

Mother: Let's do it.

Father: All right, we'll take it.

Agent: Excellent, excellent!

Mother: Yeah!

Agent: All right, I'll email you the documents later on today. You E-sign them, shoot them back to me, and I will expedite（加快办理）your escrow process（过户手续）, so you could move into your new home as soon as possible.

Mother: Yeah, thank you so much!

Agent: Congratulations!

Father: Thank you, Angie.

Agent: My pleasure.

 This is a scene where a family of three is looking at the new house led by the agent. An escrow agent（托管代理人，第三者代理商）is a person or entity holding documents and funds in a transfer of real property, acting for both parties pursuant to instructions. Typically the agent is a person (commonly an attorney), escrow company or title company, depending on local practice.

- **Video 5-2: *You guys have kids?***

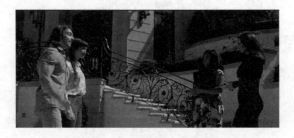

Husband: Wow, yeah, huh. I'm sorry, what year you said this was built?

Wife: Wait, wait! Can I guess?

Realtor: Sure.

Wife: Ah, 1986

Realtor: Good guess. Ah, 1985.

Wife: Ah, the year you were born. (Yeah) I think it's meant to be (有缘分,天注定).

Realtor: All right, let's go this way, so through there, is the library, and the home theater, which we will show you on the way back down. And here, of course, we have the kitchen, and the formal dining room through there, and the breakfast room here. And now we'll make our way up.

Wife: So how many rooms are there?

Realtor: Oh, we have the one bedroom downstairs, four bedrooms up here. Here's the master suite (主套间), and that one there is used as a study (书房). And here we have the master bedroom (主卧室), powder room (化妆间), walk-in closet (步入式衣帽间) right over there. And through there, we have the master bathroom.

Husband: Big enough? What do you think?

Wife: There is a his and hers sink (两人共浴的浴盆).... Can we, maybe, take the elevator down?

Realtor: Ah, so you like the elevator.

Wife: Yeah. Kids will love the elevator.

Realtor: You guys have kids?

Husband: Ah, that's probably a mid-thirties thing. We're not there yet.

Wife: Do you love kids?

Realtor: Daisy has a child.

2nd Realtor: A two year old.

Wife: Aww.

Realtor: I loathe (讨厌) the children. They're smelly and loaded with germs (细菌).

Husband: It's a real-life (真实的,现实生活中的) elevator!

 In this part, a newlywed couple is inspecting a house led by a realtor, a person in the real-estate business. With a complicated structure, and inbuilt elevator, the mansion style house is apparently not for average wage earners, showing the couple's earning power or status.

 Residential real estate is a type of property, containing either a single family or multifamily structure that is available for occupation for non-business purposes. Residences can be classified by, if, and how they are connected to neighboring residences and land. It is common practice for an intermediary (中间人) to provide real estate owners with dedicated sales and marketing support in exchange for commission (佣金). In North America, this intermediary is referred to

as a <u>real estate broker</u> (or realtor), whilst in the United Kingdom, the intermediary would be referred to as an <u>estate agent</u>.

An estate agent is a person or business that arranges the selling, renting or management of properties, and other buildings, in the United Kingdom and Ireland or other countries around the world. An agent that specializes in renting is often called a letting or management agent. Estate agents are mainly engaged in the marketing of property available for sale and a <u>solicitor</u> (律师) or <u>licensed conveyancer</u> (持证财产过户员) is used to prepare the legal documents. In Scotland, however, many solicitors also act as estate agents, a practice that is rare in England and Wales.

It is customary in the United Kingdom and in Ireland to refer to real estate or real property simply as property.

In the United States, however, real estate brokers and their salespersons who assist owners in marketing, selling, or leasing properties are commonly called <u>"listing brokers" and "listing agents."</u> (上市交易员). Real estate brokers and salespersons are licensed by each state, not by the federal government. Each state has its own laws defining the types of relationships that can exist between clients and real estate licensees, and the duties of real estate licensees to clients and members of the public. These rules differ substantially from state to state, for example, on subjects that include required documentation, agency relationships, inspections, disclosures, continuing education, and other subjects.

- **Video 5-3:** *We're extremely sorry for your loss*

Manager (Mr. Branch): Oh, Paul Barnell. Ted Watters.
Paul: Mr. Watters.
Ted: Pleasure.
Paul: Mine, too.
Manager: Ted, Mr. Barnell would like to discuss his brother's life insurance policy with us.
Ted: Raymond, right?
Paul: Yes. The thing is, as I explained to Mr. Branch, he's been gone for five years, and I thought…time to move on.
Ted: By "move on", you mean?

Paul: I mean.

Manager: I think that cashing Raymond's policy（兑现保额）.

Ted: En.

Paul: I doubt, after that time, that he's still alive. And my father always wanted us to take care of each other if something should happen, and money is a little…

Ted: Yeah, I understand, Mr. Barnell, but here is the thing. Ah, with no actual body, under Alaskan statutes（根据阿拉斯加法律）, a person has to be missing for seven years before he or she can be legally declared dead. And that's not withstanding（不算上，不考虑）an investigation period, where concerned parties（相关各方）can take up to another year to file interventions（提出干预）concerning the motion（动议）. So even though your brother's status（状态）is undetermined at this point, there's really very little we can do for you.

Manager: But we are extremely sorry for your loss.

Ted: Absolutely.

Paul in this scene encounters similar predicament and plight to all insurance policy holders. The difficulty to cash the policy is like shearing the wolf, or pulling the wolf by its ears. Hidden behind their politeness and courtesy, the cunning duplicity, scheming, unscrupulous Machiavellian（马基雅弗利主义的，不择手段的）design will never make it easy for you to get the money you want.

In insurance, the insurance policy is a contract（generally a standard form contract）between the insurer and the insured, known as the policyholder, which determines the claims which the insurer is legally required to pay. In exchange for an initial payment, known as the premium（保险金）, the insurer promises to pay for loss caused by perils（风险）covered under the policy language.

- **Video 5-4: *I'm afraid you have to pay the full amount you owe***

Wife: I can't imagine why he's late, Mr. Dale. He knew we're meeting at 10:30.

Manager: I believe this is the very nature of our problem, Mrs. Phelan. Buying a house is a major responsibility. I do not think Mr. Phelan is facing his commitment in a responsible manner. You and your husband are 120 days behind in payments. This

constitutes serious arrears（逾期欠款）to an institution（机构，这里指银行）of this small size.

Wife: Mr. Dale, we know where we stand （处于……状态）. We've been unemployed. We are both working now. We'll catch up.

Manager: You're asking much of this institution to reschedule your loan（延期偿还贷款）, especially in view of Mr. Phelan's tardiness（拖延）both in payment and today's appointment.

Wife: Where have you been?

Husband: I'll tell you later. Mr. Dale, our banker! Let me guess. You being the weenie（口语：胆小鬼，窝囊废）that you are, you're not gonna reschedule our payments. Is that right?

Manager: What? What did you say? Under the circumstances, I do not believe this institution can accommodate（帮助）you, Mr. and Mrs. Phelan.

Wife: Stop. Sam, talk to him. This is our house!

Manager: I'm afraid you have to pay the full amount you owe, or Midwest Savings and Loan （银行名：中西部储蓄和贷款银行）will be forced to finalize（最终敲定，最后确定）foreclosure proceedings（取消被告赎回抵押品权利的诉讼，此处指原告要申请法院收回被告的房屋）.

Wife: Mr. Dale, please. We have paid on the house every month on time for 5 years. Doesn't that count for anything?

Husband: What exactly is the full amount?

Manager: With penalty（违约罚金）and interest, it comes to $7,603.12.

Husband: OK. Here. 1 thousand, 2 thousand, 3 thousand, 4 thousand, 5 thousand, 6 thousand, 7 thousand, and one, two, three …12 cents. Four, five, six. You got 4 singles（四块钱零钱）? Four.

Wife: Yeah.

Husband: Thank you. US $7,605. Leslie, come on.

 In this scene, a couple delays in paying their mortgage, and the manager threatens coldly to foreclose their house. The husband comes with flying color and full pocket of money. They mock the bank by throwing money in their face and exposing their coldness and heartlessness.

 Foreclosure is a legal process in which a lender attempts to recover the balance of a loan from a borrower, who has stopped making payments to the lender, by forcing the sale of the asset used as the collateral for the loan.

 Formally, a mortgage lender (mortgagee), or other lienholder（留置权人）, obtains a termination of a mortgage borrower (mortgagor's equitable right of redemption, either by court order or by operation of law after following a specific statutory procedure).

 In the proceeding simply known as foreclosure, the lender must sue the defaulting borrower in state court. Upon final judgment (usually summary judgment) in the lender's

favor, the property is subject to auction by the county sheriff or some other officer of the court. If no other buyers step forward, the lender receives <u>title</u>（所有权）to the real property in return.

- **Video 5-5**: *Don't you call me crazy!*

Wife: I'm gonna go do the dishes.
Husband (playing a video game): Cool.
Wife: It would be nice if you help me.
Husband: (Damn it!) No problem. We'll get them a bit later. I'm just gonna <u>hit the streets</u> （玩"马路车手"游戏）here for a little bit.
Wife: Gary, come on! I don't want to do them later. Let's just do them now. Just take 15 minutes.
Husband: Well. I'm so exhausted. I just honestly want to relax for a little bit. If I could just sit here, let my food digest, and just try to enjoy the quiet for a little bit. (Get some! Get some! That's what happens) And we will do the dishes tomorrow.
Wife: Gary, you know, I don't like waking up to a dirty kitchen.
Husband: Who cares?
Wife: I care! All right? I care! I <u>busted my ass</u>（忙得要死）all day, cleaning this house and cooking that meal. And I worked today. And it would be nice if you said "thank you" and helped me with the dishes.
Husband: Fine. I'll help you do the damn dishes.
Wife: Oh, come on. You know what? No, that's...that's it. That's not what I want.
Husband: You just said you wanted me to help you do the dishes.
Wife: I want you to want to do the dishes.
Husband: Why would I want to do dishes? Why?
Wife: See, that's my whole point.
Husband: Let me see if I'm following you. OK? Are you just telling me that you're upset because I don't have a strong desire to clean dishes?
Wife: No. I'm upset because you don't have a strong desire to offer to do the dishes.
Husband: I just did!

Wife: After I asked you!

Husband: Jesus Brooke! You're acting crazy.

Wife: Don't you call me crazy! I am not crazy!

Husband: I didn't call you crazy (Wife: You just did). No, I didn't. I said, "You're ACTING crazy."

Wife: You know what? Gary, I asked you to do one thing today, one very simple thing, to bring 12 lemons, and you brought me 3.

Husband: God damn it! If I knew that it would be this much trouble, I would've brought home 24 lemons, even 100 lemons. You know what I wish? I wish everyone at that God damn table had their own private bag of lemons.

Wife: It's not about the lemons.

Husband: That's what you were talking about?

Wife: I'm saying, it would be nice if you did things I asked. It would be even nicer if you did things without me having to ask you!

All domestic fights start from house chores. The husband is being comfortable on the couch playing video games, unwilling to help his wife do the dishes. Then one thing leads to another. A little spat turns to a quarrel, then to a squabble, and then, and escalates to a fight. Trivial things, in this scene, doing the dishes, buying lemons first, can lead to casualties and even deadly consequences in a couple's relationship.

Some form of sexual division of labor is apparent in most known societies, but its particular manifestation and degree of differentiation is socially and historically relative. Women are primarily responsible for carrying out this servicing role and for ensuring that the physical and emotional needs of the family are met. A further aspect of domestic labor within the sexual divided labor is that women experience a double burden of work since they participate in both waged career labor and unwaged domestic labor.

- **Video 5-6: *I don't feel you appreciate me!***

Wife: I don't know how we got here (走到这一步). Our entire relationship, I've gone above and beyond (远远超出职责等), for you, for us. I mean, I've cooked. I've picked your shit up off the floor. I've laid your clothes out for you, like you were a four year old. I

support you. I supported you, your work. If we have dinner, or anything, I make the plans. I take care of everything. And I just don't feel like you appreciate any of it. I don't feel you appreciate me. And all I've wanted is to know...is for you just to show me that you care.

Husband: Why didn't you just say that to me?

Wife: Gary, I've tried. I've tried.

Husband: But never like that. You might have said some things that you meant to imply that, but I'm not a mind reader.

Wife: I did. Would it matter? <u>You are who you are</u>(你还是那副德行). Just leave me alone, OK? Right now, just shut my door.

The punishment is the crudest when the heart is dead. The marriage has gone wrong where the squeaky wheel needs to be greased. This is what happens when a woman's hard work is not or under appreciated by an ungrateful man. And it's never too late for him to realize that and make up for his act. Normally the couple would go to marriage counseling or therapy.

Couple's therapy is very common in the west, as a subset of relationship counseling. Depending on the duration of sessions, counseling tends to be more "here and now". Two methods of couple therapy focus primarily on the process of communicating. The most commonly used method is active listening, which helps couples learn a method of communicating designed to create a safe environment for each partner to express and hear feelings. Then the therapist helps them find out the problems and solve them.

- **Video 5-7: *Give Jack the opportunity to meet your needs***

Counselor: I have an exercise I'd like you guys to try this week. Will you try?

Husband: Sure.

Counselor: I bet you did this when you were dating. I want you to say "thank you" and "you are welcome" like you would to a total stranger. It's easy to us to take each other for granted, but a simple thing ...

Wife: Why would I thank him? It's just as much his trash as it is mine.

Husband: It's not all my trash.

Wife: I do more around the house than he does.

Husband: You tell me what it is you want me to do. I'll do it.

Counselor: Often we want our spouses (配偶) to know what it is we want without telling them, which is extremely difficult. We were being honest with ourselves, we may know what we don't want, but we don't know what we want.

Wife: I know what I want! But I'm not telling him.

Counselor: Why can't you tell Jack what it is that you want? He can't read your mind. What are you afraid of? Give Jack the opportunity to meet your needs. He is not the enemy.

A marriage counselor gives counseling to a couple on marital problems and disagreements. This couple's trouble, from the video, is how they view on house chores duties differently and have trouble in communicating each one's needs, which, according to the counselor, occurs often because we tend to take things for granted, and take each other for granted.

Licensed couple therapist (counselor) may refer to a psychiatrist, clinical social workers, psychologists, pastoral counselors, marriage and family therapists, and psychiatric nurses. The duty and function of a relationship counselor or couples therapist is to listen, respect, understand and facilitate better functioning between those involved.

The basic principles for a counselor include: provide a confidential dialogue, which normalizes feelings; to enable each person to be heard and to hear themselves; provide a mirror with expertise to reflect the relationship's difficulties and the potential and direction for change; empower the relationship to take control of its own destiny and make vital decisions; deliver relevant and appropriate information; changes the view of the relationship; improve communication. As well as the above, the basic principles for a couples therapist also include: to identify the repetitive, negative interaction cycle as a pattern; to understand the source of reactive emotions that drive the pattern; to expand and re-organize key emotional responses in the relationship; to facilitate a shift in partners' interaction to new patterns of interaction; to create new and positively bonding emotional events in the relationship; to foster a secure attachment between partners; to help maintain a sense of intimacy. Common core principles of relationship counseling and couples therapy are: respect, empathy, tact, consent, confidentiality, accountability, etc.

- **Video 5-8: *You sure you don't want a pound of flesh?***

Male council: Jerry, have a seat. Paula, pleasure to see you. Sorry to keep you waiting. Mr. Delins wants to be fair about this.

Female council: Define fair.

Male council: We're not prepared to make a proposal this time.

Female council: Well, we are. Mrs. Delins is asking for the primary residence（主要住宅）, the mountain cabin will be shared, and 50% of all assets.

Male council: You sure you don't want a pound of flesh?

Female council: We're talking about a 10 year marriage here. Mrs. Denins has been there every step of the way. She is not the one who wants this divorce. She only wants...

Husband: I agree.

Male council: Jerry?

Husband: Have the papers drawn up（起草，拟定）.

Male council: Are you sure you want to do this?

Husband: Absolutely.

Male council: We accept.

　　In this scene, both parties of the marriage, husband and wife, have their representative lawyer on their behalf for the negotiation terms of the divorce. When the wife's council raises the terms, the husband's council deems it too much, but the husband accepts it. From here, we can see the wife has the upper hand, while husband gives in without contesting the terms from her side.

　　Divorce laws vary considerably around the world, but in most countries divorce requires the sanction of a court or other authority in a legal process, which may involve issues of alimony（离婚后一方给另一方的生活费）, child custody, child visitation / access, parenting time, child support, distribution of property, and division of debt.

　　It is estimated that upwards of 95% of divorces in the U.S. are "uncontested"（无异议的）, because the two parties are able to come to an agreement (either with or without lawyers/mediators/collaborative counsel) about the property, children, and support issues. When the parties can agree and present the court with a fair and equitable agreement, approval of the divorce is almost guaranteed. If the two parties cannot come to an agreement, they may ask the court to decide how to split property and deal with the custody of their children. Though this may be necessary, the courts would prefer parties come to an agreement prior to entering court.

　　Where the issues are not complex and the parties are cooperative, a settlement often can be directly negotiated between them. In the majority of cases, forms are acquired from their respective state websites and a filing fee is paid to the state. Most U.S. states charge between $175 and $350 for a simple divorce filing. Collaborative divorce（协商离婚）and mediated divorce（调解离婚）are considered uncontested divorces.

According to a survey (2004) in America, the main causes were: adultery (通奸,婚外性行为), extramarital sex (婚外恋), infidelity (不忠) — 27%; domestic violence (家庭暴力) — 17%; midlife crisis — 13%; addictions, e.g. alcoholism and gambling — 6%; workaholism — 6%. A 2011 study found a 1% increase in the unemployment rate correlated with a 1% decrease in the divorce rate, presumably because more people were financially challenged to afford the legal proceedings.

5.3 Questions for discussion

1) What is your understanding of the soaring divorce rate now in China?
2) Do you agree that marriage is the graveyard of love?
3) The recent report says less and less young couple choose to have children or even get married. What do you think are the causes behind?
4) How would you understand Benjamin Franklin's words "Open your eyes wide before marriage and have them half shut after"?
5) Do you mind being a househusband or having a househusband?

5.4 Debate

Cohabitation before marriage or marriage before cohabitation?

5.5 Vocabulary exercises

domestic, go above and beyond, penalty, not withstanding, reschedule, intervention, motion, status, statutes, spouse

Try and fill in the blanks of the following sentences with words listed above in proper forms.

1) When he landed in China, he has to connect to a _____ flight to get to the convention destination.
2) Get some help from people around you when you're in trouble: whether this is your _____, friend or colleague
3) Many people buy luxurious things not for utility, but for show-off, i.e. for _____.
4) Under the _____ of the university, the school has no power to fire the teacher.
5) The conference is now debating the _____ and will vote on it shortly.
6) Giving you the suggestion never means an _____ in your personal affairs.
7) I'm afraid you're going to have to _____ summer plans, owing to the fact that we have to move our house.
8) He despised William Pitt, _____ the similar views they both held.

9) The _____ for evading tax is severe, subjected even to criminal punishment.
10) The doctors and nurses have been working so hard to save lives during the COVID-19 outbreak. They've been _____.

5.6 Role-play and reenactment

1) Please review Video 5-3, acting out the scene where an insurance claim is denied. Feel the part of culture.
2) Please review videos 5-5 & 6, acting out the scene where a desperate housewife reacts to an unresponsive and insensitive husband. Feel the part of culture of housework responsibilities shared by a couple.
3) Please review Video 5-7, acting out the scene where an estranged couple get mediation from a marriage counselor. Feel the part of culture about marriage counseling.
4) Please review Video 5-8, acting out the scene where a divorce negotiation happens between a couple. Feel the part of culture about represented negotiation.

PARENT & PARENTING
为人父母

6.1 Cultural tidbits

A parent is both the caregiver and the caretaker of a child. A biological parent is a person whose gamete（形成受精卵的精子或卵子）resulted in a child, a male through the sperm（精子）, and a female through the ovum（卵子）. Parents are first-degree relatives and have 50% genetic meet, which means parents' physical features will be passed down to their children by a rate up to 50%, and half from either of the parents. A female can also become a parent through surrogacy（代孕）. Some parents may be adoptive parents（养父母）, who nurture and raise an offspring, but are not actually biologically related to the child. Orphans without adoptive parents can be raised by their grandparents or other family members.

The most common types of parents are mothers, fathers, step-parents, and grandparents. A mother is a woman in relation to a child or children to whom she has given birth. The extent to which it is socially acceptable for a parent to be involved in their offspring's life varies from culture to culture, however one that exhibits too little involvement is sometimes said to exhibit child neglect（儿童照管不良）, while one that is too involved is sometimes said to be overprotective, cosseting（溺爱的）, nosey, or intrusive（侵扰的）.

An individual's biological parents are the persons from whom the individual inherits his or her genes. The term is generally only used if there is a need to distinguish an individual's parents from their biological parents, For example, an individual whose father has remarried may call the father's new wife their stepmother and continue to refer to their mother normally, though someone who has had little or no contact with their biological mother may address their foster parent as their mother, and their biological mother as such, or perhaps by her first name.

With the advance of technology, there is DNA (deoxyribonucleic acid, 脱氧核糖核酸) paternity testing to deal with paternity issues. A paternity test is conducted to prove paternity, that is, whether a male is the biological father of another individual. This may be relevant in view of rights and duties of the father, and also used in a number of events such as legal battles where a person's maternity is challenged, and where the mother is uncertain because she has not seen her child for an extended period of time, or where deceased persons need to be identified.

Parental obligations refer to the duties and responsibilities of a parent. When a female's egg and a male's sperm combine and produce an offspring, parental obligations arise. First

there is the guardianship（监护权）. A legal guardian is a person who has the legal authority（and the corresponding duty）to care for the personal and property interests of another person, called a ward（被监护人）. Most countries and states have laws that provide that the parents of a minor child are the legal guardians of that child, and that the parents can designate who shall become the child's legal guardian in the event of death, subject to the approval of the court. Some jurisdictions allow a parent of a child to exercise the authority of a legal guardian without a formal court appointment.

Then there is parenting（养育,育儿技巧）. Parenting or child rearing is the process of promoting and supporting the physical, emotional, social, financial, and intellectual development of a child from infancy to adulthood. Parenting refers to the aspects of raising a child aside from the biological relationship. There are many variants to the traditional nuclear family parenting, such as adoption, shared parenting, stepfamilies, and LGBT parenting, over which there has been controversy.

Parents' Day is a holiday combining the concepts of a Fathers' Day and Mothers' Day. The United Nations proclaimed June 1 to be the Global Day of Parents to appreciate all parents in all parts of the world for their selfless commitment to children and their lifelong sacrifice towards nurturing this relationship. It is the same day as International Children's Day. In the United States, Parents' Day is held on the fourth Sunday of July. This was established in 1994 when President Bill Clinton signed a Congressional Resolution into law（36 U.S.C. § 135）for "recognizing, uplifting, and supporting the role of parents in the rearing of children." Parents' Day is celebrated throughout the United States.

Child abuse or child maltreatment（虐待儿童）is physical, sexual, or psychological mistreatment or neglect of a child or children, especially by a parent or other caregiver. It may include any act or failure to act by a parent or other caregiver that results in actual or potential harm to a child, and can occur in a child's home, or in the organizations, schools or communities the child interacts with.

Cinderella effect（灰姑娘效应）is the alleged higher incidence of different forms of child-abuse and mistreatment by stepparents than by biological parents. It takes its name from the fairy tale character Cinderella.

In the United States of America, organizations at national, state, and county levels provide community leadership in preventing child abuse and neglect. The National Alliance of Children's Trust Funds（全国儿童信托基金联盟）and Prevent Child Abuse America（美国防止虐待儿童协会）are two national organizations with member organizations at the state level. When an alleged child abuse case is on the alert, social workers from these organizations will appear at your door and claim to probe into the charge. And if the ensuing investigation finds the parents guilty in child abuse, it may result in the forfeit of their right of guardianship over the children after a series of judicial and trial proceedings（司法审判程序）, and the child may fall

under the guardianship of a social welfare agency.

In this chapter, we're going to look at how parents are doing in raising a family and their children, being a parent's happiness, joy, trouble, and even painstaking involved.

6.2 Video examples

- **Video 6-1:** *She's tough!*

Mother: Daddy and I are making some changes, so that we can be happier and healthier. And we're starting with this meal that I prepared.
Father: I think this is great.
Mother: Doesn't it look good?
Father: What is that? <u>Grilled</u>（烤）cheeses?
Mother: No. Baked...baked tofu.
Father: Oh.
Mother: It's actually very tasty. And the <u>lettuce</u>（生菜）is so fresh and tasty that you forget how good lettuce tastes on its own without <u>dressing</u>（调料）.
Father: No. dressing always <u>gets in the way</u>（妨碍）of the natural taste of the lettuce.
Mother: And another thing we've decided is to <u>cut back on</u>（减少）all the electronics we use. Basically, what we're going to do, is get rid of the Wi-Fi, and only use the computer...
Daughter: What?
Mother: From 8:00 to 8:30 at night.
Daughter: How are we gonna go on the computer?
Mother: We're gonna have a hard line in the kitchen.
Father: Yeah. We'll <u>supervise</u>（监督）that.
Daughter: You can't do this. You can't take away the Wi-Fi.
Younger sister: No Wi-Fi! A-ha-ha.
Mother: You don't spend enough time with the family, when you're constantly on your iPhone and your computer. And, you know, you're only here for five more years.
Daughter: So you won't see me after five years?
Mother: No, but you won't be living with us. And you should get to know your little sister.

Father: You've got the perfect friend, right here.

Daughter: I don't wanna be friends with her now. I'll be friends with here when she's 20 and a normal person.

Younger sister: I don't wanna hang out with her when I'm in my 20s.

Father: You're on the computer too much as it is. You need to get outside more, do some playing outside.

Mother: Yeah. You could build things. You could build a fort（城堡）outside.

Daughter: What?

Mother: Yeah. Build a fort. Play with your friends, and have some…

Daughter: Make a fort? Outside? And do what? Do what in the fort?

Mother: When I was a kid, we used to build tree houses and play with sticks.

Daughter: Nobody plays with sticks!

Father: You and Charlotte can have a lemonade stand（卖柠檬汁的摊点）.

Mother: Play kick-the-can.

Father: Look for dead bodies.

Mother: It's fun. That's fun to do.

Father: Get a tire and then just take a stick and run down a street with it.

Daughter: Nobody does that crap（破玩意儿）. It's 2012.

Mother: You don't need technology.

Younger sister: No technology!

Mother: Charlotte, put that down!

Daughter: I don't need to be monitored all the time on the computer. I don't do anything bad.

Mother: Nobody said you were bad.

Daughter: I don't do things I'm not supposed to do. I don't illegally download music. I don't look at porn（淫秽作品,色情书刊或影碟等）like Wendy.

Mother: She's up to no good. She's not allowed to come over here anymore.

Younger sister: What's porn?

Father: No. She said corn.

Mother: This isn't turning out the way I wanted it to.

Daughter: I'm not hungry!

Mother: No computer.

Father: Listen to your mom!

Daughter: I need to use it for my homework.

Father: She's outplaying（战胜,击败）us.

Mother: I know. She's tough.

In this part, the mother tries her best to make a change in the family life style, to make it healthier, especially the elder daughter's obsession on the computer and ignoring her sister.

Obviously, the couple's well-meaning earnestness and lobbing don't seem to strike a chord (引起共鸣) in the girl's heart with those fun things they did when they were young.

Here, the mother is worried about her daughter's friend having access to porn (pornography). Many activists and politicians have expressed concern over the easy availability of Internet pornography, especially to minors. This has led to a variety of attempts to restrict children's access to Internet pornography such as the 1996 Communications Decency Act (《通信规范法案》) in the United States. Due to enforcement problems in anti-pornography laws over the Internet, countries that prohibit or heavily restrict access to pornography have taken other approaches to limit access by their citizens, such as employing content filters (过滤器,过滤程序). In response to concerns with regard to children accessing age-inappropriate content, some companies use an Adult Verification System (AVS,成人认证系统) to deny access to pornography by minors. A variety of content-control, parental control and filtering software is available to block pornography and other classifications of material from particular computers or (usually company-owned) networks.

- **Video 6-2: *I'm like one big chicken with its head cut off!***

Daughter: Mummy, mummy!
Wife: Yes. I'm coming!
Daughter: I can't find my sneakers!
Wife: Over at the door.
Daughter: Not those. The blue ones.
Wife: Yes. Put them on. You're gonna be late for school.
Daughter: Good.
Wife: Hew.
Husband: Hey. You want some?
Wife: No time for such caffeinated luxuries (含咖啡因的奢侈品,其实是说自己没时间喝咖啡). You can drop her off (送她去学校), right?
Husband: No. Honey. I can't. McManus just moved up (提前) this morning's meeting.
Wife: Oh, no...no...no. If I'm late one more time, I swear they are gonna...
Husband: OK. All right. OK. I'll figure it out.

Wife: And you can pick her up too, right?
Husband: Honey, we've got those clients from out of town. We gotta take them to drinks after work.
Wife: I know. I'm just so <u>overwhelmed</u>（被压垮的,不堪重负的）with work right now. I don't have any time this afternoon.
Husband: Can you call your mom?
Wife: Good idea. She loves spending time with Tina. I'll just give her a call. Give me a second. OK.
Grandmother:（on the phone）Good morning!
Wife: Maybe for you. I'm <u>like one big chicken with its head cut off</u>.（像一只无头苍蝇）
Grandmother: Well, it's nice to feel needed.
Wife: I do need a huge favor. Can you pick up Tina from school this afternoon? Alex and I are working late.
Grandmother: Honey. I told you I'm leaving today for a 10-day <u>cruise</u>（乘船游览）.
Wife: Oh, right. The 10-day cruise that you definitely told me about <u>way in advance</u>（提前很早；way 此处为副词,意思是"远远地,很大程度地"）, so I can schedule accordingly.
Grandmother: Sorry. Honey, I'm sure I told you.

 This is a typical nuclear family morning, with both mother and father in a rush to work, and a child to drop off to school in the morning and pick up in the afternoon. The wife has no alternatives but asks for help from her mother, who happens to be scheduled for a trip. This is the moment when some couples, if they can afford it, hire a nanny to do the job. So nanny culture is a unique part of the native way of life. The following example is a mother doing an interview with a candidate for the job.

 Work-family balance is a concept involving proper prioritizing between work/career and family life. It includes issues relating to the way how work and families intersect and influence each other. At a political level, it is reflected through policies such as maternity leave and paternity leave. Since the 1950s, social scientists as well as feminists have increasingly criticized gendered arrangements of work and care, and the male breadwinner role, and policies are increasingly targeting men as fathers, as a tool of changing gender relations.

• **Video 6-3: *You know, helicopter parenting is a pejorative（贬义的）term***

Daughter: Hey, can I borrow five bucks? Carmen and I want to study at Phil's diner after school.

Mother: I don't think that's a good idea.

Daughter: We always study at the diner.

Mother: Well, not today. We want you to come home.

Daughter: Mom, I thought we <u>were over this</u>. (不再讨论这件事)

Mother: We are over this, but I still want you to come home straight after school.

Daughter: Mom!

Mother: End of discussion.

Daughter: Dad?

Father: Do what your mom says.

Daughter: Fine.

Mother: Hey, where are you going?

Daughter: To school, or is that not allowed either?

Mother: Have your father drive you.

Daughter: You know, helicopter parenting is a pejorative term.

Mother: Hey, I love you.

Daughter: See you later.

 Opposite to <u>free-range parenting</u>（放养式教育）, a helicopter parent, also called a <u>cosseting</u>（溺爱的）parent or simply a cosseter, is a parent who pays extremely close attention to a child's or children's experiences and problems, particularly at educational institutions. Helicopter parents are so named because, like helicopters, they <u>hover</u>（盘旋,悬停）overhead, <u>overseeing</u>（监管）their child's life.

 Helicopter parents attempt to ensure their children are on a path to success by paving it for them. The rise of helicopter parenting coincided with two social shifts. The first was the comparatively booming economy of the 1990s, with low unemployment and higher disposable income. The second was the public perception of increased child endangerment, a perception which free-range parenting advocate Lenore Skenazy (2016) described as "rooted in <u>paranoia</u>（偏执狂,妄想症）".

 In the past few years, Tianjin University has been building "<u>love tents</u>"（爱心帐篷）to accommodate parents who have traveled there with their matriculating freshmen, letting them sleep on mats laid out of the gym floor. Commentators on social media have argued that the one-child policy has been an <u>aggravating</u>（加重）factor in the rise of helicopter parenting.

 The Chinese parenting style of the <u>Tiger Mother</u>（虎妈）has been compared to western helicopter parenting. Nancy Gibbs (2011) writing for *Time* magazine described them both as "extreme parenting", although she noted key differences between the two. Gibbs describes Tiger Mothers as focused on success in precision-oriented fields such as music and math, while

helicopter parents are "obsessed with failure and preventing it at all costs". Another difference she described was the Tiger Mother's emphasis on hard work with parents adopting an "extreme, rigid and authoritarian approach" toward their children.

University of Georgia professor Richard Mullendore (2016) described the rise of the cell phone as a contributing factor for helicopter parenting-having called cell phones "the world's longest umbilical cord（脐带）". Some parents, for their part, point to rising college tuition costs, saying they are just protecting their investment or acting like any other consumer.

Dr. Clare Ashton-James (2013), in a cross-national survey of parents, concluded that "helicopter parents" reported higher levels of happiness. Some studies have shown that overprotective, overbearing or over-controlling parents can cause long-term mental health problems for their offspring. "Psychological control can limit a child's independence and leave them less able to regulate their own behaviors."

- **Video 6-4:** *You have a lot of experience for being so young*

Mother: This is Miss Julie.
Julie: Hello! She is adorable!
Mother: Thank you.
Julie: It's for you.
Mother: Oh. Great! Wow, you have a lot of experience for being so young.
Julie: Huh, thank you. Um, well, I've been a nanny for two years. Em…I'm majoring in child development, hoping to graduate soon, so I can learn continual undergraduate school.
Mother: Umm. That's great, Julie.
Julie: I'm also a firm believer in constructivist（建构主义的）education.
Mother: I'm sorry. What…what is that?
Julie: Don't worry about it. It's just basically a fancy term for child-centered learning, so utilizing（利用）objects that a child can handle herself to teach after our concepts.
Mother: That sounds progressive.
Julie: Sort of, but the most important thing is that every child feel loved, truly loved for herself. But I mean, isn't that all what we're looking for?
Julie: Aren't you just a little snuggle bug（惹人爱的小乖乖）! Aww.
Mother: Oh, I'm gonna tell you. Jenny has a heart arrhythmia（心律不齐）.

Julie: Oh.

Mother: It's OK. She just has to take her medicine regularly. Right? Yeah.

Julie: Well. We just make sure you're never without your medicine little lady.

Mother: Well, I have to tell you, Carol speaks highly of you.

Julie: Oh. That is so kind of her. Mr. and Mrs. Scott are just two lovely people. I truly enjoyed taking care of their child.

Mother: Oh, I didn't realize you took care of their kids. I thought that Naomi was their only nanny.

Julie: Yes. She is. I just put cover(顶替) for her from time to time.

Mother: Of course. Well...em...I think you're fantastic. Obviously, Jenny does, too. So I don't know. You could be a great fit.

Julie: Really?

Mother: Yeah.

Julie: Me too. I feel so excited!

Mother: Great.

Julie: When can I start?

Mother: Tomorrow?

Julie: Perfect!

In this scene, the mother is interviewing a girl who is studying nursing at college, and her instant intimacy with the child gives her some credit on the spot. With her education background and approachable personality, she is granted the opportunity and lands the job successfully. From the mother's in depth investigation and interview, we can also see a recommendation from another employer is also very important for a candidate for a certain job.

A babysitter is a person engaged to care for one or more children in the temporary absence of parents or guardians. A babysitter is also called a nanny, or a sitter. Babysitting is temporarily caring for a child. Babysitting can be a paid job for all ages; however, it is best known as a temporary activity for young teenagers who are too young to be eligible for employment in the general economy.

The majority of the time, babysitting workers tend to be in middle school, high school or college. There are some adults who have in-home childcare as well. The type of work for babysitting workers also varies from watching a sleeping child, changing diapers, playing games, preparing meals, to teaching the child to read or even driving (if the age is right), depending on the agreement between parents and babysitter.

In British English the term refers only to caring for a child for a few hours, on an informal basis and usually in the evening when the child is asleep for most of the time. In American English the term can include caring for a child for the whole or most of the day, and on a regular or more formal basis, which would be described as childminding in British English.

There's also a house-sitter, i.e., someone to take care of a residence while the regular occupant is away, esp. by living in it. And some other terms like dog-sitter, cat-sitter, etc.

- **Video 6-5:** *Do you know why it hurt me so much?*

Daughter: Hi, Mom! Mom?
Mother: Hmm.
Daughter: Can I talk to you? I'm sorry. I'm sorry, for making you <u>drop me off</u>（让我下车）on the other side of the mall.
Mother: I appreciate the apology. Do you know why it hurt me so much?
Daughter: Huh, no.
Mother: Do you notice how your father and I, all the work we do around here, everything we do is for you?
Daughter: Yeah, mom, I do.
Mother: No. I don't think you do.
Daughter: Yes, I do! Mom.
Mother: Why wouldn't you let me meet your friends? Are you ashamed of me?
Daughter: No. mom, I'm not, I'm not ashamed of you!
Mother: You don't respect me. You don't know where Ashley's family got their money. You don't know if they inherited it. You don't know if they earned it, or if they have millions or they own millions. But what you do know what you see. And your parents who came from very little worked very hard to build this.
Daughter: I know that, mom. I do.
Mother: Just remember that, when your friends have money, it's not their money; it's their parent's money. Right? So just because they can buy a purse, and you can't, that doesn't make them better than you. That doesn't make them smarter, doesn't make them more interesting. Honey, I don't want you to <u>get caught up</u>（被卷入，陷入）in the Beverly Hill（贝弗利希尔斯，常译作贝弗利山，为美国加利福尼亚州西南部城市，是好莱坞影星集居地）scene, that all of that is not real. It's a <u>façade</u>（假象）. This should be the most important thing to you. This: Your father, your sister, and me. This should be the most important thing in your life.

From this dialogue we can see that some misunderstanding occurred between the daughter and mother from earlier, and the daughter's act of preventing her friends seeing her mother has hurt her so much. Here the heart-wrenched mother is trying to make sense in her daughter by clearing up four things to her: 1. her friend's money is not her money, but her family's. 2. Your parents came from very little, but have done their best for the family and for you. 3. Value yourself and not submit yourself to peer pressure. 4. The most important thing for you is your family.

Peer pressure is the direct influence on people by peers, or the effect on an individual who is encouraged and wants to follow their peers by changing their attitudes, values or behaviors to conform to those of the influencing group or individual. For the individual, this can result in either a positive or negative effect, or both. Social groups affected include both membership groups and cliques. The term "peer pressure" occurs mostly with reference to those age-groups. For children, Imitation plays a large role in children's lives and their abilities for independent decision-making; for adolescents, this is the period where a person is most susceptible to peer pressure because peers become an important influence on behavior. Peer pressure's relationship exists in various areas, including drinking, smoking, sex and substance abuse, etc. Peer pressure has expanded from strictly face-to-face interaction to digital interaction as well. Social media provides a massive new digital arena for peer pressure and influence. Research suggests there are a variety of benefits from social media use, such as increased socialization, exposure to ideas, and greater self-confidence. There is also evidence of negative influences such as advertising pressure, exposure to inappropriate behavior and/or dialogue, and fake news.

- **Video 6-6:** ***Holy shit!***

Mother: Oh, you guys. Thank you for being super patient. I appreciate it. Aww, here we go, guys.
Husband: Thanks honey.
Mother: All right, love. How was work?
Husband: Oh, I had two conference calls, and I took a nap. It was exhausting.
Mother: I bet...I bet. Oh, Dillon, baby, how was...how was your science quiz?
Sun: Mm, I got a D.
Mother: A D? But we worked so hard? Baby, what happened? Do you need extra help, so we can get you another tutor?

Son: Mm, no, I'm good.

Mother: Mike, did you hear Dillon got a D on his science quiz?

Husband: Way to go, bud!（干得不错,伙计!）

Mother: What? OK. Hum, Jane, oh my gosh, how was your soccer tryouts（选拔）?

Daughter: Coach is posting a list of who makes the team tonight at 9, and I'm so nervous.

Mother: Baby, it's OK. Relax, you will make the soccer team, I promise. Just don't freak out（行为失控,感情失控）.

Mother: I'm freaking out!

Daughter: I am, too. What time is it now?

Mother: 8:59

Daughter: Come on!

Mother: Oh, it's 9. It's 9! Go, go, go. Hit refresh（点击刷新）!

Daughter: Oh, my God. I made the team! I made the team!

Mother: I'm so relieved. Thank you! Baby, I'm so proud of you! I'm so excited!

Daughter: Oh, God. This is gonna look so awesome for my college applications.

Mother: Baby, it's great. But you're only twelve. So it's great.

Daughter: What if I don't play? What if I'm a loser benchwarmer（板凳队员,替补队员） scrub（口语:二流运动员）?

Mother: You're great. You're gonna be fine.

Daughter: No, it's not fine. Mom! Do you understand how hard it is to get into an Ivy League（常春藤联盟大学）school now? I mean they turned away（拒收）Asians.

Mother: That's a little racist, but...

Daughter: My God. I need to practice my footwork（步法）. Why did you let me eat dessert? Oh, I know, because you hate me!

Mother: Holy shit!

 There's a word in English, "underappreciated", for a housewife's work. This is a hardworking wife without any complaint in the family, but obviously, neither the husband nor the children share her sentiment and concern, not to mention appreciating her wholehearted service. The husband is useless at home, only making him comfortable after work, and the son has no intention or motivation of working hard on his schoolwork, while the daughter is on the country, an eager beaver, and is also tough to deal with.

 Ivy League is the name commonly used to refer to those eight schools as a group. The eight institutions are Brown University, Columbia University, Cornell University, Dartmouth College, Harvard University, Princeton University, the University of Pennsylvania, and Yale University. The term Ivy League also has connotations of academic excellence, selectivity in admissions, and social elitism. The use of the phrase is no longer limited to athletics, and now represents an educational philosophy inherent to the nation's oldest schools. Seven of the eight

schools were founded during the United States colonial period; the exception is Cornell, which was founded in 1865.

Ivy League schools are viewed as some of the most prestigious, and are ranked among the best universities worldwide. All eight Ivy League institutions place within the top fifteen of the U. S. News & World Report college and university rankings, including the top four schools and six of the top ten. A member of the Ivy League has been the U.S. News number-one-ranked university in each of the past 12 years: Princeton University five times, Harvard University twice, and the two schools tied for first five times.

The Ivies are all in the Northeast region of the United States. Each school receives millions of dollars in research grants and other subsidies from federal and state government. Undergraduate enrollments among the Ivy League schools range from about 4,000 to 14,000, making them larger than those of a typical private liberal arts college and smaller than a typical public state university. Overall enrollments range from approximately 6,100 in the case of Dartmouth to over 20,000 in the case of Columbia, Cornell, Harvard, and Penn. Ivy League university financial endowments range from Brown's $2.2 billion to Harvard's $32 billion, the largest financial endowment of any academic institution in the world.

The phrase Ivy League historically has been perceived as connected not only with academic excellence, but also with social elitism.

- **Video 6-7:** *If you're bad mom like me, please vote for me!*

Wow. There's a lot of you! (Her friends: Introduce yourself!)

Hi. I'm Amy Mitchell. And I'm running for PTA（家长和教师联谊会）president. (You're doing great. Just because they're not responding doesn't mean you're terrible.) You know, I know there's a lot of rumors going around about my daughter. (That's a bad place to start) And I'm guessing a lot of you think I'm a bad mom. (Yes.) No. No. No. You know what? You're right. Sometimes I'm too lenient（仁慈的）with my kids. Sometimes I'm too strict (so you've underestimated her obviously). Sometimes I'm so crazy that I don't even understand the words that are coming out of my mouth. You see what works for my daughter almost never works for my son. And whenever I think I'm actually starting to figure my kids out, they grow up and I'm back to square one（起点）. So the truth is, when it comes to being a mom, huh, I have no f-ing clue of what I'm doing. And you know what? I don't think anyone does. I think we're all bad moms, and you know why? Because being a mom today is

impossible. (I never doubted her. I never doubted her. She is doing great! She is a natural) So can we all please stop pretending like we have it figured out? And stop judging each other for once. But I'm running for PTA president because I want our school to be a place where you can make mistakes, where you can be yourself, where you're being judged on how hard you work and not on what you bring to the f-ing bake sale. I want our school to be a place where it's OK to be a bad mom. Do you know what I mean? If you're a perfect mom, who's got the whole parenting things figured out, well, then you should probably vote for Gwendolyn, 'cause she's amazing. (Yes) But if you're a bad mom like me, then you have no f-ing clue of what you're doing. Well, you're just sick of being judged all the time, then please vote for me.

In this speech, the mother is running for President of PTA, the abbreviated form of Parent-Teacher Association, which is an organization that brings together the parents of children at a particular school and the teaching staff, intended to maintain good relations and communication between them and often to raise funds for the school and organize activities on behalf of the school.

A bake sale is a fundraising activity where baked goods such as doughnuts, cupcakes and cookies, sometimes along with ethnic foods, are sold. Bake sales are usually held by small, non-profit organizations, such as clubs, school groups and charitable organizations. Bake sales are often set up around an area of pedestrian traffic, such as outside a grocery store or at a busy intersection near a mall. Bake sales are also popular fundraising activities within corporations. There are two most popular types of bake sales. One is donation sale: community or club members contribute food they have made; the other is volume sale: organizations plan for food to be made, and provide members with recipes. Within these sales different themes are often used: Season's Best; Cupcake Theme; Chocolate Theme; Cookie Theme; Cake Theme.

The three persuasive appeals laid by Aristotle in his iconic Rhetoric(《修辞学》) can be applied to the analysis of this speech, i.e., pathos(感染力), ethos(人格气质) and logos(逻辑,理性). Firstly, pathos, the passion in delivering a speech, as is shown from her way of speaking, even with the aid of crude language to strengthen her ideas. Secondly, ethos, the integrity and honesty of the speaker, as is revealed by the speaker's confession that she's a bad mother, which strikes a chord with the audience. Thirdly, logos, the logic in organizing the speech, as we can see, she takes a strategy of taking one step backward for two steps forward, or being aggressive in the disguise of compromise(以退为进的). She firstly admits that she is a bad mom, and then justifies herself and all the other mothers for being a bad mom. At last, appealing to the mothers to vote for her. So in a logical view, the development of her speech is followed in this order: I'm not a good mom-being a perfect mom is impossible-if you think you're a good mom (you're just pretending), please vote for the other candidate-if you think you're a bad mom (because we all are), please vote for me.

- **Video 6-8: *Where did the time go?***

Father: There she is! Mia, you're a vision（美好的人或事物，尤指女性）! Your mama would be so proud.

Daughter: Thanks.

Father: Look at you!

Daughter: You like it?

Father: You look gorgeous.

Step mother: Oh, your date's here!

Father: Hey, my young man!

Boy friend: Wow, you look awesome!

Daughter: Thanks.

Father: Oh, wait, wait! Picture time! Picture time! I'm not missing this. OK. Smile, now there you go, OK.

Daughter: Are we done?

Father: One more, no, hang on, just one more. And where is the pre-party（晚会前的预备晚会）?

Daughter: It's at Jenny Hogan's.

Father: Say hello to her parents for me.

Daughter: I will.

Boy friend: Oh, ah, wait till you see our ride（美俚：汽车）.

Brother: I want to see a limo（豪华轿车）.

Daughter: Come on; come and see it.

Brother: Cool!

Father: Back by midnight!

Step mother: 12:30.

Father: Fine... I just watched her take her first steps, and now she's off to prom in heels. Where did the time go?

Step mother: They grow up so fast.

In this scene, the father has mixed feelings prior to the most important event of his daughter's high school life: prom. Prom, short for promenade, a commonly held dance in the United States, and increasingly common in the United Kingdom and Canada due to the influence of American films and television shows, is a semi-formal (black tie) dance or

gathering of high school students. This event is typically held near the end of the senior year (the last year of high school). High school juniors attending the prom may call it "junior prom" while high-school seniors may call it "senior prom". In practice, this event may be a combined junior / senior dance.

At a prom, a Prom King and Prom Queen may be revealed. These are honorary titles awarded to students elected in a school-wide vote, and seniors are usually awarded these titles. The Prom Queen and Prom King may be given crowns to wear.

Similar events take place in many other parts of the world. In Australia and New Zealand, the terms school formal（须穿礼服的社交集会）, and ball（舞会）are most commonly used for occasions equivalent to the American prom, and the event is usually held for students in senior year. Many schools hold a formal graduation ball for finishing students at the end of the year in place of or as well as a formal.

Usually before the prom, there's a gathering of the partygoers called pre-party, and after the prom, parents or a community may host a "prom after-party" or "afterglow" or "post-prom" at a restaurant, entertainment venue, or a student's home. Other traditions often include trips to nearby attractions, such as amusement parks, regional or local parks, or family or rented vacation houses. Some of these post-prom events are chaperoned（陪伴,监护）and some are unsupervised（无人监管的）. Many Post Proms (After Prom Events) are at the school, and involve bringing entertainment such as interactive games, artists, and other entertainers to the school.

In the US, the legal age for young people to be allowed to drink is 21 years old, so it's a normal practice for them to be asked to present their ID card to the bar tenders before they can be served alcohol. Usually in a prom, under-aged students drink punch, which refers to a wide assortment of drinks, both non-alcoholic and alcoholic, generally containing fruits or fruit juice. The drink was introduced from India to England by employees of the British East India Company（英国东印度公司）. Punch is usually served at parties in large, wide bowls, known as punch bowls.

6.3 Questions for discussion

1) Who's to blame more for generation gap, the children or the parents?
2) Helicopter parenting and free-range parenting, which one do you prefer?
3) What's the common ground and differences between helicopter parenting and tiger mother?
4) Who would you turn to confide in first if you have to choose one: your parents or your friends?
5) Are you under any peer pressure now? How are you coping with it?

6.4 Debate

Men need more care than women.

6.5 Vocabulary exercises

cosset, intrusive, supervise, get in the way, cut back on, drop off, overwhelm, refresh, freak out, lenient

Try and fill in the blanks of the following sentences with words listed above in proper forms.

1) The judge was _____ with the wrongdoer.

2) Thank you for giving me a ride. You can _____ me _____ at the bus station.

3) When he saw the hero he admired, he was too _____ to say a word.

4) May I _____ your memory that you have promised to help us when we're in trouble?

5) He was _____ when he saw a snake lurking in the grass.

6) You need to _____ the cigarettes if you want your lungs to work better.

7) These questions are very private and may sound _____ to the interviewees.

8) When children are playing with their friends in the open field, they are _____ by their parents.

9) Nothing will _____ of your success if you've made up your mind to do it.

10) His grandpa and grandma are always _____ him, they will give him whatever he wants.

6.6 Role-play and reenactment

1) Please review Video 6-1, acting out the scene with a family of a mother, a father, and two sisters. Feel the part of culture where parenting is in a predicament.

2) Please review Video 6-2, acting out the scene with a family of a mother, a father, and a daughter. Feel the part of culture where career parents are pinched in tending to both their work and a schooled child.

3) Please review Video 6-3, acting out the scene with a mother who requires her daughter to come home after school. Feel the part of culture about parenting styles.

4) Please review Video 6-5, acting out the scene with a mother, a father, a son and a daughter. Feel the part of culture about the hardship of being a mother.

5) Please review Video 6-7, acting out the scene. Get acquainted with the part of prom culture in the United States.

Chapter 7

LGBTQ COMMUNITY
同性问题

7.1 Cultural tidbits

LGBT community, also referred to as the gay community, is a loosely defined grouping of lesbian, gay, bisexual, transgender, and queer (LGBTQ) and LGBT-supportive people, organizations, and subcultures (亚文化), united by a common culture and social movements. These communities generally celebrate pride, diversity, individuality, and sexuality. LGBT activists and sociologists see LGBT community-building as a counterbalance (制衡) to heterosexism (蔑视同性恋者的异性恋主义), homophobia (对同性恋或同性恋者的憎恶或恐惧, 恐同情绪), biphobia (对双性恋者的厌恶和偏见), transphobia (对易性癖者的憎恶或偏见), and sexualism (性别歧视). The LGBT community is diverse in political affiliation. Not all LGBT individuals consider themselves part of an LGBT community.

Symbol of the community is usually a rainbow flag. According to Gilbert Baker (吉尔伯特·贝克, 彩虹旗设计者, 美国同性恋运动人士), creator of the commonly known rainbow flag, each color represents a value in the community. Gilbert Baker designed the rainbow flag for the 1978 San Francisco Gay Freedom Celebration. The flag does not depict an actual rainbow. Rather, the colors of the rainbow are displayed as horizontal stripes, with red at the top and violet at the bottom. It represents the diversity of gays and lesbians around the world. In the original eight-color version, pink stood for sexuality, red for life, orange for healing, yellow for the sun, green for nature, turquoise (青绿色) for art, indigo (靛蓝色) for harmony, and violet for the soul.

The current struggle of the gay community has been largely brought about by

globalization. LGBT community subculture began to grow and stabilize into a nationwide phenomenon. Today, many large cities have gay and lesbian community centers. Many universities and colleges across the world have support centers for LGBT students. There is also an International Lesbian and Gay Association. In 1947, when the United Kingdom adopted the Universal Declaration of Human Rights (UDHR), LGBT activists clung to its concept of equal, inalienable (不可剥夺的) rights for all people, regardless of their race, gender, or sexual orientation. The declaration does not specifically mention gay rights, but discusses equality and freedom from discrimination.

In parts of the world, partnership rights or marriage have been extended to same-sex couples. LGBT community is still an important segment of consumer demographics (消费群体) because of the spending power and loyalty to brands that they have. LGBT community has been recognized for being one of the largest consumers in travel.

Gay bars become more and more popular in large cities. For gays particularly, increasing numbers of cruising (在公共场所寻觅性伙伴,猎艳) areas, public bath houses, and YMCAs (基督教青年会) in these urban spaces continued to welcome them to experience a more liberated way of living. Pride parades (同志骄傲大游行) for the LGBT community are events celebrating lesbian, gay, bisexual, and transgender culture and pride. The events also at times serve as demonstrations for legal rights such as same-sex marriage, and challenge hetero normative space, which also triggers opposition and controversy both with LGBT and mainstream populations on certain things often found in the parades, such as public nudity, BDSM (bondage, discipline/domination, sadism and masochism/sado-masochism,一种性亚文化) paraphernalia (某活动所需的装备), and other sexualized features. Within the academic community, there has been criticism that the parades actually set to strengthen homosexual-heterosexual divides and increase essentialist views (本质主义学者,要素主义教育主张者).

Societal attitudes toward homosexuality vary greatly in different cultures and different historical periods, as do attitudes toward sexual desire, activity and relationships in general. All cultures have their own values regarding appropriate and inappropriate sexuality; some sanction (正式许可,批准) same-sex love and sexuality, while others may disapprove of such activities. In the 1950s in the United States, open homosexuality was taboo. Legislatures in every state had passed laws against homosexual behavior. Beginning in the 20th century, LGBT rights movements have led to changes in social acceptance and in the media portrayal of same-gender relationships. The legalization of same-sex marriage and non-gender-specific civil unions is one of the major goals of gay rights supporters. Then other countries follow suit, including Argentina, Australia, Belgium, Brazil, Canada, and so on. Here are some other terms in LGBT community:

Sexual orientation (性取向) is an enduring pattern of romantic or sexual attraction (or a combination of these) to persons of the opposite sex or gender, the same sex or gender, or to

both sexes or more than one gender. These attractions are generally subsumed（归入）under heterosexuality, homosexuality, and bisexuality, while asexuality（无性，性冷淡）is sometimes identified as the fourth category.

Homosexuality（同性恋）is romantic attraction, sexual attraction or sexual behavior between members of the same sex or gender.

Heterosexuality（异性恋）is romantic attraction, sexual attraction or sexual behavior between persons of the opposite sex or gender.

Homophobia has been defined as contempt, prejudice, aversion（讨厌）, hatred or antipathy against homosexuality, and encompasses（包括）a range of negative attitudes and feelings toward homosexuality or people who are identified or perceived as being lesbian, gay, bisexual or transgender.

Getting out of the closet（出柜,公开自己的同性恋身份）is a metaphor for LGBT people's self-disclosure of their sexual orientation or of their gender identity. The opposite is closeted or in the closet, which is an adjectives for lesbian, gay, bisexual, transgender people who have not disclosed their sexual orientation or gender identity and aspects thereof, including sexual identity and sexual behavior. It can also be used to describe anyone who is hiding part of their identity because of social pressure.

Gay pride（同性恋者尊严）is the positive stance against discrimination and violence toward lesbian, gay, bisexual, and transgender people to promote their self-affirmation（自我肯定）, dignity, equality rights, increase their visibility as a social group, build community, and celebrate sexual diversity and gender variance.

Pride parades for the LGBT community are events celebrating lesbian, gay, bisexual, and transgender (LGBT) culture and pride. The events also at times serve as demonstrations for legal rights such as same-sex marriage.

New York City's LGBT pride parades began in 1970, as did Los Angeles pride, Chicago pride, and pride San Francisco that year.

The 2011 parade was held just two days after the legalization of gay marriage in the state of New York. Other pride parades include Boston pride, Chicago pride, Denver pride, Columbus pride, Cincinnati pride,

In Canada, there are Montreal's Gay pride parade, Toronto's pride, Ottawa's pride, Vancouver's pride.

There are five main pride events in the UK gay pride calendar: London, Brighton, Leeds, Manchester and Birmingham being the largest and are the cities with the biggest gay populations. Pride London is one of the biggest in Europe and takes place on the final Saturday in June or first Saturday in July each year. London also hosted a black pride in August and Soho (small office/home office, 在家上班族) pride or a similar event every September. During the early 1980s there was a women-only lesbian strength march held each year a week before the

gay pride march.

The first pride parade in Hong Kong was held on May 16, 2005 under the theme "Turn Fear into Love", calling for acceptance and care amongst gender and sexual minorities in a diverse and friendly society. By now a firmly annual event, pride 2013 saw more than 5,200 participants. The city continues to hold the event every year.

On November 1, 2003, in Taipei the first LGBT pride parade was held with over 1,000 people attending. The parade held in September 2008 attracted approximately 18,000 participants, making it one of the largest gay pride events in Asia.

(San Francisco pride parade, 2012)

Sexualism is discrimination against a person or group on the basis of their sexual orientation or sexual behavior. It usually refers to a predisposition (倾向) towards heterosexual people, which is biased against lesbian, gay, bisexual, and asexual people, among others.

Civil union (同性结合,同性婚姻), also referred to by a variety of other names, is a legally recognized arrangement similar to marriage. These unions have been established in a number of countries since the late 1990s, often developing from less formal domestic partnership legislation. Beginning with Denmark in 1989, civil unions are often seen by campaigners as a "first step" towards legalizing marriage for same-sex couples.

Gay-friendly (对同性恋者友好的,接纳同性恋者的) or LGBT-friendly are the places, policies, people or institutions that are open and welcoming to gay people (including all members of the LGBTQ community) to create an environment that is supportive of gay people and their relationships, respectful of all people, treat all people equally, and are non-judgmental. This is typically a late 20th-century North American term that is the byproduct of both a gradual implementation of gay rights and acceptance of policies supportive of LGBTQ people in the workplace and in schools, as well as the recognition of gays and lesbians as a distinct consumer group for businesses.

Gaydar (同性恋雷达,指同性恋者根据细微迹象彼此识别对方是否系同性恋者的能力) is a colloquialism (口语,俗语) referring to the intuitive ability (直觉能力) of a person to assess (评测) others' sexual orientations as gay, bisexual or heterosexual. Gaydar relies almost exclusively on non-verbal clues (非语言线索) and LGBT stereotypes. These include (but are not limited to) the sensitivity to social behaviors and mannerisms; for instance, acknowledging

flamboyant（夸张的）body language, the tone of voice used by a person when speaking, overtly rejecting traditional gender roles, a person's occupation, and grooming（梳洗）habits.

7.2 Video examples

- Video 7-1: *Who doesn't like romance?*

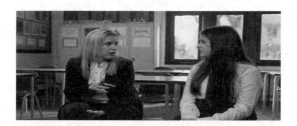

Miriam: I can never remember that. LGBTQ. LGBTQ. LGBTQ. I must remember, because people are always asking me, you know, because I'm one of them. At least I'm L, at the front, there, lesbian, yay!

Saima: Oh, my God. Lesbian, L. Gay...

Maggie: Bisexual, transgender,

Miriam: Q?

Saima: Q?

Saima's son: Queer.

Saima: No.

Saima's son: Queer.

Saima: Is it?

Saima's son: Yeah.

Ellie: It's lesbian, gay, bi, trans, queer, plus, so it's...

Cheryl: What's the plus?

Ellie: Other sexualities（性习惯）...There's, like, pansexual（泛性的，指对性对象的性别和性行为不做限制的）and things like that.

Cheryl: Is that where you fall in love with a thing?

Martha: A what?

Martha's daughter: Aromantic（没有浪漫感觉的）. You don't feel romantic attraction.

Martha: Oh, Lord, help me.

Cheryl: Who doesn't like romance? That's crazy.

Ellie: A lot of people!

Cheryl: Oh.

Ellie: I don't think it's something that you decide. All my friends were telling me that at a

very, very young age, they knew that they weren't supposed to be girls.

Maggie: There are some people who don't feel as if they're the same body that they were born into, but actually, while we should be really compassionate(有同情心的) to them, and kind…

Maggie's daughter: And accept them; it's important to still accept them.

Maggie: Exactly, but if someone is really, really unhappy with their body, and they feel that their body is wrong, then surely they need some counseling(咨询,忠告) or some help to get them be comfortable in their body.

Maggie's daughter: Yeah, mental help…instead of…I don't know…

Maggie: Medical help. Yeah.

In this group discussion (as part of sexual education in England between parents and their children), the definitions of LGBTQ+ are explored as well as the reasons behind. There's curiosity, disbelief, shock, and also the idea that understanding, compassion, respect and support should be given to those who don't choose the body they're born into, instead of discriminating and looking down on them.

- **Video 7-2: *We'd rather you be gay!***

Yes, I decided to be a comedian senior year at college. That's how I tell my parents, who were paying for college. Like, I had to sit them down. I was like, "mom, dad, something very difficult to tell you." And they were like, "You are gay." I said, "No, I want to be a comedian." And they were like, "We'd rather you be gay. Is that still an option on the table? 'cause we'll go to the parade(这里指"同志骄傲"大游行). We'll go."

I get it. People think I'm gay, 'cause every single thing about me. If you think you're not gay, people think you're gay. People will argue with you about you. Right? You know what I'm talking about. Right? Same boat(同一条船上的,这里调侃下面一个评委). They don't do that with other preferences. I went to a deli(熟食店), "Hey, do you want cucumber?" I'm like, "Nah." "Mm, you want cucumber. You look and sound like you want cucumber. You know we're gonna put one in your sandwich. You're lying to yourself."

Right, that's it. Thank you so much.

In this stand-up show, the comedian cracks a joke about how he looks like a gay man on the outside, as mentioned in gaydar, a term that refers to the intuitive ability of a person to assess other's sexual orientation as gay, via such stereotypical behaviors, in this joke, as eating a sandwich with cucumber, among others. The performer also mentions one of the judges down stage in the panel as an <u>insinuation</u>（旁敲侧击的话，影射，暗示）, making it more funny in the joke.

- **Video 7-3:** *Your party sucks!*

Girl 1: Do I look too much like a lesbian?

Girl 2: You ARE a lesbian.

Girl 1: Yeah, but I don't want to look…gay.

Girl 2: You're like, offensive to yourself.

Girl 1: I mean, I'm not offended.

Girl 1: Is that her?

Girl 2: Isn't she pretty?

Girl 1: Why is she so <u>dressed up</u>（盛装打扮）?

Girl 2: She just came from work.

Girl 1: She rich? That's a really <u>fancy</u>（时髦昂贵的，奢华的）bag.

Girl 2: I don't know. I don't know her that well. Come on, Sarah, let's just go say hi.

Girl 1: No. I don't need to <u>make a big deal out of</u>（极端重视，对……小题大做）saying hi. Just, you know, if we <u>cross paths</u>（不期而遇，意外相逢）, then I'll…

Girl 2: Come on.

Girl 1: No!

Girl 2: Sasha!

Man 1: So has Sasha ever been with a <u>dude</u>（男人，伙计）?

Man 2: Lucas, she's gay.

Man 1: Well, she <u>flirts</u>（调情）with me.

Man 2: Brian, she's gay.

Man 1: Now, she's <u>my type</u>（喜欢的类型）.

Man 2: Oh, hey. Also gay.

Man 1: Your party <u>sucks</u>（糟糕，差劲）.

There are two scenes in this party. The first focuses on two girls, one of whom is a lesbian who's unconfident and wants to downplay her status of being gay. She also tries to avoid meeting the new girl for fear of exposing herself. In the second scene, the first man wants to meet girls and have fun in the party, but the fact that too many lesbian girls in the party makes the party suck, that's why he isn't happy about it.

"Fancy" in colloquial English means of high quality, exceptional appeal, classy, and fashionable. In this dialogue, e.g., "a fancy bag". Other expressions "fancy hotel", "fancy shoes", "fancy car".

"Dude" is an American slang, meaning "fellow". In the early 1960s, "dude" became prominent in surfer culture as a synonym of guy or fella (男人, 伙计, 哥们儿). "Dude" is now also used as a unisex term, and generally used informally to address someone ("Dude, I'm glad you finally called") or refer to another person ("That dude is stealing my car").

"Suck" is another American slang, meaning "be very bad". In this scene, "The party sucks" means the party is boring. More frequently we hear Americans say in everyday life is "Life sucks." meaning "Life is miserable." "The job sucks." meaning "The job is bad".

"Gay" and "lesbian", usually refer respectively to male and female homosexuals respectively, but in daily conversation, they can be interchangeable in a specific girl-girl context. For instance, a girl can say "You look so gay" to another girl.

- **Video 7-4: I'm gay!**

Mother: Lukie, what is up with the sad face?
Son: I'm gay!
Father: What did you say?
Son: I'm sorry.
Father: Ugh, just because you can't keep a girl friend...
Son: I'm gay! ... I tried to be what you wanted, I...
Father: Hardworking, patriotic, Christian, those things? The purpose of a man and a woman is to get married and make babies. Anything else transcends (超越) the laws is nature. Tammy (to wife), I'm...you're not gay!

Not all American parents are as conservative and rigid as these parents in this movie. Some are quite open, like in the first movie example. Being gay is unacceptable and intolerant

to the parents in this scene.

Gay-friendly or LGBT-friendly are the places, policies, people or institutions that are open and welcoming to gay people (to include all members of the LGBTQ community) to create an environment that is supportive of gay people and their relationships, respectful of all people, treat all people equally, and are non-judgmental. This is typically a late 20th-century North American term that is the byproduct of both a gradual implementation of gay rights and acceptance of policies supportive of LGBTQ people in the workplace and in schools, as well as the recognition of gays and lesbians as a distinct consumer group for businesses.

- **Video 7-5: *You must come out!***

My name is Harvey Milk and I'm here to recruit（招募）you! I want to recruit you for the fight to preserve（保留）your democracy! Brothers and sisters, you must come out（这里是双关语）! Come out to your parents; come out to your friends, if indeed they're your friends. Come out to your neighbors; come out to your fellow workers. Once and for all, let's break down the myths, and destroy the lies and distortions（曲解）. For your sake, for their sake. For the sake of all the youngsters who've been scared by the votes from Dade to Eugene（均为美国城市）. On the Statue of Liberty（自由女神像）, it says, "Give me your tired, your poor, your huddled masses（挤成一堆的人群）yearning（渴望）to be free. In the Declaration of Independence（《独立宣言》）it is written, "All men are created equal and endowed（赋予）with certain inalienable（不可剥夺的,不能放弃的）rights. So, for Mr. Briggs, and Mrs. Bryant, and all the bigots（种族、宗教或政治的顽固盲从者,偏执者）out there, no matter how hard you try, you can never erase those words from the Declaration of Independence. No matter how hard you try, you can never chip（削下,凿下）those words from the base of the Statue of Liberty! That is where America is! Love it or leave it!

This is a speech given by Harvey Bernard Milk (May 22, 1930 — November 27, 1978), an American politician who became the first openly gay person to be elected to public office in California, when he was open about his homosexuality and participated in civic matters including gay movement.

Two striking features are noticed in this speech. One is three sets of parallel structure are used:

"Come out to your parents; come out to your friends, if indeed they're your friends. Come out to your neighbors; come out to your fellow workers."

"For your sake, for their sake. For the sake of all the youngsters who've been scared by the votes from Dade to Eugene."

"No matter how hard you try, you can never erase those words from the Declaration of Independence. No matter how hard you try, you can never chip those words from the base of the Statue of Liberty! That is where America is! Love it or leave it!"

The other remarkable feature is the <u>allusion</u>（暗指，引喻，典故）to two American cultural icons: the Statue of Liberty and the Declaration of Independence.

In many cultures, homosexual people are frequently subject to prejudice and discrimination. First there is gay bullying. Gay bullying can be the verbal or physical abuse against a person who is perceived by the aggressor to be lesbian, gay, bisexual or transgender, including persons who are actually heterosexual or of non-specific or unknown sexual orientation. In the US, teenage students heard anti-gay <u>slurs</u>（诽谤，诋毁，污辱）such as "homo", "faggot" and "sissy" about 26 times a day on average, or once every 14 minutes, according to a 1998 study by Mental Health America.

Homophobia is a fear of, aversion to, or discrimination against homosexual people. Similar is lesbophobia (specifically targeting lesbians) and biphobia (against bisexual people). When such attitudes manifest as crimes they are often called <u>hate crimes</u>（因种族、同性恋等歧视引起的仇恨犯罪，仇恨罪）and <u>gay bashing</u>（针对同性恋的袭击）.

In the United States, the FBI (2011) reported that 20.4% of hate crimes reported to law enforcement in 2011 were based on sexual orientation bias. 56.7% of these crimes were based on bias against homosexual men. 11.1% were based on bias against homosexual women. 29.6% were based on anti-homosexual bias without regard to gender. The 1998 murder of Matthew Shepard, a gay student, is a notorious such incident in the U.S. LGBT people, especially lesbians, may become the victims of <u>"corrective rape"</u>（以矫正为名的强暴行为）, a violent crime with the supposed aim of making them heterosexual. In certain parts of the world, LGBT people are also at risk of <u>"honor killings"</u>（荣誉谋杀，指凶手谋杀家庭成员以达到挽回家族荣誉的目的）perpetrated by their families or relatives.

- **Video 7-6:** *I wouldn't mind having a gay son*

I, oh, I like the gays. Are there any gay guys here? Well, that is statistically (统计学上地) impossible. Ah, gay guys are the best. A lot of perks (好处, 优点). You know. They're nonviolent. They fix up (解决争端,和解) neighborhoods. And they're generally smart people. You never meet an ignorant gay guy, like you never meet a gay guy who is like (spit), "I only love three things: my truck, my gun and dick." You never hear that, you know.

I had a guy say at me once, "Hey, Mark, if you like gay so much, what if you had a gay son?" I wouldn't mind having a gay son. Having a gay son is like finding a French fry in your onion rings. You act like, "Well, it's not what I expected, but I like this, too."

In this comedy show, the comedian lists some merits of gay people: non violent, friendly and civilized. And also jokes about the hypothetic question as to if he has a gay son. It's another example showing that many American parents are open to the gay community, even their children. Perhaps a flat statistic isn't very useful when talking about gay acceptance in the US society since it is so diverse. Generally religious thinking in the US is less accepting. And generally speaking, in population centers that already have cultural diversity (such as large cities) acceptance is higher. However it will be found that the individual family's religious background will have a strong influence on this.

- **Video 7-7: *Think and remember: a child is listening***

Homosexuality is a sin. Homosexuals are doomed to (注定要) spend eternity in hell (永远下地狱). If they wanted to change, they could be healed of their evil ways. If they turn away from temptation (远离诱惑), they could be normal again. If only they would try and try harder. If it doesn't work.

These are all the things I said to my son Bobby when I found out he was gay. When he told me he was homosexual, my world fell apart (崩塌). I did everything I could to cure him of his sickness. Eight months ago, my son jumped off a bridge and killed himself. I deeply regret my lack of knowledge about gay and lesbian people. I see that everything I was taught and told was bigotry (顽固盲从,偏执) and dehumanizing (灭绝人性的,非人的) slander (口头诽谤,口头诽谤罪). If I had investigated, beyond what I was told. If I had just listened to my son, when he poured his heart out (倾诉) to me, I would not be standing here today with you, filled with regret.

I believe that God was pleased with Bobby's kind and loving spirit. In God's eyes, kindness and love are what it's about. I didn't know that each time that I echoed eternal damnation(天谴，罚入地狱) for gay people, each time I referred to Bobby as sick and perverted(反常的,变态的) and a danger to our children, his self-esteem(自尊), his sense of worth, were being destroyed. And finally, his spirit broke beyond repair(无法弥补).

It was not God's will that Bobby climbed over the side of a freeway overpass(高速公路立交桥) and jumped directly into the path of an 18-wheel truck, which killed him instantly. Bobby's death was the direct result of his parents' ignorance and fear of the word gay. He wanted to be a writer. His hopes and dreams should not have been taken from him, but they were.

There are children like Bobby, sitting in your congregations(教堂会众), unknown to you. They will be listening, as you echo "Amen", and that will soon silence their prayers, their prayers to God, for understanding, and acceptance, and for your love. But your hatred, and fear and ignorance of the word gay will silence those prayers. So, before you echo "Amen" in your home and place of worship, think, think and remember: a child is listening.

This is a speech given in a church congregation by a broken-hearted mother whose son killed himself because he was not accepted in the family as gay. The remorseful mother regretted having not listened to her son and understood him. According to her, even though it is not allowed to be gay in the eyes of church, the child's personality and loving spirit should be respected, and should not be dehumanizing slandered. We should listen to them for their prayers. The speech achieves the expected effect in that the mother speaks from her heart and turns the hostile audience into friendly one that will listen to her and change their stance. This is what a persuasive speech tries to achieve: to form an idea, to change an idea and lastly, to strengthen the idea.

Societal acceptance of homosexuality is lowest in Asian and African countries, and is highest in Europe, Australia, and the Americas. Western society has become increasingly accepting of homosexuality over the past few decades. Professor Amy Adamczyk (2017) contended that these cross-national differences in acceptance can be largely explained by three factors: the relative strength of democratic institutions, the level of economic development, and the religious context of the places where people live.

Gay and lesbian youth bear an increased risk of suicide, substance abuse, school problems, and isolation because of a hostile and condemning environment, verbal and physical abuse, rejection and isolation from family and peers. Further, LGBT youths are more likely to report psychological and physical abuse by parents or caretakers, and more sexual abuse. Suggested reasons for this disparity(悬殊,差异) are that (1) LGBT youths may be specifically targeted on the basis of their perceived sexual orientation or gender non-conforming appearance, and (2) that risk factors associated with sexual minority status, including

discrimination, invisibility, and rejection by family members... may lead to an increase in behaviors that are associated with risk for victimization, such as substance abuse, sex with multiple partners, or running away from home as a teenager. A 2008 study showed a correlation between the degree of rejecting behavior by parents of LGB adolescents and negative health problems in the teenagers studied.

From the boy's experience we can see the current authoritative bodies and doctrines of the world's largest religions generally view homosexuality negatively. That can range from quietly discouraging homosexual activity, to explicitly forbidding same-sex sexual practices among adherents and actively opposing social acceptance of homosexuality. Some teach that homosexual orientation itself is sinful, others state that only the sexual act is a sin, others are completely accepting of gays and lesbians, while some encourage homosexuality. Some claim that homosexuality can be overcome through religious faith and practice.

- **Video 7-8: *I want to dedicate this to the LGBT community all around the world***

I, gee, can't breathe right now. Oh, my gosh. Thank you to this man here, Jimmy Napes. Um, to all the nominees（被提名者，被任命者）, incredible, Gaga, you're incredible.

Um, I read an article, a few months ago, by Sir（爵士）Ian Mckellen. And he said that no openly gay men had ever won an Oscar, and, and if this is the case, even if this isn't the case, I want to dedicate this to the LGBT community all around the world. I stand here tonight, as a proud gay man, and I hope we can all stand together as equals（同等的人，相等事物）one day. Thank you so much.

The 88th Oscar nominee and award winner Sam Smith is an English singer, for his original song in the 007 movie *Specture*（《幽灵党》）. In the speech, he dedicates the award to the LGBT community to win an Oscar. Smith said he was proud to be the first openly gay Oscar winner. Smith later acknowledged he wasn't 100 percent sure if that fact was true during his speech, but explained he had read an interview where Sir Ian McKellen made that claim. Later on, Smith was corrected on his statement by reporters. At a *Vanity Fair* party（《名利场》派对；《名利场》是美国著名生活杂志，每年在奥斯卡颁奖典礼结束后举办宴会）post-Oscars, Smith said, "I think I'm the second openly gay person to win it but either way it's important

that we shine light on what's going on."

Gay community in the US faces three major discriminations. <u>Employment discrimination</u> refers to discriminatory employment practices such as bias in hiring, promotion, job assignment, termination, and compensation, and various types of harassment. <u>Housing discrimination</u> refers to discrimination against potential or current tenants by landlords. <u>Hate crimes</u> (also known as bias crimes) are crimes motivated by bias against an identifiable social group, usually groups defined by race (human classification), religion, sexual orientation, disability, ethnicity, nationality, age, gender, gender identity, or political affiliation.

7.3 Questions for discussion

1) If you had a friend who confessed that she/he was gay to you, what would you do and say to him/her?
2) Do you agree that gay people should have the same rights to get married and form a family?
3) Please tell your experience where you met a gay person. What did you think of him/her?
4) Do you like any famous gay people, and how have they positively contributed to the society?
5) What would you say to your child if one day he/she confesses to you that he/she was gay?

7.4 Debate

Should homosexual culture be promoted on campus?

7.5 Vocabulary exercises

counterbalance, inalienable, sanction, dress up, make a big deal out of, preserve, distortion, statistically, fall apart, dehumanizing, pour one's heart to

Try and fill in the blanks of the following sentences with words listed above in proper forms.

1) Taiwan is a sacred territory and an _____ and integral part of China.
2) The accused's right to silence was a vital _____ to the powers of the police.
3) Whenever the poor girl _____ to me, I always give it a good listen.
4) When we treat people as human resources, we begin to define the job as_____.
5) Everyone was eagerly expecting the arrival of the new president, but I didn't _____ it.
6) The end of day described in movies are really scary, with the whole world _____

7) _____ , far more accidents happened in cars than in airplanes.

8) His words are always full of _____ when passing along other's rumors.

9) The factory's sewage discharge plan is dismissed as infeasible and not _____ by the authorities.

10) Sea turtles _____ their eggs under the sand and leaves them behind, without a care about their hatching.

11) He likes to _____ in whatever occasions he has to show up for.

7.6 Role-play and reenactment

1) Please review Video 7-2, act out the comedy and feel the part of culture of an open parent-son relationship.

2) Please review Video 7-3, act out the dialogue and feel the part of gay youngster's culture.

3) Please review Video 7-5, recite the speech and feel the part of American history.

4) Please review Video 7-6, perform the skit and feel the part of culture of stand-up comedy.

5) Please review Video 7-7, recite the speech and feel the part of culture of family, religion and gay tolerance.

6) Please review Video 7-8, recite the speech and feel the part of culture of Oscar award speech.

SEX & SEXUALITY
性的窘困

8.1 Cultural tidbits

Human sexual activity, sexual practice or sexual behavior is the manner in which humans experience and express their sexuality. In some cultures, sexual activity is considered acceptable only within marriage, while premarital（婚前的）and extramarital（婚外的）sex is taboo.

A person's sexual orientation can influence their sexual interest and attraction for another person. Sexuality also affects and is affected by cultural, political, legal, philosophical, moral, ethical, and religious aspects of life.

Interest in sexual activity typically increases when an individual reaches puberty（青春期）. Traditionally, adolescents（青少年）in many cultures were not given any information on sexual matters, with the discussion of these issues being considered taboo. Such instruction, as was given, was traditionally left to a child's parents, and often this was put off until just before a child's marriage. This deficiency（缺失）was heightened by the increasing incidence of teenage pregnancies, particularly in Western countries after the 1960s. As part of each country's efforts to reduce such pregnancies, programs of sex education were introduced, initially over strong opposition from parent and religious groups.

The outbreak of AIDS has given a new sense of urgency to sex education. Sex education is seen by most scientists as a vital public health strategy. Some international organizations such as Planned Parenthood（计划生育）consider that broad sex education programs have global benefits, such as controlling the risk of overpopulation and the advancement of women's rights.

Almost all U.S. students receive some form of sex education at least once between grades 7 and 12; many schools begin addressing some topics as early as grade 5 or 6. However, what students learn varies widely, because curriculum decisions are quite decentralized. Two main forms of sex education are taught in American schools: comprehensive and abstinence（因道德、宗教或健康原因对饮食、酒、色等的节制,禁欲）-only.

Abstinence-only sex education is a form of sex education that teaches not having sex outside of marriage. It often excludes other types of sexual and reproductive health education, such as birth control and safe sex. Comprehensive sex education, by contrast, covers the use of birth control and sexual abstinence. The topic of abstinence-only education is controversial in

the United States, with proponents（倡导者,支持者,拥护者）claiming that comprehensive sex education encourages premarital sexual activity, and critics arguing that abstinence-only education is religiously motivated and that the approach has been proven ineffective and even detrimental（有害的,不利的）to its own aims.

Like other physical activity, sex comes with risks. There are four main types of risks that may arise from sexual activity: unwanted pregnancy, contracting a sexually transmitted infection/disease (STI/STD), physical injury, and psychological injury. There are 19 million new cases of sexually transmitted diseases (STD) every year in the U.S., and worldwide there are over 340 million STD infections each year.

Most world religions have sought to address the moral issues that arise from people's sexuality in society and in human interactions. Each major religion has developed moral codes covering issues of sexuality, morality, ethics etc. However, the effect of religious teaching has at times been limited.

The Roman Catholic Church teaches that sexuality is "noble and worthy", but that it must be used in accordance with natural law, which is laid down in the Ten Commandments（十诫：上帝在西奈山上通过摩西【Moses】授予以色列人的十条诫命,见《出埃及记》）, "Thou Shalt not commit adultery（不可奸淫）". For this reason, all sexual activity must occur in the context of a marriage between a man and a woman, and must not be divorced from the possibility of conception（怀孕,受孕）. All forms of sex without the possibility of conception are considered intrinsically disordered and sinful, such as the use of contraceptives（避孕,节育）, masturbation（手淫）, and homosexual acts.

In Islam, sexual desire is considered to be a natural urge that should not be suppressed, although the concept of free sex is not accepted; these urges should be fulfilled responsibly. Marriage is considered to be a good deed. Muslims believe that sex is an act of worship that fulfills emotional and physical needs, and that producing children is one way in which humans can contribute to God's creation, and Islam discourages celibacy（独身生活,禁欲）once an individual is married. However, homosexuality is strictly forbidden in Islam, and some Muslim lawyers have suggested that gay people should be put to death.

Hinduism emphasizes that sex is only appropriate between husband and wife, in which satisfying sexual urges through sexual pleasure is an important duty of marriage. Any sex before marriage is considered to interfere with intellectual development.

Modern media contains more sexual messages than was true in the past and the effects on teen sexual behavior remain relatively unknown. The Internet may further provide adolescents with poor information on health issues, sexuality, and sexual violence. Worldwide, rates of teenage births range widely. Teenage mothers and their children in developed countries show lower educational levels, higher rates of poverty, and other poorer "life outcomes" compared with older mothers and their children.

Cohabitation（未婚同居）is an arrangement where two people who are not married live together. Such arrangements have become increasingly common in Western countries during the past few decades, being led by changing social views, especially regarding marriage, gender roles and religion. They often involve a romantic and/or sexually intimate relationship on a long-term or permanent basis. More broadly, the term cohabitation can mean any number of people living together. To "cohabit", in a broad sense, means to "coexist".

Infidelity（夫妻或伴侣间的不忠行为,通奸）is a violation of a couple's assumed or stated contract regarding emotional and/or sexual exclusivity. Other scholars define infidelity as a violation according to the subjective feeling that one's partner has violated a set of rules or relationship norms; this violation results in feelings of sexual jealousy and rivalry（竞争,对抗,较量）.

8.2 Video examples

- **Video 8-1:** *Better get him out of here before your father gets home!*

Mother: Hey.
Daughter: Hi, mom.
Mother: What are you doing?
Daughter: Nothing. Just lying down. I'm a little tired.
Mother: Were, were you talking to someone?
Daughter: No. I mean yeah. It was Brea. I just got off the phone with her.
Mother: Christy, what's going on here?
Daughter: What do you mean?
Mother: Did you have someone over here?
Daughter: No, why?
Mother: Are you sure?
Daughter: Yeah.
Mother: Then why does it smell in here?

Daughter: Mom, I don't know what you're talking about.

Mother: Christy, I want you to swear, that no one was here.

Daughter: I swear.

Mother: Okay ... Christy, you know you can talk to me, right?

Daughter: Yeah, sure.

Mother: I mean about, boys and um... sex.

Daughter: Mom...

Mother: I don't know if your father and I ever had that talk with you.

Daughter: Mom...

Mother: <u>You know, the sex talk. Anyway, it goes like this. It, um...When you reach a certain age, you... you start having feelings and...</u>

Daughter: Yeah, yeah, I know.

Mother: Oh, you do?

Daughter: Yeah. I've known this since 6th grade. Don't you remember I walked in on you and dad doing it? Dressed like <u>Superman and Lois Lane</u>（电影《超人》中的超人和他的女友）, while Tim, the creepy guy next door, took notes dressed as Jimmy the reporter?

Mother: Oh, yeah. Well...uh...good. Right. Uh...So, I'm here if...if you ever want to talk to me, right? And, um, if you ever...are going to do anything, just please be careful. And, um...use, um... you know...a condom.

Daughter: Mom.

Mother: Okay, okay！ I just want you to...I just want you to be all right.

Daughter: I'm fine, mom. Thanks.

Mother: Christy?

Daughter: Yeah?

Mother: Better get him out of here before your father gets home.

In this scene, a mother detects her daughter's ongoing sexual activity and tries to impart to her some education on it, but obviously she doesn't know her daughter entirely well.

Besides "abstinence plus" and "abstinence-only", "abstinence plus" (also known as comprehensive sex education) covers abstinence as a positive choice, but also teaches about contraception and the avoidance of STIs when sexually active. Abstinence-only sex education tells teenagers that they should be sexually abstinent until marriage and does not provide information about contraception. In the Kaiser study (2011), 34％ of high-school principals said their school's main message was abstinence-only. According to Anna Mulrine (2012) of U.S. News & World Report, records show that professionals still do not know which method of sex education works best to keep teens from engaging in sexual activity, but they are still working to find out.

Superman is a fictional superhero appearing in American comic books published by DC Comics. Superman is widely considered an American cultural icon. The character has been adapted extensively and portrayed in other forms of media as well, including films, television series, and video games. As an influential archetype of the superhero genre, Superman possesses extraordinary powers, with the character traditionally described as "Faster than a speeding bullet. More powerful than a <u>locomotive</u>（火车头）. Able to leap tall buildings in a single bound ..." Superman's large cast of supporting characters includes Lois Lane, the character most commonly associated with Superman, being portrayed at different times as his colleague, competitor, love interest and wife.

- **Video 8-2**: *Don't tell me you're pregnant!*

Mother: What's going on?

Daughter: Um, so...

Mother: Come on, what is going on here? <u>Spit it out!</u>（有话直说!）

Grandmother: Hey, come on, not so bossy. Why are you so bossy?

Mother: You know what? You are making me anxious. The two of you are making me extremely anxious. Showing up like this. Here in the middle of the day. What's going on, Sage? Why aren't you in school?

Daughter: Ah, because I'm <u>on break</u>（休假）?

Mother: Right. Are you pregnant?

Daughter: What?

Mother: Please don't tell me that you're f-ing pregnant.

Daughter: Oh, my God.

Grandmother: She's pregnant.

Mother: God damn it! God damn it! I should f-ing...you asshole. I should f-ing kill you. You know that? What happened to the box of condoms I bought you? Did you eat them? There were a hundred condoms in that box!

Secretary: Ah, your 4:30 is here. Should I tell...?

Mother: What?

Secretary: Should I tell your 4:30 that you're busy? I could tell them that maybe you're running behind...

Mother: Tell them that I will see them in the little conference room. Okay? And you two, don't go anywhere. I'll be back in 50 minutes. Do not leave. Do Not Leave! Alright, take the clients to the little conference room, and then give me an <u>espresso</u>（浓缩咖啡）. Oh, no. Wait, wait, wait! Espresso first, then clients. Don't leave!

Daughter: Mom, God!

In this scene, the mother is flying into a rage over daughter's indiscreetness and carelessness in handling contraception in her sexual activity, which causes her pregnancy. Birth control through voluntary prevention of conception by a man or a woman can be achieved by the use of various contraceptive techniques, i.e. drugs, condoms, surgery, etc. The mother here also displays her bossy style both in and out of family business.

The girl says she's on break, which means Spring Break in the U.S. Spring break is a U.S. phenomenon and an academic tradition which started during the 1930s in the United States and is observed in some other western countries. Spring break is also a vacation period in early spring at universities and schools in various countries in the world, where it is known by names such as <u>Easter vacation</u>（复活节假）, Easter holiday, April break, spring vacation, mid-term break, study week, reading week, reading period, or Easter week, depending on regional conventions. However, these vacations differ from spring break in the United States.

The Easter break in the United Kingdom is from one to two and a half weeks (depending on the local council and school policy) and fits around Easter. Canada gives a week-long break to its elementary school and secondary school students in the month of March. In the United States, spring break at the college and university level can occur from March to April, depending on term dates and when Easter holiday falls. Usually, spring break is about one week long, but many <u>K－12</u>（从幼儿园到12年级教育的,中小学及学前教育的）institutions in the United States schedule a two-week-long break known as "Easter Break", "Easter Holidays", or "Easter Vacation", as they generally take place in the weeks before or after Easter. However, in the states of Massachusetts and Maine, schools typically schedule spring break for the week of the third Monday in April to coincide with <u>Patriots' Day</u>（爱国者纪念日）.

- **Video 8-3: *You'll be in and out in under 10 minutes***

Girl: What happens next?

Nurse: You can relax. We'll just gonna talk for a few minutes.

Girl: Okay.

Nurse: I have a few questions. And then I'll walk you through the entire process. No surprises. First, is this your decision? Have you been coerced（强迫，胁迫）in anyway?

Girl: No. I mean. Yes. Yes, it's my decision. I want to do this.

Nurse: Okay, good. You have a choice between local anesthetic（局部麻醉）or sedation（施用镇静剂，全身麻醉）. Basically, during surgery, you can remain numb and awake, or asleep.

Girl: I can be asleep? Then, yes. Definitely, definitely that option.

Nurse: Okay, good. Final question. Do you have someone to take you home?

Girl: Yeah, my friend.

Nurse: Okay, great. You're doing wonderful. So here is the plan. First, change into your gown, warning, that's not cute. Then you'll get a vaginal ultrasound（阴道超声波检查）. It's not fun, but it doesn't hurt. And you don't have to look at the monitor（监视屏）if you don't want to. Next we'll draw some blood, and we'll hook you up to an IV（静脉注射）, then you'll sit with other women who are waiting for surgery. And then to the surgical suite（手术室）. The anesthesiologist（麻醉师）will put a mask on your face. You'll sleep in seconds. The doctor has a wand（细棒，细棍）that he'll insert（插入）inside you and remove the fetus（胎儿）. You will be in and out under 10 minutes. You'll wake up in the recovery room, safe and sound. And that's it.

Girl: Can I tell you something? I'm honestly pretty nervous, ugh.

Nurse: It's okay. It's normal. And I've a feeling you're gonna do just fine.

 In this scene, the girl is going through the process of having an abortion（人工流产，堕胎）. Abortion is the termination（终止）of pregnancy before the fetus is viable. In the medical sense, this term and the term miscarriage（流产，小产）both refer to the termination of pregnancy before the fetus is capable of survival outside the uterus（子宫）. Deliberate termination of pregnancy is called induced abortion（人工流产）. When this is legal it is called therapeutic abortion（治病流产，指怀孕危及母体健康时进行的人工流产）. Abortion may be performed legally under certain circumstances and in approved hospitals or clinics. Those who oppose abortion on moral grounds believe that the fetus is human or potentially human and that destruction of the fetal body is tantamount to（等同于，相当于）murder. While, many others have equally strong beliefs that abortion is a woman's right.

 The health risks of abortion depend principally upon whether the procedure is performed safely or unsafely. The World Health Organization defines unsafe abortions as those performed by unskilled individuals, with hazardous equipment, or in unsanitary facilities. Legal abortions performed in the developed world are among the safest procedures in medicine.

 In a number of cases, abortion providers and these facilities have been subjected to various forms of violence, including murder, attempted murder, kidnapping, stalking, assault, arson

（纵火）, and bombing. Anti-abortion violence is classified by both governmental and scholarly sources as terrorism. Only a small fraction of those opposed to abortion commit violence. Legal protection of access to abortion has been brought into some countries where abortion is legal. These laws typically seek to protect abortion clinics from obstruction（对生意、法律或政府的阻挠、妨碍）, vandalism（破坏他人或公共财产的行为）, picketing（示威抗议，围厂抗议）, and other actions, or to protect women and employees of such facilities from threats and harassment.

- **Video 8-4:** *Two mommies and a sperm daddy*

Son: Well, and there is one more thing I want to tell you. Get everything out on the table. I didn't want you to hear it from somebody else, or somebody else's son. Or if I needed to tell you 'cause it doesn't really involve you.

Mother: Oh, just. Come on. Spit it out!

Son: I might not have children of my own.

Mother: That much I figured.

Son: Gay people have children all the time, mom.

Mother: Do you want children?

Son: No, I do not. The point is that gay men have sperm and lesbians have wombs（子宫）. We don't need straight（异性恋的）people to tell us what we can and cannot do.

Mother: What?

Son: This is what I want to tell you.

Mother: You...you're too young to make a decision like this.

Friend: A decision like what?

Mother: Two mommies and a sperm daddy, right?

Son: Mom. What I'm saying is, if I lend my sperm to two women that I knew and trusted, then I would know that the child will be loved and cared for...

Mother: Are you saying you weren't loved? Are you trying to make me feel guilty?

Son: This has nothing to do with you! This is about me!

Mother: The gift you're giving to your friends?

Son: Yes, the gift I'm giving my friends, which I feel good about, because I love them and they love the baby.

Mother: Ah! Did he say baby?
Friend: You have a baby?
Mother: There is a baby?
Son: What did you think we're talking about?
Mother: Sperm! I thought we were talking about sperm! A baby takes nine months. What do you cut me from nine months?
Son: Mom, the more of a scene（在公开场合的争吵、吵闹）…
Mother: This has been a lovely lunch, even though we didn't have lunch.

In this scene, a man is telling his mom that he's giving his sperm to two lesbian parents, and become co-parents of the child. LGBT people can become parents through various means including current or former relationships, co-parenting, adoption, donor insemination（受孕, 授精）, and surrogacy（代孕）. Scientific research consistently shows that gay and lesbian parents are as fit and capable as heterosexual parents, and their children are as psychologically healthy and well-adjusted as those reared（抚养）by heterosexual parents.

Sperm donation is the donation by a male (known as a sperm donor) of his sperm (known as donor sperm), principally for the purpose of inseminating a female who is not his sexual partner.

Sperm may be donated privately and directly to the intended recipient, or through a sperm bank or fertility clinic. Sperm donation is a form of third party reproduction. A sperm donor is generally not intended to be the legal father of a child produced from his sperm. Depending on the jurisdiction and its laws, he may or may not later be eligible to seek parental rights or be held responsible for parental obligations.

Other movie plots involving artificial insemination by donor are seen in *Made in America*, *Road Trip*, *The Back-Up Plan*, *The Kids Are All Right*, *The Switch*, *Starbuck*, and *Baby Mama*, the latter also involving surrogacy.

- **Video 8-5: *I'm discreet, but unforgiving.***

Boss: So what can I do for you, Kayla? Why did you drop by to see me?
Girl: Well, the thing is, sir, I actually started on air（直播）during college in Central Florida. Weather. I want to convince you that that is where I belong, Mr. Else. I think I'll be freaking（加强语气, 用以替代 f-ing）phenomenal（了不起的, 非凡的）on your network

（广播网，电视网）.

Boss: Well, it's Mr. Murdoch Air（默多克的电视台）. But I did create it. I do run it. You have a pretty face. Here, stand up and give me a twirl（转动，旋转）.

Girl: Now?

Boss: Yeah. Just a quick spin（旋转）.

Girl: Oh, sure.

Boss: Ah, that's…that's good. Now, uh, pull your dress up. Let me see your legs.

Girl: Um…

Boss: It's a visual medium（视觉媒体）, Kayla. Come on. Higher. Higher. That's fine, Kayla. Why don't you sit down? Thank you. You have a great body.

Girl: Thank you, Mr. Else. I'd appreciate it if you don't mention this to …

Boss: No…no, of course. I'm here to help my employees,（It would just sound…）not to hurt them. Anything that happens here, in this room, is strictly between you and me.

Girl: Okay.

Boss: Of course, it cuts both ways（是双刃剑）. I'm discreet（谨慎的）, but unforgiving（不宽容的）. Success in broadcast television is hard…is arbitrary（武断的，专横的）. This is the most competitive industry on earth. You understand what I'm saying?

Girl: Um…hm.

Boss: We could work together. I could pluck（挖掘，使一跃成名）you out and move you all the way to the front of the line, but I want something in return. You know what that is, Kayla? Loyalty. I need to know that you're loyal. I need you to find a way to prove it. You think about that, alright? So we'll talk again, figure each other a way out.

Girl: Thank you, Sir.

Sexual harassment is bullying or coercion（强迫，胁迫）of a sexual nature, or the unwelcome or inappropriate promise of rewards in exchange for sexual favors. Inappropriate behavior of a sexual nature, such as repeated sexual advances or offensive remarks, that occurs usually in a workplace, school, or other institutional setting, especially by a person in authority with respect to a subordinate（下属）or a student, as what happened in this scene, between a boss and a subordinate.

Sexual harassment may occur in a variety of circumstances—as varied as factories, school, academia, Hollywood and the music business. Often, but not always, the perpetrator is in a position of power or authority over the victim（due to differences in age, or social, political, educational or employment relationships）or expecting to receive such power or authority in form of promotion.

The United States Equal Employment Opportunity Commission（美国就业机会均等委员会）defines workplace sexual harassment as "unwelcome sexual advances, requests for sexual favors, and other verbal or physical conduct of a sexual nature constitute sexual harassment

when this conduct explicitly or implicitly（明确或暗示地）affects an individual's employment, unreasonably interferes with an individual's work performance, or creates an intimidating, hostile, or offensive work environment".

The Me Too movement（#MeToo）, with variations of related local or international names, is a social movement against sexual abuse and sexual harassment towards women, where people publicize allegations of sex crimes. The phrase "Me Too" was initially used in this context on social media in 2006, on Myspace（"聚友网",全球第二大社交网站）, by sexual harassment survivor and activist Tarana Burke.

Similar to other social justice and empowerment movements based upon breaking silence, the purpose of "Me Too", as initially voiced by Burke as well as those who later adopted the tactic, is to empower women through empathy and solidarity through strength in numbers, especially young and vulnerable women, by visibly demonstrating how many women have survived sexual assault and harassment, especially in the workplace.

Widespread media coverage and discussion of sexual harassment, particularly in Hollywood, led to high-profile firings, as well as criticism and backlash（【尤指对政治或社会事件的】强烈反对,激烈反应）. The known victims include some high-profile film pop stars and actresses such as Lady Gaga, Gwyneth Paltrow, Ashley Judd, etc.

After millions of people started using the phrase and hashtag（主题标签,话题标记,题标【推特消息中将#号置于某些词语前,方便用户搜索同一主题的所有消息】）in this manner in English, the expression began to spread to dozens of other languages. The scope has become somewhat broader with this expansion, however, and Burke has more recently referred to it as an international movement for justice for marginalized people in marginalized communities.

The Me Too movement has been blowing up in China and the women in China have been trying to fight off the sexual abuse and harassment over the Internet. On Chinese social networks, hashtags #WoYeShi or #metoo are sometimes used to denote the #Metoo hashtag. Mitu pronounced in Mandarin 米兔, meaning "rice bunny", is also used with a hashtag of #RiceBunny.

On the Chinese mainland, the Internet censorship service has slowed down the Chinese

MeToo posts. So far, the #MeToo debate appears to be limited to universities.

Here are some other sexual harassment themed movies:

<u>Disclosure</u>(《叛逆性骚扰》), a film starring Michael Douglas and Demi Moore, in which a man is sexually harassed by his female superior, who tries to use the situation to destroy his career by claiming that he was the sexual harasser;

<u>North Country</u>(《北方风云》), a 2005 film depicting a fictionalized account of Jenson v. Eveleth Taconite Co., the first sexual harassment class action lawsuit in the U.S.;

<u>Pretty Persuasion</u> (《美丽坏姐妹》), a film starring Evan Rachel Wood and James Woods, in which students turn the tables on a <u>lecherous</u>（好色的）teacher, a <u>scathingly satirical</u>（辛辣讽刺的）film of sexual harassment and discrimination in schools, and attitudes towards females in media and society;

<u>Oleanna</u>(《男女授受不亲》), a film starring William H. Macy, in which a college professor is accused of sexual harassment by a student and it never becomes clear which character is correct;

<u>Disgrace</u>(《耻辱》), a novel about a South African literature professor whose career is ruined after he has an affair with a student.

- **Video 8-6: *Let's change the culture!***

Thank you very much. Thank you. Hey, man, how are you? Thanks. No, no, no, no. Thank you. I'm the least qualified man here tonight. Thank you. Good evening! Good evening, and thank you very much. Despite significant progress over the last few years, too many women and men, on and off college campuses, are still victims of sexual abuse. And tonight, I'm asking you to join millions of Americans, including me, President Obama, thousands of students I've met on college campuses, and the artists here tonight, to take the <u>pledge</u>（誓言）, a pledge that says, I will <u>intervene</u>（干预）in situations, where <u>consent</u>（批准,同意）has not or cannot be given. Let's change the culture! We must and we can change the culture so that no abused woman or man, like the survivors you will see tonight, ever feel they'll have to ask themselves, "What did I do?" They did nothing wrong! So folks, I really mean this. I'm sincere. Take the pledge! Go look at, visit Itsonus.org.

On the 88th Oscar Award Ceremony, <u>incumbent</u>（在职的,现任的）Vice President Joe

Biden gives a brief but firm speech on stopping sexual abuse on and off campus in America. He appeals on all people to join him in taking a pledge to intervene in situations of sexual abuse.

Sexual harassment and assault may be prevented by secondary school, college, and workplace education programs. At least one program for fraternity（美国高等学校的男生联谊会、兄弟会）men produced "sustained behavioral change".

Many sororities and fraternities in the United States take preventative measures against hazing（捉弄，欺负）and hazing activities during the participants' pledging processes（which may often include sexual harassment）. Many organizations and universities nationwide have anti-hazing policies that explicitly recognize various acts and examples of hazing, and offer preventative measures for such situations.

- **Video 8-7: *My hands are tied, morally speaking***

Pharmacist: Very nice. OK, what can I do for you, my dear?
Girl one: I would like...
Girl two: I need a plan B pill（紧急避孕药）.
Girl one: I love you.
Pharmacist: The plan B pill. Do you have any ID?
Girl two: Yeah.
Pharmacist: Yeah, we're 17. I'm sorry, but I decline to offer you the plan B pill. And have a nice day.
Girl two: What? Why? You can't do that!
Pharmacist: Yes, I can. It's a little thing called the conscience clause（道德条款：指法律上规定因当事人的宗教或道德准则所禁止而可不遵行的条款）. See, any medical professional in the great state of South Dakota（南达科他州）can refuse to sell birth control drug（避孕药）to someone if it goes against their beliefs. And around here, it does. Honestly, it really helps me sleep at night.
Girl one: OK, what about me? Her? What are we supposed to do here?
Pharmacist: I'm sorry, but my hands are tied, morally speaking.
Girl one: Conscience clause? Conscience clause? How is that eve real?

The movie follows a straight-laced（【在道德行为上】拘谨保守的, 古板的）high school student and her slacker（＜美＞【以愤世、冷漠为特征的】文化青年）best friend who, after a

regrettable first sexual encounter, have 24 hours to hunt down a Plan B pill in America's heartland(腹地,中心区域).

In this scene, girl one is looking for an urgent exit for the aftermath of her sexual act, or her first sexual experience. And her friend, girl two is trying to help her. Plan B typically means a contingency plan(应急计划). Here it refers to emergency contraception(避孕) drug, and it's also a trademark for a drug that contains levonorgestrel(左炔诺孕酮：一种紧急避孕药物).

The pharmacist in this video says he refuses to offer the girls the pill because of the conscience clause. A conscience clause in America is a clause in a law that relieves(免除) persons whose conscientious or religious scruples(顾虑) forbid compliance(服从), i.e., it's a clause in a law or contract exempting(免除) persons with moral scruples. And a conscientious objection/objector may refer to a person who objects to some cause, for example: a conscientious objector to abortion, a conscientious objector(出于道义原因而拒服兵役者).

The conscience clause in medicine in the United States says that a medical professional can refuse to sell drugs to or perform operation on a particular patient according to his beliefs, so that according to the pharmacist in this scene, he can sleep well at night, owing to the obvious reason that he doesn't believe in abortion.

On women's right to abortion, there're two sides of beliefs and advocates. One is pro-life(反堕胎的), which advocates the legal protection of human embryos(胚胎) and fetuses(胎儿), especially by favoring the outlawing(把……非法化) of abortion on the ground that it is the taking of a human life. It is an organization, pressure group, etc. that supports the right to life of the unborn, not just against abortion, experiments on embryos, and believes in right-to-life.

The other side is pro-choice(支持妇女堕胎选择权的), i.e. favoring legalized abortion as an option for an unwanted pregnancy. It is also an organization, pressure group, etc. that supports the right of a woman to have an abortion and advocates a woman's right to control her own body (especially her right to an induced abortion ＜医＞【人工流产】).

In recent years, the new legislation The Heartbeat Act(《心跳法案》) delivering harsh criminal punishment on any form of abortion in Texas in the US has caused controversy in the international community, inviting criticism from all communities including Hollywood entertainments. According to this law, a person can get a 10-thousand-dollar reward if he/she reports to the police of an ongoing or performed abortion, which has made it a nation-wide witch-hunt(【针对异见群体的】政治迫害).

8.3 Questions for discussion

1) Would you want to share your experience of first love or date with your class?
2) What would you do if you were sexually harassed or violated in a work place or any

other settings?

3) If you were a parent, how would you deal with sex education on your child?
4) Do you think sex education is doing well in China?
5) What would you say to cohabitation and sex before marriage on college campus?

8.4 Debate

Sex education of children is more up to family than to school.

8.5 Vocabulary exercises

deficiency, abstinence, proponent, detrimental, rivalry, termination, phenomenal, discreet, arbitrary, intervene, consent

Try and fill in the blanks of the following sentences with words listed above in proper forms.

1) Vitamin _____ in the diet can cause illness.
2) I read his silence as _____ but it was a misunderstanding.
3) Technology advancement has brought _____ success in connection with people in the world.
4) A state of _____ occurred between them since the application for the scholarship began last term.
5) Donald Trump's bizarre and crazy behavior is _____ to the world's peace and development.
6) The opponents say this plan is beneficial to the old people's pension, but the _____ say otherwise.
7) He suggested the sexually transmitted disease could be beaten through chastity, _____ and "correct behavior".
8) They are always _____ in handling his personal lives.
9) The choice of players for the team seemed completely random and _____.
10) How much the government should _____ in the economy in order to create jobs is the subject of discussion today.
11) He was looking for a new job with the _____ of contract in the school as a teacher.

8.6 Role-play and reenactment

1) Please review Video 8-1, act out the scene and feel the part of culture of mother-daughter sex education.
2) Please review Video 8-2, act out the scene and feel the part of culture of mother-

daughter relationship.

3) Please review Video 8-3, act out the scene and feel the part of culture of abortion.
4) Please review Video 8-5, act out the dialogue and feel sexual harassment under corporate culture.
5) Please review Video 8-6, recite the speech and feel the power of a persuasive speech.
6) Please review Video8-7 and act it out, feeling the desperateness of two girls trying to buy Plan B pills.

CAMPUS LIFE
校园一瞥

9.1 Cultural tidbits

School education is similar around the world, with slight differences between countries and states. A formal schooling system usually goes through four stages: preschool education, primary school education, secondary education and higher education.

Kindergarten, which literally means "garden for the children" is a preschool educational approach traditionally based on playing, singing, practical activities such as drawing, and social interaction as part of the transition from home to school.

In China, the equivalent term to kindergarten is "幼儿园". The children start attending kindergarten at age 3 until they are at least 6 years old. The kindergartens in China generally have the following grades: Nursery / Playgroup（小班）; Lower Kindergarten（中班）; Upper Kindergarten（大班）; Preschool（学前班）. Some kindergartens may not have preschool.

The term kindergarten is never used in the UK to describe modern pre-school education; pre-schools are usually known as nursery schools or playgroups. However, the word "kindergarten" is sometimes used in the naming of private nurseries that provide full-day child care for working parents. In the US, kindergarten is usually part of the K-12 educational system. In most state and private schools, children begin kindergarten at age 5 to 6 and attend for one year. In a typical US kindergarten classroom, resources like toys, picture books, and crayons are available for children's use.

A primary school (British English) or elementary school (American English) is a school in which children receive primary or elementary education from the age of about five to twelve, coming after preschool and before secondary school. In most parts of the world, primary education is the first stage of <u>compulsory education</u>（义务教育,强迫教育）, and is normally available without charge, but may be offered in a fee-paying independent school. The term "grade school" is sometimes used in the US though this term may refer to both primary education and secondary education.

Secondary education normally takes place in secondary schools, taking place after primary education and may be followed by higher education or vocational training. In some countries,

only primary or basic education is compulsory, but secondary education is included in compulsory education in most countries. A secondary school locally may be called <u>junior high school</u>（初中）or <u>senior high school</u>（高中）.

In the United Kingdom secondary schools offer secondary education covering the later years of schooling. Most secondary schools in England are comprehensive schools. Grammar schools have been retained in some counties in England. Grammar school in the United States means an elementary school, while in the United Kingdom it means a secondary school with a particularly academic curriculum, as opposed to a comprehensive school which is a state school and does not select its <u>intake</u>（招生人数）on the basis of academic achievement or aptitude and teach pupils in mixed ability groups or classes and for which there is no selective entry requirement.

As part of education in the United States, the definition of secondary education varies among school districts but generally comprises grades 7, 8, and 9 through 12. Grades 9 through 12 is the most common grade structure for high school, with equivalent terms for each grade as freshman, sophomore, junior and senior, in response to college duration terms.

University, in modern usage the word has come to mean "an institution of higher education offering tuition in mainly <u>non-vocational</u>（非职业的）subjects and typically having the power to <u>confer degrees</u>（授予学位）". The definition of a university varies widely, even within some countries. In the United States there is no nationally standardized definition for the term, although the term has traditionally been used to designate research institutions and was once reserved for doctorate-granting research institutions. Some states, such as Massachusetts, will only grant a school "university status" if it grants at least two doctoral degrees.

<u>Colloquially</u>（口语上,用口语）, the term university may be used to describe a phase in one's life: "When I was at university…"（in the United States and Ireland, college is often used instead: "When I was in college…"）. In Australia, Canada, New Zealand, the United Kingdom, etc., university is often <u>contracted</u>（缩写）to uni（"I've some trouble dealing with the job and studying in the uni"）

The US owns most of the best universities in the world. Among them, the most famous is the Ivy League. The Ivies are all in the Northeast region of the United States（or the New England Area）. The eight institutions are Brown University（in the state of Rhode Island）, Columbia University（in the state of New York）, Cornell University（in the state of New York）, Dartmouth College（in the state of New Hampshire）, Harvard University（in the state of Massachusetts）, Princeton University（in the state of New Jersey）, the University of Pennsylvania（in the state of Pennsylvania）, and Yale University（in the state of Connecticut）. The term Ivy League also has <u>connotations</u>（内涵意义,隐含意义）of academic

excellence, <u>selectivity in admissions</u>(精挑细选招生), and social <u>elitism</u>(精英主义).

Ivy League schools are viewed as some of the most prestigious, and are ranked among the best universities worldwide. All eight Ivy League institutions place within the top fifteen of the U.S. News & World Report college and university rankings, including the top four schools and six of the top ten. Each school receives millions of dollars in research grants and other subsidies from federal and state governments.

(Ivy covering campus of Princeton University)

The inclusion of non-Ivy League schools under this term is commonplace for some schools and extremely rare for others. Among these other schools, Massachusetts Institute of Technology (MIT) and Stanford University are almost always included. The University of Chicago and Duke University are often included as well.

In many countries, students are required to pay tuition fees. Many students look to get "student grants"(助学金) to cover the cost of university. In 2012, the average <u>outstanding student loan balance</u>(逾期不还的学生贷款额度) per borrower in the United States was US $23,300. In many U.S. states, costs are anticipated to rise for students as a result of decreased state funding given to public universities. There are several major exceptions on tuition fees. In many European countries, it is possible to study without tuition fees. Public universities in some countries were entirely without tuition fees until 2005.

The funding and organization of universities varies widely between different countries around the world. In some countries universities are predominantly funded by the state, while in others funding may come from donors or from fees which students attending the university must pay. In some countries the vast majority of students attend university in their local town, while in other countries universities attract students from all over the world, and may provide university <u>accommodation</u>(住宿) for their students.

A teacher's role may vary among cultures. Teachers may provide instruction in <u>literacy</u>(读写能力) and <u>numeracy</u>(计算能力), <u>craftsmanship</u>(手艺,技艺) or vocational training, the arts, religion, <u>civics</u>(公民学,市政学), community roles, or life skills. Formal teaching tasks include preparing lessons according to agreed <u>curricula</u>(课程), giving lessons, and

assessing（评测）pupil progress.

A teacher's professional duties may extend beyond formal teaching. Outside of the classroom teachers may accompany students on field trips, supervise study halls, help with the organization of school functions, and serve as supervisors for extracurricular（课外的）activities, educational activities not falling within the scope of the regular curriculum. Sports, drama, games, lab projects, creative designs, field trips etc. In some education systems, teachers may have responsibility for student discipline（纪律）.

In the UK, salaries for nursery, primary and secondary school teachers ranged from ￡20,133 to ￡41,004 in September 2007, although some salaries can go much higher depending on experience and extra responsibilities. Preschool teachers may earn ￡20,980 annually. Teachers in state schools must have at least a bachelor's degree, complete an approved teacher education program, and be licensed.

In the United States, in the past, teachers have been paid relatively low salaries. However, average teacher salaries have improved rapidly in recent years. US teachers are generally paid on graduated scales, with income depending on experience. Teachers with more experience and higher education earn more than those with a standard bachelor's degree and certificate. Salaries vary greatly depending on state, relative cost of living, and grade taught. Each state determines the requirements for getting a license to teach in public schools. Teaching certification generally lasts three years, but teachers can receive certificates that last as long as ten years. Public school teachers are required to have a bachelor's degree and the majority must be certified by the state in which they teach.

The term "professor" in the United States refers to a group of educators at the college and university level. In the United States, while "Professor" as a proper noun（with a capital "P"）generally implies a position title officially bestowed by a university or college to faculty members with a PhD. The common noun "professor" is often used casually to refer to anyone teaching at the college level, regardless of rank or degree, or just the courtesy title（尊称）. The title "professor" commonly occupies any of several positions in academia（学术界）, typically the ranks of assistant professor（助理教授）, associate professor（副教授）, or professor, and tenure（终身教职）. Tenured positions are usually those full-time faculty members with PhDs or other highest level degrees; engage in both undergraduate and graduate teaching, mentoring, research, and service. Salaries vary widely by field and rank, ranging from $45,927 for an assistant professor in theology（神学）to $136,634 for a full professor in legal professions and studies. Median（中位数的）salaries were $54,000 for assistant professors, $64,000 for associate professors and $86,000 for full professors 2005. Full professors at elite institutions commonly enjoy six-figure incomes, such as $123,300 at UCLA or $148,500 at Stanford.

9.2 Video examples

• **Video 9-1:** *You can't promise a student something, and then take it away!*

President: Sorry for the wait. My apologies, ladies. I'm a bit under the weather（身体不适的，心情不好的）.
Cathy: That's OK.
President: I have some bad news. Your lads college scholarship（全称为 Lads to Leaders Scholarship，是一种奖励优秀大学生的奖学金）has been defunded.
Mother: What? But you can't do that!
Cathy: Mum.
Mother: You've worked so hard to be here. And...and at the start of your sophomore year you have to drop out because of university budget cuts? No, no! You can't promise a student something, and then take it away!
President: We are seeing massive cuts across the board（全面地）. It's not just Cathy.
Mother: Cathy won that scholarship because she's got straight As in her entire freshmen year!
President: She's a model student.
Mother: With her accounts in arrears（拖欠，这里指奖学金不能按时发放）.
President: I've heard the library might have some openings. Perhaps we're still...
Mother: That's a fifteen thousand dollar scholarship. You think Cathy can make that up by reshelving（将图书等重新放到架子上）library books?
President: Perhaps it's time you and your daughter start looking into securing some private loans. I have the information for some lenders right here. I'm really sorry. I wish there was more I can do. The funding is just not there.
Daughter: Thank you.

In this scene, mother is petrified with the university's cancellation of her daughter's scholarship and they have to look for private loans. A scholarship is an award of financial aid for a student to further their education at a college, university, or other academic institution. Scholarships are awarded based upon various criteria, such as academic merit, diversity and

inclusion, athletic skill, financial need, among others. Or some combination of these criteria. Scholarship criteria usually reflect the values and goals of the donor or founder of the award.

While scholarship recipients are not required to repay scholarships, the awards may require that the recipient continue to meet certain requirements during their period of support, such as maintaining a minimum grade point average (GPA) or engaging in a certain activity (e.g., playing on a school sports team for athletic scholarship holders, or serving as a teaching assistant for some graduate scholarships). Scholarships may provide a monetary award, an in-kind award (e.g., waiving of tuition fees or fees for housing in a dormitory), or a combination.

Some prestigious, highly competitive scholarships are well-known even outside the academic community, such as Fulbright Scholarship（富尔布莱特奖学金）and the Rhodes Scholarship（罗德奖学金）.

While the terms are frequently used interchangeably, there is a difference. Scholarships may have a financial need component but rely on other criteria as well.

Academic scholarships typically use a minimum Grade Point Average or standardized test score such as the ACT or SAT to select awardees.

Athletic scholarships are generally based on athletic performance of a student and used as a tool to recruit high-performing athletes for their school's athletic teams.

Merit scholarships can be based on a number of criteria, including performance in a particular school subject or club participation or community service.

Grants, another equivalent term for scholarship, however, are offered based exclusively on financial need and determined using the applicant's FAFSA information.

- **Video 9-2:** *I promised that I'll manage all the college payments*

Mother: Are you sure you're all right? Trina? But you can always come back home.
Trina: No, Mom. I'm fine. It's like what you said when Dad left, everyday is a new opportunity, right? Hey, are you sure you didn't get any notification from the University, about my scholarship?
Mother: Nothing came in the mail. Is there a problem?
Trina: Uh, it's...it's nothing. I...I'll figure it out.
Mother: I can send a check.
Trina: No, Mom. No, you need the money for bills（账单，这里指日常开销）. And, besides,

　　　　　I promised that I'll manage all the college payments. And I'm gonna make you proud.
Mother: Sweetheart, you've already made me incredibly proud.
Trina: Just wish I could handle the jobs and classes half as well as you did.
Mother: huh, I never got grades as good as you.
Trina: No, you just <u>put a roof over my head</u>（给了我一个家，养育了我）, and gave me love more than I could've asked for. It's a lot to <u>look up to</u>（尤指对年长者敬仰、钦佩、仰慕）.
Mother: I don't want you to spend all your time struggling, OK? It's okay to take a breath and enjoy your college years.
Trina: Um, yeah, I'll try. I love you.
Mother: I love you so much. Call me if you need anything at all.

　　In this scene, the daughter is apparently trapped in tuition problem, but she would rather deal with it herself than asking for money from her mother. In western countries, it's common practice for a student without ample scholarship or family financial support to turn to student loan. A student loan is a type of loan designed to help students pay for college fees, such as tuition, books and supplies and living expenses. It may differ from other types of loans in that the interest rate may be substantially lower and the repayment schedule may be <u>deferred</u>（推迟的，延期的）while the student is still in school. Student loans in the United Kingdom are primarily provided by the state-owned Student Loans Company. Interest begins to accumulate on each loan payment as soon as the student receives it, but repayment is not required until the start of the next tax year after the student completes (or abandons) their education. In the United States, there are two types of student loans: federal loans sponsored by the federal government and private student loans, which broadly includes state-affiliated nonprofits and institutional loans provided by schools. The overwhelming student loans are such that deferring is quite common. There are many documented cases of Americans committing extreme actions because of large student loan balances. A case is shown in the following picture. The student is a member of Occupying Boston in protest for student loan debt.

- **Video 9-3:** *I know, professor, that's why I'm here to learn*

Teacher: OK, so let's <u>divert</u>（转移，改变方向或用途）into our <u>pitches</u>（推销的话，说教）for your year-long project—a truly useful <u>application</u>（应用程序）. Shall we start with...? Oh, I don't know. Sarah?

Sarah: Really?

Teacher: For someone so eager to be in this class, I would expect some preparation.

Sarah: Oh, I'm prepared.

Teacher: Great. What's your pitch?

Sarah: Well, it's a place to share our thoughts.

Teacher: Oh, good. Just the world needs another digital <u>dumping ground</u>（垃圾倾倒场）for its <u>collective stream-of-consciousness</u>（集体意识流）.

Sarah: Wouldn't be <u>random</u>（随意的）thoughts; would be things we never share on social media.

Teacher: Then why would we share them on your app?

Sarah: Because I'd make it <u>anonymous</u>（匿名的）, and <u>cathartic</u>（情感宣泄的）. See we're all accustomed to typing our thoughts on social media, but think about how good it feels to actually speak the words, you know, to <u>get something out of your chest</u>（发泄出来）. This app will allow you to speak directly into the phone and reveal the biggest secrets, then everyone is <u>filtered</u>（过滤）into this anonymous voice, that we can all safely listen to each other's secrets without judgment.

Teacher: Vocal <u>algorithms terms</u>（算法规则）are hard enough to <u>crack</u>（解决）.

Sarah: I know professor, that's why I'm here to learn.

Teacher: Very good, Sarah. Let's hope we can. OK, who else is ready for the pitch?

　　In this part, a student is scheduled in class by the professor to pitch her APP project. Pitch (both a noun and a verb) is a term used by a person trying to sell things or persuade people to do something, in this case, to sell her idea of an app design. From this scene, we see the professor is both encouraging and challenging the student at the same time during her presentation.

　　A presentation is the process of presenting a topic to an audience. It is typically a demonstration, introduction, lecture, or speech meant to inform, persuade, or build good will.

The term can also be used for a formal or ritualized introduction or offering, as with the presentation of a <u>debutante</u>（首次以某身份出现的女子，初入社交界的年轻富家女）. Sometimes visuals are needed for a good presentation. A presentation program is often used to generate the presentation content, some of which also allow presentations to be developed collaboratively, e.g. using the Internet by geographically <u>disparate</u>（迥然不同的）collaborators. Presentation viewers can be used to combine content from different sources into one presentation.

- **Video 9-4: I'm afraid <u>the odds are not in your favor</u>（形势对你不利），Kevin**

Student: Plagiarism?

Teacher: They have this wonderful new program, called I-Compare, that correlates instances of a selected text against known sources on the Internet.

Student: It could have been a coincidence?

Father: 47 times?

Teacher: I'm afraid the odds are not in your favor, Kevin.

Student: OK, I'm sorry. I just ran out of time! I didn't know what else to do.

Teacher: Usually I would have to report this to the principal, but I think in this case, one week suspension.

Father: I can do better than that. One month. No Internet, no allowance, no phone, no video games, and no car.

Teacher: And of course, I'll need you to redo your assignment, in your own words and in your own handwriting this time.

Student: No Internet?

Teacher: Two more last days this semester. I want your new assignment on my desk no later than 9 o'clock tomorrow morning.

Student: Or?

In this scene, a student is being punished by his teacher and his father for having violated the regulation and committed some misconduct/misbehavior—plagiarism in homework. And the punishment is severe. School systems set rules, and if students break these rules they are

subject to discipline. These rules may, for example, define the expected standards of clothing, timekeeping, social conduct, and work ethic. The term discipline is applied to the punishment that is the consequence of breaking the rules. Discipline often has a negative connotation, but discipline can be a positive way of instilling community values upon youth. Now <u>corporal punishment</u>（体罚）in schools has now disappeared from most western countries, including all European countries. Here are some most common forms of disciplining punishment for students at school.

<u>Detention</u>（课后留校处罚）is one of the most common punishments in schools in the United States, the United Kingdom, Ireland, Singapore, Canada, Australia, New Zealand South Africa and some other countries. It requires the pupil to report to a <u>designated area</u>（指定的地方）of the school during a specified time on a school day.

<u>Suspension or temporary exclusion</u>（暂时停学处分）is <u>mandatory leave</u>（强制休假）assigned to a student as a form of punishment that can last anywhere from one day to a few weeks, during which time the student is not allowed to attend regular lessons. In some US, UK, Australian and Canadian schools, there are two types of suspension: In-School and Out-of-School. In-school requires the student to report to school as usual but attend a designated suspension classroom or room all day. Out-of-school suspension bans the student from being on school grounds during school hours while school is in session. Schools are often required to notify the student's parents/guardians of the reason for and duration of the out-of-school suspension, and usually also for in-school suspensions. Suspended students are often required to continue to learn and complete assignments from the days in which they miss instruction.

<u>Expulsion</u>（开除）terminates the student's education. This is the <u>ultimate last resort</u>（终极手段）, when all other methods of discipline have failed. However, in extreme situations, it may also be used for a single offense. In some US public schools, expulsions and exclusions are so serious that they require an appearance before the <u>Board of Education</u>（教育委员会）or the court system. In the UK, <u>head teachers</u>（校长）may make the decision to exclude, but the student's parents have the right of appeal to the local education authority. Expulsion was completely banned for compulsory schools in China. This has proved controversial in cases where the head teacher's decision has been overturned (and his or her authority thereby undermined), and there are proposals to abolish the right of appeal.

<u>Counseling</u>（咨询,辅导）is also provided when a student will have to see a school counselor if they behave badly. The purpose of counseling is to help the student recognize their mistakes and find positive ways to make changes in the student's life. Counseling can also help the student clarify the expectations and standards of the school, as well as understand the consequences of failing to meet those standards.

- **Video 9-5: *Community college is nothing to be ashamed of***

Advisor: OK, What is your last name?

Tim: Timmerman, Tim Timmerman.

Advisor: Timmerman, Tim. OK. Here you are. Now Tim, have you decided how many colleges you want to apply to?

Tim: Just Yale.

Advisor: Yale?

Tim: Yes.

Advisor: The Ivy League school! Wow!

Tim: I'm going to politics. It's a perfect fit.

Advisor: OK, well. Your SATs and your ACTs are definitely good enough to go to Yale and that's yummy, and your GPA...

Tim: Yeah, I need to talk to some teachers about changing some of those grades.

Advisor: Look, Tim, I'm gonna play honesty planet with your right now. With a GPA like this, umm, Yale is going to be pretty much out of your reach.

Tim: Well, that's pretty much presumptuous（自负的,傲慢的）.

Advisor: You know normally in a situation like this, I would suggest the university of Utah, but with your grades...

Tim: All my brothers went to U of U, and besides, I have the presidential scholarship if I want it.

Advisor: Oh, no, see, the presidential scholarship at U of U requires a GPA at least 3.0. You've got a 2.45.

Tim: Thanks for the reminder.

Advisor: I think a good fit for you is gonna be Salt Lake community college.

Tim: Timmermans do not go to SLCC.

Advisor: Tim, community college is nothing to be ashamed of.

Tim: Good to know.

 In this scene, a high school student is seeking advice for potential college application from a school advisor. Here the advisor is assessing his performance and applicability in three indexes: the SAT, ACT and GPA.

 The SAT（学业能力倾向测验,为美国高等学校入学标准测试）, introduced in 1926,

was first called the Scholastic Aptitude Test, then the Scholastic Assessment Test, is a standardized test for most college admissions in the United States. The SAT is owned, published, and developed by the College Board (全国大学委员会), a nonprofit organization in the United States. It was formerly developed, published, and scored by the Educational Testing Service which still administers the exam. The test is intended to assess a student's readiness for college. SAT takes three hours and forty-five minutes to finish, and costs $50 ($81 International), excluding late fees. Possible scores range from 600 to 2400, combining test results from three 800-point sections (Mathematics, Critical Reading, and Writing). Taking the SAT or its competitor, the ACT, is required for freshman entry to many, but not all, universities in the United States.

The ACT, originally an abbreviation of American College Testing (美国高等院校考试, 为一些高中生入读高等院校前参加的考试), is a standardized test used for college admissions in the United States. ACT assessment measures high school students' general educational development and their capability to complete college-level work with the multiple choice tests covering four skill areas: English, mathematics, reading, and science. The main four ACT test sections are individually scored on a scale of 1 - 36, and a composite score (the rounded whole number average of the four sections) is provided. It is accepted by all four-year colleges and universities in the United States as well as more than 225 universities outside of the U.S.

The majority of colleges do not indicate a preference for the SAT or ACT exams and accept both, being treated equally by most admissions officers. Historically, the SAT has been more popular among colleges on the coasts and the ACT more popular in the Midwest and South.

GPA (grade point average, 平均成绩) is calculated by using the number of grade points a student earns in a given period of time. GPAs are often calculated for high school, undergraduate, and graduate students, and can be used by potential employers or educational institutions to assess and compare applicants. GPA is a measure of a student's performance for all of his or her courses. Most nations have their own grading system, and different institutions in a single nation can vary in their grading systems as well. Most colleges and universities in the United States award a letter grade A (best), B, C, D, or F (fail) for each class taken (potentially with + or - modifiers). These letter grades are then used to calculate a GPA from 0 to 4.0, using a formula where 4.0 is the best. The average GPA is 3.3 at private institutions and 3.0 at public institutions.

In this dialogue, the advisor mentions Salt Lake community college. The term community college can have different meanings in different countries: many community colleges have an open enrollment for students who have graduated from high school. The term usually refers to a higher educational institution that provides workforce education and college transfer academic

programs.

In the United Kingdom, except for Scotland, this term is not commonly used. A community college is a school which not only provides education for the school-age population (11 - 18) of the locality, but also additional services and education to adults and other members of the community. In the United States, community colleges, sometimes called junior colleges, technical colleges, two-year colleges, or city colleges, are primarily two-year public institutions providing lower-level tertiary education, also known as continuing education. They grant certificates, diplomas, and associate degrees. After graduating from a community college, most students transfer to a four-year liberal arts college or university for two to three years to complete a bachelor's degree.

Before the 1970s, community colleges in the United States were more commonly referred to as junior colleges. That term is still used at some institutions. However, the term "junior college" is generally applied to private two-year institutions, whereas the term "community college" is used to describe publicly funded two-year institutions. Community colleges primarily attract and accept students from the local community, and are often supported by local tax revenue. They may also work with local businesses to ensure students are being prepared for the local workforce. In general, community colleges in the UK and US are similar to the equivalent junior colleges in China.

Generally, the college search begins in the student's junior year of high school with most activity taking place during the senior year, although students at top high schools often begin the process during their sophomore year or earlier. Applying to colleges can be stressful. The outcome of the admission process may affect a student's future career <u>trajectory</u>（轨迹）considerably. Entrance into top colleges is increasingly competitive, and many students feel pressure during their high school years. Private and affluent public primary education, test-prep courses, <u>"enrichment programmes"</u>（充实计划）, volunteer service projects, international travel, music lessons, sports activities—all the high-cost building blocks of the perfect college application—<u>put crushing pressure</u>（压得喘不过气来）on the upper middle class life, mostly similarly in China.

Students are usually notified of a college's decision in April, sometimes in the last two weeks of March, unless they had applied using an early approach, and are usually notified by email, although some colleges still send "fat" envelopes （usually an acceptance） or "thin" envelopes （usually a rejection）.

Here are some more major movies recommended on college entrance and admissions:
Admission（《爱在招生部》）; *Accepted* （《录取通知》）; *Legally Blond*（《律政俏佳人》）; *College Road Trip*（《大学之旅》）; *Sydney White*（《大学新生》）; *College*（《大学预备生》）.

- **Video 9-6: *We're each gonna make a toast for change***

Teacher: Okay, guys and <u>gals</u>（姑娘，女子）, listen up! This is what I want you to do. I want each of you to step forward and take one of these Borders bags which contain the four books we're gonna read this semester. (All right!) They're very special books, and they each remind me, in some way, of each of you. But, before you take the books, I want you to take one of these glasses of <u>sparkling</u>（起泡的）<u>cider</u>（苹果酒，苹果汁）, and I want each of you to <u>make a toast</u>（举杯祝福）. We're each gonna make a toast for change. And what that means is, from this moment on, every voice that told you "You can't" is silenced. Every reason that tells you things will never change, disappears. And the person you were before this moment, that person's turn is over. Now it's your turn. Okay? So let's party!

Here, the high school teacher makes a special arrangement on the graduation day for the students, both as a reward and an encouragement for them. In America, many lower class families in impoverished areas have no choice but send their children to inferior, substandard or even run-down public schools. In this movie, the dedicated teacher puts all her heart and soul in the students' progress and welfare, and successfully transforms these students who came from broken families, unemployed parents, single problem parents etc. Most importantly, they've

regained their dignity, self-value and confidence, which is the theme of the movie.

The meaning of public schools is different in different countries:

In the United States, state school (public school), a tuition-free school, funded and operated by the government. Charter school(特许学校,为一种公共资助的独立学校,由教师、家长或社区团体经政府特许后建立), a no-tuition United States or Canadian school that operates outside the public school system, but receives government funding.

In the United Kingdom, public schools mean the registered charities, charging tuition fees, which do not receive state funding.

In Australia the Great Public Schools are privately run schools for boys, but otherwise Public School is the normal name for a state-run primary school.

Public university, in some countries, e.g. the United States, any university operated by the state, as opposed to a privately owned organization

• **Video 9-7: *This is a formal warning***

Dean: I'm disappointed to do this, but this is a formal warning.

Professor: Err, ah, I, I don't understand.

Dean: Understand this! I've received a report that you've been seen in private with a student in your department. And that you're involved. Now, that's all I know. That's all I want to know. But if I find out anything definitive (确凿的) I will terminate (免职,解雇) you immediately. So I suggest whatever is going on, you put an end to it (把它了结). This day and age, even the scent (线索,踪迹) of impropriety (不正当,不得体) between a faculty (全体教员) member and a student, it jeopardizes (危及,损害) all of us, and the prestige (声望) of this university. Do I make myself clear?

Professor: Yes, ma'm (madam 的口语形式:女士、夫人,为对高级别或高职位女性的称呼).
　　　　　May I go?

Dean: You may go.

In this scene, the professor is involved with a student in an inappropriate relationship and is being warned by the Dean. Sexual misconduct is misconduct of a sexual nature. The term may be used to condemn an act, but in some jurisdictions it has also a legal meaning. Among educators, a US Department of Education found in 2010 that 9.6% of high school students have experienced some form of sexual misconduct.

Here the Dean gives him a formal warning first. Her strategy is trying to nip it in the bud（防患于未然）in dealing with the case of the professor, in protection of the professor and in accordance of the school's statutes at the same time, fit for her status.

In law, misconduct（行为不端）is wrongful, improper, or unlawful conduct motivated by premeditated or intentional purpose or by obstinate indifference to the consequences of one's acts.

Two categories of misconduct are sexual misconduct and official misconduct. In connection with school discipline, "misconduct" is generally understood to be student behavior that is unacceptable to school officials but does not violate criminal statutes, including absenteeism, tardiness, bullying, and inappropriate language. Misconduct in the workplace generally falls under two categories. Minor misconduct is seen as unacceptable but is not a criminal offense (e.g. being late, faking qualifications). Gross misconduct can lead to dismissal (e.g. stealing or sexual harassment). "Gross misconduct" can lead to immediate dismissal or even criminal offenses because it is serious enough, e.g. stealing or sexual harassment, in the case of this professor, inappropriate involvement with a college student.

- **Video 9-8: *That's the power of a good book***

Teacher: Let's get started. Jane Austin's masterpiece. Who in here has already read *Pride and Prejudice*? And what did you think of it on the first read? Let's hear from our newcomer, Mr. Scott. All right, folks.

Scott: *Pride and Prejudice*? Elizabeth Bennet needs to chill（放松,冷静）. She gave Darcy a way worse time than he deserved.

Teacher: Are you saying that Darcy was not in love with Elizabeth?

Scott: Love is just a transaction（交易）. We're all hardwired（天生的）to desire. We present the correct set of desirable traits, and boom! We can turn it on and we can turn it off.

Teacher: Yes, Miss, um... Young, Tessa.

Tessa: I think that it was the most revolutionary feminist novel that I'd ever read. That a woman of that era would have the strength to reject Darcy when he treated her poorly.

Scott: That's a load（胡说八道）. It was Darcy's very attitude that attracted Elizabeth to him.

Tessa: Darcy's attitude was rude and mocking. I think he was lucky to be with a woman, with as much integrity（诚实正直）as Elizabeth.

Scott: The only reason he even asked her to marry him was she wouldn't stop throwing

　　　　herself...
Tessa: Throwing herself at（勾引）him?　He was pursuing her.
Scott: She's clearly not satisfied with her life, and is looking for excitement wherever she can get it.
Tessa: I think that it's obviously all in his head that she had any feelings for him at all.
Teacher: Well. There you have it. That's the power of a good book.

　　In this scene of a typical American college class, a girl student is presenting her idea of a book reading experience and engaged by a male student in the ensuing debating.

　　The most common type of collaborative（合作的）method of teaching in a class is classroom discussion. It is the also a democratic way of handling a class, where each student is given equal opportunity to interact and put forth their views. A discussion taking place in a classroom can be either facilitated（促进，推动）by a teacher or by a student（in this scene, a teacher）. A discussion could also follow a presentation（观点的陈述，报告）or a demonstration（展示）. Class discussions can enhance student understanding, add context to academic content, broaden student perspectives, highlight opposing viewpoints, reinforce knowledge, build confidence, and support community in learning. The opportunities for meaningful and engaging in-class discussion may vary widely, depending on the subject matter and format of the course. Motivations for holding planned classroom discussion, however, remain consistent. An effective classroom discussion can be achieved by probing more questions among the students, paraphrasing the information received, using questions to develop critical thinking with questions like:

"What do you think of ...?"

"Can we take this one step further?"

"What solutions do you think might solve this problem?"

"How does this relate to what we have learned about...?"

"What are the differences between ... ?"

"How does this relate to your own experience?"

"What do you think causes ... ?"

"What are the implications of ... ?"

- **Video 9-9: *I didn't quite mean it as a compliment***

Professor: As I was saying, the trouble with Chomsky（乔姆斯基，美国当代语言学家，转换-生成语法奠基人之一）is he cannot leave his politics out of it, and now that for me, in my view, compromises（违背【原则】，达不到【标准】）the science.

Student: Some ones say Chomsky is just true to his conscience.

Professor: Oh.

Student: Advise me!

Professor: Oh, I think you've worked it out pretty well on your own.

Student: No. I mean, be my advisor, next year. I will not let you down!

Professor: You're a very serious young woman.

Student: Well, thank you.

Professor: I didn't quite mean it as a compliment. It sounds as though you're hurrying somewhere in such a way the journey will yield very little pleasure. Slow down. College should not necessarily be about narrowing your focus; it's about broadening your experience. I'm sorry, but I can't be your advisor.

Student: I know you don't take on freshmen, but with my AP credits（大学预修课程成绩）, I'm technically entering Middleton（米德尔顿【英格兰西北部城镇】）as a sophomore.

Professor: I'm leaving Middleton at the end of next week, as a matter of fact.

Student: Well, you're going to another school?

Professor: I'm going on a sabbatical（休假，尤指供大学教师进行学术研究或旅行的公休假）.

In this video, the girl student is filled with passion in discussion and eager to study with the professor, but from whom her enthusiasm meets a lukewarm response.

A sabbatical is a period of time when especially a teacher at a university is allowed to stop their normal work in order to study or travel. Some of the professors will use it to write a book or do some travel-study business on the side.

AP credits here mean Advanced Placement credits, a North American program offering college level courses at schools. It is a program in the United States and Canada created by the College Board（大学委员会）which offers college-level curricula and examinations to high school students. American colleges and universities may grant placement and course credit to students who obtain high scores on the examinations. The AP curriculum for each of the various subjects is created for the College Board by a panel of experts and college-level educators in that field of study.

9.3 Questions for discussion

1) Do you agree that having a relationship in college time is an important part of one's life experience?

2) What is your ideal of a good teacher and a good class teaching?
3) In terms of parent-child relationship, tuition fees payment are different between western culture and Chinese culture. Share your opinions on it, please.
4) Are you an active participant in class? If not, what do you think is the problem?
5) What kind of student-teacher relationship in college did you expect and how disappointed or satisfied are you?

9.4 Debate

College students can get married at school.

9.5 Vocabulary exercises

compulsory, accommodation, assess, conscientious, obsession, defer, anonymous, impeccable, indiscretion, expel, terminate, prestige, jeopardize, transaction, collaborative

Try and fill in the blanks of the following sentences with words listed above in proper forms.

1) The success of this project owes to the _____ effort between the two departments.
2) The _____ is completed by payment of the fee after you put in the pin number.
3) The contract with the foreign teacher is going to be _____ and not to be renewed.
4) To _____ the students' performance, the teacher gave them a mid-term test.
5) He was _____ last year for violating the school regulations.
6) The University can provide _____ for its students upon request.
7) He believes that study of history should be _____ for all the students.
8) His _____ with the computer game wasted a lot of time and energy.
9) Mortgage payment to the bank is _____ owing to the bad economic recession.
10) Hiring some prominent professors has enhanced the school's _____ in the last few years.
11) His _____ resume attracts a lot of potential employers in the job fair.
12) _____ people will persist in a task even when there's no good reason to do so.
13) The donor asked the charity organization not to disclose his name and to remain _____.
14) Forgive me if any _____ on my part has embarrassed you.
15) We don't want any mistake in our team to _____ this project.

9.6 Role-play and reenactment

1) Please review Video 9-1, act out the scene and feel the part of student scholarship and loan culture.
2) Please review Video 9-2, act out the dialogue between mother and daughter, and experience the culture of tuition problem.
3) Please review Video 9-4, act out the dialogue between a teacher, a father and the father's son about violating the regulation in school work.
4) Please review Video 9-7, act out the dialogue between the Dean and the professor, and have a grasp of the part of culture.
5) Please review Video 9-8, act out the class discussion among two students and a teacher, and feel the classroom culture.
6) Please review Video 9-9, act out the discussion between a professor and a student.

FEMINISM IN DILEMMA
女权困惑

10.1 Cultural tidbits

Feminism is a range of political movements, ideologies（意识形态）, and social movements that share a common goal: to define, establish, and achieve political, economic, personal, and social rights for women. This includes seeking to establish educational and professional opportunities for women that are equal to such opportunities for men.

Feminist movements have campaigned and continue to campaign for women's rights, including the right to vote, to hold public office, to work, to earn fair wages or equal pay, to own property, to receive education, to enter contracts, to have equal rights within marriage, and to have maternity leave（产假）. Feminists have also worked to promote bodily autonomy（身体自主）and integrity（完整，健全）, and to protect women and girls from rape, sexual harassment, and domestic violence（家暴）.

Feminist campaigns are generally considered to be a main force behind major historical societal changes for women's rights, particularly in the West. Although feminist advocacy is, and has been, mainly focused on women's rights, some feminists, argue for the inclusion of men's liberation within its aims because men are also harmed by traditional gender roles. Feminist theory, which emerged from feminist movements, aims to understand the nature of gender inequality（性别不平等）by examining women's social roles and lived experience; it has developed theories in a variety of disciplines in order to respond to issues concerning gender.

Numerous feminist movements and ideologies have developed over the years and represent different viewpoints and aims. Some forms of feminism have been criticized for taking into account only white, middle class, and college-educated perspectives. This criticism led to the creation of ethnically specific or multicultural forms of feminism, including black feminism and intersectional（交叉的）feminism.

The history of the modern western feminist movements is divided into three "waves". Each wave dealt with different aspects of the same feminist issues. The first wave comprised women's suffrage movements of the nineteenth and early twentieth centuries, promoting women's right to vote. The second wave was associated with the ideas and actions of the

women's liberation movement beginning in the 1960s. The second wave campaigned for legal and social equality for women. The third wave is a continuation of, and a reaction to, the perceived failures of second-wave feminism, which began in the 1990s.

(A women's liberation march in Washington, D.C., 1970)

The feminist movement has effected far-reaching impact in cultural, social and literary areas, as well as change in Western society, including women's suffrage（选举权）; greater access to education; more nearly equitable pay with men; the right to initiate divorce proceedings; the right of women to make individual decisions regarding pregnancy (including access to contraceptives and abortion); and the right to own property.

Different groups of people have responded to feminism, and both men and women have been among its supporters and critics. Among American university students, for both men and women, support for feminist ideas is more common than self-identification as a feminist. The US media tends to portray feminism negatively and feminists "are less often associated with day-to-day work/leisure activities of regular women." However, as recent research has demonstrated, as people are exposed to self-identified feminists and to discussions relating to various forms of feminism, their own self-identification with feminism increases. Roy Baumeister (2001) has criticized feminists who "look only at the top of society and draw conclusions about society as a whole. Yes, there are mostly men at the top. But if you look at the bottom, really at the bottom, you'll find mostly men there, too."

In the nineteenth century, anti-feminism was mainly focused on opposition to women's suffrage. Later, opponents of women's entry into institutions of higher learning argued that education was too great a physical burden on women. Other anti-feminists opposed women's entry into the labor force, or their right to join unions, to sit on juries, or to obtain birth control and control of their sexuality.

Some people have opposed feminism on the grounds（理由）that they believe it is contrary to traditional values or religious beliefs. These anti-feminists argue, for example, that social acceptance of divorce and non-married women is wrong and harmful, and that men and

women are fundamentally different and thus their different traditional roles in society should be maintained. Other anti-feminists oppose women's entry into the workforce, political office, and the voting process, as well as the lessening of male authority in families.

10.2 Video examples

- **Video 10-1: *Your resistance made me stronger!***

What I would like to say to all the women here today is this, women have been so oppressed (压迫) for so long, they believe what men have to say about them. And they believe they have to back (支持) a man to get the job done. And there're some very good men worth backing, but not because they're men, because they're worthy. As women, we have to start appreciating our own worth, and each other's worth. Seek out strong women, to be friends, to align yourself with (与……一致), to learn from, to be inspired by, to collaborate with, to support, to be enlightened (启发) by.

As I said before, it's not so much about receiving this award as it is having this opportunity to stand before you and really say thank you, as a woman, as an artist, as a human, not only to the people who have loved and supported me along the way. So many of you are sitting in front of me right now. You have no idea, no. You have no idea how much your support means. But to the doubters, the naysayers (否定者,唱反调的人), to everyone who gave me hell, and said I could not, that I would not, that I must not, your resistance made me stronger, made me push harder, made me the fighter that I'm today, made me the woman that I'm today, so thank you.

This is part of the speech made by Madonna who won the 2016 *Billboard* (《公告牌》,美国的一本音乐周刊) Women in Music Award. The first part of the speech focuses on the hardship as a woman in her music pursuit. In the second part, she speaks on women's behalf in supporting their rights, appreciating their worth and working together. In the end, she believes what she has suffered in the past makes her stronger today.

Madonna (born August 16, 1958) is an American singer, songwriter, actress, and businesswoman. She achieved popularity by pushing the boundaries of lyrical content in mainstream popular music and imagery in her music videos, which became a fixture on MTV.

Referred to as the "Queen of Pop", Madonna is often cited as an influence by other artists.

In this speech, as by many other feminists, what Madonna condemns coincides with the feminist movement's agenda includes acting as a counter (对抗,反击) to the patriarchal strand (父系,男权) in the dominant culture. While differing during the progression of waves, it is a movement that has sought to challenge the political structure, power holders, and cultural beliefs or practices.

Not only has the movement come to change the language into gender neutral but the feminist movement has brought up how people use language is gendered and ingrained into everyday life. Such metaphors as "the aggressive sperm and passive egg" felt natural to people. Other expressions: chairperson, spokesperson, Ms., humanity, etc. This is a goal in feminism to see these gendered metaphors and bring it to the public's attention. The outcome of looking at things in a new perspective can produce new information.

- **Video 10-2:** *I really love having sisters*

Interviewer: Uh, so, tell me a little bit about yourself.
Interviewee: Well, I'm definitely a self starter (有主见的人,做事主动的人). Oh, at my last job, I was the first one in and the last one to leave, so I'm more of a Type A (A型个性:一种性格类型,特征为高进取心,性情急躁,易感到压力和得心脏病;相对应的为 Type B,特征为悠闲轻松及低紧迫感). So you don't have to tell me to do anything twice.
Interviewer: Okay. Full disclosure (开诚布公的话). Um, I don't even know if I'm allowed to be asking you this, but you wouldn't have any problem assisting a woman, would you?
Interviewee: Oh, no, of course not. No, I actually have four sisters.
Interviewer: Four? Wow, I'm the only child, so.
Interviewee: Yeah, I really love having sisters. I think having brothers miss out on (错过,错失) a lot.
Interviewer: Like what?
Interviewee: Grace. Yeah, I think that's hard to find in a pubescent (青春期的) boy.
Interviewer: Yeah, I can see that.

In this interview session, the interviewer is hiring an assistant to her, so the natural question followed is about the interviewee's stance on feminism, i.e. if he has problem working for a woman. And obviously, the latter succeeded in dealing with this question with his own experience in the family.

A job interview is a one-on-one interview consisting of a conversation between a job applicant and a representative of an employer which is conducted to assess whether the applicant should be hired. Two major types that are used frequently and that have extensive empirical support are situational questions and behavioral questions. Situational interview questions ask job applicants to imagine a set of circumstances and then indicate how they would respond in that situation; hence, the questions are future oriented. While, behavioral questions are about how job applicants have handled situations in the past that are similar to those they will face on the job, employers can gauge how they might perform in future situations. Behavioral interview questions include:

Describe a situation in which you were able to use persuasion to successfully convince someone to see things your way.

Give me an example of a time when you set a goal and were able to meet or achieve it.

Tell me about a time when you had to use your presentation skills to influence someone's opinion.

Give me an example of a time when you had to conform to a policy with which you did not agree.

- **Video 10-3: *Hey, I'm just trying to sleep with you***

I mean these are just jokes. I don't mean to offend the girls. I try to be a good feminist, I do, which is tough nowadays, 'cause some women are feminists, some are not. So as a guy, how do I know how to act? Like some girls, you open the door for them, they're like, "Wow, a gentleman, thank you very much!"

Other girls, you open the door for them, they're like, "What, you think I can't open my own door?" I'm like, "Oh, hey, I'm just trying to sleep with you." Gee, please, nothing to worry here.

In this stand-up performance, the actor reveals his confusion and awkwardness when he encountered different women. Being a gentleman may not come up with the anticipated result.

This is the lesson he learned. What a dilemma!

The term gentleman refers to any man of good, courteous conduct. It may also refer to all men collectively, as in indications of gender-separated facilities, or as a sign of the speaker's own courtesy when addressing others. The modern female equivalent is lady.

In its best use, moreover, gentleman involves a certain superior standard of conduct. The word gentle, originally implying a certain social status, had very early come to be associated with the standard of manners expected from that status. Thus, by a sort of punning process, the "gentleman" becomes a "gentle-man". In another sense, being a gentleman means treating others, especially women, in a respectful manner and not taking advantage or pushing others into doing things he chooses not to do.

The Far East held similar ideas to the West of what a gentleman is, which are based on Confucian principles. The term Jūnzǐ (君子) is a term crucial to classical Confucianism. Literally meaning "son of a ruler", "prince" or "noble", the ideal of a "gentleman", "proper man", "exemplary person", or "perfect man" is that for which Confucianism exhorts all people to strive. In modern times, the masculine bias in Confucianism may have weakened, but the same term is still used; the masculine translation in English is also traditional and still frequently used. A <u>hereditary elitism</u>（遗传精英主义）was bound up with the concept, and gentlemen were expected to act as moral guides to the rest of society. They were to: cultivate themselves morally; participate in the correct performance of ritual; show filial piety and loyalty where these are due; and cultivate humaneness.

- **Video 10-4:** *Hey, wanna come back to my house that I own?*

It sucks. It sucks because I feel like I worked my ass off to accomplish my goals, to accomplish my dreams. Now I feel like I have the best life ever. I have the career I want, but guys are not <u>into</u>（喜欢）that. Guys aren't into <u>self-sufficient</u>（独立自主的）girls, you know, who are independent. That's not a <u>turn-on</u>（刺激，令人兴奋的人或物）. I'm not a sexy woman. My dirty talk is not sexy. I'm like, "Hey, wanna come back to my house that I own?" Not a turn-on. Guys like girls should be like…<u>vulnerable</u>（脆弱的，易受伤害的）, and <u>coy</u>（腼腆的，羞答答的）. Guys like girls should be like, "Mm, I'm lost. Can you help me?"

In this comic show, the performer looks at feminism in her view, that is, it's stereotypical

of men to like vulnerable and weak women instead of independent ones, which is unacceptable for her. This is also a dilemma, since for women, with or without success, neither works well for them.

In this part, we can learn some colloquial expressions. First, "be into" means to like. A "turn on" means sexual arousal or sexual desire, and the opposite is a "turn-off".

"Be like" is substituted by "to say". For example: When I got home late last night, my mother was worried and she <u>was like</u>, "How could you be so late?"

"…someone's ass off" means trying hard to something. For example: bust one's ass off.

- **Video 10-5:** *I don't want to sound too forward or anything*

Woman: So, how did you like your coffee?

Man: Perfect! Your friend? She's kind of sweet.

Woman: Oh, she is <u>one in a million</u>（百里挑一的人）. Are you sure you don't want anything else?

Man: Nah, the coffee is fine.

Woman: Alright. Listen, ah, I don't want to sound too <u>forward</u>（鲁莽的，冒失的）or anything, but would you maybe want to go out and grab a dinner sometime?

Man: Are you <u>asking me out</u>（约会）?

Woman: Just two old acquaintances getting to know each other again.

Man: Sarah says I should get out and meet more people.

Woman: Well, Sarah is a very smart girl.

Man: You know what? I'm gonna <u>take you up on your offer</u>（接受你的好意）.

Woman: Perfect. I am off all day tomorrow. Call me when you're done?

Man: I will. Thank you.

In this scene, the woman takes the initiative to ask a man out, which is not common even in the western culture. Besides the dialogue, the body language and the environment are also good for cultural learning. The sentence "You should go out and meet more people" is familiar advice for American people.

Dating is about two or more people exploring whether they are romantically or sexually compatible by participating in dates with the other. With the use of modern technology, people

can date via telephone or computer or meet in person, or in a traditional way, through matchmakers, either a friend, family member or computer and smart phone apps. There are considerable differences between social and personal values. Each culture has particular patterns which determine such choices as whether the man asks the woman out, where people might meet, whether kissing is acceptable on a first date, the substance of conversation, who should pay for meals or entertainment, or whether splitting expenses is allowed. In this part, the woman takes it into her own hands and expresses her love in her own way by taking the imitative to ask the man out.

- **Video 10-6:** *It's on us, all of us*

Tonight we celebrate artists whose music and message help shape our culture, and together we can change our culture for the better by ending violence against women and girls. Right now, nearly one in five women in America has been a victim of rape or attempted rape. And more than one in four women has experienced some form of domestic violence. It's not OK. And it has to stop. Artists have a unique power to change minds and attitudes, and get us thinking and talking about what matters. And all of us, in our own lives, have the power to set an example. Join our campaign to stop this violence. Go to itsonus.org, and take the pledge (宣誓), and to the artists at the Grammies (格莱美奖,奖杯为小留声机形状,每年由美国国家录音艺术与科学学会颁发) tonight, I ask you to ask your fans to do it too. It's on us, all of us to create a culture where violence isn't tolerated, or survivors are supported, and where all our young people, men and women, can go as far as their talents and their dreams will take them. Thanks!

In this speech, Barack Obama first depicts the serious situation of domestic violence going on in America, and then urges people to join the campaign and set an example to stop it. At last, he issues a strong appeal to the artists to play their role in inspiring our young people to realize their dreams.

Domestic violence (also named domestic abuse, battering, or family violence) is a pattern of behavior which involves violence or other abuse by one person against another in a domestic setting, such as in marriage or cohabitation. Globally, the victims of domestic violence are overwhelmingly women, and women tend to experience more severe forms of violence.

A Grammy Award, or Grammy, is an honor awarded by the Recording Academy（美国录音学院） to recognize outstanding achievement in the mainly English-language music industry. The annual presentation ceremony features performances by prominent artists, and the presentation of those awards that have a more popular interest. It shares recognition of the music industry as that of the other performance awards such as the Emmy Awards（艾美奖，为美国电视界最高奖项）, the Tony Awards（托尼奖，美国话剧和音乐剧最高奖）, and the Academy Awards（学院奖，奥斯卡金像奖）. The general four awards which are not restricted by genre are: Album of the Year（年度专辑）, awarded to the performer and the production team of a full album if other than the performer; Record of the Year（年度唱片）, awarded to the performer and the production team of a single song if other than the performer; Song of the Year（年度歌曲）, awarded to the writer (s)/composer (s) of a single song; Best New Artist（最佳新艺人）, awarded to a promising breakthrough performer who releases, during the Eligibility Year, the first recording that establishes the public identity of that artist（which is not necessarily their first proper release）.

- **Video 10-7:** *My empathy was used against me*

My name is Brooke Axtell, and I'm a survivor of domestic violence. After a year of passionate romance with a handsome, charismatic（有魅力的） man, I was stunned when he began to abuse me. I believed he was lashing out（猛打，痛斥） because he was in pain and needed help. I believed my compassion（同情，怜悯） could restore him and our relationship. My empathy（同情，同感，共鸣） was used against me. I was terrified of him and ashamed I was in this position. What bound（使结合，使依恋） me to him was my desire to heal him. My compassion was incomplete because it did not include me. When he threatened to kill me, I knew I had to escape. I revealed the truth to my mom and she encouraged me to seek help at a local domestic violence shelter（庇护所，收容所）. This conversation saved my life. Authentic love does not devalue another human being. Authentic love does not silence, shame, or abuse. If you're in a relationship with someone who does not honor and respect you, I want you to know that you're worthy of love. Please reach out for help. Your voice will save you. Let it extend into the light; let it part（分开） the darkness; let it set you free to know who you truly are: valuable, beautiful, loved.

The speaker combines description, narration and explanation in an effort to urge people to face up to domestic violence and to love and value themselves. Studies have found high incidence of psychopathology（心理病理学，精神病理学）among domestic abusers, as the man abuser in this speech.

Psychological theories focus on personality traits（人格品质）and mental characteristics of the offender（冒犯者，违法者，犯罪者）. Personality traits include sudden bursts of anger, poor impulse control, and poor self-esteem. Various theories suggest that psychopathology is a factor, and that abuse experienced as a child leads some people to be more violent as adults. Correlation has been found between juvenile delinquency（少年犯罪）and domestic violence in adulthood.

10.3 Questions for discussion

1) What is your idea about feminism? Can you give an example in daily life?
2) Have you seen or experienced domestic violence in China?
3) For boys, would you have problems working for a female employer in the future?
4) China is witnessing a soaring divorce rate now. What do you think is the main reason for that?
5) Would you agree that a domestic man is a weak-minded man?

10.4 Debate

Men and women are equal in modern competition world.

10.5 Vocabulary exercises

on the grounds that, align... with, enlighten, disclosure, miss out on, pubescent, vulnerable, compassion, empathy, charismatic

Try and fill in the blanks of the following sentences with words listed above in proper forms.

1) The case was dismissed _____ there was not enough evidence.
2) We must _____ our thoughts and conducts _____ the core socialist values.
3) I was charmed with his _____ personality and witty remarks.
4) Confucianism and Taoism both stress the importance of _____.
5) Lacking _____, people act only out of self-interest, without regard for the well-being or feelings of others.
6) The teacher finds it hard to deal with the messy _____ boys in his class.
7) I will go to game to cheer for you; I wouldn't _____ such a good opportunity

for the world.

8) More girls become victimized in the area because they're _____ and lack of self-protection.
9) The _____ of the news shocked the public.
10) This TV program can _____ the audience on environment problems facing us in the world.

10.6 Role-play and reenactment

1) Please review Video 10-1, recite the speech by Madonna and feel the part of culture of women's rights in America.
2) Please review Video 10-2, act out the dialogue and feel the part of interview sessions in corporate culture.
3) Please review Video 10-3, act out the comedy and feel the part of culture of feminism.
4) Please review Video 10-5, act out the dialogue and feel the part of culture of dating.
5) Please review Video 10-6, recite the speech and feel the part of culture of fighting domestic violence.

GENERATION GAP
代沟问题

11.1 Cultural tidbits

Generation gap is a difference of opinions between one generation and another regarding beliefs, politics, or values. In today's usage, "generation gap" often refers to a perceived（察觉的，发觉的）gap between younger people and their parents and/or grandparents. There are several ways to make distinctions between generations in the following.

Language use

It can be distinguished by the differences in their language use. The generation gap has created a parallel gap in language that can be difficult to communicate across. As new generations seek to define themselves as something apart from the old, they adopt new lingo（行话，隐语）and slang（俚语）, allowing a generation to create a sense of division from the previous one. This is a visible gap between generations we see every day. Ramaa Prasad (1992): "Man's most important symbol is his language and through this language he defines his reality." As slang is often regarded as an ephemeral（短暂的）dialect, a constant supply of new words is required to meet the demands of the rapid change in characteristics. To establish or reinforce social identity or cohesiveness（凝聚力）within a group or with a trend in society at large, each successive generation of society struggles to establish its own unique identity among its predecessors（前任，前辈）. While most slang terms maintain a fairly brief duration of popularity, slang provides a quick and readily available vernacular（本地的，乡土的）screen to establish and maintain generational gaps in a societal context.

Technology

With the development of technology, understanding gaps have widened between the older and younger generations. The term "communication skills," for example, might mean formal writing and speaking abilities to an older worker. But it might mean e-mail and instant-messenger savvy to a twenty something. A study looked at Baby Boomers（born in 1946—1964）, Generation X'ers（born in 1965—1980）, Generation Y'ers（born in 1981—2000）and Generation Z'ers（born in the mid 1990s or 2000 to present）, and showed generational gaps between the different forms of technology used. Perhaps the most commonly cited difference between older and younger generations is technological proficiency（熟练，精通）. Studies have

shown that their reliance on technology has made millennials（千禧一代）less comfortable with face-to-face interaction and deciphering（破译,解释,辨认）verbal cues. However, technological proficiency also has its benefits; millennials are far more effective in multitasking（多任务处理）, responding to visual stimulation, and filtering information than older generations

Workplace attitudes

A popular belief held by older generations is that the characteristics of millennials can potentially complicate professional interactions. To some managers, this generation is a group of coddled（溺爱,娇惯）, lazy, disloyal, and narcissistic（自我陶醉的,孤芳自赏的）young people, who are incapable of handling the simplest task without guidance. For this reason, when millennials first enter a new organization, they are often greeted with wary coworkers. Career was an essential component of the identities of Baby boomers; they made many sacrifices, working 55 to 60 hour weeks, patiently waiting for promotions. Millennials, on the other hand, are not workaholics and do not place such a strong emphasis on their careers.

Growing up, millennials looked to parents, teachers, and coaches as a source of praise and support. They were a part of an educational system with inflated（虚增的,夸张的）grades in which they were skilled at performing well. They were brought up believing they could be anything and everything they dreamed of. As a result, millennials developed a strong need for frequent, positive feedback from supervisors. Millennials crave success, and good paying jobs have been proven to make them feel more successful.

Intergenerational conflict also describes cultural, social, or economic discrepancies（差异）between generations, which may be caused by shifts in values or conflicts of interest between younger and older generations.

On the way these lived experiences shape a generation in regard to values, the result is that the new generation will challenge the older generation's values, resulting in tension. This challenge between generations and the tension that arises is a defining point for understanding generations and what separates them.

In China, the post-80s are those who were born in between the year 1980 to 1989 in urban areas of the Chinese Mainland. Growing up in modern China, the post-80s has been characterized by its optimism for the future, newfound excitement for consumerism and entrepreneurship and acceptance of its historic role in transforming modern China into an economic power. There is also the similarly named post-90s and post-00s, referring to modern teenagers and college students. A broader generational classification would be the "one child generation" born between the introduction of the one-child policy in 1980 and its softening into a "two-child policy" in 2013. The lack of siblings has had profound psychological effects on this generation, such as egoism（利己主义,自我中心）due to always being at the centre of parents' attention as well as the stress of having to be the sole provider once the parents retire.

11.2 Video examples

- **Video 11-1:** *It's a photo from my life; how do you like it?*

... like my daughter, takes pictures of herself all day long. She just takes pictures, Instagram（照片墙，为Facebook公司旗下社交应用）photos. She takes photo for Snapchat（色拉布，是由斯坦福大学两位学生开发的一款"阅后即焚"照片分享应用），for Twitter（推特，是供人们互相发送短信息的社交网络）. And they're amazing. They're amazing, beautiful photos. But it's a little bit of obsession with getting feedback（反馈，评论）. That must be stressful for a kid to feel like you have to look good all day long and present it all the time. I mean, when I was a kid, I never really looked at myself. I just didn't think about it that much. I certainly wouldn't share photographs. I mean, in the 70s, if I took a photo, and mailed it to someone, they would think I was a lunatic（疯子，狂人）. They would be like, "What's this?" "It's just a photo from my life. How do you like it?"

This is an example of the generation gap, difference of ideas of about life style in the event of technology advances. The comedian compares posting photos on the internet apps of the younger generation to his generation sending photos to people in the old time by mail. With new technology and keyboards, newer generations no longer need these older communication skills, such as film cameras. As time goes on, technology is being introduced to individuals at younger and younger ages. With different forms of technology used, the largest gap was shown between texting and talking on the phone, i.e. phones are for communication in an entertaining way.

Between the father and daughter, as with most parent-child, there's also a digital divide. A digital divide does not so much exist in access to the devices or technology, as in the skills and digital literacy.

Millennials, also known as the Millennial Generation or Generation Y, are the demographic the early 1980s as starting birth years and ending birth years ranging from the mid-1990s to early 2000s. Generation Z, also known as the post-millennials, the iGeneration, is the cohort（一群，一帮）of people born after the millennials. Demographers and researchers typically use starting birth years ranging from the mid-1990s to early 2000s, while there is little consensus yet regarding ending birth years.

- **Video 11-2:** *I just mean I'm OK if you ever want to start dating again*

Daughter: Are you ever lonely?

Mother: What?

Daughter: Sorry, forget I even said anything.

Mother: No...no, that's fine. Go on.

Daughter: Okay, I just mean I'm OK if you ever want to start dating again.

Mother: Okay. Um, thank you. I...I just want you to know that whenever you decide to start dating, those boys better watch their back...What was that?

Daughter: What?

Mother: That! Oh my gosh, you like somebody.

Daughter: No.

Mother: Yes, you do. Tell me about him.

Daughter: Okay, yeah. Yeah, there's this guy and he's really handsome. And he's really nice. I...just...I don't think it's gonna go anywhere（我觉得不会有结果）.

Mother: No. Any handsome nice boy will be lucky to take you out.

Daughter: Well. If it does go somewhere, I promise you will be the first person I tell.

Mother: Before Toni（Antonia 的昵称，女子名，是此对话中女儿的好友）.

Daughter: Yeah, before Toni.

 In this scene, the girl and her mother understand and support each other by sharing each other's secrets. In this scene, the mother-daughter generation gap is bridged via putting herself into each other's shoes. In this relationship, the mother is a lonely housewife, and needs someone to understand her, at the same time, the daughter lives with the single mother. The concept of intergenerational living（不同代人一起生活）is put forward by Frey（2010）. "Both social isolation and loneliness in older men and women are associated with increased mortality, according to a 2012 Report by the National Academy of Sciences of the United States of America." Intergenerational living is one method being used currently worldwide as a means of combating such feelings.

 There are psychological and sociological dimensions in the sense of belonging and identity that can define a generation. Parents must be mindful that there are as many differences in

attitudes, values, behaviors, and lifestyles within a generation as between generations.

Intergenerationality（不同代之间互动）is interaction between members of different generations. Sociologists study many intergenerational issues, including equity（平等）, conflict, and mobility（流动性）.

Intergenerational equity is the concept or idea of fairness or justice in relationships between children, youth, adults and seniors, particularly in terms of treatment and interactions.

Intergenerational conflict is either a conflict situation between teenagers and adults or a more abstract conflict between two generations, which often involves all inclusive prejudices against another generation.

- **Video 11-3:** *Don't look at me. Look down*

Father: What's going on in there? I know you're not cleaning your room. What's going on? Why was the music so loud?

Daughter: Oh, I was just going second base with（来自棒球术语"上二垒"，这里指男女朋友关系的第二个阶段，即抚摸）my boyfriend. And I just didn't want you to hear.

Father: Of course you were. Listen, dinner is on the table.

Daughter: What's that supposed to mean?

Father: That I got take-out（外卖）on the way from work.

Daughter: No, no, no. You don't think I have a boyfriend, do you?

Father: Huh, I didn't say that, Jules.

Daughter: So you meant no.

Father: No. Honey, you know, I got a really long day. And I...I can't even have this conversation.

Daughter: Just tell me what you meant.

Father: Because you don't have a boyfriend. Because you never mentioned a boy. All right? And I've never seen you with a boy. Let's cross the boyfriend bridge（翻过这一页）and when we get to it...How? Why? Who? ...Don't look at me. Look down.

In this part, miscommunication and gap between the daughter and her father has accumulated to a level where the daughter thinks it's unbearable, so she pulls off this stunt to blow her father's mind in order to appeal to his attention that his daughter has grown up and he needs to change his view about her. Part of the reason is because father is too much buried in his work that he ignored his only family, the daughter's physical and mental health.

The discord (不和谐) between generations may sometimes be a "threat to stability" but at the same time they represent "the opportunity for social transformation". Amanda Grenier (2007) offers yet another source of explanation for why generational tensions exist. Grenier asserts that generations develop their own linguistic models that contribute to misunderstanding between age group.

Analyzing young people's experiences in place contributes to a deeper understanding. Being able to take a closer look at youth cultures and subcultures in different times and places adds an extra element to understanding the everyday lives of youth. This allows a better understanding of youth and the way generation and place play in their development.

- **Video 11-4:** *So Marty can stay?*

Father: Okay.

Daughter: You don't have to worry. When it comes to sex, Marty is the one who wants to wait.

Father: What about that sentence? Is it supposed to give me comfort?

Daughter: Dad, I love him.

Father: Honey.

Daughter: I love him.

Father: Oh.

Daughter: I love him. I love him. I love him.

Father: No, you don't.

Daughter: What we have is true love. And just because you don't have it, doesn't mean you have to punish us.

Father: Infatuation (一时的热恋,痴迷) is not love. Sexual attraction is not love.

Daughter: You don't understand.

Father: I don't understand.

Daughter: No, you don't even understand that you don't understand.

Father: What don't I understand? Cara? Please, help me out! What is it? Is it frustrating you can't be with this person? That…that there's something keeping you apart? That there's something about this person that you really connect with? Whenever you're near him, this person, and you don't know what to say. And you say

everything. It's in your mind, in your heart. And you know, that if you could just be together, that this person helps you become the best possible version of yourself.
Daughter: So Marty can stay?

In this scene, the young daughter is madly in love with a boy, but without the father's approval. So there is father's lecture about love, only to find that his words fall right into her heart. Actually, the father is also in love with another woman, so what he lectures about love is exactly how he thinks about love, and just what the daughter expects to hear.

Puppy love (早恋, also known as calf love), sometimes used in a derogatory (贬义的) fashion for its shallow and transient romantic feelings, is an informal term for feelings of love, romance, or infatuation, often felt by young people during their childhood and adolescence. It is named for its resemblance (相似) to the adoring, worshipful affection that may be felt by a puppy. It may also be able to describe short/long-term love interest.

Puppy love is a very widespread experience in the process of maturing. It may be difficult to not have cases of "puppy love" sometime during the maturing process. The object of attachment (依恋对象) may be a peer, but the term can also be used to describe the fondness of a child for an adult, for example, students being attracted to their teachers, their friends' parents, or children to older celebrities: indeed, some consider that in puppy love "usually the object of such infatuation is some highly idealized person who is some years older—a teacher, a friend of the family, an actor, or rock star"—and typically the sufferer is "greatly moved with emotion... spending much time in daydreams and wishful fantasies about them. When people have wishful fantasies about their love interest, they may have a fantasy about having their first kiss with them, or maybe have a fantasy about marrying them one day."

However, according to some scholars, puppy love gives young people a new sense of individualism. For the first time, they love someone outside their family. Others warn, however, that the old saying may be true: "If you marry on the strength of puppy love, you'll end up leading a dog's life."（如果仅凭幼犬那样的痴恋而结婚,婚后的日子会过得像狗一样）

Another term infatuation or crush（热恋,热恋的对象）is the first stage of a relationship before developing into a mature intimacy. Phillips describes how the illusions of infatuations inevitably lead to disappointment when learning the truth about a lover. It is an object of extravagant, short-lived passion or temporary love of an adolescent. The girl in this case is more close to this phenomenon.

- **Video 11-5:** *I don't want you guys to think anything different, I'm still me*

Son: Actually, uh, I DID want to talk to you guys about something.

Mother: What is it?

Son: Ah, well.

Father: Let me guess. You got somebody pregnant. No, you're pregnant. Ha, ha, ha, I knew it.

Son: Yeah, Yeah. I'm pregnant.

Father: I knew it. He's got that glow（脸上的红光、红晕）, by the way, baby.

Son: No...eh... I...I'm gay.

Mother: Honey.

Son: And I don't want you guys to think anything different. I'm still me. Ah.

Mother: Of course you are.

Father: Yeah.

Mother: Simon.

Father: So you're gay. Which one of your old girl friends has turned you? Was it the one with the big eyebrow? Or the one with the braces（牙箍）?

Daughter: Why don't you shut the hell up?

Father: I'm kidding! I'm kidding.

Daughter: It's not funny.

Father: Laura, just open up your gift. Please.

 This is a scene where generation gap could develop and fall into sexualism, if the parents don't approve homosexuality. When the son pours his heart to father about his coming out, the father obviously doesn't take it well. Behind the jokes and banters, there's disappointment and shock. The daughter, and the younger sister, in the scene is exceptionally premature and understanding, though.

 Coming out of the closet, or simply coming out, is a metaphor for LGBT people's self-disclosure of their sexual orientation or of their gender identity. The term coming out can also be used in various non-LGBT applications（e.g. atheists, 无神论者）.

 Coming out of the closet is the source of other gay slang expressions related to voluntary disclosure or lack thereof. LGBT people who have already revealed or no longer conceal their sexual orientation or gender identity are out, i.e. openly LGBT. Oppositely, LGBT people who have yet to come out or have opted not to do so are labeled as closeted or being in the closet. Outing is the deliberate or accidental disclosure of an LGBT person's sexual orientation or gender identity, without their consent. By extension, outing oneself is self-disclosure. Glass closet（不出柜的同性恋名人）means the open secret of when public figures' being LGBT is considered a widely accepted fact even though they have not officially come out.

 Being closeted or in the closet means being aware of one's lesbian, gay or bisexual orientation or true gender identity yet averse to（反对的, 厌恶的）revealing it because of

various personal or social motivations. It can also include denial or refusal to identify as LGBT. Overall, most reasons not to come out stem from homophobia, transphobia and heterosexism, which marginalize（使……边缘化）LGBT people as a group.

In the U.S., observed annually on October 11, by members of the LGBT communities and their straight allies（支持同性恋者享有平等权利的异性恋者同盟）, National Coming Out Day（全国出柜日）is a civil awareness day for coming out and discussing LGBT issues among the general populace in an effort to give a familiar face to the LGBT rights movement.

On a personal level, there are internal conflicts involving religious beliefs, upbringing, and internalized homophobia in addition to feelings of fear and isolation. Also, there are potential negative social, legal, and economic consequences such as disputes with family and peers, job discrimination, financial losses, violence, blackmail, legal actions, restrictions on having or adopting children, criminalization, or in some countries even capital punishment.

Given the number of unpleasant, harmful or even fatal consequences of coming out in world societies, it is questionable to call being closeted a bad choice. As a strategy, remaining closeted is the result of various goals to minimize potential loss and harm not just for average people but also for social figures such as entertainers, athletes, pastors and political leaders.

- **Video 11-6: *When you live in my house, you're a Taliban***

Daughter: Mom, dad's home.
Father: Hi, hon（honey的简称, 亲爱的, 宝贝儿）.
Mother: Hey, how was your day?
Father: Usual. Yours?
Mother: Good.
Daughter: Hey, love you. Bye.
Father: Whoa...whoa...whoa...wait a second! Wait a second! You're going out?
Daughter: Yeah, I'm going out.
Father: What...what are you wearing?
Daughter: Shorts（短裤）.
Father: Shorts? That's... that's a Maxi Pad（一种卫生巾品牌）.

Daughter: Dad, they're designer（由著名设计师设计的，名牌的）shorts. They're French. Huh, goodbye.

Father: Could you just come over here? Sit down for a second.

Daughter: I don't have time for this.

Father: Come here. Sit down.

Daughter: I'm late, and they're waiting for me.

Father: I know, but you're still living in my house for another few months. Okay?

Daughter: Yeah, I know.

Father: Now when you dress like that, you send signals. You know what kind of guy you attract like that? You attract a guy with the... with his pants around his ass at the mall.

Daughter: No, I don't!

Father: Yes. You do!

Mother: Sweetheart, he is right.

Father: Lacey, I'm saying you're beautiful. You're smart. You're a good person. You just got accepted into Stanford（斯坦福大学）.

Mother: We're so proud of you.

Father: I'm just saying...know your value. OK? And if a guy doesn't see that, he doesn't deserve you.

Mother: No, and you don't want to be with those guys, honey.

Daughter: OK, then I'll go change.

Father: Thank you. And could you change the picture on your Facebook page?

Daughter: Dad!

Father: It's just because we love you.

Daughter: Love me less!

Father: I don't want any bikini pictures on the Internet. When you live in my house, you're a Taliban（塔利班人，其妇女出门必须戴一种叫"布尔阁"的长面纱，从头到脚将身体包起来，只露出眼睛）. OK? Keep your body a secret, except you get to... you know, go to school...read books.

In this part, the daughter and her parents have vast difference in the ideas of fashion and dress. For the parents, girls' over-revealing dress is frowned upon not only in that it is an invitation of bad intentions and potential self-endangering from boys, but that it is self-devaluating and underselling of oneself.

It is also a parenting style on the parents' side, called helicopter parenting, in the way that parents are over protective of their children, sometimes helpful, sometimes annoying, yet always hovering over their children and making noise, just like a helicopter.

When the father goes to extreme by saying that "when you live in my house, you're a Taliban", the metaphor Taliban here refers to the women enforced strict Islamic laws and even

cruel treatment in the Islamic <u>fundamentalists</u>（宗教激进主义）terrorist group in Afghanistan.

11.3 Questions for discussion

1) How did you deal with generation gap in your family?
2) If there's any legacy in your family, what would it be and how do you value it?
3) Who is more important for educating a child, the family or the school?
4) How has technology changed the relationship between you and your parents and other people around you?
5) What's your parents' view about you having a relationship in college?

11.4 Debate

Generation gap can never be bridged.

11.5 Vocabulary exercises

perceive, predecessor, cohesive, proficiency, narcissistic, discrepancy, inflate, glow, egoism, averse to

Try and fill in the blanks of the following sentences with words listed above in proper forms.

1) Students must _____ for themselves the relationship between success and effort.
2) What are the reasons for the _____ between girls' and boys' academic performance in school?
3) We recognize that a good team acts not as a collection of individuals, but as a _____ unit.
4) He was insufferable at times—self-centered and _____.
5) The new leader wants to escape from the shadow of his _____.
6) The principal effect of the demand for new houses was to _____ prices.
7) The fresh air had brought a healthy _____ to her cheeks.
8) Human nature has both the characteristic of _____ and altruism.
9) Foreign language _____ is essential in today's survival skill package.
10) _____ others' comment on her pictures, she refuses to post them on the internet.

11.6 Role-play and reenactment

1) Please review Video 11-1, recite the comedy and feel the part of culture of parents' frustration in generation gap.

2) Please review Video 11-2, act out the dialogue and feel the part of mother-daughter culture.
3) Please review Video 11-3, act out the dialogue and feel the father-daughter gap.
4) Please review Video 11-4, act out the dialogue and feel the father's mood.
5) Please review Video 11-5, act out the dialogue and feel the part of generation gap between father and son.

RELIGION & RELIGIOUS
宗教生活

12.1 Cultural tidbits

The five largest religious groups by world population, estimated to account for 5.8 billion people and 84% of the population, are Christianity, Islam, Buddhism, Hinduism and traditional folk religion.

Christianity is based on the life and teachings of Jesus of Nazareth（拿撒勒人耶稣）as presented in the New Testament（《新约》）. The Christian faith is essentially faith in Jesus as the Christ, the Son of God, and as Savior and Lord. Almost all Christians（基督徒）believe in the Trinity（三位一体，即圣父、圣子、圣灵合成一神）, which teaches the unity of Father, Son（Jesus Christ）, and Holy Spirit as three persons in the Godhead. The main divisions of Christianity are: the Catholic Church（天主教）, Eastern Christianity（东正教）, Protestantism（新教）, as well as some smaller groups, such as Jehovah's Witnesses（耶和华见证人）, Anglicanism（英国国教，基督教圣公会的教义）, Baptists（浸礼会教友）, Calvinism（加尔文主义）, Methodism（基督教循道宗教义，循道公会）, and so on.

Islam is based on the Quran（《古兰经》或《可兰经》，为伊斯兰教经典）, one of the holy books considered by Muslims to be revealed by God, and on the teachings of the Islamic prophet Muhammad, a major political and religious figure of the 7th century. Islam is the most widely practiced religion of Southeast Asia, North Africa, Western Asia, and Central Asia. There are some other Asian religions. Hinduism has been called the oldest religion in the world, which contains a broad range of philosophies, practiced or founded in the Indian subcontinent（印度次大陆）. Taoism and Confucianism, as well as Korean, Vietnamese, and Japanese religion are influenced by Chinese thought.

Western culture, throughout most of its history, has been nearly equivalent to Christian culture, and a large portion of the population of the Western hemisphere can be described as cultural Christians. Christianity has had a significant impact on education as the church created the bases of the Western system of education, and was the sponsor of founding universities in the Western world.

Christians assemble for communal worship on Sunday, the day of the resurrection（耶稣复活）. Scripture readings are drawn from the Old and New Testaments. Bible is a collection of

sacred texts or scriptures that Jews and Christians consider to be a product of divine inspiration and a record of the relationship between God and humans. Christian Old Testament overlaps with the Hebrew Bible; The New Testament is a collection of writings by early Christians, believed to be mostly Jewish disciples(信徒,门徒) of Christ, written in first-century. Bible is held to reflect true unfolding revelation(启示,神示内容) from God.

Religion in the United States is characterized by a diversity of religious beliefs and practices. Various religious faiths have flourished within the United States. A majority of Americans report that religion plays a very important role in their lives, a proportion unique among developed countries.

The majority of Americans identify themselves as Christians, while close to a quarter claims no religious affiliation. According to a 2014 study by the Pew Research Center, 70.6% of the American population identified themselves as Christians, with 46.5% professing attendance at a variety of churches that could be considered Protestants(新教徒,指不受天主教或东正教控制的其他任何基督教徒), and 20.8% professing Roman Catholic beliefs. The same study says that other religions (including Judaism, Buddhism, Hinduism, and Islam) collectively make up about 6% of the population. According to a 2016 Gallup poll(盖洛普民意测验), Mississippi with 63% of its population described as very religious (say that religion is important to them and attend religious services almost every week) is the most religious state in the country, while New Hampshire with only 20% as very religious.

(The Salt Lake Temple in Salt Lake City, Utah)

After Christianity, Judaism(犹太教) is the next largest religious affiliation in the US, though this identification is not necessarily indicative of religious beliefs or practices. There are between 5.3 and 6.6 million Jews. A significant number of people identify themselves as American Jews on ethnic and cultural grounds, rather than religious ones. Islam is the third largest faith in the United States, after Christianity and Judaism, representing 0.9% of the population. There are also Asian religions including Buddhism(佛教), Hinduism(印度教),

Taoism（道教）, etc. There are also atheists, agnostics（不可知论者）, deists（自然神论者，理神论者）and humanists（人文主义者）, and people who describe their religion as "nothing in particular".

"Spiritual but not religious"（SBNR）is a popular phrase used to self-identify a life stance of spirituality that takes issue with organized religion as the sole or most valuable means of furthering spiritual growth. Spirituality places an emphasis upon the well-being of the "mind-body-spirit", so "holistic"（整体疗法的）activities such as tai chi（太极）, reiki（灵气疗法, 其理论是治疗专家能用触摸的方法将能量导入病人体内, 从而激活病人机体的自然康复过程, 并恢复其肉体和感情的健康）, and yoga（瑜伽）are common within the SBNR movement. In contrast to religion, spirituality has often been associated with the interior life of the individual.

Even though politicians frequently discuss their religion when campaigning, ending with "God bless America!" and there are religious slogans and inscriptions in court and public offices like "In God We Trust", the First Amendment（美国宪法《第一修正案》, 主要保障言论、宗教自由及和平集会的权利）guarantees both the free practice of religion and the non-establishment of religion by the federal government.

Historically Catholics were heavily Democratic before the 1970s, while mainline Protestants comprised the core of the Republican Party. Joe Biden is the first Catholic vice president. A Gallup poll released in 2007 indicated that 53% of Americans would refuse to vote for an atheist as president, up from 48% in 1987 and 1999.

(The Palace of Westminster, the seat of the Parliament of the United Kingdom)

In England, according to the 2011 census, 59.4% of the population is Christian, 24.7% non-religious, 5% Muslim, while 3.7% of the population belongs to other religions. Christianity is the most widely practiced religion in England, as it has been since the Early Middle Ages.

The 2nd-largest Christian practice is the Catholic Church, and a form of Protestantism known as Methodism is the third largest Christian practice. Since the 1950s, religions from the former British colonies have grown in numbers, due to immigration. Islam is the most common of these, now accounting for around 5% of the population in England. Hinduism, Sikhism（锡克教）and Buddhism are next in number, adding up to 2.8% combined introduced from India and South East Asia.

(Canterbury Cathedral, Canterbury, England)

The Church of England is the <u>state church</u> （或 established church，国教，即经国家法律认可并获得经济上支持的官方教会）of England. The <u>Archbishop of Canterbury</u>（坎特伯雷大主教，或称坎特伯雷圣座，是全英国教会的主教长，又是全世界圣公会的主教长、普世圣公宗精神领袖）is the most senior cleric, although the <u>monarch</u>（君主）is the supreme governor. The Church of England is also the mother church of the international Anglican Communion.

12.2 Video examples

- **Video 12-1:** *Do for others only what you would have others do for you*

Blessed are you poor—for yours is the Kingdom of God. Blessed are you who hunger now—for you shall be filled. Blessed are you who weep now—for you shall laugh. Blessed are you when men hate you and reject you and insult you and say you are evil, all because of the <u>Son of Man</u>（人子，耶稣基督自称）. Be glad when that happens and dance for joy, because a great reward is kept for you in heaven—for their ancestors did the very same things to the <u>prophets</u>（先知，神的代言者）. *How terrible for you* who are rich now—you have had your easy life. *How terrible for you* who laugh now—for you shall mourn and weep. *How terrible when* all men speak well of you—for their ancestors said the very same things about the false prophets. But I tell you who hear me: Love your enemies. Do good to those who hate you. Bless those who curse you. Pray for those who mistreat you. <u>If anyone strikes you on the one cheek, let him hit the other one also.</u> And if someone takes away your coat, let him have your shirt as well. Give to everyone who begs from you. *And if someone* takes what is yours, do not ask for it back again. <u>Do for others only what you would have others do for you.</u> If you love only

the people who love you, why should you receive a blessing—for even sinners（宗教、道德上的罪人）love those who love them. And if you do good to those who do good to you, why should you receive a blessing—even sinners do that. No, love your enemies and do good to them. And lend expecting nothing back. And then you will have a great reward—for you will be sons of the Most High God. For He is good to the ungrateful and to the wicked（邪恶的）. Be merciful just as your Father is merciful. Judge not and you will not be judged. Condemn（谴责）not and you will not be condemned. Forgive and you will be forgiven. Give and it will be given to you—for the measure you give will be the measure you get back. One blind man cannot lead another. If he does, they will both fall into a ditch（沟，渠）.

This part is one of the most famous sermons in Christianity, i.e., the Sermon on the Plain（平原训众，也称"平原垂训""平原宝训"，为耶稣的训诲性言论集）refers to a set of teachings by Jesus. Luke（《路加福音》，为《圣经·新约》中的一卷）details the events leading to the sermon. In it, Jesus spent the night on the mountain praying to God. Two days later, he gathered his disciples and selected 12 of them, whom he named Apostles. On the way down from the mountain, he stood at "a level place" where a throng of people had gathered. After curing those with "unclean spirits", Jesus began what is now called the Sermon on the Plain. Notable messages in the Sermon include:

Love your enemies and turn the other cheek.

Treat others the way you want to be treated.

Don't judge and you won't be judged; don't condemn and you won't be condemned; forgive and you will be forgiven; give and you will receive.

The central meaning is to love all, including your enemies; to suffer all, and take it as a blessing. There are the striking parallel structures and balanced sentences from the speech:

Blessed are you poor...Blessed are you when....

How terrible for you who... How terrible for you who... How terrible for you when...

If anyone... And if someone...

All these sentences are quoted all the time in the daily life of the western world, especially those who believe in Christianity.

- **Video 12-2: *Prosperity enables us to do the right thing***

The principles (准则) of the Republican Party more closely parallel (与……一致) the moral vision of the God of Abraham (《圣经》中对上帝的称呼之一) than anyone else. So the question: Does God want people to be... liquid? The answer is yes. The answer is yes. Prosperity enables us to do the right thing, to be able to help our fellow men, to be stewards (管家, 管理员) of civilization. In Biblical times, taxes never rose above 20%, which is a lesson we could learn today. Ladies and gentlemen, the Republican Party (美国共和党) lights the way for America, and may I say, the rest of the globe.

This is a speech made by a candidate running for a seat in the congress as a representative for the Republican Party. The ideas in this speech go in accordance with the Puritanism in America, when their favorite slogan is: work hard to make money, save money and then donate it. Another famous quote is: To prove how faithful you believe in God, show him how much wealth you have achieved.

The Republican Party's current ideology is American conservatism, which contrasts with the Democrats' more progressive platform (also called modern liberalism). Further, its platform involves support for free market capitalism, free enterprise, fiscal conservatism, a strong national defense, deregulation, and restrictions on labor unions. In addition to advocating for conservative economic policies, the Republican Party is socially conservative, and seeks to uphold traditional values based largely on Judeo-Christian (犹太教与基督教共有的) ethics.

Modern Republicans advocate the theory of supply side economics, which holds that lower tax rates increase economic growth. Many Republicans oppose higher tax rates for higher earners, which they believe are unfairly targeted at those who create jobs and wealth. They believe private spending is more efficient than government spending.

Republicans strongly believe that free markets and individual achievement are the primary factors behind economic prosperity. To this end, they advocate in favor of fiscal conservatism, and the elimination of government run welfare programs in favor of private sector nonprofits and encouraging personal responsibility.

- **Video 12-3: *...and in fear of God***

...Dearly beloved, we are gathered together here in the sight of God and in the face of this congregation, to join together this man and this woman in holy matrimony（婚礼）, which is an honorable estate（状况，阶段，条件）instituted（建立，制定）of God in time of man's innocency（清白，单纯，无知）, signifying（标志着）unto us the mystical union, that is betwixt（＝between）Christ and His church, therefore, is not by any to be enterprised（买卖）, nor to taken in hand unadvisedly（不谨慎地，鲁莽地，不明智地）, lightly（轻率地，轻浮地，轻佻地）, or wantonly（不负责任地，莽撞地）, but reverently（恭敬地，虔敬地）, discreetly（谨慎地，慎重地）, and advisedly（深思熟虑地）, soberly（严肃地，持重地）, and in the fear of God; therefore, if any man can show any just cause why they may not be lawfully joined together, let him speak now, or else, hereafter, forever hold his peace.

A church wedding is a ceremony presided over by a Christian priest or pastor. Ceremonies are based on reference to God, and are frequently embodied into other church ceremonies such as Mass. Most Christian churches give some form of blessing to a marriage; the wedding ceremony typically includes some sort of pledge by the community to support the couple's relationship.

In this scene, the priest presides the wedding ceremony in a church, and begins with the Christian routine which is in line with the bible: Since the ancient times in Christian world, marriage has been set forth as a sacred obligation between a man and a woman. According to Mathew 19:5（《马太福音》第19章第5节）, "Therefore a man shall leave his father and his mother and hold fast to his wife, and the two shall become one flesh."

At traditional Chinese weddings, the tea ceremony is the equivalent of an exchange of vows at a Western wedding ceremony. This ritual is still practiced widely among rural Chinese, however young people in larger cities tend to practice a combination of Western style of marriage together with the Tea Ceremony.

Tea Ceremony is an official ritual to introduce the newlyweds to each other's family, and it's a way for newlyweds to show respect and appreciation to their parents. The newlyweds kneel in front of their parents, serving tea to both sides of parents, as well as elder close relatives. Parents give their words of blessing and gifts to the newlyweds.

- **Video 12-4:** *We also pray for peace in the world, and in our lives. Amen*

Brother: Duke, Why don't you lead us in prayer?

Duke: OK, everybody join hands. Let's bow our heads. Heavenly Father, we come to you on bent knee, body bowed, as humble as we know how. We're grateful for this opportunity to share another Thanksgiving Day as a family. We thank you for our health, O Lord, for our friends, who honor us with their presence. We also pray for peace in the world, and in our lives. Amen.

All: Amen.

In this scene, there's a prayer before Thanksgiving Day dinner. Prayer before dinner (a common practice in a religious family) as a ritual is giving thanks to God, an act of religious observance or a celebration in acknowledgment of divine favors.

Thanksgiving Day is a national holiday mainly celebrated in Canada, the United States. It began as a day of giving thanks for the blessing of the harvest and of the preceding year. Thanksgiving is celebrated on the second Monday of October in Canada and on the fourth Thursday of November in the United States, and around the same part of the year in other places. Although Thanksgiving has historical roots in religious and cultural traditions, it has long been celebrated as a <u>secular</u>(世俗的,非宗教的) holiday as well.

- **Video 12-5: *With kind words, and loving deeds. Amen***

Let's bow our heads, dear heavenly father, we thank thee for thy food. Feed our souls on the bread of life. And help us to do our part, with kind words, and loving deeds. Amen.

This is a short prayer, and a common one. In normal day to day life, thanksgiving prayers are also arranged at the dinner table, the prayer is about thanks to God for the food, the healthy family, friendship and so on. There are two ways of expressing it: to say prayer or to say grace, both meaning a ritualized activity at a family dinner gathering table. To say a prayer before a meal, typically to give thanks for or ask for God's blessing on the food one is about to eat. But if you're an atheist, it always feels a little awkward when you are asked to join together with the family and say grace before dinner, the same way you feel when you implicate or refer to God in a conversation to a non-religious foreign person, who will probably respond to you, "Sorry, I don't believe in God". Or "I'm not religious".

- **Video 12-6: *Let us pray today, for the strength, the grace and the love to forgive***

 I'd like to read to you this morning, from <u>Galatians</u>(《加拉太书》,为《圣经·新约》中的一卷)3, Verse 13. <u>Bear with</u>(容忍)each other, and forgive one another, if any of you has <u>grievance</u>(委屈,怨愤)against someone. Forgive as the Lord forgave you. You know in the Old Testament, when the <u>Israelites</u>(古以色列人,《圣经》中的希伯来人、以色列人)in God's <u>covenant</u>(契约), people would displease him. He would send punishments, famine, plague, <u>hordes of locusts</u>(成群的蝗虫), to drive the people back to living like the way he wanted them to live. But it wouldn't last. Sooner or later, they <u>gave in to temptation</u>(屈从于诱惑)and sin again. Of course, God could have forced his will on the Israelites; forced them to live on the <u>path of righteousness</u>(正义之路). But from the beginning, God has always wanted loving disciples serving their own free will, not mindless slaves, so he sent a savior for them, for all of us. He sent his son, Jesus Christ. In the New Testament, Christ teaches us through his example, and his words, compassion, acceptance, forgiveness. We learned that we are forgiven through God's love. And we're expected to forgive others through our love for our fellow men. Sometimes it's tough. It's easy to love those who're good to us, right? But the folks that are not so good to us, not so much. Love your enemies enough to forgive them. Bring us close to living our lives the way God wants us to live them, the way Jesus lived his life in any other thing that Christians can do. Let us pray today, for the strength, the grace and the love to forgive.

 This is a sermon on God's love and punishment to his people delivered by a clergy as a part of church service. A sermon is an oration, lecture, or talk by a religious institution or a clergy, usually expounding on a type of belief, law or behavior within both past and present contexts. The sermon has been an important part of Christian services since Early Christianity, and remains prominent in both Roman Catholicism and Protestantism. Sermons also differ in the amount of time and effort used to prepare them. And the delivery methods also differ in the following ways:

 <u>Extemporaneous</u>(经过准备但不用讲稿的或不是背熟的)preaching—preaching without overly detailed notes and sometimes without preparation. Usually a basic outline and scriptural references are listed as notes.

Impromptu（事先无准备的，即兴的）*preaching*—*preaching without previous preparation.*
Scripted preaching—*preaching with previous preparation. It can be with help of notes or a script, or rely on the memory of the preacher.*

In the sense of the first two ways, we can say sermon is an unprepared speech.

- **Video 12-7: *Consider it pure joy whenever you face trials of many kinds***

Good morning, church. (Good morning) Listen, if you have your bibles, say, "Got it." (Got it) Good. James（《雅各书》，为《圣经·新约》中的一卷）Chapter One. This is what the Bible says, "Consider it pure joy whenever you face <u>trials</u>（麻烦，痛苦，考验）of many kinds, knowing that the trying of your faith, the testing of your faith develops <u>perseverance</u>（毅力）in your life." And we should allow perseverance to have their work in our life, because God uses that to complete us and to mature us. And I'm looking at a family here this morning when went through a severe trial, <u>a beast of</u>（恶劣，粗野）a trial. The Leon family, and you know, remember, we all prayed for them, and we asked God to do a miracle, and God did answer our prayers, and Vanessa woke up from her <u>coma</u>（昏迷）. And I tell you, I just want to thank God. To God be the glory. Amen. (Yes!) Hallelujah. To God be the glory.

Now finally the Bible says this that today is the day of <u>salvation</u>（拯救）, that now is the acceptable time to receive the Lord Jesus Christ as our savior. And I'm just going to <u>open up</u>（敞开胸怀）. I'd just like you to all stand up with me, and I really sense that there may be someone here today that would like to come forward and kneel before us and say, "Yes, I'm going to open my life up to the Lord Jesus Christ. I'm confessing Jesus as my Lord today." Anyone want to come, kneel before us and open their life before the Lord?

This is another example of preaching God's trial and salvation of his people. According to the routine preaching, God's punishment is how he shows love to his people and a way to salvage them. In most <u>denominations</u>（教派，宗派）, modern preaching is kept below forty minutes, but historic preachers of all denominations could at times speak for several hours, and use techniques of rhetoric and <u>theatre</u>（戏剧效果，表现手法）that are today somewhat out of fashion in mainline churches. This is why sermon has a negative meaning, i.e. an often lengthy and tedious speech, or an oratorical type of <u>didactic</u>（说教的，学究气的）work presenting ethical demands and compelling the listener to emotionally accept these demands. Hence the English idiom: practice what you preach（以身作则）.

12.3 Questions for discussion

1) Have you seen a religious person around you?
2) Do you agree that money is the root of all evil?
3) Have you visited any religious places or places of worship?
4) What religion in China impresses you the most?
5) Can you give an example where Chinese philosophy meets religion?

12.4 Debate

Money pursuit and moral pursuit can go hand in hand.

12.5 Vocabulary exercises

revelation, condemn, principle, parallel, soberly, discreetly, give in to, perseverance, salvation, preach

Try and fill in the blanks of the following sentences with words listed above in proper forms.

1) The _____ of his past lead to his resignation.
2) He said he was trying to _____ peace and tolerance to his people, but he was booed by the audience.
3) We must be _____ aware that there is still a long way ahead of us.
4) He refused to _____ bullying and threats.
5) To be a champion of women's rights requires great courage and _____
6) The country's _____ lies in forcing through democratic reforms.
7) I took the phone, and she went _____ into the living room
8) A railway and a highway run _____ in this city.
9) Political leaders united yesterday to _____ the latest wave of violence.
10) There is one exception to this general _____.

12.6 Role-play and reenactment

1) Please review Video 12-2, act out the speech and feel the part of political campaign culture.
2) Please review Video 12-3, recite the words by the priest and feel the part of wedding ceremony culture in a church.
3) Please review Video 12-4, understand the words and act out the prayer.

4) Please review Video 12-5, act out the prayer and feel the thanksgiving culture.

5) Please review Video 12-6, recite the preaching and feel the part of bible culture.

RACISM & STEREOTYPING
种族偏见

13.1 Cultural tidbits

Racism is defined as discrimination and prejudice towards people based on their race or ethnicity. Today, the use of the term "racism" does not easily fall under a single definition. Racism and racial discrimination are often used to describe discrimination on an ethnic or cultural basis. Racist ideology can become manifest in many aspects of social life. Racism can be present in social actions, practices, or political systems that support the expression of prejudice or aversion（嫌恶）in discriminatory practices. Associated social actions may include nativism（排斥外来文化的本土文化保护主义）, xenophobia（对外国人或域外事物的恐惧或憎恶）, otherness（非同类）, segregation（隔离）, hierarchical ranking（等级排序）, supremacism（至上主义,尤指种族和性别方面）, and related social phenomena.

In the US earlier violent and aggressive forms of racism have evolved into a more subtle form of prejudice in the late 20th century. This new form of racism is sometimes referred to as "modern racism" and characterized by outwardly acting unprejudiced while inwardly maintaining prejudiced attitudes, displaying subtle prejudiced behaviors such as actions informed by attributing qualities to others based on racial stereotypes, and evaluating the same behavior differently based on the race of the person being evaluated. There is widespread racial discrimination in workplace, job offs, housing, product markets, labor markets, car sales, home insurance applications, provision of medical care, rental apartment market and even hailing taxis（叫出租车）.

There's another trend called reverse discrimination（反向歧视）. Reverse discrimination is discrimination against members of a dominant or majority group in favor of members of a minority or historically disadvantaged group. Political correctness（政治正确）sped up this trend, which is avoidance of expressions or actions that can be perceived to exclude or marginalize（边缘化）or insult people who are socially disadvantaged or discriminated against. A 2016 poll found that 38％ of Americans thought whites faced a lot of discrimination. There is evidence that whites believe they're the victims of discrimination to prove their own self-esteem in response to racial progress.

White supremacy（白人至上论）or white supremacism is a racist ideology based upon the belief that white people are superior in many ways to people of other races and that therefore

white people should be dominant over other races. In Donald Trump administration, racial divide has been enlarged sharply and at the same time white supremacy gone rampant unprecedentedly(空前的).

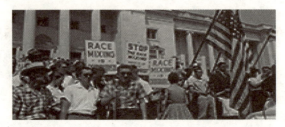

(A rally against school integration in 1959)

In social psychology, a stereotype(成见,刻板印象) is any thought widely adopted about specific types of individuals or certain ways of behaving intended to represent the entire group of those individuals or behaviors as a whole, for example, Asians are bad drivers, Chinese know Kung fu; Mexicans do dirty jobs, etc. These thoughts or beliefs may or may not accurately reflect reality. Stereotypes can be efficient shortcuts and sense-making tools. They can, however, keep people from processing new or unexpected information about each individual, thus biasing(偏见) the impression formation process.

Similarly, experiments suggest that gender and racial stereotypes play an important role in judgments that affect hiring decisions. Because stereotypes simplify and justify social reality, they have potentially powerful effects on how people perceive and treat one another. As a result, stereotypes can lead to discrimination in labor markets and other domains(领域). Some specific stereotypes loom large in many labor markets.

Stereotypes can affect self-evaluations and lead to self-stereotyping(自我刻板化). People's self-stereotyping can increase or decrease depending on whether close others view them in stereotype-consistent or inconsistent manner. Stereotyping can also play a central role in depression, when people have negative self-stereotypes about themselves. This depression that is caused by prejudice can be related to a group membership. If someone holds prejudicial beliefs about a stigmatized(侮辱,污蔑) group and then becomes a member of that group, they may internalize(使内在化) their prejudice and develop depression. People may also show prejudice internalization through self-stereotyping because of negative childhood experiences such as verbal and physical abuse.

Stereotype threat occurs when people are aware of a negative stereotype about their social group and experience anxiety or concern that they might confirm the stereotype. Stereotype threat has been shown to undermine(暗中破坏,逐渐损害或削弱) performance in a variety of domains.

Self-fulfilling prophecy(自我实现的预言) happens when stereotypes lead people to expect certain actions from members of social groups. These stereotype-based expectations may

lead to self-fulfilling prophecies, in which one's inaccurate expectations about a person's behavior, through social interaction, prompts that person to act in stereotype-consistent ways, thus confirming one's erroneous（错误的）expectations and validating（证实）the stereotype.

Some contemporary studies indicate that racial, ethnic and cultural stereotypes are still widespread in Hollywood blockbuster（流行大片，畅销巨著）movies. Portrayals of Latin Americans in film and print media are restricted to a narrow set of characters. Latin Americans are largely depicted as sexualized figures such as the Latino macho（壮汉）or the Latina vixen（悍妇）, gang members, (illegal) immigrants, or entertainers. By comparison, they are rarely portrayed as working professionals, business leaders or politicians. Stereotypes are also common in video games, with women being portrayed as stereotypes such as the "damsel in distress（落难女子）" or as sexual objects. Black men are portrayed most often in stereotypical roles such as athletes and gangsters. And also in literature and art, stereotypes are clichéd（陈腐的，老套的）or predictable characters or situations.

13.2 Video examples

- **Video 13-1: *We don't shut down for anything!***

Everyone knows a threatening government shutdown（停业，关门）. Government shutdown? Yo, there is no government shutdown with Asian people in charge. We don't shut down for anything! Yo, we don't shut down for Christmas! Do you understand? We work through public holidays. Any city in America, when at 3 am, and you're hungry, where do you go? You go to Chinatown! That's where you go, because things are affordable, delicious and open. Does that sound like a country where I'm living? We don't shut down for anything. Thanksgiving? Means nothing to me. Do you have any idea how meaningless the concept of thanksgiving is to me? F-turkey（火鸡）. It's dry!

In this comedy performance, Ronny Chan thinks Americans should have an Asian president. He defends himself for the following reasons: Asians don't have holidays; they're fair and square; they don't take sides in American racial conflicts, and most importantly, they work 24 hours and don't complain. And the food is affordable, delicious and they're always open. This is the stereotype they have for Chinese and other Asians in America.

Areas known as "Chinatown" exist throughout the world, including the Americas, Europe, Africa, Australasia, Southeast Asia, and East Asia. The Chinatown in San Francisco is one of the largest and the oldest in North America. Most Chinatowns are centered on food, and as a result Chinatowns worldwide are usually popular destinations for various ethnic Chinese and other Asian cuisines such as Vietnamese, Thai, and Malaysian. Some Chinatowns, such as in Singapore, have developed their own localized style of Chinese <u>cuisine</u>（烹饪，烹饪术，烹调法）. In many Chinatowns, there are now many large, authentic Cantonese seafood restaurants, restaurants specializing in other varieties of Chinese cuisine such as <u>Hakka</u>（客家）cuisine, Szechuan cuisine, Shanghai cuisine, and small restaurants with <u>delicatessen</u>（熟食）foods.

- **Video 13-2: *You don't actually have any work experience?***

Interviewer: You don't actually have any work experience?

Sasha: No, but I just graduated from <u>Fordham</u>（Fordham University，福特汉姆大学）

Interviewer: How long ago?

Sasha: About a year ago.

Interviewer: So what have you been doing since?

Sasha: I've been working on my own collection, which takes a lot of my time.

Interviewer: What about <u>internships</u>（实习岗位，实习期）?

Sasha: Isn't that just the way for companies to <u>exploit</u>（剥削）people for free labor?

Interviewer: So how do you expect to get any experience?

Sasha: By getting a job?

Interviewer: How do you support yourself, exactly?

Sasha: My dad helps a little. A lot...

Interviewer: Hmm, well, thanks for coming in. Err, we'll be in touch after we've reviewed all the candidates.

Sasha: OK, thank you. Um, I'm not getting this job, am I?

Interviewer: Excuse me?

Sasha: This is my 6th interview this month. Everyone says they'll get in touch, but they never do. Look, I know I don't have any work experience, but how am I supposed to get any experience if I can't get hired? All I need is a chance. I have great ideas! I can bring

so much to your brand.

Interviewer: Look, your drawings aren't bad. That's what got you in here. But you think you could waltz（大摇大摆地走）out of fashion school and get a job in designing. Girls intern for years just to get an assistant job. Daddy may have paid your way through school, but out here in the real world, you have to work your way up（自己往上爬）.

Sasha: So I guess you won't be getting in touch.

Interviewer: Good luck, Sasha.

In this unsuccessful interview for Sasha, she is declined again for almost the same reason every time as before, that is, she has no experience. But according to her, if she hasn't been hired once, how can she have any experience? It sounds like a simple paradox to her, but in the eyes of the interviewer, she's just a spoiled rich girl, without awareness of hardship of the real world and how other people have been through to get successful. Again, in the perspective of the interviewer, Sasha is not just a spoiled rich girl, but a spoiled rich Asian girl.

Generally, just as the girl says about internship being exploitation of free labor (a little on the extreme note), an internship consists of an exchange of services for experience between the student and an organization. Students can also use an internship to determine if they have an interest in a particular career, to create a network of contacts, to acquire a recommendation letter to add to their curriculum vitae（缩写为CV，简历）, or to gain school credit. Some interns find permanent, paid employment with the organizations for which they worked upon completion of the internship. This can be a significant benefit to the employer as experienced interns often need little or no training when they begin regular employment. It also helps an employer in gauging（估计，判定）a student's aptitude, since grade inflation（分数贬值）has undermined the reliability of academic grades. Unlike a trainee program, employment at the completion of an internship is not guaranteed. In the United States, many internships are career specific. Students often choose internships based on their major at the university or college level. It is not uncommon for former interns to acquire full-time employment at an organization once they have enough necessary experience. The challenging job market has made it essential for college students to gain real world experience prior to graduation.

In the United Kingdom, work experience is offered as part of the national curriculum to secondary school students in years 10 and 11 (14 to 16 years of age.) Generally, these placements are unpaid. During their degree program, students may apply for internships during the summer holidays. University staff give students access, and students apply direct to employers. Some students opt to（选择，做出抉择）apply for year-long placements, often referred to as "sandwich placements"（三明治实习）, between the penultimate（倒数第二的）

and final year of their degree. This is done as part of a degree program. Some universities and employers hold fairs and exhibitions to encourage students to consider the option and to enable students to meet potential employers. In the modern labor market, graduates with internship work experience are deemed more desirable to employers.

Internship positions in China generally follow the academic calendar, starting in late summer and finishing in late spring. There is a growing trend for overseas students (particularly those from Australia, the UK, and the US) to compete for increasing internship opportunities available in China. It is common for overseas students to use the services of (for-profit) China-based internship providers to secure their internship.

- **Video 13-3: *Your English accent is so good!***

So after two nights completely jet-lagged (有时差反应的), I went down to the reception, trying to ask what time breakfast was, 'cause I couldn't stay up so I might as well eat something, so I went down to reception. This Chinese woman at the reception thought I was Chinese. I'm like, "Excuse me, what time is breakfast?" She starts to speak Chinese to me. I don't speak Chinese, so I have no idea what she was saying. She went straight, "…" and I said, "I'm not Chinese. I'm just jet-lagged. What time is breakfast?" She starts to laugh at me, "hahaha…" I'm like, "Seriously, I'm not Chinese. Speak English to me!" And she just went, "Your English accent is just so good!" "Because I've lived there for 38 years." And she went, "Welcome home!" True story!

In this comedy show, the laughable point is how the speaker looks like an Asian, or more specifically, Chinese. This makes the audience all share the same empathy and laugh at it. Early studies suggested that stereotypes were only used by rigid, repressed, and authoritarian people. This idea has been refuted by contemporary studies that suggest the ubiquity (普遍存在,无所不在) of stereotypes and it was suggested to regard stereotypes as collective group beliefs, meaning that people who belong to the same social group share the same set of stereotypes. Modern research asserts that full understanding of stereotypes requires considering them from two complementary perspectives: as shared within a particular culture/subculture and as formed in the mind of an individual person.

- **Video 13-4:** *Because we have real things to protest at the time.*

Now, the thing is, why are we protesting? That's it, the big question is, why this Oscars? Why this Oscars? You know. It's the 88th Academy Award. It's the 88th Academy Award, which means this whole no-black-nominee thing has happened at least 71 other times. Okay? You gotta figure that it happened in the 50s and 60s. You know, in the 60s, one of those years when <u>Sidney</u>（指美国著名黑人演员 Sidney Pottier）didn't put out a movie, I'm sure there were no black nominees some of those years, say, 62, 63, and black people did not protest. Why? Because we have real things to protest at the time. You know? We have real things to protest. You know, too busy being raped and <u>lynched</u>（私刑）to care about who won <u>Best Cinematography</u>（最佳摄影奖）. You know, when your grandmother was <u>swinging</u>（吊死）from a tree, it's really hard to care about <u>Best Documentary Foreign Short</u>（最佳外语纪录短片）. But what happened this year? What happened? People went mad! You know, <u>Spike</u>（指著名黑人导演 Spike Lee）got mad, <u>Sharpton</u>（指美国黑人人权领袖 Al Sharpton）got mad, and <u>Jada</u>（指美国黑人女星 Jada Koren Pinkett-Smith,是 Will Smith 的妻子）went mad, and <u>Will</u>（指美国黑人演员 Will Smith）went mad. Everybody went mad. You know. It's quite like…Jada got mad. Jada said she's not coming. Protesting. I'm like, "Isn't she on the TV show?" Jada was gonna <u>boycott</u>（抵制）the Oscars. Jada boycotting the Oscar is like me boycotting Rihanna's（蕾哈娜,为美国女黑人流行歌手）<u>panties</u>（内裤）. I wasn't invited! Ho, ho…O, that's not an invitation I would <u>turn down</u>（拒绝）.

This is 88th Oscars opening, with host Chris Rock cracking jokes about black actors boycotting this Oscars. There are two supporting details to expand his idea why we should not care too much about this matter this year: first is that it is not the first time that happened in history; second, those who joined the boycott neither really matter much nor have sound reasons to do so. For the first reason, the host reveals the part of the tragic history in America. Even though the massive Civil Rights Movement in the 1960s achieved some results, one <u>monolithic</u>（坚如磐石的,庞大的,大一统的）document is the <u>Civil Rights Act</u>（《人权法案》）of 1964, signed by President Johnson, banned discrimination based on "race, color, religion, sex or national origin" in employment practices and public accommodations. Racism has never stopped and still going on in various aspects in America.

The <u>Academy Awards</u>（学院奖）, now officially known as the Oscars, are a set of awards given annually for excellence of cinematic achievements. The <u>Oscar statuette</u>（奥斯卡小金人）is officially named the Academy Award of Merit. Organized and overseen by the <u>Academy of Motion Picture Arts and Sciences</u>（美国电影艺术与科学学院）, the awards are given each year at a formal ceremony. The awards themselves were later initiated by the Academy as awards "of merit for distinctive achievement" in the industry.

- **Video 13-5**: *Jimmy, do you have a cancer?*

I know I make fun of my parents, but at the end, I love them very much. I think we all do, right? But Asian people, we don't ever say "I love you" to each other. That's just not our thing. One time I <u>got high</u>（因酒精或毒品而极度兴奋的）and I called my mom. I was like, "Mom, I just want to tell you mom, I love you!" and you can hear she started like crying on the other side of the line, "Oh, Jimmy, do you have a cancer?"

We just got different ways of showing love. Like when I see my grandmother, I don't give her a hug; I just give her a <u>solid</u>（结实的）handshake. We're not bothered about hugging. Asian grandmothers are the best. You give her a handshake; she is like a <u>vending machine</u>（自动售货机）. You give her a handshake, out comes a <u>red envelope</u>（红包）. And you gotta pretend you don't want that sh-. You're like, "No, no, no….please, please, okay, thank you." That's just how we show love.

My dad still calls me like 20 times a day, just to check up on me. It's annoying, but I understand that's just how he shows his love. I was talking to my friend here, and he was like, "Oh, I haven't…I haven't talked to my dad in 3 weeks." I'm like, "What? Is he in jail?" He was like, "No, I live with him. I just haven't talked with him for 3 weeks." I'm like, "You do understand if I don't call my dad back in three hours, he's gonna call 911."

"911. What's your emergency?"

"My son is dead!"

"Sir, is everything OK? Is your son dead?"

He is like, "No, but he's dead to me. Okay, bye."

That's just how we show love.

This is another comedy show about stereotyping. The actor shows how Chinese people are

a reserved nation from three examples, his mother, grandmother and father. Chinese people do not show PDA (public display of affection) as westerners. Thus, Chinese people are categorized into this pattern. Stereotypes can help make sense of the world. They are a form of categorization that helps to simplify and systematize information. Thus, information is more easily identified, recalled, predicted, and reacted to. Stereotypes are categories of objects or people. Between stereotypes, objects or people are as different from each other as possible.

One positive side of stereotyping is that stereotypes function as time- and energy-savers (省时省力的东西) that allow people to act more efficiently. People find it easier to understand categorized information. First, people can consult a category to identify response patterns. Second, categorized information is more specific than non-categorized information, as categorization accentuates (强调) properties that are shared by all members of a group. Third, people can readily describe object in a category because objects in the same category have distinct characteristics. Finally, people can take for granted the characteristics of a particular category because the category itself may be an arbitrary (任意的) grouping.

- **Video 13-6:** *If you're a girl, you have to play the game*

If you're a girl, you have to play the game. What is that game? You're allowed to be pretty, and cute and sexy, but don't act too smart, don't have an opinion. Don't have an opinion that's out of line (出格,离谱) with the status quo (现状) at least. You're allowed to be objectified (物化) by men, and dress like a slut (荡妇), but don't own your sluttiness. And do not, I repeat, do not share your own sexual fantasies with the world. Be what men want you to be, but more importantly, be what women feel comfortable with you being around other men. And finally, do not age (变老), because to age is a sin. You'll be criticized; you'll be vilified (污蔑,诋毁,中伤). And you'll definitely not be played on the radio.

When I first became famous, there were nude photos of me in *Playboy* and *Penthouse* (《花花公子》《阁楼》,均为著名成人杂志)magazines, photos that were taken from art schools that I posed for, back in the day, to make money. They weren't sexy, in fact, I looked quite bored. I was. Um, but I was expected to feel ashamed when these photos came out. And I was not, and this puzzled people. Eventually, I was left alone, because I married Sean Penn (西恩·潘,为美国著名演员). And not only would he bust a cap in your ass (相当于 kill you), but I

was taken off the market, so for a while, I was not considered a threat. Years later, divorced and single. Sorry, Sean. I made my *Erotica* album, and my *Sex* book was released. I remember being the headline of every newspaper and magazine. And everything I read about was damning（谴责的，咒骂的）. I was called a whore, and a witch. One headline compared me to Satan（撒旦，魔王）. I said, wait a minute. Isn't Prince（普林斯·罗杰斯·内尔森，为美国流行歌手）running around with fishnet（网眼织物）and high heels and lipstick with his butt hanging out. Yes, he was, but he was a man. This is the first time I truly understood that women did not have the same freedom as men. I remember feeling paralyzed（不知所措的）. It took me a while to put myself together（重新振作）, and get on with my creative life, to get on with my life.

In this speech, Madonna lashes out at discrimination against women in entertainment industry, or to be more specific, in Hollywood. According to her, women are objectified, vilified, and condemned by men. Or simply, sexism. Gender discrimination and sexism refer to beliefs and attitudes in relation to the gender of a person, such beliefs and attitudes are of a social nature and do not, normally, carry any legal consequences. Sex discrimination, on the other hand, may have legal consequences. Though what constitutes（构成）sex discrimination varies between countries, the essence is that it is an adverse（负面的）action taken by one person against another person that would not have occurred had the person been of another sex.

Sexual discrimination can arise in different contexts, which can impose unnecessary requirement, putting one sex at a disproportionate disadvantage compared to the opposite sex. In this example, Madonna feels she is discriminated against and wrongly treated in her career because she is a woman.

- **Video 13-7:** *The N-word is a tricky word*

The N-word is a tricky word. You know. I told a joke about the N-word at another show. The crowd got real quiet like it just did. I felt bad so I tried to do crowd work to loosen them up and make them have fun again. And it worked, people started having a good time, and they forgot what I was talking about. I forgot what I was talking about. So I wanted to finish the joke. I was like, "What was I just talking about?" And this white lady in the back yells out,

"Niggas". You laugh at that shit, but that other audience did not. They were horrified. They all gasped. They were like, "Hit her! Hit her!" I'm like, "I'm not gonna hit her. She is one hundred percent correct; that's exactly what I was talking about." It's not like I said, "Yes, me and my brother were playing basketball…What was I talking about?" "Nigags!" It wasn't that. It's also the way she said it too, because she wasn't like "Niggas". She was like "Nigags, oh God!" like she realized something. She clearly wasn't being a racist. She just wanted to hit the punch line. I couldn't be upset with her for that, you know. I couldn't be upset with her.

If it was a white guy, maybe I would have been more upset. Only because it put a lot of pressure on me as a black dude. And I don't know if you know this or not, but if a white guy says the N- word, and I hear it, it means I gotta fight him. Even if I'm not that upset, I gotta fu-ing fight him. It's in that black dude contract or some reason. And I gotta win the fight, because if I lose, that means he gets to say it again. I gotta go tell people that shit. I can't be like, "Yeah, this white dude called me a nigga yesterday." "Well, son, what did you do?" "Well, I didn't. I got my ass kicked for 15 minutes." Then he yelled it again, and rode up on a city bike. It was embarrassing. That's just the whitest vehicle I can think of, a city bike. I don't know why.

Nigga is a colloquial and vulgar term used in African-American Vernacular(本地的,地方的) English that began as a dialect form of the word "nigger", an ethnic slur against black people. In dialects of English (including standard British English), "nigger" and "nigga" are often pronounced the same.

In practice, its use and meaning are heavily dependent on context. Presently, the word "nigga" is used more liberally among younger members of all races and ethnicities in the United States. In addition to African Americans, other ethnic groups have adopted the term as part of their vernacular, although this usage is controversial.

Some African-Americans only consider "nigga" offensive when used by people of other races, seeing its use outside a defined social group as an unwelcome cultural appropriation. Used by blacks, the term may indicate "solidarity or affection", similar to the usage of the words "dude", "homeboy", and "bro". Others consider "nigga" non-offensive except when directed from a non-African-American towards an African-American. Yet others have derided this as hypocritical and harmful, enabling white racists to use the word and confusing the issue over nigger. Conversely(相反地), nigga has been used an example of cultural assimilation, whereby members of other ethnicities (particularly younger people) will use the word in a positive way, similar to the previously mentioned "bro" or "dude".

Some TV shows use the word, either to create a realistic atmosphere or as a way of presenting social discussion, specifically ones relating to the wealth gap between the rich and the poor. The word is also used for comedic effect.

13.3 Questions for discussion

1) What's your idea on stereotyping a woman or a man or any group of people that you're aware of in our life?
2) Do you have a friend that does not belong to the same racial group as you? How do you view the differences between you, if there is any?
3) Which is more important to you, love or career?
4) Do you have someone to look up to as an idol?
5) Do you have trouble working for a female boss if you're a male or vice versa?

13.4 Debate

Foreign culture is good for ethnic culture development.

13.5 Vocabulary exercises

reverse, unprecedented, stereotype, internalize, undermine, boycott, turn down, arbitrary, status quo, adverse

Try and fill in the blanks of the following sentences with words listed above in proper forms.

1) The wrong attitude will have exactly the _____ effect.
2) The improper use of medicine could lead to severe _____ reactions.
3) You have to get out of your comfort zone and break the _____.
4) He makes unpredictable and _____ decisions.
5) Opposition leaders had called for a _____ of the vote
6) Proper learning requires time to _____ the new information and experiment with it.
7) There're always unpleasant _____ about successful businessmen.
8) He accused me of slandering him and trying to _____ his position
9) His hard work and dedication into his project has achieved some _____ results.
10) This is an offer that I would never _____.

13.6 Role-play and reenactment

1) Please review Video 13-1, act out the show and feel the part of Chinese American culture.
2) Please review Video 13-2, act out the dialogue with your partner and feel the part of interviewing culture in America.

3) Please review Video 13-3, act out the show and understand the culture where stereotyping happens between races and genders.
4) Please review Video 13-4, and feel the Oscars culture.
5) Please review Video 13-5, and act out the show and feel the difference between America and Chinese culture.

Chapter 14

IN & OUT OF COURT
法庭内外

14.1 Cultural tidbits

The system of courts that interprets and applies the law is collectively known as the judiciary（司法系统）. The room where court proceedings occur is known as a courtroom, and the building as a courthouse; court facilities range from simple and very small facilities in rural communities to large buildings in cities.

In both common law（习惯法,判例法）and civil law（民法）legal systems, courts are the central means for dispute resolution（解决争端）, and it is generally understood that all persons have an ability to bring their claims before a court. Similarly, the rights of those accused of a crime include the right to present a defense（有权聘请辩护律师）before a court.

The practical authority given to the court is known as its jurisdiction（司法权）—the court's power to decide certain kinds of questions or petitions（申诉）put to it. A court is constituted by a minimum of three parties: the plaintiff（原告）, who complains of an injury done; the defendant（被告）, who is called upon to make satisfaction for it, and the judicial power（审判权）, which is to examine the truth of the fact, to determine the law arising upon that fact. Often, courts consist of additional barristers（律师）, bailiffs（法警）, reporters, and perhaps a jury（陪审团）.

Trial courts may conduct trials with juries as the finders of fact (these are known as jury trials,陪审团审案) or trials in which judges act as both finders of fact and finders of law (in some jurisdictions these are known as bench trials【法官审案】). Juries are less common in court systems outside the Anglo-American common law tradition. Appellate courts（上诉法院）are courts that hear appeals of lower courts and trial courts.

This common standard of law became known as "Common Law". This legal tradition is practiced in the English and American legal systems. In the common law system, most courts follow the adversarial（抗辩的）system.

In England, the courts of England and Wales consist of the Court of Appeals（上诉法院）, the High Court（高等法院,主要审理重大民事案件）, the Crown Court（刑事法院）, the county courts（郡法院）, and the magistrates' courts（治安法院）. In the United States there are two distinct systems of courts, federal and state. Each is supreme in its own sphere（范围）, but if a matter simultaneously affects the states and the federal government, the

federal courts have the decisive power. The district court is the lowest federal court. Each state has at least one federal district, and some of the more populous states contain as many as four districts. There are 13 circuit courts of appeals（巡回上诉法院）in the U.S., including a court of appeals for the District of Columbia（哥伦比亚特区）and the Court of Appeals for the Federal Circuit（联邦巡回上诉法院）. These hear appeals from the district courts. There are, in addition, various specialized federal courts, including the Tax Court and the federal Court of Claims. Heading the federal court system is the U.S. Supreme Court（美国最高法院）.

A judge presides over court proceedings, either alone or as a part of a panel of judges. American judges frequently wear black robes（黑袍）. American judges have ceremonial gavels （会议主席、拍卖商或法官用的小槌）, although American judges have court bailiffs and contempt of court（藐视法庭或法官）power as their main devices to maintain order in the courtroom. In some countries, especially in the Commonwealth of Nations（英联邦国家）, judges wear wigs（假发）. In many states throughout the United States, a judge is addressed as "Your Honor" or "Judge" when presiding over the court. The judges of the Supreme Court of the United States, and the judges of the supreme courts of several US states and other countries are called "justices"（法官）.

（A trial in the United States）

A jury is a sworn body of people convened（召集）to render an impartial verdict（公正的裁决）officially submitted to them by a court, or to set a penalty or judgment. The role of the jury is described as that of a finder of fact（真相的发现者）. The jury determines the truth or falsity of factual allegations and renders a verdict on whether a criminal defendant is guilty.

In England and Wales jury trials are used for criminal cases, requiring 12 jurors（between the ages of 18 and 75）. Unanimous jury verdicts（陪审团一致通过的裁定）have been standard in US American law. However, in some states (such as Alabama and Florida), the ultimate decision on the punishment is made by the judge, and the jury gives only a non-binding（无约束力的）recommendation. The judge can impose the death penalty even if the jury recommends life without parole（假释）.

A witness（证人）in law is a someone who, either voluntarily or under compulsion, provides testimonial evidence, either oral or written, of what he or she knows or claims to know about the matter before some official authorized to take such testimony. An expert

witness(专家证人) is one who allegedly has specialized knowledge relevant to the matter of interest, which knowledge purportedly(据说) helps to either make sense of other evidence.

The prosecutor(公诉人,检察官) is the legal party responsible for presenting the case in a criminal trial against an individual accused of breaking the law. The prosecutor typically represents the government in the case brought against the accused persona defendant(被告人) is a person accused of a crime in criminal prosecution or a person against whom some type of civil relief(民事赔偿) is being sought in a civil case. The plaintiff is a person who starts the civil action through filing a complaint.

Cross-Examination(反诘问,指诉讼当事人的一方向对方证人就其所提供的证词进行盘问,以便发现矛盾,推翻其证词). In law, cross-examination is the interrogation of a witness called by one's opponent. It is preceded by direct examination(直接询问,即由要求证人作证一方的律师直接询问证人). The questioning of a witness or party during a trial, hearing, or deposition(宣誓作证) by the party opposing the one who asked the person to testify in order to evaluate the truth of that person's testimony, to develop the testimony further, or to accomplish any other objective. The interrogation of a witness or party by the party opposed to the one who called the witness or party, upon a subject raised during direct examination—the initial questioning of a witness or party—on the merits(法律意义,法律依据) of that testimony.

In the law, testimony(证词) is a form of evidence that is obtained from a witness who makes a solemn statement or declaration of fact.

Perjury(伪证,伪证罪) is the intentional act of swearing a false oath or of falsifying an affirmation to tell the truth, whether spoken or in writing, concerning matters material to an official proceeding. Perjury is considered a serious offense as it can be used to usurp(篡夺,侵占,非法使用) the power of the courts, resulting in miscarriages of justice(司法). In the United States, for example, the general perjury statute(法规,法令) under Federal law classifies perjury as a felony(重罪) and provides for a prison sentence of up to five years.

Capital punishment(极刑), also known as the death penalty, is a government sanctioned practice whereby a person is put to death by the state as a punishment for a crime. Etymologically(从词源来说), the term capital (lit. "of the head") in this context alluded to execution by beheading(砍头). The sentence that someone be punished in such a manner is referred to as a death sentence, whereas the act of carrying out the sentence is known as an execution(处决). Crimes that are punishable by death are known as capital crimes or capital offences(死罪), and they commonly include offences such as murder, treason(叛国), espionage(间谍罪), war crimes, crimes against humanity and genocide(种族灭绝). The following methods of execution are usually used: hanging, shooting, lethal injection(死亡注射), electrocution and gas inhalation(电刑处死和毒气吸入).

A miscarriage of justice primarily is the conviction and punishment of a person for a crime they did not commit. Most criminal justice systems have some means to overturn a wrongful

conviction, but this is often difficult to achieve. In some instances a wrongful conviction is not overturned for several years, or until after the innocent person has been executed, released from custody, or has died.

Acquittal（宣告无罪，无罪开释）in the common law tradition is an acquittal formally certifies that the accused is free from the charge of an offense. In the United States an acquittal cannot be appealed by the prosecution because of constitutional prohibitions against double jeopardy.

Double jeopardy（一罪不受两次审理原则，指禁止法院对同一罪行重复起诉的普通法和宪法原则）happens in the United States because an acquittal cannot be appealed by the prosecution because of constitutional prohibitions against double jeopardy. In some other countries, including Canada and Mexico, the guarantee against being "twice put in jeopardy" is a constitutional right.

Pro bono（为慈善机构、穷人等提供的无偿专业性服务）is a Latin phrase for professional work undertaken voluntarily and without payment. Unlike traditional volunteerism, it is service that uses the specific skills of professionals to provide services to those who are unable to afford them. Pro Bono in the United Kingdom describes the central motivation of large organizations, such as the National Health Service and various NGOs which exist "for the public good" rather than for shareholder profit, but it equally or even more applies to the private sector where professionals like lawyers and bankers offer their specialist skills for the benefit of the community or NGOs.

A jury trial, or trial by jury, is a legal proceeding in which a jury makes a decision or findings of fact, which then direct the actions of a judge. It is distinguished from a bench trial in which a judge or panel of judges makes all decisions. A bench trial is a trial by judge, as opposed to a trial by jury. The term applies most appropriately to any administrative hearing（行政听证会）in relation to a summary offense to distinguish the type of trial. Many legal systems use bench trials for most or all cases or for certain types of cases.

Pleading the Fifth（拒绝答复，拒绝自证其罪）. The Fifth Amendment（美国宪法《第五修正案》，主要规定在刑事案中任何人不得被迫自证其罪）says that no one can be forced to say something against their own self-interest. Neither lawyers nor judges can compel people to violate that right.

Objections（反对的理由，异议）. When either side of the trial lawyer (or witness) invokes objection, the judge has to rule on it and then the lawyer should know to stop talking when he/she hears an objection and waits for the judge to rule. The most common objections are hearsay（传闻，道听途说）and badgering（纠缠）the witness.

Continuance（延期审理）. A continuance is just an adjournment（休庭）, i.e. asking for a delay by a day or more. The judge will need a good cause for that delay, without which, the motion for continuance is denied by the judge.

Gavel（法槌）. A gavel is a small wooden hammer that the person in charge of a law court, an auction, or a meeting bangs on a table to get people's attention or give order. There is a lot more gavel banging on TV and films than in real life.

Defendant testifying（被告作证）. Defendants only testify on their own behalf in the minority of cases, although they have the right to.

Witness outburst（证人情绪失控）. It happens when the opposite lawyer tries to break the witness, and asks him/her the questions that escalate to a level that the witness bursts out in emotion. But at this moment, the judge will intervene the further exchange between the lawyer and witness, and normally rules that the witness doesn't have to answer that question, which may incriminate himself/herself（自证其罪）.

Protesting the verdict（抗议判决）. It's hard for any lawyer to lose a case, so he/she might protest the verdict when it's passed down by the judge. The possible result is being warned by the judge or being held in contempt（被判藐视法庭罪）, or even worse, he/she could face ethical sanctions from the bar（律师协会的道德处罚）or loses his/her job.

Calendar call（待审日程宣读）. Every judge has a lot of cases that are all in a different posture, so the lawyers will have to hear the announcement of the trial date from the judge.

Mitigating circumstances（从轻处罚情节）. Many defense lawyers would use it in trying to persuade a prosecutor to make a lower offer. Usually a moral stance in a situation is suggested under consideration. It's common for lawyers to negotiate a disposition（处置，安排）during downtime（停工，休息，非庭审期间）in court in situations like that.

Court demonstration（庭上示范）. The lawyer uses objects to demonstrate for/against the witness, or call the defendant to the stand to testify about it.

Hostile witness（恶意证人）. When your own witness unexpectedly contradicts your case, then you can ask for permission to treat him as hostile.

Violent witness（暴力证人）. When the witness is agitated（惹恼，煽动）by a lawyer in court gets violent, the judge usually intervenes or asks the court officers to do so as soon as it looks like things are getting violent. It's rare for a witness/defendant to get violent in court, and that's why there are armed court officers in every court room for criminal trials（刑事审判）.

Character witness（品格证人）. Under the rule of evidence, a character witness can only testify about something that's at issue. The issue is whether or not the defendant is a good person/has a good reputation in the community.

Jury selection（遴选陪审团）. Before the trial, both sides of the trial have a set number of peremptory challenges（绝对回避，不诉理由要求陪审员回避）they can use to strike（剔除）potential jurors. They can both agree to strike anyone that doesn't count against them. And no one can strike a juror on the base of a protected category like race, gender, ethnicity, or sexual orientation. It's a process of psychoanalysis on the potential jurors on both sides, mostly based

on what they're wearing and the way they comport（举止，表现）themselves. So it's basically guesswork. In this process, the lawyers on both sides will question the potential juror about their ability to serve. It's called Voir Dire（预先审查）.

Removing the witness（移除证人，把证人带走）. The judge would reprimand（训斥，斥责）any lawyer or witness who uses bad language in the court room. Most lawyers would work closely with the defendant before he takes the stand in order to guard against those emotional outbursts. Court officers are trained to respond to a judge's orders immediately.

Settlement（和解）. When the parties involved have agreed to a settlement, a plea bargain（辩诉交易）or a settlement disposition is possible in both criminal and civil cases without having to go through to the conclusion of a trial. But if the defendant accepts a plea bargain, he/she will be convicted a felony, and would have to plead guilty to a lesser charge, sometimes no jail and no trial, which may sound ugly on the defendant side. When the jury has been impaneled（选任，就位）, and opening statements are about to begin. It's very common that plea negotiations would continue through a trial. Plea negotiations have to happen outside the awareness of the jury.

Courtroom attire（出庭着装）. The formality of courtroom attire is that appropriate dress is demanded, but it has decreased in recent years.

Rest my case（陈述完毕）. The lawyer says this to indicate that he/she has no further questions for the witness in the cross-examination, or the case as a whole for that matter at the moment.

Applause in the gallery（观众鼓掌）. When a lawyer asks a dramatic question, everyone in the courtroom can feel the tenseness of the situation. In modern days, applause is not allowed in the courtroom, but on TV or films, people would go to watch proceedings as part of their entertainment. And during that time, sometimes, there would be applause in the courtroom.

Contempt of court（藐视法庭）. If an act on the side of the lawyer or witness is out of line in court, the judge may reprimand the person by saying "Mr./Mrs…., I find you guilty of contempt." The judges are threatening to hold people in contempt all the time in court, and sometimes it's bluffing（虚张声势，唬人）.

Arraignment（传讯，提审）is the first time that someone who's charged with a crime hears the charges read formally against them. When someone gets arraigned, their lawyer sometimes says waiving the reading, not the rights. A subpoena（传票）is a legal document telling someone that they must attend a court of law and give evidence as a witness. If someone subpoenas a person, they give them a legal document telling them to attend a court of law and give evidence. If someone subpoenas a piece of evidence, the evidence must be produced in a court of law.

Waiving the right（放弃辩护）. Usually a defendant is assigned a back-up counsel who actually has legal training. Sometimes a defendant waives the right to a lawyer, and chooses to

represent himself, and he will be granted more leeway（自主权，余地）than a lawyer is.

Setting bail（设定保释金）. The basic options when a judge is making a decision about bail are releasing someone on their own recognizance（保证书，保证金）, which means counting on them to return to court on their own free will. Setting bail, which means determining an amount of collateral（抵押品）that they will give over and that is likely to ensure that they return and remanding（还押，归还）them, which means that no amount of money or collateral will allow them to be released while the charges are pending（待定的）. It depends on the gravity of the charges, the defendant's criminal history, their community ties, and their access. Often, it has the result of meaning that someone can't make the bail and therefore, stays in custody.

Readback（记录回溯）. When a lawyer doesn't hear or loses track of what the response has been, they can ask the stenographer（速记员）to read back from the transcription. Readback can happen during the trial for a lawyer, or a jury can ask for readback during their deliberations（审议）if there's something they don't remember.

Surprise witness（出其不意的证人）. The prosecution has to disclose their witnesses in advance of trial to permit the defense to appropriately prepare. When something changes and a new witness comes to light, the prosecutor might be permitted to call that witness, but the defense would then be granted plenty of time to be able to prepare to cross-examine that new witness.

Miranda rights（米兰达权利：美国法律规定，被捕者有聘请律师和保持缄默的权利）. Miranda is the case that officers have to read a defendant their rights before questioning them. The verb use is to mirandize someone. When a suspect is not mirandized, the statement is made suppressed as evidence（以强迫手段获得证据）, which means it can't be used against the defendant.

Approach the bench（上法官席）. This happens when the judge asks one of the lawyers to approach the judge, but uncommon for one lawyer to do so ex parte（单方面地）, i.e. without the other lawyer. The point of approaching the bench is so that the talk between the judge and the lawyers cannot be heard by the courtroom.

Conference in the judge's chambers（到法官休息室协商）. When the judges and lawyers are combative with each other, they retreat to assemble in the judge's chamber to have a discussion and settle the argument in private.

Summation, or closing statement（结案陈述）. Summations can only be about the facts that are in evidence. This is the moment for a lawyer to get theatrical on summation when a lawyer lays out his view of the facts of the case and then makes a powerful argument about bias. That's exactly the appropriate use of a summation.

14.2 Video examples

- **Video 14-1**: *I didn't do anything!*

Police: Please come with me.

Girl: Why?

Policeman: This way, please.

Girl: But I didn't even see him. I swear.

Policeman: Evan Mitchell, You're under arrest for obstruction and <u>making false statements</u> (作伪证) in the murder of Alexander Cosby.

Girl: Mom, what's happening? I didn't…

Policeman: You have the right to remain silent, anything you say or do can and will be used against you in the court of law. If you can't afford a lawyer, one will be appointed for you by the court.

Mother: Detective, this is ridiculous. She didn't do anything!

Girl: Wait. I didn't do anything!

- **Video 14-2**: *You have the right to remain silent*

Girl: Mama!

Policeman: You have the right to remain silent. Anything you say can and will be used against you in the court of law.

Girl: You know what happened!

Policeman: You have the right to an attorney.

Girl: You know. Just tell them!

Policeman: If you cannot afford an attorney, one will be provided for you. Do you understand these rights as I explained them to you?

The two similar scenes above are when arresting happens. The police must announce these rights to him/her in the process. Miranda rights（米兰达权利，如被捕者有聘请律师和保持缄默的权利）are the rights that a person who is being arrested must be informed of, such as the right to remain silent or the right to have legal counsel. It is also called the Miranda warning（米兰达警告）, given by police in the United States to criminal suspects in police custody (or in a custodial interrogation) before they are interrogated to preserve the admissibility（可采纳性）of their statements against them in criminal proceedings.

The Miranda warning is part of a preventive criminal procedure rule that law enforcement are required to administer to protect an individual who is in custody and subject to direct questioning or its functional equivalent from a violation of his or her Fifth Amendment right against compelled self-incrimination（自证其罪，指刑事案件中作不利于自己或有可能使自己受到刑事起诉的证言，美国宪法认定此种证言不合法）.

Another two full versions of the warning in police custody are as follows:

"_____ You are arrested for the crime of _____. You have the right to remain silent. Any statement you make may be used against you in a court of law. You have the right to have a competent and independent counsel preferably of your own choice. If you cannot afford the services of a counsel, the government will provide you one. Do you understand these rights?

"You have the right to remain silent and refuse to answer questions. Anything you say may be used against you in a court of law. You have the right to consult an attorney before speaking to the police and to have an attorney present during questioning now or in the future. If you cannot afford an attorney, one will be appointed for you before any questioning if you wish."

One full version in custodial interrogation（拘留审问）when the attorney is not present:

"If you decide to answer questions now without an attorney present, you will still have the right to stop answering at any time until you talk to an attorney. Knowing and understanding your rights as I have explained them to you, are you willing to answer my questions without an attorney present?"

- **Video 14-3:** *How you tell the story, that's all that matters*

Father: They have been in trouble before.

Mother: That McCormick girl? Lying bitch. She withdrew (收回) the whole complaint.
Father: Police say they got evidence. Blood and DNA.
Counsel: Television.
Mother: Really?
Counsel: In a jury trial, there're two stories. The jury picks the story they like the best. The story, and how you tell it. That's all that matters.
Father: So how much for your story?
Counsel: Ho, ho...I like that. Cut right to the chase (直截了当, 直话直说). 850 an hour. 1250 in court.
Father: Blow me (见你的鬼吧).
Counsel: That's against a 50,000 retainer (聘用定金) fee for each boy.
Father: We cannot do that.
Mother: Oh, yes, we can. And we will. Our house.
Father: I worked 30 years to pay that off. It's all we got.

In this scene, the trial lawyer is negotiating with the defendant's family for the charge of the trial. In this case, we can see a lawyer is crucial in winning or losing a court case. The common title is a counsel or a counselor who at law is a person who gives advice and deals with various issues, particularly in legal matters. It is a title often used interchangeably (互换地) with the title of lawyer. The legal system in England uses the term counsel as an approximate synonym for a barrister-at-law. In the United States of America, the term counselor-at-law designates, specifically, an attorney admitted to practice in all courts of law; but as the United States legal system makes no formal division of the legal profession into two classes, as in the United Kingdom, most US citizens use the term loosely in the same sense as lawyer, meaning one who is versed in (or practicing) law.

- **Video 14-4: *So would you like to serve?***

Judge: Now, please take your time in answering this question. I want you to take a good look at Mr. Buffalo, the man sitting in front of you there. Tell me if you've ever seen him before.
Woman: No. Sir, I haven't.
Judge: I'm sorry. I can't hear you. Would you pull the mic (话筒) a little closer, please?

Woman: No, Sir, I haven't.

Judge: On TV, in the newspapers?

Woman: No. Sir.

Judge: Do you read newspapers? Ma'am?

Woman: When I have the time.

Judge: How often is that?

Woman: Never. I'm a single mother, your honor, and I'm trying to be a sculptor. I have this job all day, and when I get home, I take care of my son. I feel stupid saying that I don't keep up with the news, but, that's just how it is. I don't, I don't have time.

Judge: Ma'am, are you saying you heard nothing about this case?

Woman: No. I have heard something. When I told my son that I might be picked up for a jury duty, he said, "Hey, maybe you get picked for that big mafia (黑手党,起源于意大利西西里,19世纪由意大利移民传入美国,是从事全球性讹诈、贩毒等非法活动的秘密犯罪组织) case." And I said, "What big mafia case?" And he said, "You know, Louise Buffalo. He's gonna be tried for popping those guys. And he said, popping is when you kill somebody. And I said, "Okay, I've got that, but who is Louise Buffalo?" and he said, "Mom, come on. He's the big Spaghetti-O (Louise Buffalo的绰号)."

Judge: Okay, people. Enough! Well, Ma'am, but I want you to understand that this is maybe a lengthy trial, and that you would be sequestered (隔离) during the deliberation (商议). So if you tell me that it will prove a great hardship for you to serve on this jury, I'll excuse you.

Woman: I think I can get someone to take care of my son for...when I'm sequestered.

Judge: So you would like to serve?

Woman: Oh, yes, I would. Yes.

 In this scene, a single mother is being questioned by the judge about the possibility of her serving on the jury. In America, jurors are selected from a jury pool (陪审团候选名单) formed for a specified period of time—usually from one day to two weeks—from lists of citizens living in the jurisdiction of the court. The lists may be electoral rolls (i.e., a list of registered voters in the locale), people who have driver's licenses or other relevant data bases. When selected, being a member of a jury pool is, in principle, compulsory.

 For juries to fulfill their role of analyzing the facts of the case there are strict rules about their use of information during the trial. Juries are often instructed to avoid learning about the case from any source other than the trial (for example from media or the internet) and not to conduct their own investigations (such as independently visiting a crime scene). Parties to the case, lawyers, and witnesses are not allowed to speak with a member of the jury. Doing these

things may constitute reversible error. Rarely, such as in very high-profile cases, the court may order a jury sequestered for the deliberation phase or for the entire trial.

Jurors are generally required to keep their deliberations in strict confidence during the trial and deliberations, and in some jurisdictions even after a verdict is rendered. In English law, the jury's deliberations must never be disclosed outside the jury, even years after the case; to repeat parts of the trial or verdict is considered to be contempt of court, a criminal offense. In the United States, confidentiality is usually only required until a verdict has been reached, and jurors have sometimes made remarks that called into question whether a verdict was properly reached. In Australia, academics are permitted to scrutinize the jury process only after obtaining a certificate or approval from the Attorney-General.

Because of the importance of preventing undue influence on a jury, jury tampering (like witness tampering) is a serious crime, whether attempted through bribery, threat of violence, or other means. Jurors themselves can also be held liable if they deliberately compromise their impartiality.

In this scene, the woman is still willing to serve on the jury regardless of her personal and family inconveniences and engagements. Jurors can be released from the pool for several reasons including illness, prior commitments that can't be abandoned without hardship, change of address to outside the court's jurisdiction, travel or employment outside the jurisdiction at the time of duty, and others.

- **Video 14-5:** *I guess it's my duty*

Bailiff: Next juror, Valerie Alston.

Valerie: Here.

Prosecutor: Good afternoon, Miss Alston. Can you tell us what it is that you do for a living?

Valerie: I own an antique clothing (古董衫，一般指20世纪20年代以前出产的衣服) store downtown.

Prosecutor: You married?

Valerie: Divorced.

Prosecutor: Do you have any children?

Valerie: I have one son.

Prosecutor: Being on a jury in a major organized crime prosecution like this could represent considerable inconvenience to you.

Valerie: Yes. It could.

Prosecutor: But you're willing to do it anyway.

Valerie: I guess it's my duty.

Prosecutor: Do you know the defendant? Or anybody connected with him?

Valerie: No.

(Defense: She's perfect. Prosecution: Like putty in our hands（易为摆布或操纵）.

Prosecutor: We accept Miss Alston, you honor.

Defense: We applaud Miss Alston's sense of civic duty（公民义务）, you honor. Defense welcomes her to this jury.

In this scene, both parties of the trial, the defense and the prosecution are selecting a juror in asking the candidate a line of questioning.

Prospective jurors are sent a summon and are obligated to appear in a specified jury pool room on a specified date. At this point the judge often will ask each prospective juror to answer a list of general questions such as name, occupation, education, family relationships, time conflicts for the anticipated length of the trial. These questions are to familiarize the judge and attorneys with the jurors and gather biases, experiences, or relationships that could jeopardize the proper course of the trial.

After each prospective juror has answered the general slate of questions the attorneys may ask follow-up questions of some or all prospective jurors. Each side in the trial is allotted a certain number of challenges to remove prospective jurors from consideration. A jury is formed, then, of the remaining prospective jurors in the order that their names were originally chosen.

For the drama materials to further understand American jury trial, here are some great movies recommended:

12 Angry Men《十二怒汉》

The Juror《陪审员》

Time to Kill《杀戮时刻》

The Runaway Jury《失控陪审团》

The Truth《真相》

Finding Me Guilty《判我有罪》

Witness for the Prosecution《控方证人》

The Wrong Man《申冤记》

Trial by jury《陪审团审案》

The Juror is a 1996 American crime thriller drama film based on the 1995 novel by George Dawes Green. It was directed by Brian Gibson and stars Demi Moore as a single mother picked for jury duty for a mafia trial and Alec Baldwin as a mobster sent to intimidate her.

- **Video 14-6: *We'll have our case prepared, your honor***

Judge: Good morning, Miss Sullivan. What do we have?

Prosecutor: The people versus Ellen Plainview（The people 这里指政府检察机构代表的公诉方）, <u>assault with intent committed murder</u>（故意伤害罪和蓄意谋杀罪）. The victim in this case, Miss Faye Walker has been unconscious since the assault, therefore unable to ID her attacker this time. However the people will provide evidence in the form of <u>security camera footage</u>（监控镜头）which clearly shows that the defendant was in the parking garage at the time of the assault. Additionally, the people will show that victim was beaten with a <u>tire iron</u>（轮胎撬棒）, consistent with the kind provided a standard equipment with the defendant's <u>make of car</u>（车的品牌）. Brown hair, which lab tests confirm has come from the defendant, was found on the victim's clothing. And the people will provide an eye witness who will testify having seen Ellen Plainview depositing a tire iron in a <u>dumpster</u>（大垃圾桶）not far from the assault, ah, just moments after the crime.

Council: I'll check and search. Just a bunch of rubbish. Oh, you honor, the defense moves to have this case dismissed based on a complete lack of <u>motive</u>（动机）.

Prosecutor: And the people will provide <u>ample and compelling</u>（充分有力的）motive, you honor.

Judge: I'm setting a trial date for two month hence. Monday, June 7th. Is that enough time for you, Miss Sullivan?

Prosecutor: We'll have our case prepared, you honor.

Council: I'll be ready too, you honor.

Defendant: We're going to trial? Mr. Flinch, shouldn't you...?

Judge: Council, aren't you forgetting something?

Council: You honor?

Judge: Your client has the right to ask for a bail adjustment（调整保释金）?

Council: Well, I was just getting to. OH, you honor, we request the defendant be released on her own recognizance（具结,向法院保证随传随到的保证书,交付法院保证被告随传随到的保证金）. She is a wife and mother with a job, who has never been charged with crime.

Judge: Miss Sullivan?

Prosecutor: Due to the severity of the potential penalties of this case, we feel that she is a flight risk（弃保潜逃风险）. The people ask that bail remains at 35,000 dollars.

Council: Come on, Kate.

Judge: The defendant is to be released on her own recognizance.

Council: You're free. Let's get out of here. Thank you, you honor.

In some common law nations, a recognizance is a conditional obligation undertaken by a person before a court. It is an obligation of record, entered into before a court or magistrate duly authorized, whereby the party bound acknowledges (recognizes) that they owe a personal debt to the state. The concept of a recognizance exists in Scotland, Canada and the United States. People who are released on their own recognizance are subject to appearing before a judge on a certain day in the near future.

Recognizances are most often encountered regarding bail in criminal cases. In the United States, by filing a bail bond（保释保证书）with the court, the defendant will usually be released from imprisonment pending a trial or appeal. If the defendant is released without bail having been set, the defendants are released "on their own recognizance". Release on recognizance is sometimes abbreviated as RoR, OR (own recognizance, particularly in the United States), or PR (personal recognizance).

- **Video 14-7:** *She is a killer, and the worst kind!*

Judge: Are the people ready to proceed? Mr. Garret?

Prosecutor: Yes, you honor. Andrew Marsh made, what turned out to be, the fatal mistake: he fell in love. He fell in love with a <u>ruthless</u>（残忍的）, <u>calculating</u>（工于心计的）woman who went after an elderly man with a bad heart and a big bank account. You all can see the defendant Rebecca Carlson. But as this trial <u>proceeds</u>（进行）, you will see she is not only the defendant, she is the murder weapon herself.

If I hit you and you die, I am the cause of your death, but can I be called a weapon? The answer is yes. And what kind of weapon Rebecca Carlson has made of it? <u>The State</u>（政府，这里指公诉方）will prove that she <u>seduced</u>（引诱）Andrew Marsh and <u>manipulated</u>（操纵）his affections until he <u>rewrote his will</u>（修改遗嘱）, leaving her 8 million dollars, that she insisted on increasingly <u>strangling</u>（窒息的）sex, knowing he had severe heart condition. And when that didn't work faster enough for her, she secretly <u>doped</u>（给……服麻醉剂或毒品）him with <u>cocaine</u>（可卡因）. His heart couldn't take the <u>combination</u>（并发作用）, and she got what she wanted.

She is a beautiful woman, but when this trial is over, you will see her no differently than a gun or a knife or any other instruments used as a weapon. She is a killer, and the worst kind, a killer who <u>disguised</u>（伪装）herself as a loving partner.

In this scene, the prosecutor is giving an opening statement. An opening statement is an introductory statement made by the attorneys for each side at the start of a trial. The opening statement, although not <u>mandatory</u>（强制的）, is seldom <u>waived</u>（放弃）because it offers a valuable opportunity to provide an overview of the case to the jury and to explain the anticipated proof that will be presented during the course of the trial.

The defense may present its opening statement after the plaintiff or prosecution has given its opening statement. The defense also has the option of reserving the opening statement until after the plaintiff has presented its case. Courts have discretion to direct a different order of presentation of opening statements if it finds good reasons for such change in order.

Opening statements allow attorneys for each side to introduce themselves and to introduce the parties involved in the lawsuit. Additionally, attorneys will usually outline the important facts of the case during the opening statement to assist the jury in understanding the evidence that will be presented during the trial. An opening statement generally contains a brief explanation of the applicable law and a request for verdict. In a request for verdict, the attorney explains the verdict sought and explains the facts that will support the verdict. A well-planned opening statement serves as a <u>road map of the trial</u>（审案路线图）.

Opening statements are often informal and narrative in form. The attorney tells the client's story and explains to the jury what the evidence will show. An opening statement, however, does not constitute evidence, and the jury cannot rely on it in reaching a verdict. The opening

statement should be brief and general rather than long and detailed.

An attorney is limited in what he or she can say during an opening statement. An attorney may not discuss inadmissible evidence（在法庭上不被采纳的证据）. This is especially true where the evidence was ruled inadmissible in a pretrial motion hearing（开庭前听证会）. The attorney must reasonably believe that the matters stated will be supported by the evidence. In addition, statements that are purely argumentative are not proper during opening statements. An attorney may not assert personal opinions, comment about the evidence, or comment about the credibility of a witness during an opening statement.

Objections by opposing counsel during an opening statement are appropriate where the attorney presenting the opening statement engages in improper conduct. If the attorney fails to object to the inappropriate conduct, the objection is deemed waived, and the attorney cannot complain of such misconduct later in the trial. A court usually has the discretion to employ one of several remedies for misconduct during an opening statement. The most common remedy for misconduct during an opening statement is jury admonition（陪审团谏言）, where the judge simply instructs the jury to disregard the improper statement（不考虑错误的言论）.

An attorney can make damaging statements during the opening statement that legally bind the client. Such statements, known as "admissions", are not limited to the opening statement but can occur throughout the litigation process（诉讼过程）. Attorneys must use caution during the opening statement to avoid making damaging admissions.

A strong opening statement will have a lasting impact on the trier of fact（事实审查员）. It is often the jury's first introduction to the parties, the issues, and the trial procedure. The opening statement begins the process of persuasion, the ultimate goal of which is a favorable verdict.

- **Video 14-8:** *It is your duty to carry it out*

Judge: Mr. Jackson, proceed with your summation（证据总结）.
Council: "Who so ever shall harm one of my children, it is better for a mill stone to be hung around his neck, and for him to be cast into the sea." Members of the jury, I ask the words of Mark 9: 42（《马可福音》第9章第42节）, to remind you of your responsibility, as they remind me of mine. Two days before Christmas, Willingham committed the ultimate（终极的）crime. Can there be a more righteous case for the

> imposition（执行）of the ultimate penalty. Whether capital punishment in this case would deter（震慑）others, I don't know, but I do know, it will deter Cameron Todd Willingham, and that is what the state tax is asking what you to do today. Willingham wrote his own death sentence when he killed those children. It is your duty to carry it out.

Similar to opening statement, a concluding argument is the final argument of an attorney at the close of a trial in which he/she attempts to convince the judge and/or jury of the virtues of the client's case.

The final argument by an attorney on behalf of his/her client after all evidence has been produced for both sides. The lawyer for the plaintiff or prosecution (in a criminal case) makes the first closing argument, followed by counsel for the defendant, and then the plaintiff's attorney can respond to the defense argument. Unlike the opening statement, which is limited to what is going to be proved, the closing argument or summation may include opinions on the law, comment on the opposing party's evidence, and usually requests a judgment or verdict (jury's decision) for his/her client.

Closing arguments and rebuttals（反驳）vary in duration. Hollywood court dramas often make the closing argument a brief, terse statement; in real life, it can go on much longer. Summations lasting an hour or more are typical. Depending on the complexity of a case, the entire summation period may last several days, particularly in jury trials where numerous witnesses and difficult scientific evidence have been presented. However, most attorneys avoid droning on（唠唠叨叨说个不停）, for fear of losing the jury's attention or possibly incurring its antagonism（敌对，敌意）. Ultimately, the length of a closing argument is left to the discretion of the judge, who may impose a time limit. Judges can also sustain objections by the opposing side if the scope of the rebuttal is deemed too far-reaching（深远的,广泛的）.

Just as trials begin with attorneys making statements about the case, they end with a direct address to the judge or jury. The Opening Statement lays out what each side intends to prove; the closing argument, which is generally more forceful, has broader ambitions. By recapitulating（扼要重述）the facts, evidence, and testimony presented during the trial, the closing argument tries to deal a fatal blow（致命的打击）to the opposing case while definitively proving the attorney's own. Trial lawyers put great emphasis on their closing argument, or summation, because it is their last chance to be persuasive before the judge or jury begins deliberations. An art form in itself, the closing argument often brings forth a trial's most dramatic speech, marked by criticism, appeals to emotion and reason, and florid（文体或艺术风格等绚丽的、过分华丽的）rhetoric.

In an age when jury consultants warn about short attention spans, contemporary attorneys shy away from（回避，避免）arch rhetoric. Most lawyers want to reach the jury's emotions through plain, but pointed, speech. Rhetorical questions（反问句）are still used powerfully;

quotations（引用）from literature are featured to a somewhat lesser extent. Charts, graphs, and even photographs play a large role in keeping juries focused.

- **Video 14-9: *We find the defendant not guilty.***

Bailiff: All rise! Everyone have a seat please.
Judge: Ladies and gentlemen of the jury, have you reached a verdict?
Head juror: We have, Your Honor.
Judge: Will the defendant please rise.
Head juror: Case 18527, State of California VS Cassidy Miller in the charge of murder of first degree, we find the defendant not guilty.
Judge: Order in the court!

The decision of a jury is called a verdict, which is the formal decision or finding made by a jury concerning the questions submitted to it during a trial. The jury reports the verdict to the court, which generally accepts i.e. jury is charged with hearing the evidence presented by both sides in a trial, determining the facts of the case, applying the relevant law to the facts, and voting on a final verdict. There are different types of verdicts, and the votes required to render a verdict differ depending on whether the jury hears a criminal or civil case. Though most verdicts are upheld by the judge presiding at the trial, the judge has the discretion to set aside a verdict in certain circumstances.

A general verdict（普通裁决）is the most common form of verdict. It is a comprehensive decision on an issue. In civil cases the jury makes a decision in favor of the plaintiff or the defendant, determining liability and the amount of money damages. In criminal cases the jury decides "guilty" or "not guilty" on the charge or charges against the defendant. In cases involving a major crime the verdict must be unanimous. In minor criminal cases, however, some states allow either a majority vote or a vote of 10 to 2. In civil cases many states have moved away from the unanimity requirement and now allow votes of 10 to 2.

A special verdict（特殊裁决）is sometimes used in civil cases where the judge gives the jury a series of specific, written, factual questions. Based upon the jury's answers, or findings of fact, the judge will determine the verdict. Special verdicts are used only infrequently because parties often have a difficult time agreeing on the precise set of questions.

A directed verdict（直接裁决）is not made by a jury. It is a verdict ordered by the court

after the evidence has been presented and the court finds it insufficient for a jury to return a verdict for the side with the burden of proof. A court may enter a directed verdict before the jury renders its verdict. If the court allows the jury to make a verdict but then disagrees with the jury's evaluation of the evidence, the court can decide the case by issuing an order.

• **Video 14-10: *You're hereby served***

Boss: Yes, sir.
Policeman: Yes, I'm here to see Mr. Carter Duncan. I understand he's in this office.
Boss: <u>In regard to...</u>（有何要事？）
Policeman: I have something to deliver to him. Carter Duncan?
Carter: Yes.
Policeman: <u>You're hereby served</u>（公文已送达给你）. This is a temporary <u>restraining order</u>（法庭禁止令，尤指禁止接触某一指定的人的临时性命令）issued by the <u>LA County Sheriff's office</u>（洛杉矶县治安官办公室）. You're legally <u>prohibited</u>（禁止）from contacting Miss Leah Vaughn. You're further ordered to maintain a distance of no less than 50 yards from Miss Vaughn's person, her residence and workplace. You have any questions, Mr. Duncan? Have a good day.
Carter: Mr. Forsy...
Boss: Carter! You better go. Now!

In this scene, a police is serving the man a restraining order from the court. A restraining order is an official command issued by a court to refrain from certain activity. Restraining orders are sought by plaintiffs in a wide variety of instances for the same reason: the plaintiff wishes to prevent the defendant from doing something that he or she has threatened. Restraining orders are used in a variety of contexts, including employment disputes, copyright infringement, and cases of harassment, domestic abuse, and <u>stalking</u>（跟踪，跟踪罪）. All restraining orders begin with an application to the court, which decides the merits of the request by using a traditional test. Limited in their duration and effect, restraining orders are distinguished from the more lasting form of court intervention called an <u>injunction</u>（禁制令，为法院强制被告从事某项行为或不得从事某项行为的正式命令）. Generally they are sought as a form of immediate relief while a plaintiff pursues a permanent injunction.

Usually, restraining orders are not permanent. They exist because of the need for

immediate relief: the plaintiff requires fast action from the court to prevent injury. Seeking a permanent injunction can take months or years because it involves a full hearing, but the process of obtaining a restraining order can take a matter of days or weeks.

Harassment of an individual can result in a permanent restraining order. This command of the court is also called a protective order. All states permit individuals to seek a restraining order when they are subjected to harassment by another individual or organization, typically involving behavior such as repeated, <u>intrusive</u>（侵犯的）, and unwanted acts. Application for such an order usually is made to the district court. If granted, it prohibits the party named from initiating any contact with the protected party. In the 1990s most states passed anti-stalking laws designed to protect women from criminal harassment by men. These laws generally require that a plaintiff first secure a restraining order before criminal charges can be filed.

14.3 Questions for discussion

1) Share your one experience where you used law to protect yourself and people related.
2) How would you protect yourself from sexual harassment?
3) What are the things in our daily life that we do sometimes without realizing it's against the law?
4) Talk about what you have learned from a court speech made by the lawyers.
5) Talk about what safety measures you have in mind to protect yourself in your daily life.

14.4 Debate

Abidance by law is restriction of freedom.

14.5 Vocabulary exercises

convene, impartial, non-binding, withdraw, compulsory, prospective, assault, motive, compelling, mandatory, intrusive

Try and fill in the blanks of the following sentences with words listed above in proper forms.

1) People hate the presence of cameras everywhere because they're _____.
2) After the interview session, the _____ employees can decide whether the job is fit for him.
3) He was charged with _____ and vandalizing.
4) There seemed to be no _____ for the murder in this case.
5) It is _____ for students to take the labor course before graduation in college.
6) He's welcome to join the panel of judges, because he's known for his unbiased and ____

_____ judgment.

7) Party members _____ every week to discuss the matters of the organization.

8) Activities provided outside the contract are tacit, according to this _____ contract.

9) He regretted his hurting words to his friend and _____ them.

10) With _____ evidence presented in front of everyone, he has to give up and admits what he has done.

11) It's _____ for aspiring teachers to pass the certificate test before taking a post as a teacher.

14.6 Role-play and reenactment

1) Please review videos 14-1 and 2, learn to recite the Miranda rights and feel the part of culture.
2) Please review videos 14-4 & 5, act out the dialogue with your partner and feel the part of jury culture in America.
3) Please review videos 14-7 & 8, act out the show and understand the culture of opening and closing speeches in the court.
4) Please review Video 14-10, act out the scene and feel the culture about serving a restraining order.

CORPORATE WORMS & OFFICE DRONES
无奈职场

15.1 Cultural tidbits

In many countries (such as Australia, Canada, New Zealand, United Kingdom, and the United States), a person who performs professional, managerial, or administrative work is a white collar. White-collar work is performed in an office, <u>cubicle</u>(小房间,隔间), or other administrative setting. Other types of work are those of a blue-collar worker, whose job requires manual labor and a pink-collar worker, and whose labor is related to customer interaction, entertainment, sales, or other service-oriented work.

In English-speaking countries, a blue-collar worker is a working class person who performs non-agricultural manual labor. Blue-collar work may involve skilled or unskilled manufacturing, mining, sanitation, <u>custodial</u>(监护的,照管的) work, oil field work, construction, <u>mechanical maintenance</u>(机械维修), warehousing, firefighting, <u>technical installation</u>(技术安装) and many other types of physical work.

The term "wage slavery" has been used to criticize exploitation of labor and social <u>stratification</u>(成层,分层), seen primarily as unequal bargaining power between labor and capital (particularly when workers are paid comparatively low wages, e.g. in sweatshops), and lack of workers' self-management, fulfilling job choices, and leisure in an economy.

"Gold collars" refer to the knowledge workers, because of their high salaries, as well as their relative independence in controlling the process of their own work. Most knowledge workers prefer some level of <u>autonomy</u>(自治,自治权), and do not like being overseen or managed. Those who manage knowledge workers are often knowledge workers themselves, or have been in the past. Projects must be carefully considered before assigning to a knowledge worker, as their interest and goals will affect the quality of the completed project. Knowledge workers must be treated as individuals.

In American society, the middle class may be divided into two or three sub-groups. When divided into two parts, the lower middle class, also sometimes simply referred to as "middle class", consists of roughly one third of households, roughly twice as large as the upper middle class. These individuals commonly have some college education or perhaps a Bachelor's degree and earn a comfortable living.

A supervisor, when the meaning sought is similar to <u>foreman</u>(工头,工长,领班),

 CORPORATE WORMS & OFFICE DRONES 无奈职场

foreperson, boss, overseer, cell coach, facilitator, monitor, or area coordinator, is the job title of a low level management position that is primarily based on authority over a worker or charge of a workplace. A Supervisor can also be one of the most senior in the staff at the place of work, such as a Professor who oversees a <u>PhD dissertation</u>（博士论文）. Supervision, on the other hand, can be performed by people without this formal title, for example by parents. The term Supervisor itself can be used to refer to any personnel who have this task as part of their job description.

The supervisor may participate in the hiring process as part of interviewing and assessing candidates, but the actual hiring authority rests in the hands of a Human Resource Manager. The supervisor may recommend to management that a particular employee be terminated and the supervisor may be the one who documents the behaviors leading to the recommendation but the actual firing authority rests in the hands of a manager. A supervisor is also given the power to approve work hours and other payroll issues. Normally, budget affecting requests such as travel will require not only the supervisor's approval but the approval of one or more layers of management.

A <u>hierarchy</u>（等级制度）is a system or organization in which people or groups are ranked one above the other according to status or authority. <u>Superior</u>（上级）is a higher level or an object ranked at a higher level, and a <u>subordinate</u>（下级）is a lower level or an object ranked at a lower level.

An office lady, often abbreviated OL, is a female office worker who performs generally pink collar tasks such as serving tea and secretarial or clerical work. Office ladies are usually full-time permanent staff, although the jobs they perform usually have little opportunity for promotion, and there is usually the <u>tacit</u>（心照不宣的）expectation that they leave their jobs once they get married.

Due to some Japanese pop culture influence in China, the term is also in common usage. However, the meaning of the word is slightly different. In China, the word represents the white-collar women (usually highly educated, high-pressure, high-income, and smartly dressed), the combination of beauty and wisdom.

A personal assistant, also referred to as personal aide (PA) or personal secretary (PS), is a job title describing a person who assists a specific person with their daily business or personal task. A personal assistant helps with time and daily management, scheduling of meetings, correspondence, and note taking. The role of a personal assistant can be varied, such as <u>running errands</u>（跑腿）, arranging travel (e.g., travel agent services such as purchasing airline tickets, reserving hotel rooms and rental cars, and arranging activities, as well as handling more localized services such as recommending a different route to work based on road or travel conditions), finance (paying bills, buying and selling stocks), and shopping (meal planning, remembering special occasions like birthdays).answering phone calls, taking

notes, scheduling meetings, emailing, texts etc.

Along with lad culture（少年文化）in the U. K., some youth subcultures such as skinheads（光头仔,尤指特别仇视移民的流氓团伙成员）, punks（小流氓,小阿飞;朋克摇滚乐手,朋克摇滚乐迷）, rockers（摇滚乐表演者,喜欢摇滚乐的人）and metalheads（重金属乐迷）have been associated with working class culture. In the U.S., especially, some White Americans have reclaimed the usually derogatory（贬义的）term redneck（红脖人,指颈脖晒得红红的美国南部贫苦农民,尤指其中观念狭隘保守者）as an identifier with working class white Americans. Many may deliberately embrace redneck stereotypes but choose to avoid usage of the word due to its frequent association with negative attitudes such as racism.

In this chapter, we're going to look at some phenomena, events, episodes, interludes that happen in the office and corporate setting, which reflect the life of the office drones and corporate worms, from job interview, late hour working, being bullied by the boss, sexual harassment, being hired or fired, and so on.

15.2 Video examples

- **Video 15-1:** ***I'm a highly qualified applicant for that position!***

Interviewer: Mr. Walker. I'm Joyce Robertson, sorry to keep you waiting. Ah, would you mind if I have something to eat here? I have another meeting right after you.
Bobby: Go right ahead.
Interviewer: So, looks like you worked for GTX for 12 years.
Bobby: I did, divisional（部门的）sales leader for three of those years.
Interviewer: Yeah. Surprised they let you go.
Bobby: Huh, you and me both.
Interviewer: Have you handled regional sales?（区域销售）
Bobby: Came up from regional sales. I worked for Martin Marietta（马丁·玛丽埃塔,为美国公司,主要从事建筑事业相关的骨材生产）in California.
Interviewer: Well, we're looking to expand in the South. We need someone in Little Rock（小石城）.
Bobby: In Arkansas（堪萨斯州）?
Interviewer: Is relocation（调往异地）a problem?

Bobby: Ah, no, no. Um, I had hoped to stay here because I'm from the area...

Interviewer: You left the salary space blank on your application.

Bobby: Well, you know, that's a negotiation. I was making 120（这里指 12 万年薪）at GTX, plus incentives（奖金）. But, I know that times are different now. I'd be willing to accept 100 and hope for bonuses.

Interviewer: Well, our base salary（底薪）is 65 thousand a year for regional sales directors.

Bobby: I responded to an ad for the vice president of marketing（销售，营销）.

Interviewer: Well, we had a number of highly qualified applicants for that position.

Bobby: I'm a highly qualified applicant for that position! I'm a highly qualified applicant for that position! Excuse me, sorry. Must have had too many cups of coffee while I was out there sitting in your f-ing waiting room for two hours. Thanks for your time, Joyce.

In this scene, the man is bewildered and dismayed by two things in the interview: one is that he has to relocate to a different city if he takes the job, and then the disheartening salary package offer, then compounded with the intended position discrepancy and belittlement of his value. In the end, he takes his anger out on this woman interviewing him for wasting his time.

In a typical interview session, the interviewer asks questions, the interviewee responds, with participants taking turns talking. Interviews usually involve a transfer of information from interviewee to interviewer, which is usually the primary purpose of the interview, although information transfers can happen in both directions simultaneously. One can contrast an interview which involves bi-directional communication with a one-way flow of information, such as a speech or oration.

- **Video 15-2: *Then why should I give a shit?***

Woman: Hey Mark?

Boss: Hey, what's up?

Woman: I was hoping if you would mind if I ducked out（悄然离开，这里指提前下班）earlier Fridays to pick up my kid from school. She has to have this for the rest of the year.

Boss: Rest of the year? No.

Woman: No! No. the rest of the school year.

Boss: No.

Woman: What if I got somebody to cover my shift（顶我的班）. Mercedes said she would

cover...

Boss: Oh, my God, come on! Took me forever to figure out everyone's stupid schedule.

Woman: I know.

Boss: I mean. Really?

Woman: Please, I wouldn't ask if it wasn't for my kid. OK? She is going through this difficult time at school. She's at that difficult age...

Boss: Am I the father?

Woman: What?

Boss: Am I the father?

Woman: No.

Boss: Okay, then why should I give a shit? Right? Don't you have, like a babysitter or nanny or something?

Woman: I can't afford that.

Boss: Well, you know. If you put in more hours, instead of racing out of here all the time, right? More hours, more money. More money, a babysitter. Problem solved. Crag's got two kids, you don't see him rushing home every time when someone got a <u>nosebleed</u>（鼻出血）. He's here doing his shift...I can't do it.

In this scene, the woman is asking the boss for a short leave on Friday afternoons so as to be able to pick up her child from school. The way they talk and the boss's attitude shows that the woman is a factory worker or a wage laborer. A wage laborer is a person whose primary means of income is from the selling of his or her labor. Wage labor is the socioeconomic relationship between a worker and an employer, where the worker sells their labor under a formal or informal employment contract.

From what they talk about having no money for hiring a babysitter, we can see that employment is no guarantee of escaping poverty, the International Labor Organization (ILO) estimates that as many as 40% of workers are poor, not earning enough to keep their families above the $2 a day poverty line. Both increased employment opportunities and increased labor productivity (as long as it also translates into higher wages) are needed to tackle poverty. Increases in employment without increases in productivity leads to a rise in the number of "working poor", which is why some experts are now promoting the creation of "quality" not "quantity" in labor market policies.

- **Video 15-3:** *There's no way I'm showing you my hotel room*

Man: My first act as DC bureau chief（我上任华盛顿办事处负责人第一件事）— I want you down here full time（我要你到这里做专职）.

Woman: Oh, my God. That's amazing! Yes!

Man: You do know what this means for you?

Woman: Oh, Brian, I will not let you down. I'm gonna bust my ass for you.（为你效犬马之劳）

Man: Well, Rudy, Come on. That's a given（这是板上钉钉的事）. But, uh, look. You do get how I feel about you, right?

Woman: Well, I'm glad you said that, Brian, because I really respect you too.

Man: No. no, I mean. How I really feel. All I want from you, Rudy, is to see the inside of your hotel room. That's all it's gonna take.

Woman: Brian, if I've done anything to make you think I feel that way about you, I apologize. We're friends! We have a great professional vibe（职业氛围，这里指职业关系）. I just don't do that. I've never had to do that for a job.

Man: I know, I know.

Woman: You know I would kill for DC, but there's no way I'm showing you my hotel room.

Man: Well, now I feel like a creep（卑鄙小人）.

Woman: No, you're so not.

…（They fired me. I'm a lousy reporter, apparently, assholes!）

This is a typical work environment scene, the man takes advantage of his position as the woman's boss in an attempt for sexual advance, or job offer in exchange for sex favors. This is a textbook sexual harassment, an unwelcome sexual advance, request for sexual favors, and other verbal or physical conduct of a sexual nature that tends to create a hostile or offensive work environment.

Sexual harassment is a form of sex discrimination that occurs in the workplace. Persons who are the victims of sexual harassment may sue under Title VII of the Civil Rights Act of 1964, which prohibits sex discrimination in the workplace. The federal courts did not recognize sexual harassment as a form of sex discrimination until the 1970s, because the problem originally was perceived as isolated incidents（个别事件）of flirtation in the workplace. Employers are now aware that they can be sued by the victims of workplace sexual harassment.

- **Video 15-4:** *We need sort of play catch up*

Boss: Hello, Peter, What's happening? Um, I'm gonna need you to go ahead and come in tomorrow, so if you can be here around nine, that would be great! Okay? Oh, oh, and I almost forgot, er, I'm also gonna need you go ahead and come in on Sunday, too. Okay? We lost some people this week; we need sort of play catch up（赶工，赶进度）. Thanks.

In this office setting, the poor man is obviously trying to avoid his boss at the knockoff time, but he fails to do so. Overtime is the amount of time someone works beyond normal working hours. In this case, the man is asked by the boss to work Saturday and Sunday.

Most nations have overtime labor laws designed to dissuade or prevent employers from forcing their employees to work excessively long hours. These laws may take into account other considerations than the humanitarian（人道主义的）, such as preserving the health of workers so that they may continue to be productive, or increasing the overall level of employment in the economy. One common approach to regulating overtime is to require employers to pay workers at a higher hourly rate for overtime work. Overtime pay rates can cause workers to work longer hours than they would at a flat hourly rate. Overtime laws, attitudes toward overtime and hours of work vary greatly from country to country and between different economic sectors. Here, the man is bullied by his boss into unwillingly accepting overtime work.

- **Video 15-5: *I can crush you anytime I want***

Boss: But I need you to stay and work late, because you are an invaluable member of this operation. I need you in the position that you're currently in.
Employee: Well, tough shit. Okay? I've been in that position for 8 years now. Why would I stay here after being treated like this?
Boss: Oh, because I make sure that nobody in this industry would ever hire you again.
Employee: Bullshit.
Boss: Oh, oh, no? Because they're gonna want my letter of recommendation. Right? So, I'm perfectly willing to write that you're an insubordinate（不服从的）, dishonest drunk.
Employee: You can't do that! That's not true.
Boss: Let me tell you something. You stupid little runt（矮子，劣等人）. I own you. You're my bitch, so don't walk around here thinking you have free will, because you don't. I can crush you anytime I want. So settle in（安顿下来）, 'cause you are here for the long haul（费时费力的工作）.

In this scene, the boss can bully this man unscrupulously, mostly for the trump card he has in his hand—the letter of recommendation. In the western world, most of the times, a recommendation letter is needed in a job application or job hops.

A recommendation letter or letter of recommendation, also known as a letter of reference, reference letter or simply reference, is a document in which the writer assesses the qualities, characteristics, and capabilities of the person being recommended in terms of that individual's ability to perform a particular task or function. Letters of recommendation are typically related to employment (such a letter may also be called an employment reference or job reference), admission to institutions of higher education, or scholarship eligibility(奖学金推选资格).

In some countries such as Germany, employees can legally claim an employment reference, including the right to a correct, unambiguous(清楚的,明确的) and benevolent(善意的,仁慈的) appraisal. An employment reference letter is usually written by a former employer or manager, but references can also be requested from co-workers and customers. Teachers and professors may also supply references; this typically applies in the case of recommendations for academic purposes, but also for employment, particularly if the person is applying for their first job.

The content of an employment reference letter can cover topics such as: the employee's tasks and responsibilities; the duration of employment or tasks/responsibilities; the position relative to the author of the reference letter; the employee's abilities, knowledge, creativity, intelligence; the employee's qualifications (foreign languages, special skills); the employee's social attitude; the employee's power of rapport; reason(s) of employment termination; some text with the actual recommendation itself (e.g. "I unequivocally recommend ... [name] as a ... [function/role] and would be happy to hire him/her again").

- **Video 15-6:** ***We hope you understand that this is in no way personal***

Lady: Excuse me, Mr. Dale. This way.
Dale: Okay.
Chief: I'm obviously sorry that we're here today, but these are extraordinary times as you very well must know.
Dale: Look, I run risk management(风险管理). I don't really see how that is a natural place

to start cutting jobs...

Lady: We hope you understand that this is in no way personal. A majority of this floor is being let go today. Ms. Bratberg is now going to run through the details of what the firm is offering.

Dale: OK.

Chief: Mr. Dale, the firm is offering you six months <u>severance</u>（离职金，遣散费）at half your salary. You'll keep all <u>unvested options</u>（非归属期权）that you currently hold. <u>Health</u>（医保）will be extended through that period. You have until tomorrow at 4:47 to either take the offer or it will be <u>revoked</u>（撤回）. Do you understand?

Dale: Yes.

Chief: Unfortunately Mr. Dale, due to the highly sensitive nature of your work here, the firm has to take certain <u>precautions</u>（预防措施）, for security purposes that may seem <u>punitive</u>（惩罚性的）in nature. I hope considering your over 19 years of service to the firm, you will understand that these measures are in no way are a reflection of the firm's feelings towards your performance or your character.

Dale: I don't understand.

Lady: She's apologizing for what's about to happen.

Chief: Your company email, access to the server, access to the building, and your mobile data and phone service will all be <u>severed</u>（切断）as of this meeting. And this gentleman will take you to your office so you can clear out your personal belongings.

Dale: What about the, um, what I'm currently working on? I'm <u>in the middle of something</u>（忙于处理某事）...

Chief: The firm has worked out its <u>transition plan</u>（过渡方案）and it's prepared to move forward. But we do appreciate your concern.

Lady: We understand that this is very difficult, and here is my card. Please contact me over the next few weeks if you need any assistance with this transition in your life.

Security: Sir?

Dale: OK...OK...OK.

 This scene shows us a process of an employee being laid off. There are different terminologies for this: firing someone, sacking someone, being let go etc. other <u>euphemisms</u>（委婉语）are downsizing, excess reduction, reduction in force, while "redundancy" is a specific legal term in UK labor law. Layoffs create lower job security overall, and an increased competitiveness for available and opening positions. Layoffs have generally two major effects on the economy and stockholders. Unemployment is the biggest effect on the economy that can come from layoffs. The amount of compensation will usually depend on what level the employee holds in the company.

 A <u>severance package</u>（解雇金，离职金，退职金）is pay and benefits employees receive

when they leave employment at a company. In addition to their remaining regular pay, it may include some of the following: Severance pay was instituted to help protect the newly unemployed. Sometimes, they may be offered for those who either resign, regardless of the circumstances, or are fired.

In the United States, severance agreements are more than just a "thank you" payment from an employer. They could prevent an employee from working for a competitor and waive any right to pursue a legal claim against the former employer. Also, an employee may be giving up the right to seek unemployment compensation. In the United Kingdom, Labor Law provides for redundancy pay（相当于 severance pay）. The maximum amount of statutory（法定的） redundancy pay is £14,250.

A golden handshake（丰厚的退职金）is a clause in an executive employment contract that provides the executive with a significant severance package in the case that the executive loses his or her job through firing, restructuring, or even scheduled retirement. This can be in the form of cash, equity（股票）, and other benefits, and is often accompanied by an accelerated vesting of stock options（优先认股权）.

A golden parachute（黄金降落伞，指规定员工如被解职即可获得大笔补偿金的聘约条款）is an agreement between a company and an employee（usually upper executive）specifying that the employee will receive certain significant benefits if employment is terminated. Most definitions specify the employment termination is as a result of a merger or takeover（兼并或收购）. The benefits may include severance pay, cash bonuses, stock options, or other benefits.

- **Video 15-7: *You know you're turning into a real corporate asshole***

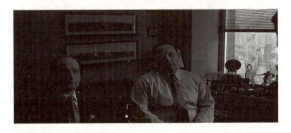

Dan: Guys, I feel really terrible about what I'm about to say. I'm afraid you are both being let go.
1st man: Let go? What's that mean?
Dan: It means you're being fired, Louise. Believe me, if I had any choice in this, I would... Anyway, I thought you should hear from me, because I'm the one who hired you.
1st man: Oh, wait a minute, are you being fired too?
Dan: No, no, um. This isn't my decision.
2nd man: Oh, so it's not your decision, so therefore it's not your fault, right then?
Dan: I didn't say that.

1st man: You know, this is bullshit!

2nd man: Louise.

1st man: No. you know something? I look at you like a brother. I would've stood in front of a bus for you, you piece of shit! You know you're turning into a real <u>corporate asshole</u>（混蛋老板）. You know that, Dan?

Dan: Louise!

1st man: Do me a favor. When you see my friend Dan, tell him I'm looking for him.

Dan: Louise!

2nd man: Dan, what the hell am I gonna tell my wife? I mean, she already <u>wears the pants</u>; now <u>she's gonna wear the tie and jacket, too.</u>（wear the pants 指女人当家掌权；wear the tie and jacket 是进一步幽默诙谐的隐喻）

Dan: Rudy, I am so very sorry.

2nd man: I know this must've been hard for you, Dan. You're a good boss. I mean that you always treated everyone with respect and I...Look, I appreciate it.

In this scene, Dan's friend Louise uses the curse word naming him as a corporate asshole. The English word ass (meaning donkey) may also be used as a term of contempt, referring to a silly or stupid person. In the United States, the words arse and ass become <u>synonymous</u>（同义的）.

Colloquially, the word asshole is mainly used as a <u>vulgarity</u>（粗俗语）, generally to describe people who are viewed as stupid, <u>incompetent</u>（无能的）, unpleasant, or <u>detestable</u>（令人讨厌的）. A corporate asshole is an American slang, usually meaning someone who is a high ranking executive in a company, and viewed by his subordinates as 1. someone who considers himself of much greater moral or social importance than everyone else and likes to criticize and pass judgment on others; 2. who allows himself to enjoy special advantages and does so systematically; 3. who does this out of an <u>entrenched sense of entitlement</u>（根深蒂固的特权意识）; 4. who is <u>immunized</u>（使免疫）by his sense of entitlement against the complaints of other people. 5. who feels he is not to be questioned because of his position and privilege in the company.

Recommending two movies:

The Assistant《女助理》

Office Space《上班一条虫》

15.3 Questions for discussion

1) What's your career plan in the future?
2) What's the most important thing in securing a successful job interview?
3) What's your idea about corporate culture?
4) Do you accept or agree to having a life-long job?
5) Would you consider self-employment after graduation?

15.4 Debate

A *life-long job is a life-long insurance*

15.5 Vocabulary exercises

autonomy, derogatory, humanitarian, insubordinate, revoke, precaution, immunize, punitive, incompetent, sever

Try and fill in the blanks of the following sentences with words listed above in proper forms.

1) During the rampage of the COVID-19, some states in the United States wanted to break away from the federal government and asked for _____.
2) Being demoted from his job title is _____ in nature by the company management.
3) Wearing a mask will not _____ you from the virus attack.
4) The new meaning of this word is neutral, not _____.
5) _____ aid from around the world is flooding to this country after the earthquake.
6) His membership is _____ owing to no payment of the club fee.
7) New measures and _____ are taken and strengthened against the virus infection

in the school.

8) It's a heart wrenching torture and torment to work for an _____ employer.
9) He _____ the relationship with his father after he cut him off in supplying him the daily expense.
10) No boss will like _____ employees.

15.6 Role-play and reenactment

1) Please review Video 15-1, act out the dialogue and feel the part of culture of job interview.
2) Please review Video 15-2, act out the dialogue with your partner and feel the part of corporate culture in America.
3) Please review Video 15-3, act out the dialogue and understand the culture of sexual harassment in corporate settings.
4) Please review Video 15-6, feel the culture about laying off employees.
5) Please review Video 15-7, act out the scene and feel the part of culture of laying off employees.

Chapter 16

TO VOTE & TO BE VOTED FOR
选举生活

16.1 Cultural tidbits

To elect means "to choose or make a decision". An election is a formal decision-making process by which a population chooses an individual to hold public office. This process is also used in many other private and business organizations.

Most democratic constitutions provide that elections are held at fixed regular intervals（间隔）. When elections are called, politicians and their supporters attempt to influence policy by competing directly for the votes of constituents（选民）in what are called campaigns. Supporters for a campaign can be either formally organized or loosely affiliated（附属的, 隶属的, 有党派归属的）, and frequently utilize campaign advertising.

Election campaigns are a game of money spending. American political campaigns have become heavily reliant on broadcast media and direct mail advertising. Though virtually all campaign media are sometimes used at all levels (even candidates for local office have been known to purchase cable TV ads), smaller, lower-budget campaigns are typically more focused on direct mail, low-cost advertising (such as lawn signs), and direct voter contact. This reliance on expensive advertising is a leading factor behind the rise in the cost of running for office in the United States. This rising cost is considered by some to discourage those without well-moneyed（有金钱支持的）connections or money themselves, from running for office. Fundraising techniques include having the candidate call or meet with large donors, sending direct mail pleas（请求, 恳求）to small donors, and courting（向……献殷勤）interest groups（利益集团）who could end up spending millions on the race if it is significant to their interests. The most expensive election campaign included US $7 billion spent on the United States presidential election, in 2012.

(Donald Trump at a 2016 campaign event)

Election fraud（选举欺诈）includes violation of the secret ballot, ballot stuffing, tampering with（篡改）voting machines, destruction of legitimately cast ballots, voter suppression, voter registration fraud, failure to validate voter residency, fraudulent tabulation of results, and use of physical force or verbal intimation at polling places. Among these tampering with machine and fraudulent tabulation（列成表格，列表显示）of results are what Donald Trump has always been accusing the Democrats doing and refusing to accept the voting result in this year's election.

Another way of voting in our daily life is the secret ballot（无记名投票）, a voting method in which a voter's choices in an election is anonymous. The most basic form of secret ballot utilizes blank pieces of paper, upon which each voter writes his or her choice. Without revealing the votes to anyone, the voter would fold the ballot paper and place it in a sealed box, which is emptied later for counting.

An opinion poll（民意调查）is also a way of election, sometimes simply referred to as a poll, is a human research survey of public opinion from a particular sample. Opinion polls are usually designed to represent the opinions of a population by conducting a series of questions.

A referendum（全民公决）is a direct vote in which an entire electorate（全体选民）is asked to vote on a particular proposal. This may result in the adoption of a new law. "Brexit"（英国脱欧）a portmanteau（紧缩词，混合词，合并词）of "British" (or "Britain") and "exit." is the nickname given to the 2016 vote in favor of the UK leaving the European Union. A "Brexiter"（赞同英国脱欧的人）is one who voted in favor of the UK leaving the European Union in 2016.

Suffrage（选举权）is the right to vote in public and political elections (although the term is sometimes used for any right to vote). Woman's suffrage is, by definition, the right of women to vote. This was the goal of the suffragists（尤指在妇女没有选举权的社会中主张妇女拥有选举权的人）and the suffragettes（为妇女争取选举权的女性）.

An election campaign（竞选活动）is an organized effort which seeks to influence the decision making process within a specific group. In democracies, political campaigns often refer to electoral campaigns, by which representatives are chosen or referendums are decided. In modern politics, the most high-profile political campaigns are focused on general elections and candidates for head of state or head of government, often a president or prime minister. The message of the campaign contains the ideas that the candidate wants to share with the voters. It is to get those who agree with their ideas to support them when running for a political position. Running as a candidate for a position requires the applicant or candidates to compete against each other in presenting his ideas and convince the audience or voters for favor or support. The occasion comes in a various forms and levels, from schools to corporate settings, from communities to political campaigns. The most striking features of this speech is stirring（激动人

心的）, agitating（鼓惑煽动的）and arousing（振奋的）in order to gain support and votes from the audience.

16.2 Video examples

- **Video 16-1:** *It's your civic responsibility*

Father: Um, what is it?

Daughter: Egg salad.

Father: Again?

Daughter: You like egg salad.

Father: Well, not every damn day I don't! You could mix up a little.

Daughter: We're on a budget（钱不多的）. You wanna eat better? Drink less beer.

Father: Fine.

Daughter: Fine. And don't forget today.

Father: What's...What's today?

Daughter: Election day, dummy（笨蛋）! I'm supposed to do a report on you voting, remember?

Father: I already told you before I'm not even registered.

Daughter: I registered for you in the mail.

Father: Well, that's great! I could get jury duty（陪审义务）now.

Daughter: It's your civic responsibility（公民义务）.

Father: It's my civic... my what?

Daughter: It's your civic responsibility.

Father: My civic responsibility... Where did you learn this crap（胡扯,鬼话）?

Daughter: Mrs. Abernathy.

Father: Yeah? Well, stay away from her.

Daughter: She is my teacher!

Father: Ah.

In this scene, the precocious（早熟的）daughter is giving her father a lecture on civic responsibility, and reminds him that it's Election Day today.

Election Day（选举日）refers to the day when general elections are held. In many countries, general elections are always held on a Sunday, to enable as many voters as possible to participate, while in other countries elections are always held on a weekday. However, some countries or regions within a country, always make a weekday election day a public holiday, thus satisfying both demands. Many countries permit absentee ballots or early ballots to be cast by mail prior to the election, thereby avoiding the problem altogether.

In the United States, Election Day is the day set by law for the general elections of federal public officials. It is statutorily（法定的）set as "the Tuesday next after the first Monday in the month of November" or "the first Tuesday after November 1". The earliest possible date is November 2, and the latest possible date is November 8（as it was for the 2016 election）.

For federal offices（President, Vice President, and United States Congress）, Election Day occurs only in even-numbered（偶数的）years. Presidential elections are held every four years, in years divisible by four, in which electors for President and Vice President are chosen according to the method determined by each state. Elections to the United States House of Representatives（众议院）and the United States Senate are held every two years; all Representatives are elected to serve two-year terms and are up for election every two years, while Senators serve six-year terms. General elections in which presidential candidates are not on the ballot are referred to as midterm elections（中期选举）. Terms for those elected begin in January the following year; the President and Vice President are inaugurated（sworn in）on Inauguration Day（就职日）, which is usually on January 20. Many state and local government offices are also elected on Election Day as a matter of convenience and cost saving.

Election Day is a civic holiday in some states, including Delaware, Hawaii, Kentucky, Montana, New Jersey, New York, Ohio, and West Virginia. Some other states require that workers be permitted to take time off with pay. California Elections Code Section 14000 provides that employees otherwise unable to vote must be allowed two hours off with pay, at the beginning or end of a shift.

- **Video 16-2:** *It's a social contract*

Daughter: Sign this.

Father: What is it?

Daughter: A questionnaire（问卷，调查表）. I'm supposed to ask you about your politics.

Father: Well, go ahead.

Daughter: I already filled it in. I wanted you to sound smart.

Father: Well, give me the first question anyway.

Daughter: What's your political affiliation（与政党、宗教等的隶属关系）?

Father: Alright, I'm a conscientious objector（出于道德或宗教上的原因而拒服兵役者）.

Daughter: It's not a war, bud. It's an election. And you're an independent（无党派人士）.

Father: Independent? Why in the hell would I be an independent?

Daughter: Because the two party system has neglected the needs of the working poor. That's why.

Father: Let me tell you something, baby...

Daughter: Here we go again.

Father: No. The voting doesn't count（有价值，有重要意义）for a God damn thing. Okay? Just a way to make you feel like you're in control of something. It doesn't matter who you vote for...won't change the fact that we can't afford insurance and if you get sick I'm gonna have to start selling my blood again.

Daughter: Well, Mrs. Abernathy said every vote counts. It's a social contract（社会契约）.

Father: It's a social contract...Well, this Mrs. Abernathy is...is full of shit（满口胡言）.

 In this scene, against daughter's innocence, the cynical father is not ready to vote in the belief that it makes no point in improving poor people's life as well as his.

 Also the father claims he's an independent voter, who is often called an unaffiliated（独立的，无党派的）voter in the United States, is a voter who does not align themselves with a political party. An independent is variously defined as a voter who votes for candidates and issues rather than on the basis of a political ideology or partisanship; a voter who does not have long-standing loyalty to, or identification with, a political party; a voter who does not usually vote for the same political party from election to election; or a voter who self-describes as an independent. Voting systems outside of the United States, including the British parliamentary system, may include independent voters as being "floater voters" or swing voters.（流动投票者或摇摆投票者）

 The father in this dialogue says he is a conscientious objector. A conscientious objector is a person who, on the grounds of freedom of thought, conscience, or religion, resists the authority of the state to perform military service. Such resistance, emerging in time of war, may be based on membership in a pacifistic（和平主义的）religious or on personal religious or humanitarian conviction. Some conscientious objectors consider themselves pacifist, non-interventionist（非干预主义者）, non-resistant（非抵抗者）, non-aggressionist（非侵略者）,

or antimilitarist（反军国主义者）.

A representative conscientious objector in the United States was the boxer Muhammad Ali（穆罕默德·阿里，为美国拳击运动员，三度获得世界重量级拳击冠军）. In 1966, he refused to be drafted（征募，征召……入伍）to join the army to fight in Vietnam war, and his famous words were, "I ain't got no quarrel with them Viet Cong ... They never called me nigger.（我跟越共没有仇，他们从不叫我黑鬼）"

- **Video 16-3**: *Either a veterinarian or Chairman of the Fed*

Molly: All the world's great civilizations have followed the same path, from bondage（奴役）, to liberty（自由）, from liberty to abundance（富裕）, from abundance to complacency（满足）, from complacency to apathy（冷漠）, from apathy back to bondage. If we're to be the exception（例外）to history, then we must break the cycle（打破循环）. For those who do not remember the past are condemned to repeat it.（美国哲学家George Santayana的名言：忘记过去的人注定要重蹈覆辙）

Teacher: Very good, everybody, very good.

Reporter: Hold this.

Teacher: Okay, remember, no running till you get out to the playground.

Reporter: Your last one was great. I'd like to use it on the news.

Teacher: Molly?

Reporter: Yes.

Teacher: Molly, come here. Molly, this is Ms. Madison. She's the reporter from the news.

Reporter: Hi, Molly.

Molly: Hi.

Reporter: How are you doing?

Molly: Good.

Reporter: Your essay was very thoughtful.

Molly: Thanks.

Teacher: Ms. Madison is going to show your essay tonight. Isn't that exciting?

Molly: Yes, Madam.

Reporter: Tell me something, Molly. What do you want to be when you grow up?

Molly: Well, I go back and forth（拿不定主意）, either a veterinarian（兽医）or Chairman of the Fed（美联储主席）.

In this part, the ambitious girl displays her genius in politics at such a young age. When interviewed by the TV reporter, she says her dream swings between two extremes: either a veterinarian or Chairman of the Fed. The Chair of the Board of Governors of the Federal Reserve System is the head of the central banking system of the United States. The position is known colloquially as "Chair of the Fed" or "Fed Chair". The incumbent Chairman is Janet Yellen appointed by Barack Obama since February 1, 2014.

Federal Reserve is the US central bank, a system of 12 Federal Reserve banks, each serving member commercial banks in its own district. This system, supervised by the Federal Reserve Board, has broad regulatory powers（调控权，监管权）over the money supply（货币供应量）and the credit structure（信贷结构）.

- **Video 16-4: *An America where Americans come first***

Bud, in the last four years, President Boone has allowed millions of illegal aliens to cross the border, flooding cities like Los Angeles, New York and Texas. With your help, Bud, my administration will mend our broken borders, and stop insourcing（内包，指将原本外包给供应商的工作分配给内部员工的做法）. A vote for Greenleaf is a vote for America, an America where Americans come first. This land is our land, bud. Help me keep it that way.

In this scene, the presidential candidate is giving a speech in a campaign commercial in an effort to win the vote. His pitch is the US border control, which echoes to the policy of Donald Trump's administration in reality.

Trump's immigration policies were intensely discussed during the campaign. Trump vows to build a more substantial wall on the Mexico-United States border to keep out illegal immigrants, a wall which Trump promises Mexico will pay for. He pledged to massively deport illegal immigrants residing in the United States.

In August 2016, Trump hinted he might soften his position calling for the deportation of all undocumented immigrants. On August 31, 2016, he visited Mexican President Enrique Nieto, saying he wanted to build relations with the country. However, in a major speech later that night, Trump laid out a 10-point plan reaffirming his hard-line positions, including building

a wall along the Mexican border to be paid for by Mexico, potentially deporting "anyone who has entered the United States illegally", denying legal status to such people unless they leave the country and apply for re-entry, and creating a deportation task force. He said the focus of the task force would be criminals, those who have overstayed their visas, and other "security threats".

In 2017, after Trump's ban on admitting immigrants, causing worldwide airport and airplane-scheduling chaos, the <u>ACLU</u> (American Civil Liberties Union: 美国公民自由协会，美国公民自由联盟) and others filed legal briefs challenging the travel ban.

- **Video 16-5:** *Let it never be said that a single vote counts for nothing*

Good evening. This is Kate Madison, coming to you <u>live</u>（现场直播）from Curry County, New Mexico. Over the last 24 hours, the American political process has <u>ground</u>（搁浅）to a <u>virtual standstill</u>（几乎停滞）as the world watches, waiting for the outcome of an election. Earlier today, I uncovered the identity of the person the entire world has been looking for, the one swing voter who will decide this selection. Those of you hoping to hear that decision will be sorely disappointed, because you are about to meet a registered independent who claims to be keeping an open mind. Imagine, on this man's shoulders stands the future of the free world. Let it never again be said, that a single vote counts for nothing.

In this TV report, the woman anchor is announcing the latest development of the election of the US president, which is hanging by a single swing vote. A swing voter or floating voter is a voter who may not be affiliated with a particular political party (Independent) or who will vote across party lines. In American politics, many <u>centrists</u>（中间派）, <u>liberal Republicans</u>（自由共和党派）, and <u>conservative Democrats</u>（保守民主党派）are considered "swing voters" since their voting patterns cannot be predicted with certainty. In the United States, they may be dissatisfied Republicans or Democrats who are open to the idea of voting for other parties, or they could be people who have never had a strong affiliation with any political party, and will vote depending on certain things that influence them: Health care, benefits, election campaign etc. Swing voters occasionally play a huge part in elections, as have happened in the history of Presidential Election.

- **Video 16-6:** *I cannot make my days longer, so I strive to make them better*

Poet Henry David Thoreau once wrote, "I cannot make my days longer, so I strive to make them better." With this election, we here at Carver also have an opportunity to make our high school days better. During this campaign, I've spoken with many of you about your many concerns. I spoke to Eliza Ramirez, a freshman, who says she feels <u>alienated</u>（疏远的，不友好的）from her own <u>homeroom</u>（同一年级教室里的学生）. I spoke to a sophomore, Reggie Banks, who said his mother works in the <u>cafeteria</u>（自助餐馆）and can't afford to buy him enough <u>spiral notebooks</u>（螺旋笔记本）for his classes. I care about Carver and I care about each and every one of you. And together we can all make a difference. When you <u>cast</u>（投）your vote for Tracy Flick next week, you won't just be voting for me. You'll be voting for yourself and for every other student here at Carver. Our days might not be any longer but they can sure be better. Thank you.

In this scene, the girl student is giving a speech in running for President of Student Body (or Student Council). In the US, the Student Government President (generically known as Student Body President, Student Council President, or School President) is the highest-ranking officer of a student government group or a student union association at the high school, college, or university level. It is in Elementary schools too. A student government president is different from a class president. Class presidents represent a specific grade level of students, while a student body president represents students of all grade levels. Class presidents are common in middle and high schools and some colleges and universities in the U.S. A close equivalent would be a freshman, sophomore, junior, or senior class representative (or senator).

The authority and responsibility of Presidents vary according to their respective institutions. Students performing in this role typically serve a ceremonial and managerial purpose, as a spokesperson of the entire student body. The president may oversee his or her association's efforts on student activity events and planning, school policy support from students, budget allocation, fiscal planning, recognition of developing issues pertaining to students, and communication between faculty/staff and the student body.

- **Video 16-7:** *Vote for me, because I don't even want to go to college*

Who cares about this stupid election? We all know it doesn't matter who gets elected president of Carver. Do you really think it's going to change anything around here? Make one single person smarter or happier or nicer? The only person it does matter to is the one who gets elected. The same pathetic <u>charade</u>（易识破的伪装，象征性动作）happens every year, and everyone makes the same pathetic promises, just so that they can put it on their <u>transcripts</u>（成绩单）to get into college. So vote for me, because I don't even want to go to college, and I don't care. And as president, I won't do anything. The only promise I will make is that if elected I will immediately <u>dismantle</u>（解散）the student government, so that none of us will ever have to sit through one of these stupid <u>assemblies</u>（集会）again!

This candidate's speech is more of an outrageous one. She claims that if she is elected, she will dismantle the student government. She actually has no power to do that.

The Student Body President's duties usually include working with students to resolve problems, informing school administration of ideas emanating from the student body, and managing the student government. In this role, they may make student appointments, campus-wide committees and boards, and may represent the institution to other associations or bodies. In the United States, more than 70% of student government presidents are <u>compensated</u>（给……报酬）.

The office holder typically serves one school year in most schools, but some may serve more than one term. Presidents, and sometimes their running mate, the Student Government Vice President, are generally elected via one of three methods: by a general election of the student body at large; by the student council, usually out of its own membership; by the general student body, in elections held after the Student Council has been selected.

16.3 Questions for discussion

1) Talk about an experience where you have been elected to a position.
2) Have you ever voted for someone on an important occasion? What was the result?
3) How much can you learn from being a member of the student Council/Union?
4) How do you balance your academic study and social activities in college?

5) What's your understanding of a civic responsibility?

16.4 Debate

Social order relies on ethics or laws?

16.5 Vocabulary exercises

voluntary, agitating, civic, affiliation, bandage, complacency, standstill, alienated, dismantle, assembly

Try and fill in the blanks of the following sentences with words listed above in proper forms.

1) Most of the food for the homeless is provided by _____ organizations.

2) The president is addressing the _____ on an important decision of the company.

3) Developed countries must _____ trade barriers to poor countries.

4) During the COVID-19 outbreak in 2019, many people's normal life was at a _____.

5) People of different political and religious _____ gathered together in this event.

6) It's our _____ duty to observe public moralities and social ethics.

7) During her _____ speech, the crowd becomes fired up and kept on applauding and shouting.

8) A _____ was put on her knee and some ointment was applied.

9) No one is an _____ island. We are all connected and one piece of a continent.

10) We have achieved something great, but there's still no room for _____.

16.6 Role-play and reenactment

1) Please review videos 16-1 & 2, act out the dialogue and feel the part of culture of father-daughter relationship and culture in America.

2) Please review Video 16-3, and act out the part of the girl's speech in class.

3) Please review Video 16-4, and act out the part of the presidential candidate's speech.

4) Please review Video 16-5, act out the report and feel the part of culture of election in America.

5) Please review videos 15-6 & 7, recite the speech and feel the part of culture of student election in American high schools.

BETWEEN THE FENCES
邻里之间

17.1 Cultural tidbits

A neighbourhood (British English), or neighborhood (American English), is a geographically localized community within a larger city, town, suburb or rural area. A neighborhood is generally defined spatially as a specific geographic area and functionally as a set of social networks. Neighborhoods, then, are the spatial units in which face-to-face social interactions occur—the personal settings and situations where residents seek to realize common values, socialize youth, and maintain effective social control.

Neighborhoods are typically generated by social interaction among people living near one another. In this sense they are local social units larger than households not directly under the control of city or state officials.

Neighborhoods are common, and perhaps close to universal, since most people in urbanized areas would probably consider themselves to be living in one.

Neighborhoods are convenient, and always accessible, since you are already in your neighborhood when you walk out your door.

In addition to these benefits, considerable research indicates that strong and <u>cohesive</u>（团结的）neighborhoods and communities are linked—quite possibly causally linked—to decreases in crime, better outcomes for children, and improved physical and mental health. The social support that a strong neighborhood may provide can serve as a <u>buffer</u>（起缓冲作用的人或物）against various forms of <u>adversity</u>（厄运,逆境）.

(Atypical house in an American upscale neighborhood)

On the mainland of the People's Republic of China, the term is generally used for the

urban administrative division found immediately below the district level, although an intermediate, subdistrict level exists in some cities. They are also called streets (administrative terminology may vary from city to city). Neighborhoods encompass (包含) 2,000 to 10,000 families. Within neighborhoods, families are grouped into smaller residential units or quarters of 100 to 600 families and supervised by a residents' committee (居民委员会). In most urban areas of China, neighborhood, community, residential community, residential unit, residential quarter have the same meaning—社区 or 小区 or 居民区 or 居住区, and is the direct sublevel of a subdistrict (街道办事处), which is the direct sublevel of a district (区), which is the direct sublevel of a city (市).

In the United Kingdom, the term has no general official or statistical purpose, but is often used by local boroughs (自治市镇) for self-chosen subdivisions of their area for the delivery of various services and functions. It is used as an informal term to refer to a small area within a town or city.

In the United States and Canada, neighborhoods are often given official or semi-official (半官方的) status through neighborhood associations, neighborhood watches or block watches. These may regulate such matters as lawn care and fence height, and they may provide such services as block parties, neighborhood parks and community security. In some other places the equivalent organization is the parish (教区), though a parish may have several neighborhoods within it depending on the area.

A neighborhood watch (邻里守望, 居民联防), also called a crime watch or neighborhood crime watch, is an organized group of civilians devoted to crime and vandalism prevention within a neighborhood. The aim of neighborhood watch includes educating residents of a community on security and safety and achieving safe and secure neighborhoods. However, when a criminal activity is suspected, members are encouraged to report to authorities, and not to intervene (干预).

In the United States, neighborhood watch builds on the concept of a town watch from Colonial America (殖民地时期的美国). The town watch program is similar to that of the neighborhood watch, the major difference is that the Town Watch tend to actively patrol in pseudo-uniforms (非正规的制服), i.e. marked vests or jackets and caps, and is equipped with two way radios to directly contact the local police. The Town Watch serves as an auxiliary to the police which provides weapons (if any), equipment, and training. The town watch usually returns their gear at the end of their duty. Like the town watchman of colonial America, each civilian must take an active interest in protecting his or her neighbors and be willing to give his or her time and effort to this volunteer activity.

(A warning sign set up by the neighborhood watch)

　　With neighborhood comes community. A community is commonly considered a social unit (a group of people) who have something in common, such as norms, values, identity, and often a sense of place that is situated in a given geographical area (e.g. a village, town, or neighborhood). The word "community" derives from the Old French comuneté which comes from the Latin communitas (from Latin communis, things held in common). Although communities are usually small relative to personal social ties (micro-level), "community" may also refer to large group affiliations (or macro-level), such as national communities, international communities, and virtual communities. They may share intent, belief, resources, preferences, needs, and risks in common, affecting the identity of the participants and their degree of cohesiveness. These communities are key to our modern day society, because we have the ability to share information with millions in a matter of seconds.

(A warning sign set up by the neighborhood watch)

17.2 Video examples

- **Video 17-1: *Do you want to play in my room?***

Mother: Oh, so many pillows...Which one is your favorite?
Neighbor: Hi, I'm Suzie, your neighbor across the street. I just saw your drive in and wanted to come say hi and make sure I give you these.
Mother: Oh...
Neighbor: They're my special carrot and apple muffins（松饼）, vegans（严格的素食主义者，指不吃任何畜产品如干酪、黄油或牛奶等的素食主义者）in case you are.
Mother: Well, we're omnivores（杂食动物,杂食的人）around here. But thank you, I'm sure they're delicious. It's so nice to meet you. I'm Karen. This is Miles.
Neighbor: Hi, Miles.
Mother: And this is?
Neighbor: This is Finn. He's six.
Son: Do you want to play in my room?
Mother: Go ahead guys.
Son: Cool, let's go upstairs.
Mother: Come on in!

In this dialogue, the woman says she is omnivore. Omnivore is a consumption classification for animals that have the capability to obtain chemical energy and nutrients from materials originating from plant and animal origin.

Other classifications are herbivore（食草动物）: An herbivore is an animal anatomically and physiologically adapted to eating plant material, for example foliage, for the main component of its diet.

Carnivore（食肉动物）: A carnivore is an animal that feeds chiefly on the flesh of other animals. Carnivores include predators such as lions and alligators, and scavengers such as hyenas and vultures.

In this part, we have the word vegan. A vegetarian who eats plant products only, especially

one who uses no products derived from animals, as fur or leather. A vegan is a strict vegetarian, i.e., a person who refrains from using any animal product whatever for food, clothing, or any other purpose. Dietary vegans (or strict vegetarians) refrain from consuming animal products, not only meat but also eggs, dairy products and other animal-derived substances.

- **Video 17-2:** *Would you like to come in?*

Neighbor: Hi, You must be the new neighbors. I'm Lisa Beasly. I live on the other side of the street, and we share a backyard.

Mother: Oh, of course. I'm so glad you came by! I'm Karen Morgan, this is Miles.

Neighbor: Hi, hello! This is just a little "Welcome to the neighborhood" gift.

Mother: Oh..., that's so nice of you, Lisa. Thank you so much.

Neighbor: You're welcome.

Son: Mommy, can we go inside?

Mother: Of course. Would you like to come in?

Neighbor: Oh, sure.

Mother: Please, yeah.

Neighbor: Okay.

Mother: Go ahead, Miles, do you want to <u>lead the way</u>（引路，带路）?

In this scene, the mother is being greeted by a neighbor, who comes also with a gift, which is a bottle of wine, as a token of kindness and welcoming gesture. Gifts usually consist of something for the new house (such as a potted plant, a vase, or a picture frame) or something to be enjoyed during the party (such as a bottle of whiskey, a bouquet of flowers, or a gift basket of foodstuffs).

As we can see here, the bottle is nicely wrapped. In many cultures gifts are traditionally packaged in some way. For example, in Western cultures, gifts are often wrapped in wrapping paper and accompanied by a gift note which may note the occasion, the recipient's name, and the giver's name. In Chinese culture, red wrapping <u>connotes</u>（意味着）luck. Although inexpensive gifts are common among colleagues, associates and acquaintances, expensive or <u>amorous</u>（表示爱情的，含情脉脉的）gifts are considered more appropriate among close

friends, romantic interests or relatives.

- **Video 17-3: *Can you help?***

Woman: Hi, you changed your mind!
Man: Ah, actually, I just wonder if you have a problem with the internet? Mine doesn't seem to be working.
Woman: Yeah.
Girl: Yeah, that happens a lot. Especially when I'm playing Major Quest, my favorite game. I'll teach you how to play later.
Man: That sounds good. Yeah, I was streaming（流播，在线观看）this truly terrible movie. I need to know how it ends.
Woman: Yeah, I can reset the router（路由器）from my phone. OK, it should be back up and running in about five minutes.
Man: Great, Thanks!
Girl: Wait! You are tall.
Man: Uh, Thank you?
Woman: We can't reach the top of our Christmas tree. Can you help?
Man: Yeah, sure.
Woman: Yeah, right this way.

In this scene, the next-door man is asked to help the family to decorate the Christmas tree by putting up Christmas ornaments (usually made of glass, metal, wood, or ceramics). Lighting with electric lights (Christmas lights or, in the United Kingdom, fairy lights) is commonly done. A tree-topper, sometimes an angel but more frequently a star, completes the decoration.

- **Video 17-4: *I thought you would never ask!***

Jill: Hi!

Karen: Hi, I'm Karen Wagner. I live just down the lake, two houses over. Didn't mean to interrupt, but I just want to welcome you to the neighborhood!

Jill: That's so sweet of you, and fast!

Karen: Oh, yes, well, these were actually for a bake sale. I made a few extra, so it's a little bit of a <u>cheat</u>（这里指违规行为）.

Jill: Well, thank you. I'm Jill, by the way.

Karen: Oh.

Jill: Oh, do, do you want to come in?

Karen: I thought you would never ask! Oh, Wow!

In this scene, a new neighbor is welcomed by a woman who comes to the door with a welcome gift of some bakery. A bake sale is common in the United States as a charity fundraising activity, including doughnuts, cupcakes and cookies. Sometimes the activity in schools is held by PTA, i.e. Parent-Teacher Association as a campaign to raise money for the student bodies or a school project.

- **Video 17-5:** *This is what neighbors do*

Woman 1: Let's just think it's all a little dramatic.

Woman 2: You're right.

Woman 3: I want you to take a group and get over to Deversee and 6th.

Woman 1: I doubt he's gone that far.

Woman 3: He's a little boy. Anything is possible. Now the rest of you, I want you to fan out.

Woman 1: We've been on our feet for six hours, Lydia.

Woman 3: If it was the twins, would you stop now?

Woman 1: Has anybody seen officer Wells?

Woman 2: Yes.

Woman 3: Oh, please, I've seen more comets than I've seen that imbecile. We only have a few hours of daylight. Now let's find the body!

Woman 1: Find the boy. You heard the lady.

Mother: Anything yet? Thank you so much for doing this.

Woman 3: Oh, this is what neighbors do. I mean if my security camera hadn't been <u>on the fritz</u> （出故障）. All it does show black, then I could have at least seen where the boy went.

Mother: Come on, please, you can't blame yourself.
Woman 3: Well, you know, just…

　　In this scene, the mother's boy is gone, and the neighbors all join in the search. The woman in this scene may be the head of neighborhood watch whose responsibility includes educating residents of a community on security and safety and achieving safe and secure neighborhoods. However, when a criminal activity is suspected, members are encouraged to report to authorities, and not to intervene.

　　She could also be a <u>citizen observer</u>（公民执勤者）, who is a resident appointed by the chief of police, or by the deputy sheriff, who has met the specific application, background and training requirements for patrolling his or her neighborhood or city subdivision to observe and report suspicious persons and criminal activity. A citizen observer also seeks to mediate between law enforcement and civilians in an effort to establish unity between them. Occasionally, a citizen observer helps law enforcement in the patrolling of businesses as well. A citizen observer is a civilian working in behalf of law enforcement and does not have law enforcement titles, authority or prerogatives. In large cities where a citizen observer patrol is present, crime is often minimized considerably and fewer criminal acts go unreported to authorities. In addition, civilians in the community feel more secure, and better relations exist between law enforcement and them.

- **Video 17-6:** *It's just worth it*

　　One of my next door neighbors is a 90-year old man suffering from <u>Alzheimer's</u>（阿尔茨海默病）, and every single morning at 9 a.m., he knocks on my door and he asks me if I have seen his wife, which means, that every single morning, at 9 a.m., I have to explain to a 90-year old man suffering from Alzheimer's that his wife has been dead for quite some time. Now I've thought about moving. I've thought about just not answering my door in the morning, but to be honest, it's worth it just to see the smile on his face.

　　In this short comedy sketch, the comedian tells a story about his next door neighbor who gets satisfied every time when he knows that his wife has died, without knowing that he has Alzheimer's disease, which is a progressive <u>degenerative</u>（退化的）disease of the brain that causes <u>impairment</u>（损害，损伤）of memory and <u>dementia</u>（痴呆）manifested by confusion, visual-spatial disorientation, impairment of language function progressing from <u>anomia</u>（忘名症）to fluent aphasia, inability to calculate, and <u>deterioration</u>（恶化）of judgment; delusions and <u>hallucinations</u>（幻觉）may occur. The most common degenerative brain disorder, it makes

up 70% of all cases of dementia. Onset is usually in late middle life, and death typically ensues in 5-10 years.

- **Video 17-7: *Can we just deal with this later since we're neighbors?***

Man: Oh!

Woman: Hey, I didn't see you in there.

Man: You didn't see my car either, huh?

Woman: Well, it was blocking my driveway, so...

Man: Ah, I wouldn't say it's blocking your driveway. It's got a pretty wide berth（泊位，停泊处）here.

Woman: En, yeah, but you're over the line.

Man: Over the line?

Woman: Yeah.

Man: This... the line.

Woman: Yeah, well, even if I were over the line, I don't think that means you can just run into my car.

Woman: I'm gonna be late for work, so can we just deal with this later since we're neighbors?

Man: I should report this to my insurance today. I mean, it's a brand-new car. My wife would kill me. You're insured, right?

Woman: Of course, I'm insured.

Man: Okay.

Woman: I really don't see how this is my fault.

Man: Yeah, well, you know, we can just let the insurance companies deal with all that. Okay. There you go. Thank you. Drive safe.

Woman: I always do.

In this scene, the woman is texting and backing up her car and she hits the neighbor's car. Texting while driving（边开车边用手机发短信）leads to increased distraction behind the wheel and can lead to an increased risk of an accident. In 2006, Liberty Mutual Insurance Group conducted a survey with more than 900 teens from over 26 high schools nationwide. The results showed that 87% of students found texting to be "very" or "extremely" distracting. A study by AAA found that 46% of teens admitted to being distracted behind the wheel due to

texting. One example of distraction behind the wheel is the 2008 Chatsworth train collision, which killed 25 passengers. In 2009, the Virginia Tech Transportation Institute released the results of an 18-month study that involved placing cameras inside the cabs of more than 100 long-haul trucks, which recorded the drivers over a combined driving distance of three million miles. The study concluded that when the drivers were texting, their risk of crashing was 23 times greater than when not texting.

<u>Sexting</u>（用手机发送色情信息或照片）is sending, receiving, or forwarding sexually explicit messages, photographs or images, primarily between mobile phones. It may also include the use of a computer or any digital device. The term was first popularized in the early 21st century, and is a <u>portmanteau</u>（两词音义合并的混成词）of sex and texting, where the latter is meant in the wide sense of sending a text possibly with images. In August 2012, the word sexting was listed for the first time in *Merriam-Webster's Collegiate Dictionary*（《韦氏大学英语词典》）.

- **Video 17-8：*I got cash***

Sister: I thought you said you were only visiting. Why are you selling all your stuff?
Brother: I am. But I kind of the need the money to get there and back. Unless you want to let me borrow some.
Sister: Absolutely not. Do mommy and dad know that you're going to London?
Brother: Lily, please. I'm an adult. They don't have to know.
Sister: On the outside, <u>technically</u>（从严格意义上来讲）, yes, you're an adult. But up here, we're talking <u>preschool</u>（幼儿园）.
Customer: Is that car for sale?
Brother: No.
Customer: I could give you three <u>grand</u>（一千英镑，一千美元，一千）for it.
Brother: No man, I'm still making payments on it.
Customer: I got cash.
Brother: Sold.
Sister: <u>Case in point</u>（恰当的例子）.
Brother: Shut up.

In America, there're two major forms of selling personal things in the neighborhood, one is garage sale, the other is yard sale. A garage sale is one of selling used household belongings, typically held outdoors in a driveway or in a garage at the home of the seller. Yard sale is a sale of used or unwanted household belongings, typically held outdoors in the yard of the seller.

Both are an informal event for the sale of used goods by private individuals, in which sellers are not required to obtain business licenses or collect sales tax (though, in some jurisdictions, a permit may be required).

Popular motivations for a garage sale are for "spring cleaning," moving or earning extra money. The seller's items are displayed to the passers-by or those responding to signs, flyers, classified ads or newspaper ads. In some cases, local television stations will broadcast a sale on a local public channel. The venue at which the sale is conducted is typically a garage; other sales are conducted at a driveway, carport, front yard or inside a house. Some vendors, known as "<u>squatters</u>（擅自占地或空屋者）", will set up in a high-traffic area rather than on their own property.

Items typically sold at garage sales include old clothing, books, toys, household decorations, lawn and garden tools, sports equipment and board games. Larger items like furniture and occasionally home appliances are also sold. Garage sales occur most frequently in suburban areas on weekends with good weather conditions, and usually have designated hours for the sale. Buyers who arrive before the hours of the sale to review the items are known as "early birds" and are often professional restorers or resellers. Such sales also attract people who are searching for bargains or for rare and unusual items. Bargaining, also known as haggling, on prices is routine, and items may or may not have price labels affixed. Some people buy goods from these sales to restore them for resale.

In some areas, garage sales have taken on a special meaning to a community and have become events of special local significance. Large areas of a community then hold a <u>communal</u> （公共的, 共有的, 共同的）garage sale involving numerous families at the same time.

- **Video 17-9: *I'm not gonna do $125***

Will: All I know is I bought this for $125.
Customer: I'm not gonna do $125.
Will: I'm not asking you to.

Customer: Okay.

Will: I'm asking $25.

Customer: I'll do $15.

Will: What about $22?

Customer: $20.

Wil: 21.

Customer: Okay.

Customer: How much is this?

Boy: $10.

Will: Hey, that should be $15. I got engaged in that suit.

Boy: I saw you checking out the blender. I can do both for 25.

Customer: All right, deal.

Boy: Rule No. one, always have electricity, so people can test appliances.

In this scene, the man is organizing a sale in his front yard on the lawn, and people from the neighborhood come and girl, asking for prices and bargaining and buying. another case of yard sale. There are other similar terms of sales:

<u>A white elephant sale</u>（不值钱的东西甩卖）. A white elephant sale is a collection of used items being sold, much akin to a yard sale or garage sale, often as a fund-raiser for a cause. A "white elephant sale" sells items that retain some value but have no intrinsic use; White elephant sales are typically organized by non-profit organizations such as churches and schools to raise money for a charity cause or a special occasion like Easter or Mother's Day. They operate in a manner similar to Salvation Army thrift shops. Members or friends of the organization holding the white elephant sale will donate old items which they no longer use, or otherwise no longer care to own. White elephant sales are often useful to buyers and collectors, because they provide a way to purchase older and harder to find items. In the days before online auction and trading websites, white elephant sales, along with thrift stores, yard sales and pawn shops were popular ways to procure collectibles and odd items not available in retail stores.

<u>Jumble sale</u>（义卖）. A jumble sale, bring & buy sale (U. K, Australia, occasionally Canada) or rummage sale (U. S. and Canada) is an event at which second hand goods are sold, usually by an institution such as a local <u>Boys' Brigade Company</u>（基督少年军）, <u>Scout group</u>（童子军）, or church, as a <u>fundraising</u>（筹款）or charitable effort. A rummage sale by a church is called a church sale or white elephant sale.

<u>Thrift store</u>（二手店）. Some larger churches or charities have permanent "thrift stores" where donated goods are offered either daily, weekly, or monthly, etc. The <u>Salvation Army</u>（救世军）and <u>Goodwill Industries</u>（慈善企业）are known for their daily-operated thrift stores, frequently located in donated space in major retail locations. Other "thrift stores" are either for-profit, or operated by corporations which are a charity in name only, as only a small fraction of

profits are used charitably.

Flea market (跳蚤市场). In the U.S., the term refers to many commercial venues where informal sales are conducted, of both second-hand and new goods by different private sellers. Frequently the sellers pay a fee to participate.

Give-away shop (赠送店). Give-away shops, swap shops, free shops, or free stores are stores where all goods are free. They are similar to charity shops, with mostly second-hand items—only everything is available at no cost. Whether it is a book, a piece of furniture, a garment or a household item, it is all freely given away, although some operate a one-in, one-out-type (拿走一件留下一件) policy.

Charity shop (公益店). A charity shop or thrift shop is a retail establishment run by a charitable organization to raise money. Charity shops are a type of social enterprise. They sell mainly used goods such as clothing, books, CDs, DVDs, and furniture donated by members of the public, and are often staffed by volunteers. Because the items for sale were obtained for free, and business costs are low, the items can be sold at competitive prices. After costs are paid, all remaining income from the sales is used in accord with the organization's stated charitable purpose.

Video 17-10: Welcome to the new neighborhood

Neighbor 1: Been a long time since we had a lemonade stand in the neighborhood. Between you and me, yours is better.
Daughter: Thanks.
Mother: Well, have a cookie.
Neighbor 1: Oh, maybe just one for later. Oh, how much do I owe you?
Daughter: A dollar, please.
Neighbor 1: Here you are, sweetie. I'm Ellen, by the way. I live right over there, second house from the corner.
Mother: Hi, Ellen, I'm Rebecca. And this is my daughter, Matty.
Neighbor 1: Pleasure meeting you. Well, I better get back to working my new hip.
Mother: Good luck with that.
Neighbor 2: Hi, Ellen.

Neighbor 1: Lana.

Neighbor 2: I see you met Ellen.

Mother: Oh, yeah, she seems really nice.

Neighbor 2: Yes, and more than a little <u>nosey</u>(爱打听的,好管闲事的). So how is business?

Daughter: You just missed the mad <u>rush</u>(抢购).

Neighbor2: Good, then no waiting in line.

Neighbor 3: This is so cute. Well, I'll take two glasses. Just what the doctor ordered, huh.

Neighbor 2: By the way, this is my friend, Catherine.

Mother: Hi.

Neighbor 3: Hi, welcome to the neighborhood.

Mother: Thanks, you look so familiar!

A <u>lemonade stand</u>(售卖柠檬汁摊点)is a business that is commonly owned and operated by a child or children, to sell lemonade. The concept has become iconic of youthful summertime Americana to the degree that <u>parodies</u>(模仿) and variations on the concept exist across media. The term may also be used to refer to stands that sell similar beverages like iced tea, and even some fruit and vegetables like squash and cucumbers, and sometimes some cookies and cakes, too. In the United States, unlicensed lemonade stands have gotten in trouble with rules about <u>permits</u>(许可证,执照). The stand may be a folding table, while the <u>archetypical</u>(典型的) version is custom-made out of <u>plywood</u>(胶合板) or <u>cardboard boxes</u>(硬纸盒,纸板箱). A paper sign on front advertises the lemonade stand, as is shown in the video.

For education benefit, lemonade stands are often viewed as a way for children to experience business at a young age. The ideas of profit, economic freedom, and teamwork are often attributed to traits lemonade stands can instill. However, unlike a real business, they benefit from free labor and rent, and may have a lack of expenses. And there's the legality problem. In some areas, lemonade stands are usually in technical violation of several laws, including operation without a business license or permit, lack of adherence to health codes, and sometimes child labor laws.

17.3 Questions for discussion

1) Talk about a particular neighbor you have, either a good one or a bad one.
2) What's your view about the difference between China and the west in neighborhood culture?
3) Have you had any experience where you were helped/hurt by a neighbor?
4) Charity, how far is it from you?
5) Have you ever helped someone out of trouble?

17.4 Debate

A good fence makes a good neighbor.

17.5 Vocabulary exercises

cohesive, encompass, intervene, connote, amorous, degenerative, deterioration, impair, hallucination, a case in point

Try and fill in the blanks of the following sentences with words listed above in proper forms.

1) China will never _____ with another sovereign nation's internal affairs.
2) Receiving his _____ letters from her boy friend makes the girl sleepless at night.
3) It's always troublesome to compare the advancement of technology with the _____ ability of learning a foreign language among our youngsters.
4) Facial expressions _____ important meanings in communication.
5) His hearing was _____ in his childhood owing to an accident.
6) The patient has been troubled with _____ and nightmares at night, which the doctors feel helpless about.
7) Winning more and more titles and competitions haven't made the team more _____.
8) _____ is that he never sticks to his plan, and this time again.
9) A river is built to _____ the city.
10) _____ of our environment is appealing to more and more of our attention in the world.

17.6 Role play and reenactment

1) Please review videos 17-1 & 2, act out the dialogues and feel the part of culture of greeting a new neighbor.
2) Please review videos 17-3 & 4, act out the dialogues and feel the part of culture of neighbor's helping out each other.
3) Please review Video 17-5, act out the joke and feel the humor of standup performance.
4) Please review Video 17-6, act out the dialogues and feel the part of culture of texting while driving.
5) Please review videos 17-7 & 8, act out the dialogues and feel the part of culture of yard sale and garage sale in America.

附录1　练习参考答案

第一章

5. Vocabulary exercises

1) comprised of; 2) peddle; 3) slammed; 4) peer pressure; 5) compassion; 6) liquid; 7) integrity; 8) Having no care in the world; 9) mantra; 10) retrieve; 11) insidious; 12) prestige

第二章

5. Vocabulary exercises

1) chatted me up; 2) compelled; 3) flipping; 4) compulsion; 5) succumb to; 6) up your sleeve; 7) flirting; 8) coincidence; 9) tore up; 10) altruism

第三章

5. Vocabulary exercises

1) narcissism; 2) philanthropy; 3) facilitator; 4) Platonic; 5) altruistic; 6) spotted; 7) downplay; 8) exhilarating; 9) compatibility; 10) amenable; 11) anecdote

第四章

5. Vocabulary exercises

1) abrupt; 2) lights up; 3) assent; 4) snuggle; 5) compulsory; 6) sanction; 7) ritual; 8) constant; 9) solemn; 10) sacred; 11) committed; 12) sloppy; 13) conform with (to)

第五章

5. Vocabulary exercises

1) domestic; 2) spouse; 3) status; 4) statutes; 5) motion; 6) intervention; 7) reschedule; 8) not withstanding; 9) penalty; 10) going above and beyond

第六章

5. Vocabulary exercises

1) lenient; 2) drop me off; 3) overwhelmed; 4) refresh; 5) freaked out; 6) cut back on; 7) intrusive; 8) supervised; 9) get in the way; 10) cosseting

第七章

5. Vocabulary exercises

1) inalienable; 2) counterbalance; 3) pours her heart; 4) dehumanizing; 5) make a big deal out of; 6) falling apart; 7) Statistically; 8) distortions; 9) sanctioned; 10) preserve; 11) dress up

第八章

5. Vocabulary exercises

1) deficiency; 2) consent; 3) phenomenal; 4) rivalry; 5) detrimental; 6) proponent; 7) abstinence; 8) discreet; 9) arbitrary; 10) intervene; 11) termination

第九章

5. Vocabulary exercises

1) collaborative; 2) transaction; 3) terminated; 4) assess; 5) expelled; 6) accommodation; 7) compulsory; 8) obsession; 9) deferred; 10) prestige; 11) impeccable; 12) Conscientious; 13) anonymous; 14) indiscretion; 15) jeopardize

第十章

5. Vocabulary exercises

1) on the grounds that; 2) align...with; 3) charismatic; 4) compassion; 5) empathy; 6) pubescent; 7) miss out on; 8) vulnerable; 9) disclosure; 10) enlighten

第十一章

5. Vocabulary exercises

1) perceive; 2) discrepancy; 3) cohesive; 4) narcissistic; 5) predecessor; 6) inflating; 7) glow; 8) egoism; 9) proficiency; 10) Averse to

第十二章

5. Vocabulary exercises

1) revelation; 2) preach; 3) soberly; 4) give in to; 5) perseverance; 6) salvation; 7) discreetly; 8) parallel; 9) condemn; 10) principle

第十三章

5. Vocabulary exercises

1) reverse；2) adverse；3) status quo；4) arbitrary；5) boycott；6) internalize；7) stereotypes；8) undermine；9) unprecedented；10) turn down

第十四章

5. Vocabulary exercises

1) intrusive；2) prospective；3) assault；4) motive；5) compulsory；6) impartial；7) convene；8) non-binding；9) withdrew；10) compelling；11) mandatory

第十五章

5. Vocabulary exercises

1) autonomy；2) punitive；3) immunize；4) derogatory；5) Humanitarian；6) revoked；7) precautions；8) incompetent；9) severed；10) insubordinate

第十六章

5. Vocabulary exercises

1) voluntary；2) assembly；3) dismantle；4) standstill；5) affiliations；6) civic；7) agitating；8) bandage；9) alienated；10) complacency

第十七章

5. Vocabulary exercises

1) intervene；2) amorous；3) degenerative；4) connote；5) impaired；6) hallucinations；7) cohesive；8) A case in point；9) encompass；10) Deterioration

附录2 经典影视台词

《阿甘正传》(Forest Gump)

Life is like a box of chocolates, you never know what you're gonna get.
生命就像一盒巧克力,你永远不知道会吃到什么味道。
If you are ever in trouble, don't try to be brave, just run, just run away.
你若遇上麻烦,不要逞强,你就跑,远远跑开。
Death is just a part of life, something we're all destined to do.
死亡是生命的一部分,是我们注定要做的一件事。
You are no different than anybody else is.
你和别人没有任何的不同。

《乱世佳人》(Gone with the Wind)

Land is the only thing in the world worth working for, worth fighting for, worth dying for, because it's the only thing that lasts.
土地是世界上唯一值得你去为之劳作,为之战斗,为之牺牲的东西,因为它是唯一永恒的东西。
Frankly, my dear, I don't give a damn.
坦白说,亲爱的,我一点也不在乎。
In spite of you and me and the whole silly world going to pieces around us, I love you.
哪怕到了世界末日,天崩地裂,我都会爱着你.
We become the most familiar strangers.
我们变成了世上最熟悉的陌生人。
You're throwing away happiness with both hands, and reaching out for something that will never make you happy.
你把自己的幸福拱手相让 ,去追求一些根本不会让你幸福的东西。

《泰坦尼克》(Titanic)

Outwardly, I was everything a well-brought up girl should be. Inside, I was screaming.
外表看我是个教养良好的小姐,骨子里我在反叛。
Make each day count.
要让每一天都有所值。
I love waking up in the morning and not knowing what's going to happen, or who I'm going to meet, where I'm going to wind up.
我喜欢早上起来时一切都是未知的,不知会遇见什么人,会有什么样的结局。
You jump, I jump.

你跳,我就跟着跳。

《加菲猫》(Garfield)

Money is not everything. There's MasterCard.
钞票不是万能的,有时还需要信用卡。
Behind every successful man, there is a woman. And behind every unsuccessful man, there are two.
每个成功男人的背后都有一个女人;每个不成功的男人背后都有两个。

《甜心先生》(Jerry Maguire)

You had me at hello. 你一句问候我就被你征服了。

《肖申克的救赎》(Shawshank Redemption)

Some birds are not meant to be caged; their feathers are just too bright.
有些鸟儿注定不会被关在牢笼里,因为它们的羽毛太耀眼。
Fear can hold you prisoner, hope can set you free.
怯懦囚禁灵魂,希望赋予自由。
A strong man can save himself; a great man can save another.
强者自救,圣者渡人。

《狮子王》(The Lion King)

Everything you see exists together in a delicate balance.
世界上所有的生命都在微妙的平衡中生存。
When the world turns its back on you, you turn your back on the world.
如果这个世界对你不理不睬,你也可以这样对待它。
I'm only brave when I have to be. Being brave doesn't mean you go looking for trouble.
我只是在必要的时候才会勇敢,勇敢并不代表你要到处闯祸。

《功夫熊猫》(Kung Fu Panda)

One meets its destiny on the road he takes to avoid it.
往往一个人在逃避命运的路上与之不期而遇。

《当幸福来敲门》(The Pursuit of Happyness)

I'm the type of person, if you ask me a question, and I don't know the answer, I'm gonna to tell you that I don't know. But I bet you what: I know how to find the answer, and I'll find the answer.
我是这样的人,如果你问的问题我不知道答案,我会直接告诉你"我不知道"。但我向你保

证：我知道如何寻找答案，而且我一定会找出答案的。

《教父》(Godfather)

Let your friends underestimate your advantages and the enemy overestimate your weaknesses.
让朋友低估你的优点，让敌人高估你的缺点。
Don't hate your enemy, or you will make wrong judgment.
不要憎恨你的敌人，那会影响你的判断力。
I'm going to make him an offer he can't refuse.
我会开出一个他无法拒绝的条件。
Do you spend time with your family? Good. Because a man that doesn't spend time with his family can never be a real man.
你经常跟家人一起吗？不错。因为不顾家的男人永远也成不了真正的男人。

《越狱》(Prison Break)

Keep your friends close and your enemies closer.
跟朋友保持亲密，跟敌人要更亲密。

《罗马假日》(Roman Holiday)

I don't know how to say good bye. I can't think of any words.
我不知道该怎么道别。我想不出告别的话。
Well, life isn't always what one likes, isn't it?
嗯，人生不会尽如人意，不是吗？

《简·爱》(Jane Eyre)

Do you think, because I am poor, obscure, plain, and little, I am soulless and heartless? You think wrong! I have as much soul as you, and full as much heart! And if God had gifted me with some beauty and much wealth, I should have made it as hard for you to leave me, as it is now for me to leave you. I am not talking to you now through the medium of custom, conventionalities, nor even of mortal flesh: it is my spirit that addresses your spirit; just as if both had passed through the grave, and we stood at God's feet, equal—as we are!
难道就因为我一贫如洗、默默无闻、长相平庸、个子瘦小，就没有灵魂，没有心肠了？你想错了！我的心灵跟你一样丰富，我的心胸跟你一样充实！要是上帝赐予我一点姿色和充足的财富，我会使你同我现在一样难分难舍，我不是根据习俗、常规，甚至也不是血肉之躯同你说话，而是我的灵魂同你的灵魂在对话，就仿佛我们两人穿过坟墓，站在上帝脚下，彼此平等——本来就是如此！

《卡萨布兰卡》(Casablanca)

Of all the gin joints in all the towns in all the world, she walks into mine.
世上有那么多城镇，镇上有那么多酒馆，她偏偏走进了我这家。
Louis, I think this is the beginning of a beautiful friendship.
路易斯，我想这是一段美好友谊的开始。

《傲慢与偏见》(Pride and Prejudice)

It is a truth universally acknowledged that a single man in possession of a good fortune must be in want of a wife.
凡是有钱的单身汉，总想娶位太太，这是一条举世公认的真理。

《爱情故事》(Love Story)

Love means never having to say you're sorry!
爱意味着永不要说道歉。

《音乐之声》(Sound of Music)

When the Lord closes a door, somewhere he opens a window.
主现在把这扇门关起来了，但是在某处他为你开了一面窗子。

《四个婚礼一个葬礼》(Four Weddings and a Funeral)

I thought that love would last forever. I was wrong.
我以为爱情会天长地久，我错了。

《我不是天使》(I'm No Angel)

It's not the men in your life that counts; it's the life in your men.
你生命中有哪些男人不重要，重要的是你的男人有没有生命力。

《勇敢的心》(Brave Heart)

Tell your enemies that they may take our lives, but they'll never take our freedom!
告诉敌人，他们也许能夺走我们的生命，但是他们永远夺不走我们的自由！

《老人与海》(The Old Man and the Sea)

A man can be destroyed, but never defeated.
一个人可以被毁灭，但绝不能被打败。

《这个杀手不太冷》(Leon)

Is life always this hard, or is it just when you're a kid? —Always.
人生总是这么苦么,还是只有童年的时候苦?——总是如此。

《绿野仙踪》(The Wizard of Oz)

There's no place like home.
世上没有像家一样美好的地方。(金窝银窝舍不得狗窝)

《我最好朋友的婚礼》(My Best Friend's Wedding)

Choose me. Marry me. Let me make your happy.
选择我,嫁给我,让我来给你幸福。

《全民情圣》(Hitch)

There's only one person that makes me feel like I can fly. That's you.
世上只有一个人让我觉得自己能够飞起来,她就是你。

《如果能再爱一次》(If Only)

If you can hold something up and put it down, it is called weight-lifting; if you can hold something up but can never put it down, it is called burden-bearing. Pitifully, most of people are bearing heavy burdens when they are in love.
举得起放得下叫举重,举得起放不下叫负重。可惜,大多数人的爱情都是负重。

《分手信》(Dear John)

If you leave me, please don't comfort me because each sewing has to meet stinging pain.
离开我就别安慰我,要知道每一次缝补会遭遇穿刺的痛。

《附注我爱你》(P.S. I Love You)

In this world, only those men who really feel happy can give women happiness.
在这个世界上,只有真正快乐的男人才能带给女人真正的快乐。

《返老还童》(Benjamin Button)

I know someone in the world is waiting for me, although I've no idea of who he is, but I feel happy every day for this.
我知道这世上有人在等我,尽管我不知道她是谁,但是我每天会因此而非常快乐。

《恋恋笔记本》(The Notebook)

In your life, there will at least one time that you forget yourself for someone, asking for no result, no company, no ownership nor love. Just ask for meeting you in my most beautiful years.

一生至少该有一次,为了某个人而忘了自己,不求有结果,不求同行,不求曾经拥有,甚至不求你爱我。只求在我最美的年华里遇到你。

《七宗罪》(Seven)

The world is a fine place and worth fighting for. I believe the second part.

这个世界如此美好,值得人们为之奋斗,但我只信后半部分。

《绝望主妇》(Desperate Housewives)

Everyone has a little dirty laundry.

每个人都有一些不可告人的秘密。

《星球大战》(Star wars)

Anakin, this path has been placed before you. The choice is yours alone.

阿纳金,路就在你脚下,你自己决定。

《角斗士》(The Gladiator)

Death smiles at us all. All a man can do is smile back.

死神在向我们每个人微笑,我们所能做的只有回敬微笑。

《原罪》(Original Sin)

I am someone else when I'm with you, someone more like myself.

当我与你相处时,我变成了另外一个人,一个更像我自己的人。

《搏击俱乐部》(The Fight Club)

The things you own end up owing you.

你所拥有的东西最终拥有了你。

《第六感》(The Sixth Sense)

Sometimes people think they lose things and they didn't really lose them. It just gets moved.

人们有时以为失去了什么,其实没有,只是被移到了别处。

《魔戒》（Lord of the Rings）

There's some good in this world, and it's worth fighting for.
这世上一定存在着善良，值得我们奋战到底。

《剪刀手爱德华》（Edward Scissorhands）

I love you not because of who you are, but because of who I am when I am with you.
我爱你并不因为你是谁，而是在你面前我可以成为谁。

《飞屋环游记》（UP!）

It's nice to be sitting alone with a person without having to talk.
能和一个人坐在一起而不必交谈真好。

《廊桥遗梦》（The Bridges of Madison County）

We all live in the past. we take a minute to know someone, one hour to like someone, and one day to love someone, but the whole life to forget someone.
我们每个人都生活在各自的过去中，人们会用一分钟的时间去认识一个人，用一小时的时间去喜欢一个人，再用一天的时间去爱上一个人，到最后呢，却要用一辈子的时间去忘记一个人。

《英国病人》（The English Patient）

——Will you love me for the rest of my life?
——No, I'll love you till the end of my life.
——你会爱我直到我生命的尽头吗？
——不，我会爱你直到我生命的尽头。

《消失的爱人》（Gone Girl）

If we're together, everything else is just background noise.
只要我们在一起，尘世一切只是背景噪音。

《死亡诗社》（Dead Poets Society）

Carpe diem. Seize the day, boys.
孩子们，及时行乐，把握今天。

附录3 中国大学生跨文化能力自测量表

（吴卫平等，2018）

填写说明： 本部分是中国大学生跨文化能力自评量表，包括六个方面（本国文化知识、外国文化知识、跨文化态度、跨文化交流技能、跨文化认知技能、跨文化意识）。请依据你自己的实际情况，从"1"到"5"中选择一个数字进行自我评分并在数字上打钩（"1"代表程度最低，依次递增，"5"代表程度最高），具体参照如下：

1	2	3	4	5
非常弱/些微	较弱/较少	一般/一些	较强/较多	非常强/非常多

1. 本国文化知识

1) 了解本国的历史知识　　　　　　　　　　　　　　（1 2 3 4 5）
2) 了解本国的社会规范知识　　　　　　　　　　　　（1 2 3 4 5）
3) 了解本国的价值观知识　　　　　　　　　　　　　（1 2 3 4 5）

2. 外国文化知识

4) 了解外国的历史知识　　　　　　　　　　　　　　（1 2 3 4 5）
5) 了解外国的社会规范知识　　　　　　　　　　　　（1 2 3 4 5）
6) 了解外国的价值观知识　　　　　　　　　　　　　（1 2 3 4 5）
7) 了解外国的文化禁忌知识　　　　　　　　　　　　（1 2 3 4 5）
8) 了解外国人言语行为知识　　　　　　　　　　　　（1 2 3 4 5）
9) 了解跨文化交流与传播等概念的基本知识　　　　　（1 2 3 4 5）
10) 了解一些成功进行跨文化交流的策略和技巧　　　（1 2 3 4 5）

3. 跨文化态度

11) 愿意和来自不同文化的外国人进行交流和学习　　（1 2 3 4 5）
12) 愿意尊重外国人的生活方式和习俗　　　　　　　（1 2 3 4 5）
13) 愿意学好外国语言和文化　　　　　　　　　　　（1 2 3 4 5）

4. 跨文化交流技能

14) 出现跨文化交流误解时和对方协商的能力　　　　（1 2 3 4 5）
15) 出现语言交流障碍时借助身体语言或其他非语言方式进行交流的能力
　　　　　　　　　　　　　　　　　　　　　　　　（1 2 3 4 5）
16) 使用外语和来自不同社会文化背景和领域的人进行成功交流的能力
　　　　　　　　　　　　　　　　　　　　　　　　（1 2 3 4 5）

17) 在与外国人交流时礼貌对待他们的能力　　　　　　　　　　(1　2　3　4　5)
18) 在与外国人交流时尽量避免用不恰当的语言和行为冒犯他们的能力
　　　　　　　　　　　　　　　　　　　　　　　　　　　(1　2　3　4　5)
19) 在与外国人交流时尽量避免对他们产生偏见的能力　　　　　(1　2　3　4　5)
20) 在与外国人交流时会避免提到他们有关隐私话题的能力　　　(1　2　3　4　5)
21) 具有对跨文化差异敏感性的能力　　　　　　　　　　　　　(1　2　3　4　5)
22) 看待其他国家发生的事件时会从对方文化和多角度看问题的能力
　　　　　　　　　　　　　　　　　　　　　　　　　　　(1　2　3　4　5)

5. 跨文化认知技能

23) 具备通过与外国人的接触直接获取跨文化交际相关知识的能力
　　　　　　　　　　　　　　　　　　　　　　　　　　　(1　2　3　4　5)
24) 具备运用各种方法、技巧与策略帮助学习外国语言和文化的能力
　　　　　　　　　　　　　　　　　　　　　　　　　　　(1　2　3　4　5)
25) 出现跨文化冲突和误解时进行反思和学习并寻求妥善解决途径的能力
　　　　　　　　　　　　　　　　　　　　　　　　　　　(1　2　3　4　5)

6. 跨文化意识

26) 意识到与外国人交流时彼此存在文化相似性和差异性　　　　(1　2　3　4　5)
27) 意识到与外国人交流时文化身份的差异性　　　　　　　　　(1　2　3　4　5)
28) 意识到要基于不同文化视角审视跨文化交流情景　　　　　　(1　2　3　4　5)
29) 意识到英文名字及其背后的文化内涵　　　　　　　　　　　(1　2　3　4　5)
30) 意识到身边英语标识的意义,并有查询弄懂的想法　　　　　(1　2　3　4　5)
31) 意识到一个好的英语句子,并大声朗读它　　　　　　　　　(1　2　3　4　5)
32) 意识到英语背诵对语言学习的重要性　　　　　　　　　　　(1　2　3　4　5)
33) 意识到自己有时候说出或写下的是中式英文　　　　　　　　(1　2　3　4　5)
34) 意识到英语表达的多样性　　　　　　　　　　　　　　　　(1　2　3　4　5)
35) 意识到自己喜欢的欧美流行文化的深层次特点　　　　　　　(1　2　3　4　5)
36) 意识到听、唱英文歌的重要性　　　　　　　　　　　　　　(1　2　3　4　5)
37) 意识到公众场合英语演讲的重要性　　　　　　　　　　　　(1　2　3　4　5)
38) 意识到手势语的中英文化差别　　　　　　　　　　　　　　(1　2　3　4　5)
39) 意识到跟外教在真实场合交流的重要性　　　　　　　　　　(1　2　3　4　5)
40) 意识到从影视作品中学习文化的重要性　　　　　　　　　　(1　2　3　4　5)

References

[1] Schacter, Daniel L., Gilbert, Daniel T., and Wegner, Daniel M. Human Needs and Self-Actualization[M]. Psychology(2nd ed.). New York: Worth, Incorporated, 2011.

[2] Kipling, Rudyard. The Second Jungle Book[M]. Middlesex: The Echo Library, 2007.

[3] Berne, Eric. Sex in Human Loving[M]. NY: Penguin Books, 1970.

[4] Putzi, Sibylla. A to Z World Lifecycles: 175 Countries—Birth, Childhood, Coming of Age, Dating and Courtship, Marriage, Family and Parenting, Work Life, Old Age and Death[M]. LA: World Trade Press, 2008.

[5] Kontula, O & Mannila, E. Sexual Activity and Sexual Desire[M]. NY, Routledge, 2009.

[6] Roughgarden, Joan. Diversity, Gender, and Sexuality in Nature and People[M]. LA, University of California Press, 2004.

[7] Luker, Kristen. When Sex Goes to School: Warring Views on Sex—and Sex Education—since the Sixties[M]. London, W. W. Norton & Company, 2006.

[8] Kelly, Kimberly. The Spread of "Post Abortion Syndrome" as Social Diagnosis[J]. Social Science & Medicine.102: 18-25, 2014.

[9] Okonofua, F. Abortion and Maternal Mortality in the Developing World[J]. Journal of Obstetrics and Gynaecology. Canada, 2006 (11): 974-979.

[10] Parents Explore Dating Scene for Choosy Children. Beijing: China Daily. 2010-12-09.

[11] Martin, Judith. Miss Manners on Painfully Proper Weddings New York[M]: Crown Publishers, 1995: 126.

[12] Emmett, William. The National and Religious Song Reader[M]. New York: Haworth Press, 1996: 755.

[13] Howard, Vicky. Brides Inc.: American Weddings and the Business of Tradition[M]. Philadelphia: University of Pennsylvania Press, 2006: 34.

[14] Macfarlane, Michael. Wedding Vows: Finding the Perfect Words[M]. NY: Sterling Publishing Company, 1999.

[15] Sen, Amartya. Gender and Cooperative Conflicts. In Tinker, Irene. Persistent Inequalities[M]. New York: Oxford University Press, 1990: 123-149.

[16] Mowbray, Albert H.; Blanchard, Ralph H. Insurance: Its Theory and Practice in the United States (5th ed.)[M]. New York: McGraw-Hill, 1961: 73.

[17] Teachman, Jay. Premarital Sex, Premarital Cohabitation, and the Risk of Subsequent

Marital Dissolution among Women[J]. Journal of Marriage and Family, 2004: 65(2): 444-455.

[18] Smith, L. K.; Fowler, S. A. "Positive Peer Pressure: The Effects of Peer Monitoring on Children's Disruptive Behavior". Journal of Applied Behavior Analysis, 1984: (2): 213-227.

[19] Leila J. Rupp, Toward a Global History of Same-Sex Sexuality[J]. Journal of the History of Sexuality 10, 2001: 287-302.

[20] Rosario, M., Schrimshaw, E., Hunter, J., & Braun, L. Sexual Identity Development among Lesbian, Gay, and Bisexual Youths: Consistency and Change over Time[J]. Journal of Sex Research, 2006: 43(1), 46-58.

[21] Manning, Robert D. Credit Cards on Campus: The Social Costs and Consequences of Student Debt[M]. Washington, D.C.: Consumer Federation of America, 1999.

[22] Petrina, S. Advance Teaching Methods for the Technology Classroom (pp.125-153). Hershey, PA: Information Science Publishing, 2007.

[23] Walters, Margaret. Feminism: A Very Short Introduction[M]. Oxford University, 2005: 1-176.

[24] Astell, Mary. "Inspired by Ideas (1668-1731)". In Spender, Dale. There's Always Been a Women's Movement[M]. London: Pandora Press, 1983: 29.

[25] Russell Hochschild, Arlie; Machung, Anne. The Second Shift: Working Families and the Revolution at Home[M]. New York: Penguin Books, 2003.

[26] Chivers, M. L.; Rieger, G.; Latty, E.; Bailey, J. M. A Sex Difference in the Specificity of Sexual Arousal[J]. Psychological Science, 2004 (11).

[27] Woodman, Dan; Wyn, Johanna. Youth and Generation Rethinking Change and Inequity in the Lives of Young People[M]. London: Sage Publications Ltd., 2015: 122.

[28] Strauss, William; Neil Howe. Generations: The History of Americas Future[M], 1584 to 2069. New York: Harper Perennial, 1991: 279.

[29] O'Brian, Harriet. The Complete Guide to Cathedral Cities in the UK[M]. London, 2009.

[30] Kodjak, Andrej. A Structural Analysis of the Sermon on the Mount[M]. New York: M. de Gruyter, 1986.

[31] McConahay, J. B. Modern Racism and Modern Discrimination: The Effects of Race, Racial Attitudes, and Context on Simulated Hiring Decisions[J]. Personality and Social Psychology Bulletin, 1983 (4): 551-558.

[32] Wildman, Stephanie M. Privilege Revealed: How Invisible Preference Undermines America[M]. NYU Press, 1996: 87.

[33] Fukurai, Hiroshi. Race, Social Class, and Jury Participation: New Dimensions for

Evaluating Discrimination in Jury Service and Jury Selection[J]. Journal of Criminal Justice, 1996 (1): 71-88.

[34] Mahoney, Kevin J. Relentless Criminal Cross‑Examination. Costa Mesa [M]. California: James Publishing, 2008.

[35] Davenport, Thomas H. Thinking for a Living: How to Get Better Performance and Results from Knowledge Workers[M]. Boston: Harvard Business School Press, 2005.

[36] Drucker, Peter F. Management Challenges of the 21st Century [M]. New York: Harper Business, 1999.

[37] Arrow, Kenneth J. Social Choice and Individual Values. 2nd ed. [M]. New Haven, CT: Yale University Press, 1963.

[38] Mueller, Dennis C. Constitutional Democracy[M]. Oxford: Oxford University Press, 1996.

[39] Rubin, H. J. Renewing Hope within Neighborhoods of Despair: The Community‑Based Development Model[M]. Albany, NY: State University of New York, 2000.

[40] Racino, J. Public Administration and Disability: Community Services Administration in the US[M]. London and NY: CRC Press, 2014.

[41] Richard Francis. Fruitlands: The Alcott Family and Their Search for Utopia[M]. New Haven: Yale University Press, 2010.

Bibliography

[1] Byram M. Teaching and Assessing Intercultural Communicative Competence [M]. Clevedon: Multilingual Matters, 1997.

[2] Byram M., Gribkova B. & Starkey H. Developing the Intercultural Dimension in Language Teaching: A Practical Introduction for Teachers [M]. Strasbourg: Council of Europe, 2002.

[3] Baumann, U. & M. Shelley. Distance Learners of German and Intercultural Competence [J]. Open Learning, 2006 (21): 191-204.

[4] Chen, G. M. & Starosta, W. J. Intercultural Communication Competence: A Synthesis [J]. Communication Yearbook, 1996 (19): 353-383.

[5] Deardorff, D. K. The Identification and Assessment of Intercultural Competence as a Student Outcome of International Education at Institutions of Higher Education in the United States [P]. Unpublished dissertation, North Carolina State University, Raleigh, 2004.

[6] English, S. L. Internationalization through the Lens of Evaluation [A]. In Mestenhauser, J. A. & Ellingboe, B. J. (eds). Reforming the Higher Education Curriculum [C]. Phoenix, AZ: Oryx, 1998: 179-197.

[7] Fantini A. E. Assessing Intercultural Competence: Issues and Tools [A]. In Deardorff D. K. (ed.) The SAGE Handbook of Intercultural Competence [C]. London: Sage Publications, 2009: 456-476.

[8] Freire, P. & D. Macedo. Ideology Matters [M]. Boulder. Colo.: Rowman and Littlefield, 1998.

[9] Gómez, R., Fernando, L. Fostering Intercultural Communicative Competence through Reading Authentic Literary Texts in an Advanced Colombian EFL Classroom: A Constructivist Perspective [J]. Profile Issues in Teachers Professional Development, 2012(1).

[10] Kim, Y. Y. Becoming Intercultural: An Integrative Theory of Communication and Cross-Cultural Adaptation[M]. Thousand Oaks, CA: Sage Publications, Inc., 2001.

[11] Lustig, M. W. & Koester, J. Intercultural Competence. Interpersonal Communication across Cultures [M]. Boston: Allyn and Bacon, 2003.

[12] Readings on Communicating with Strangers: An Approach to Intercultural Communication [C]. New York: McGraw-Hill, 1992: 401-414.

[13] Spitzberg B. H. & Changnon G. Conceptualizing Intercultural Competence [A]. In Deardorff D. K. (ed.) The SAGE Handbook of Intercultural Competence [C]. London: Sage Publications, 2009: 2.

[14] Samovar, L. A. & R. E. Porter. Communication between Cultures [M]. Beijing: Peking University Press, 2004.

[15] Sinicrope, C., Norris, J. & Watanabe, Y. Understanding and Assessing Intercultural Competence: A Summary of Theory, Research, and Practice (technical report for the foreign language program evaluation project) [J]. Second Language Studies, 2007 (1): 1-58.

[16] Spitzberg, B. H. A Model of Intercultural Communication Competence [A]. In Samovar, L. & Porter, R. (eds) Intercultural Communication: A Reader [C]. Belmont, CA: Wadsworth, 2000.

[17] Trooboff, S., Vande Berg, M. & Rayman, J. Employer Attitudes toward Study Abroad [J]. Frontiers: The Interdisciplinary Journal of Study Abroad, 2007 (15): 17-33.

[18] Wiseman, R. L. Intercultural Communication Competence [A]. In Gudykunst, W. B. (eds) Cross-Cultural and Intercultural Communication [C]. Thousand Oaks, CA: Sage, 2003: 167-190.

[19] 贾玉新. 跨文化交际学[M]. 上海：上海外语教育出版社, 1997.

[20] 刘宝权. 跨文化交际能力与语言测试的接口研究[D]. 上海：上海外国语大学, 2004.

[21] 许力生. 跨文化能力构建再认识[J]. 浙江大学学报（人文社会科学版）, 2011(3): 132-139.

[22] 杨洋. 跨文化交际能力的界定与评价[D]. 北京：北京语言大学, 2009.

[23] 张卫东, 杨莉. 跨文化交际能力体系的构建——基于外语教育视角和实证研究方法[J]. 外语界, 2012(2): 8-16.

[24] 王艳萍, 余卫华. 非英语专业大学生跨文化交际能力的对比研究[J]. 南华大学学报（社会科学版）, 2008(3): 103-106.

[25] 吴卫平, 樊葳葳, 彭仁忠. 中国大学生跨文化能力维度及评价量表分析[J]. 外语教学与研究, 2013(4): 581-592.

[26] 常晓梅, 赵玉珊. 提高学生跨文化意识的大学英语教学行动研究[J]. 外语界, 2012(2): 27-34.

[27] 迟若冰, 张红玲, 顾力行. 从传统课程到慕课的重塑——以《跨文化交际》课程为例[J]. 外语电化教学, 2016(6): 29-34.

[28] 付小秋, 张红玲. 综合英语课程的跨文化教学设计与实施[J]. 外语界, 2017(1): 89-95.

[29] 葛春萍, 王守仁. 跨文化交际能力培养与大学英语教学[J]. 外语与外语教学, 2016(2): 79-86.

[30] 顾晓乐. 外语教学中跨文化交际能力培养之理论和实践模型[J]. 外语界, 2017(1): 79-88.

[31] 何克抗. 从 Blending Learning 看教育技术理论的新发展（上）[J]. 中国电化教育,

2004(3): 5-10.

[32] 胡文仲. 跨文化交际能力在外语教学中如何定位[J]. 外语界, 2013(6): 2-8.
[33] 黄文红. 过程性文化教学与跨文化交际能力培养的实证研究[J]. 解放军外国语学院学报, 2015(1): 51-58.
[34] 廖鸿婧, 李延菊. 大学英语课程评估与跨文化能力培养的实证研究[J]. 外语与外语教学, 2017(2): 18-25.
[35] 刘晓民. 论大学英语教学思辨能力培养模式构建[J]. 外语界, 2013(5): 59-66.
[36] 彭仁忠. 中国大学生跨文化路径研究[M]. 北京: 中国社会科学出版社, 2017.
[37] 彭仁忠, 吴卫平. 跨文化能力视域下的中国大学生跨文化接触路径研究[J]. 外语界, 2016(1): 70-78.
[38] 孙淑女, 许力生. 大学英语教学中计算机主导的跨文化能力培养研究[J]. 外语界, 2014(4): 89-95.
[39] 孙有中. 外语教育与跨文化能力培养[J]. 中国外语, 2016(3): 1, 17-22.
[40] 王艳. 以语言能力、思辨能力和跨文化能力为目标构建外语听力教学新模式[J]. 外语教学, 2018(6): 27, 69-73.
[41] 颜静兰. 外语教学中的跨文化教育实践与思考——以英语报刊公选课为例[J]. 外语界, 2018(3): 18-23.
[42] 杨桂华, 赵智云. 培养跨文化能力的大学英语阅读教学实践研究[J]. 外语界, 2018(3): 24-29.
[43] 杨华, 李莉文. 融合跨文化能力与大学英语教学的行动研究[J]. 外语与外语教学, 2017(2): 9-17.
[44] 张红玲. 以跨文化教育为导向的外语教学: 历史、现状与未来[J]. 外语界, 2012(2): 2-7.
[45] 张红玲, 赵涵. 民族志跨文化外语教学项目的设计、实施与评价[J]. 外语界, 2018(3): 2-9, 45.
[46] 郑萱, 李孟颖. 探索反思性跨文化教学模式的行动研究[J]. 中国外语, 2016(3): 4-11.
[47] 胡文仲. 跨文化交际学概论[M]. 北京: 外语教学与研究出版社, 1999.
[48] 胡文仲. 跨文化交际能力在外语教学中如何定位[J]. 外语界, 2013(6).